COMMERCIAL VISIONS

COMMERCIAL VISIONS

SCIENCE, TRADE, AND VISUAL CULTURE
IN THE DUTCH GOLDEN AGE

Dániel Margócsy

THE UNIVERSITY OF CHICAGO PRESS
CHICAGO & LONDON

Dániel Margócsy is assistant professor at Hunter College, City University of New York.

The University of Chicago Press, Chicago 60637
The University of Chicago Press, Ltd., London
© 2014 by The University of Chicago
All rights reserved. Published 2014.
Printed in the United States of America

23 22 21 20 19 18 17 16 15 14 1 2 3 4 5

ISBN-13: 978-0-226-11774-4 (cloth)
ISBN-13: 978-0-226-11788-1 (e-book)
DOI: 10.7208/chicago/9780226117881o.01.0001

Published with generous support from:
C. Louise Thijssen-Schoute Stichting
The Shuster Faculty Fellowship Fund, Hunter College
Stichting Historia Medicinae
The Warner Fund, The University Seminars, Columbia University

Library of Congress Cataloging-in-Publication Data

Margócsy, Dániel, author.
Commercial visions : science, trade, and visual culture
in the Dutch Golden Age / Dániel Margócsy.
pages cm
Includes bibliographical references and index.
ISBN 978-0-226-11774-4 (cloth : alkaline paper) — ISBN 978-0-226-11788-1 (e-book) 1. Science—
Netherlands—History. 2. Netherlands—Commerce—History. 3. Scientists—Netherlands.
I. Title.
Q127.N2M37 2014
382.09492—dc23
2014006569

CONTENTS

LIST OF ILLUSTRATIONS

FIGURES

TABLES

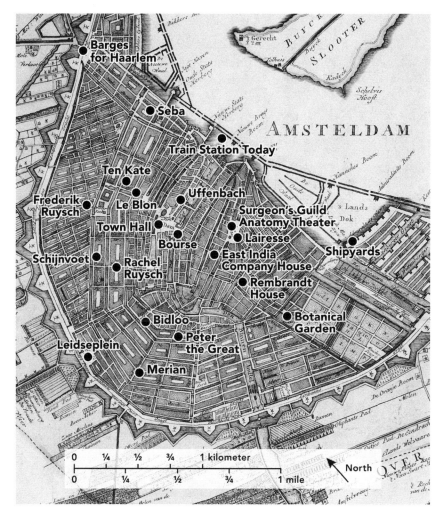

Fig. I/1. This map of Amsterdam shows the lodgings of this book's characters (not necessarily at the same point in time), together with major points of interest back then and today. For each character, only one domicile is shown even when several locations are documented. Mol, *Nieuwe Kaart van de Wydberoemde Koopstat Amsteldam,* Amsterdam, 1770, map by William Rankin.

❧ I ❧

BARON VON UFFENBACH GOES ON A TRIP

THE INFRASTRUCTURE OF INTERNATIONAL SCIENCE

"We arrived in Amsterdam finally at eleven o'clock around mid-day, where we had a bite at Mr. Henckel's in the *Groote Keysershof or the Emden Arms* on the Nieuwendijk."[1] And so began the extended stay of Baron Zacharias Conrad von Uffenbach in Amsterdam with a lunch at his lodgings on the street that is the thoroughfare today for tourists walking from the Central Railway Station to the Town Hall on the Dam. Back in 1710, when the 29-year-old Uffenbach was in the second year of his leisurely travels across Northern Europe in the company of his younger brother Johann Friedrich, the street was just as narrow and filled with shops as nowadays. Not a man to waste his time, Uffenbach hastened to the theater soon after lunch to watch a comedy at four o'clock, but complained about the low quality of the musicians. In the following days, Uffenbach dined at the private garden of a local patrician, bought travel supplies, and visited the Nieuwekerk on the Dam, praising the woodwork of its pulpit.

The two brothers also explored what the city had to offer for lovers of learning, science, and the arts. While Johann Friedrich lavished his money on "the beautiful engravings of the Old Masters" in Nicolaas Visscher's shop for art and maps, Baron Zacharias Conrad set his eyes on a shop across from his lodgings on the Nieuwendijk that offered "all sorts of curiosities" for the tourist.[2] Heeding to the age-old stereotype, Zacharias Conrad expected to see an assortment of cheap, Delftware porcelain knickknacks daubed in blue, but the shop turned out to be a veritable treasure trove. Shells and other *naturalia*, *artificialia*, cameos, paintings,

and antiquities filled the shelves, but the shopkeeper priced them too highly. "He offered a beautiful, almost four-feet tall, Andromeda made out of metallic ore, for a hundred Dutch guilders, and a Hercules, made out of stone, for seventeen guilders," complained our German tourist, whose penchant for spending was matched only by his eagerness to deplore the greediness of shopkeepers. In the end, he decided to purchase a large number of cameos and ancient coins.[3]

Uffenbach was the ideal type of the wealthy, learned traveler of early modern Europe, with an interest in antiquities, the arts, and, importantly, what we call the natural sciences today.[4] During his travels between 1709 and 1711, he stopped for months in major cities, such as Amsterdam and London, and spent several days in smaller towns that a twenty-first-century tourist would be finished within half a day. A well-educated *curioso,* a freethinker, and a renowned collector of books, he burrowed in private and public libraries for long days, carefully noting down what they held, and engaged in conversation with local scholars, amateur scientific practitioners, merchants, and artisans. He visited churches, both Catholic and Protestant, and even went to a service at the Portuguese synagogue of Amsterdam, remarking on its divergence from the Judaic tradition in Germany. And, to turn to this book's main subject, he also frequented botanical gardens, anatomical theaters, and cabinets of curiosities to learn about the new discoveries of human anatomy, never ceasing to admire the numerous shells, insects, and plants that the Dutch had imported from the East and West Indies.

When, after a visit to England, Uffenbach returned to Amsterdam in February 1711, he therefore paid a visit to the renowned naturalist Maria Sibylla Merian, whose groundbreaking research on insect metamorphosis was universally praised.[5] Although she was already sixty-two, Uffenbach found her a "spirited, industrious woman with rather polite manners, very skillful in the painting of watercolors."[6] Merian told him how she had left Nuremberg after her husband's death to come to Amsterdam (in reality, the two of them had separated and the husband was still alive). The naturalist also told him about her extended stay in Suriname, a Dutch sugar plantation colony in Latin America, cut short after a year and a half only because she could not bear the heat. Uffenbach was pleased to see her numerous drawings of the colony's fauna and flora, as well as her designs for Georg Eberhard Rumphius' *Amboinsche Rariteit-kamer,* an atlas of the seashells and marine life of the Dutch East Indies.[7] Written and illustrated on the island of Ambon, Rumphius' manuscript became damaged during its prolonged travels to the publisher in Amsterdam, who therefore had to hire Merian to supplement some of the lost images to this magnificent volume. Duly impressed by the artful naturalist, Uffenbach purchased a hand-colored copy of her

Metamorphoses insectorum Surinamensium for 45 guilders, two smaller, illuminated volumes of European insects for twenty guilders, and some original drawings, as well. Maybe not a huge expense for wealthy Uffenbach, this was not an insignificant sum in a period when a skilled worker was happy to earn 400 guilders a year.[8]

Uffenbach found colonial natural history fascinating, and spared no effort to learn more about Rumphius. The naturalist was still very much a presence in Amsterdam, even though he had been dead for eight years, after a life spent in the East Indies. Two weeks after visiting Merian, Uffenbach saw the cabinet of Jean Houbakker, and made note of the 36 bottles of snakes, birds, and crocodiles that the collector had purchased from Rumphius himself. Uffenbach also became acquainted with Simon Schijnvoet, the Amsterdam-based editor of Rumphius' *Amboinsche Rariteit-kamer*, who boasted that he had written some three hundred of its entries, casting doubt on the authorship of the atlas. Yet Schijnvoet's shells and minerals were beautiful and symmetrically arranged in specially designed chests, of which Uffenbach made a sketch.[9] He also learned that a collector had offered Schijnvoet 2,000 guilders for just sixty of his shells, and another *curioso* had already purchased 300 drawers of insects from him. As this anecdote exemplifies, Uffenbach relied on his own sense of beauty and the financial estimates of other *curiosi* to determine a collection's significance.[10] Finance and aesthetics played a similar, combined role in Uffenbach's encounters with art and the anatomy of the human body. When visiting the Amsterdam theater of anatomy in the Waag, a weighing hall that also housed the headquarters of several guilds, he singled out a painting of the *Dissection of the Renowned Anatomist Tulpius*. Failing to note Rembrandt's authorship, Uffenbach wrote that the artwork was "rather charming," and that "a mayor of the city had offered a thousand guilders" for it.[11]

While the anatomy theater was definitely worth a visit, the German tourist learned most about the human body in private collections of curiosities. As this book argues, these cabinets were a primary site of knowledge production in the early modern Netherlands.[12] In a country without professional scientific societies, Dutch physicians, surgeons, and natural historians frequently performed their research in a domestic setting. The naturalist Johann Frederik Gronovius grew exotic plants in his backyard, and the famous microscopist Jan Swammerdam even performed vivisections on dogs in his bedroom before he was evicted by his landlord.[13] Most Dutch scientific practitioners and burghers owned at least one cupboard full of rarities. Rembrandt, the burgomasters of Amsterdam, and hundreds of their fellow citizens all had their walls decorated with shells, pinned butterflies, ancient coins, Siberian dresses, dried crocodiles, and, obviously, paintings.[14] When Uffenbach visited such cabinets, he extensively

discussed their contents with the owner. Every object had its own history and proved a rich source of information about the natural world. Or almost every object. When Uffenbach visited the lithotomist Johannes Rau on March 13, 1711, he was deeply disappointed. Rau behaved like a "mountebank" and praised his curiosities excessively, although his wet preparations (specimens of the human organs preserved in a bottle) were cheap. The preserving liquid did not fully cover the specimens, because Rau wanted to save money on the expensive alcohol, or so Uffenbach presumed.[15] The human bones, the teeth, the testicles, and kidney stones, the subjects of Rau's own research interests, were nonetheless quite something to see.

Cabinets of curiosities were not only the source of scientific knowledge. They were also expensive and could even provide an income for their owner. After Rau, Uffenbach saw the Ruysch family next and they proved worthy of their fame. On March 14, the German tourist paid a visit to Rachel Ruysch, a celebrated painter of flower and *sottobosco* still lifes.[16] He was particularly taken by two paintings, destined for the Leiden textile magnate de la Court family. These two still lifes, showing flowers and fruits, were valued at 1,500 guilders, more than the alleged worth of Rembrandt's *Anatomy of Tulp*. Two days later, it was time for Rachel's father, the world-renowned anatomist Frederik Ruysch. Ruysch's cabinet was one of the must-sees of contemporary Amsterdam, and Uffenbach was stunned by the collection's rich display of anatomical specimens, tightly stacked in five spacious rooms. He wondered how the aged anatomist had time to "bring together so many preparations, which he made himself for the most part."[17] These specimens were prepared according to Ruysch's own invention, a secret method of injecting the specimen's circulatory system with wax, and then preserved either in a dry form or in a bottle of an alcohol-based solution. Ruysch boasted that, assembled together, the preserved human organs in his cabinet would have made up two hundred cadavers. As luck would have it, Uffenbach could sit in on a private lecture of Ruysch. The anatomist frequently offered lessons in his collection to students of medicine, apprentice surgeons, and curious visitors, and charged the hefty sum of fifteen and a half guilders for an eight-week course.[18] On March 14, Ruysch decided to lecture on the male reproductive organ, a fascinating topic for Uffenbach because only the best anatomists could create a satisfactory preparation of the penis. Yet Ruysch's lecturing style was tedious, saved only by the beauty of his preparations. After the lecture, Uffenbach saw the famous, preserved head of a young girl that looked so vivid that the Russian czar Peter the Great had once kissed it. The girl's head appeared rosy and full

of life because Ruysch injected red wax into its veins, a practice that Uffenbach found strangely disturbing. As he noted, "this does not appear to be natural to us, as Rau has already assured us that his [i.e., Ruysch's] objects are excessively smeared with dyes and lacquer multiple times."[19] The anatomist was an artist, like his daughter, applying his secret mixture of make-up to dead bodies.

Uffenbach was a discerning traveler and a sharp critic of curiosities. While an inexperienced tourist might have presumed that crocodiles, shells, and human heads looked the same in their natural state and in a cabinet, Uffenbach realized that exhibited curiosities were always representations. They were not the real thing. Pinned on a nail, a butterfly from the Caribbean might have had some its legs missing, torn off on its voyage or eaten by moths.[20] An exotic fish, prepared in a bottle, no longer showed its fantastic colors.[21] And, as Ruysch's example showed, anatomical specimens looked lifelike only because the preparer *artificially* injected red dye into their veins.

When visiting the miniature painter Jacob Christoph Le Blon, the grand-nephew of Maria Sibylla Merian, Uffenbach might well have wondered about the comparative advantages of the various methods in use for coloring natural historical prints.[22] While Merian painstakingly hand-colored the engraved illustrations of her atlases (and charged three times as much for them as for a monochrome edition), Le Blon had recently gained fame for his invention of mechanically reproducible color printing, which promised to eliminate the need for hand-coloring. As we nowadays know, for making one print, Le Blon's technique relied on the idea of engraving three copper plates, inking each of them with one of the primary colors (blue, yellow, and red), and then superimposing them on the same sheet of paper, where the three pigments mixed together to recreate the whole color spectrum.[23] It was this invention that caught Uffenbach's interest most, although he was also pleasantly surprised by the artist's collection of plaster casts. Uffenbach's brother, Johann Friedrich, was an avid collector of manuscripts on making pigments, and questioned Le Blon extensively about his technique. Yet the artist refused to divulge his secret, saying that "it would be for great gentlemen who would have to pay him handsomely before he made his invention public."[24] Tourists were welcome to buy Le Blon's prints and miniatures, but his methods of production were not public property. The Uffenbachs found the amateur linguist and mathematician Lambert ten Kate similarly reticent to disclose his own findings. A good friend of Le Blon, ten Kate showed them his renowned collection of plaster casts, including a copy of the Laocoön group, brought out his preparations of exotic animals, and then proceeded to discuss

the art of perspective. Ten Kate claimed that this art could be reduced to three simple laws, which he refused to share with Uffenbach, and, as a result, today we know nothing about these laws.[25]

Money, curiosities, and secret inventions. These topics fascinated Uffenbach during his voyage across northern Europe, and these topics drive the argument of this book. Early modern Europeans learned about the natural world through the mediation of colored prints, atlases, and prepared specimens. Yet these two- and three-dimensional representations were expensive luxury items, traded on the international markets of curiosities. They were created, shaped, and preserved by entrepreneurial naturalists, physicians, printmakers, and artisans, who claimed ownership over their inventive, and often secret, methods of production and preparation. As a result, the sciences of natural history and anatomy, these predominantly visual disciplines, became infused with commercial interests. Financial considerations deeply influenced how scientific practitioners portrayed and represented nature. Yet how do you practice science, evaluate research, and establish a consensus over results when the scientific community consists of entrepreneurial practitioners, driven by their monetary investments? How do you determine whether a particular scientific illustration is a faithful representation of the plant or animal that it purports to depict? These questions are of crucial importance in the science of the twenty-first century, but they were equally pressing in the early modern Netherlands, the birthplace of modern capitalism.[26]

This book argues that entrepreneurial rivalries, secrecy, and marketing strategies transformed the honorific, gift-based exchange system of the early modern Republic of Letters into a competitive marketplace. Instead of working together towards establishing a consensus, early modern scientific practitioners hoped to gain an edge over rivals by debunking each other's discoveries and research methods. Trade brought about a culture of scientific debate in the Netherlands and throughout Europe. As a result, the visual culture of early modern science underwent a transformation and became fractured. Early modern and Enlightened visual culture was not united by one, commonly shared epistemology. Instead, market competition led scientific practitioners to invent competing and incompatible visual epistemologies or, in other words, to develop opposing philosophical systems to promote the representational claims of their imaging techniques. As later chapters reveal, financial motives spurred an important pamphlet war over the proper method to represent human anatomy, and also engendered the

early eighteenth-century debate over the use of color theory in printmaking. The early capitalism of the Netherlands promoted the disunity of science, the culture of argumentation, and strategical secrecy. And, arguably, we still live in the same world of science today.

This book focuses on the commercial networks of those Dutch scientific practitioners whom Uffenbach encountered during his visit: Ruysch, Le Blon, Ten Kate, Merian, and Rumphius. These names will consistently recur throughout the book. During the Golden Age of the Dutch Republic, such practitioners successfully established an international market for scientific products, catering for wealthy customers such as Uffenbach, the London chocolate magnate Hans Sloane, and the Russian czar Peter the Great. Uffenbach himself encountered some of these international correspondents, and found that they were driven by the same commercial interests that characterized Dutch naturalists. For instance, while in London Uffenbach visited James Petiver, the publisher of the English edition of Rumphius' *d'Amboinsche Rariteit-Kamer*. He brought the English collector a package of fossil fish, originally from Eisleben, sent by a certain Rißner in Frankfurt. Uffenbach found Petiver's Latin pitiful, his shells beautiful, and his attitude mercantile. As he recounted, whenever Petiver received a new specimen, he would immediately have it "engraved in copper, and dedicate it [...] to his fellow countrymen and foreigners, for which they will have to give him a few Guineas," a cause that made his dedicatees complain.[27] Equally embarrassingly, Petiver would also offer foreign visitors an exemplar of his publications, and then charge too much for it.[28] Yet the insect collection, purchased from Merian herself, made the visit worthwhile.

A REPUBLIC OF LETTERS OF CREDIT

The transnational networks of scientific exchange went by the name of the Republic of Letters in the early modern period. In the past few decades, historians like Lorraine Daston, Anne Goldgar, and Anthony Grafton have argued that modern science emerged as the collaborative efforts of humanist scholars, erudite physicians, antiquaries, and natural philosophers across Europe, who formed an intellectual network, the international Republic of Letters, maintained by the free or reciprocal gift exchange of ideas.[29] Modern science, this historiography has suggested, was not the invention of isolated luminaries. It developed because of the increased circulation of ideas through scientific journals, printed books, and manuscript correspondence. In recent years, scholars have expanded this insight, giving it a global reach and one that traversed boundaries of class and gen-

der and race. They have emphasized how Muslim ulamas, English "mechanicks," aristocratic women, artisans, booksellers, and slaves transported through the Atlantic participated in the circulation of knowledge, not only exchanging ideas but also trading with books, images and material objects.[30]

This book joins this scholarship by emphasizing the mercantile orientation of many of these knowledge exchanges.[31] It brings into relief the tension between the commercial *ethos* of trading networks and the supposedly honorific, gift-oriented, intellectual ideals of the Republic of Letters. Robert Merton and other sociologists have traditionally argued that scientists follow the norms of communalism and disinterestedness in their work, freely exchanging knowledge in a collaborative manner, without vested financial and personal interests in the outcome of the research.[32] Following the work of Jürgen Habermas, historians have applied similar concepts to the study of early modern and especially eighteenth-century science.[33] They argued that, with the growth of coffeehouses, the establishment of scientific academies, and the ubiquity of printed publications, a public sphere developed in which natural philosophers freely conversed with each other and exchanged knowledge without the expectation of cash remuneration for their contributions. They made their own researches public thanks to the incentive of honorific credit—for example, an appointment as a corresponding member to a scientific academy.[34]

Yet, from the perspective of Uffenbach, members of the Republic of Letters did not appear to follow the norms of communalism or disinterestedness. They treated scientific knowledge as a commodity, and not as a public good. As later chapters will show in detail, even when they offered some specimens as gifts, this was only part of a larger, commercialized system of exchange. Frederik Ruysch, for example, surely appreciated that he was elected as *associé étranger* to the French Académie des Sciences to fill the seat of Isaac Newton in 1727, but this appointment did not change the then 89-year-old anatomists's mercantile and secretive behavior. When Uffenbach visited the famed botanic gardens of Leiden University on January 11, 1711, for instance, he asked the gardener whether they had engaged in a regular exchange of plants with the Amsterdam *hortus botanicus* (a garden one could only visit by paying an entrance fee).[35] The answer was negative. Under the leadership of Ruysch, the Amsterdam gardeners were "jealous and thought of their own things too highly."[36] Even between Leiden and Amsterdam, a short, eight-hour trip on a barge across the canals, plant specimens did not travel freely because of the Amsterdam garden's lack of willingness to cooperate with the botanists of Leiden.

Uffenbach learned to recognize the limitations of public science at the Leiden

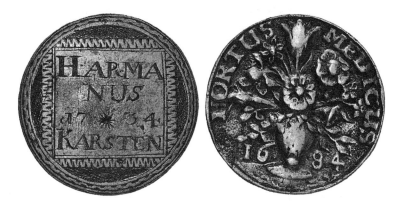

Fig. I/2. Entrance Token to the Amsterdam *hortus botanicus*, 1734.

anatomy theater, as well. During his first visit on January 21, the museum guide quickly rushed him through the collections with all the other foreign tourists, without letting them see anything in great detail. Uffenbach made a deal, however, and arranged for a second, private visit by paying an extra guilder. When he came back on January 23, Gerard Blanken, the anatomy servant, slowly walked Uffenbach through all the attractions of the theater. During this visit, Uffenbach relied on a printed exhibition catalogue, checking off each specimen as they walked around. When he came to page 13 of the catalogue, however, the exhibits were nowhere to be seen. Blanken, never reticent to voice his complaints, explained naggingly that the anatomy professor Govard Bidloo "took them home for his classes."[37] Instead of showing his specimens to the larger public in the theater, Bidloo kept them at home for the sake of his private, paying students. Payment was essential for accessing scientific knowledge. Fortunately for Uffenbach, however, a few of Bidloo's specimens could still be seen in the exhibition space. He found the lung preparations especially impressive, but the embryos, however, appeared less well-done than those of Caspar Schamberger in Leipzig.[38]

As the commercial enterprise of mercantile practitioners, the long-distance exchange of scientific knowledge worked in early modern Europe because it relied on the trading routes, communication systems, and financial infrastructure that merchants established. Highly valued, luxurious curiosities and atlases of natural history circulated in increasing numbers, despite the high costs of transportation.[39] By the beginning of the eighteenth century, many scientific products had turned into a commodity that one could profitably trade with at an international scale. While Uffenbach's travels in the Netherlands and in England al-

lowed him to procure ancient coins, prints, and scientific instruments at a lower price, he would have been able to mail-order the same goods from his hometown in Frankfurt. When he visited the shell collection of Balthasar Scheid in Amsterdam, the owner explained that he traded both in shells and "in flowers, and assured us that Eberhard in Frankfurt acquired many of these from him."[40] Like the little-known Eberhard, Uffenbach could also have used the services of such a professional merchant of curiosities without much hassle. This book reconstructs how Dutch scientific entrepreneurs like Scheid established connections in major European cities, and invested in the creation of an infrastructure that allowed them to turn foreign naturalists and collectors into paying customers.

When Uffenbach decided to sell his own library in 1729, at the age of 46, he himself turned into a long-distance scientific merchant like Scheid. He organized a public sale, and expected customers from all corners of Europe. Following established practice, he put out an advertisement for the sale in the *Leipziger Neuer Zeitung*, and also distributed a printed auction catalogue of his books, indicating the price of each volume.[41] A special introduction to the catalogue

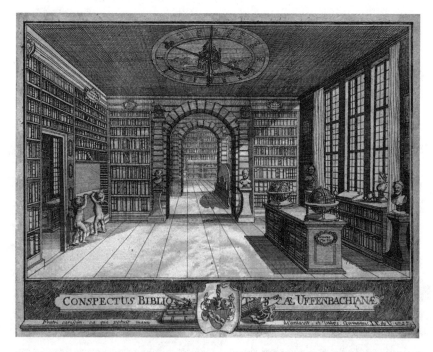

Fig. I/3. Uffenbach's library was renowned throughout Europe. The shelves on the back right hold the diaries of the learned, an indirect reference to Uffenbach's own travel journals. Uffenbach, *Bibliotheca Uffenbachiana*, frontispiece.

fixed the terms of sale for customers at a distance. They did not need to worry about not being able to inspect the books. They were all properly bound and in good condition. The price could not be negotiated, unless the customer spent more than 50 or 100 Reichsthalers. Foreigners were informed that payment could be made only in well-known currencies, for which an exchange rate was set and published. Armed with all this information, Uffenbach's customers did not need to make a trip to Frankfurt. They had access to a catalogue, the quality of the books was guaranteed, they could pay by international money transfer, and the books would be delivered by parcel post.

THE INFRASTRUCTURE OF EARLY MODERN TRADE

The Netherlands was the major commercial center of seventeenth-century Europe, and its success was in no small part thanks to its development of a complex infrastructure for long-distance trade. As Fernand Braudel claimed, it was the entrepôt of European commerce where commodities from foreign countries were exchanged.[42] Herrings, grains, and timber were brought to the country from the North Sea and the Baltic countries, and textiles and clothes were sold to the Mediterranean countries.[43] From the late sixteenth century, the Dutch also became an important player in world trade. Their colonial empire imported spices from the Far East, and became a participant in the long established, inter-Asiatic mercantile network that connected East Africa, India, China, Japan, and the Indonesian archipelago. The Dutch were also producers of cane sugar in the West Indies, and played a prominent role in the atrocious trade of shipping slaves from Africa to the American continent.[44]

For the management of this commerce, the Dutch developed important innovations in the corporate and monetary culture of the day. The Amsterdam Wisselbank (Bank of Exchange) was founded in 1609, where merchants could handle financial transactions by the virtual transfer of money from one account to another, and similar exchange banks were established in Middelburg, Delft, and Rotterdam by 1640.[45] The Wisselbank served as a controlling mechanism to enhance trust in financial exchanges, and the city ordered that every bill of exchange over 600 guilders be handled through its accounts. In the absence of actual coins, merchants did not need to worry about debased or fake money, a constant fear for everyone in the period. Thanks to these safeguards, a virtual guilder on a Wisselbank account had a higher value than an actual one-guilder coin.[46] As the Jewish refugee Abraham van Idaña noted about the success of this system, "ready cash is hardly ever used, because they arrange it differently. Each

creditor has a special, numbered page in the bank's books where the amount of his deposit is noted."[47] By the 1720s, the Amsterdam Wisselbank boasted over 2,900 account holders, whose total deposits reached fifteen million guilders soon thereafter. As Marjolein 't Hart has shown, the Bank had also established mutual exchange agreements with "all major financial centres of the world" by then, turning cumbersome international money transfer into an established, everyday practice.[48] If monetary transactions were handled through the Exchange Bank, the Amsterdam Bourse regulated the trade in shares for hundreds of commodities, although crops were traded at the Grain Exchange, which was established in 1617. Next to the regular and futures trade of commodities, the Bourse was also vital in arranging marine insurance and real estate contracts. To facilitate transparency and the circulation of information, all professional brokers were required to be physically present in the Bourse during its trading hours between 11 am and noon, and current stock prices were published on a weekly basis.[49]

To facilitate long-distance marine trade, a risky business with a significant chance of sinking ships taking a merchant's investment to the bottom of the ocean, Dutch cities also came up with various institutional frameworks to spread risk and insure the investment of individuals.[50] It became a standard practice that ownership of a ship and its cargo be divided between various merchants and investors, who would then stand less than total loss when a ship did not return. As a particularly powerful example of such risk-sharing, the colonial trade with the Indies came to be handled by joint-stock corporations in the early 1600s, when everyone could invest in the fleets departing for Asia and the Americas. The Dutch East India Company (VOC) was chartered in 1602 and held a monopoly over trade with Eastern Asia. After the Dutch truce with Spain ended in 1621, the Dutch West India Company (WIC) would receive a similar monopoly over the Americas, both to pursue regular trade and to engage in privateering against Spanish ships and ports. The West India Company traded with slaves, sugar, and fur, captured the Spanish silver fleet in 1628, and occupied a part of Portuguese Brazil in the 1630s, only to lose it in 1654. The East India Company imported millions of tons of spices, porcelain, and other Asian commodities, brought a large number of Europeans to the Far East, many of whom perished on the voyage, and waged wars with local sovereigns and competing colonial powers. While their stock prices fluctuated and then fell throughout the years, both companies survived into the last decade of the eighteenth century.

During his travels between 1709 and 1711, Uffenbach himself experienced the benefits of an established infrastructure for handling the long-distance travel of

people and commodities. For tourists and business travelers, information on all aspects of the infrastructure of travel was available in the popular tourist guides of the age, which published useful information not only on the major sights of each city of Europe, but also on trustworthy inns, exchange rates, and the schedules of coaches and barges between major and minor cities.[51] For lodging in Amsterdam, for instance, both the 1689 and the 1729 editions of Jan ten Horne's *Reys-boek* (the early modern Michelin) listed, among many others, the *Keysershof or the Emden Arms*, where Uffenbach himself stayed.[52] First published in 1679, and frequently reprinted thereafter, the different editions of the *Reys-boek* also offered daily prayers for the travelers, provided a short course on book-keeping, advised on how to use one's own hands as a sundial, and included a perpetual calendar. For his travels, Uffenbach relied on similar travel guides, including Claude Jordan's multivolume *Voyages historiques de l'Europe*.[53] He also realized that, for his scientific shopping sprees in Amsterdam and London, he needed to have access to a well-established system for international bank transfer and shipping. When Uffenbach arrived in London, his first visit was to the Bourse to get cash from his agent, and he also retained a merchant in Amsterdam to handle the shipping of his books.[54] It took him more efforts to evade having to pay customs on his luggage, which were especially expensive in the Netherlands. Fortunately, Uffenbach learned that students could transport their luggage for free throughout the country, so his brother registered as a student at Leiden University in order to save money.

Last but not least, it was thanks to trading networks of the East and West India Companies that Uffenbach could admire so many *exotica* in the Dutch cabinets of curiosities. The ships of the VOC and the WIC brought into the Netherlands a wide variety of plants, animals, and other curiosities from all corners of the world. From his post on Ambon island, Rumphius could participate in the scientific life of the Netherlands because the ships of the East India Company regularly, although not always reliably, transported his letters, specimens, and manuscripts to Amsterdam. Many other Dutch naturalists gained fame for their researches while in the employ of the East India Company, including Paul Hermann who spent six years in Asia in the 1670s, assembled an impressive herbarium that survives to this day, and then published the renowned botanical encyclopedia *Paradisus batavus*. By 1711, Hermann was dead, but Uffenbach managed to pay a visit to his son, Paul Jr., who lived in poverty, and, to earn some money, had given away most of his father's curiosities to Leiden University, which provided him with a yearly income of 300 guilders in return.

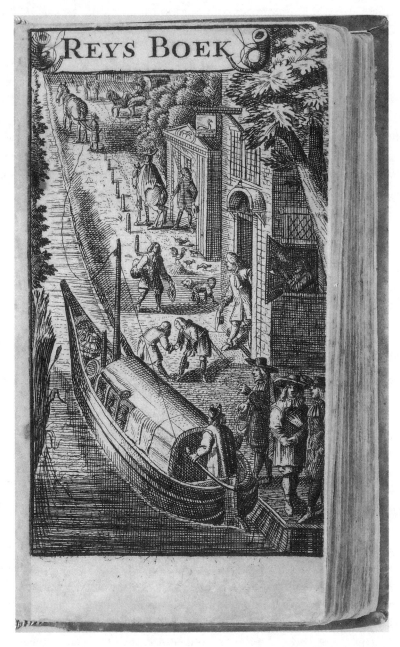

Fig. I/4. Drawn by horses, barges were the regular means of travel in the Netherlands, with regular times of departure and arrival in each city. Ten Horne, *Naeuw-keurig Reysboeck*, frontispiece.

ENTREPRENEURIAL PRACTITIONERS

Yet commercial networks did not only provide an infrastructure for long-distance scientific exchange, they also shaped how science was done. *Commercial Visions* argues that trading companies and entrepreneurs directly contributed to the development of natural history and anatomy, and in the process transformed the practices and intellectual claims of these disciplines. Given the predominance of pepper, nutmeg, and other spices in the East Asian trade, the East India Company (VOC) had a self-serving interest in natural history.[55] Apothecaries and physicians on the colonies explored at length the flora and fauna of their environment, and became acquainted with the medical knowledge of indigenous populations. The ships of the VOC both facilitated the circulation of this knowledge and exercised considerable control over the flow of botanical and medical information. The VOC banned the importation of exotic plants outside official channels, although pervasive smuggling considerably lessened the impact of these regulations. Works on East Asian natural history were sometimes censored, most notably in the case of Rumphius' *Herbarium Amboinense*, which was published only four decades after the author's death.[56] Despite these limitations, exotic scientific knowledge and objects still flooded the Netherlands, and, through Dutch intermediaries, the rest of Europe. Some of the best-known fruits of this encounter were tea, pineapple, and the practice of acupuncture. Exotic animals and flowers served less utilitarian purposes, but were nonetheless much sought after. The leaders of the East and West India Companies often passionately collected insects and shells that displayed the variability and playfulness of nature. In the first half of the seventeenth century, for instance, beautiful tulips appeared in the gardens of wealthy burghers in the towns of Haarlem, Enkhuizen, and Amsterdam. Exorbitant sums were exchanged for particular bulbs, and the price of tulips increased beyond recognition until a financial crash occurred in 1637.[57] Despite this particular crisis, the Dutch continued to trade *exotica* extensively. As Benjamin Schmidt has shown, the Netherlands remained deeply interested in selling knowledge about Asia, Africa, and America even after their colonial empire had collapsed.[58]

The interactions of commerce, collecting, and science were also stimulated by developments within the Netherlands. Dutch instrument-makers invented new scientific instruments for observing nature and techniques for marketing these instruments to the larger public ever since the contested invention and the failed patenting of the telescope in 1609.[59] Leeuwenhoek perfected the microscope in the 1660s, flooded the budding *Philosophical Transactions* with his accounts of

the world of animalcules, and, to keep a monopoly in the field, refused to sell his instruments or to disclose the exact method by which the lenses were produced.[60] Uffenbach suspected that Leeuwenhoek was keeping his microscopes to himself so as to provide a source of income for his daughter after his death, who would then be able to sell them at a heightened price. By the end of the seventeenth century, the Musschenbroeks of Leiden became one of the prime instrument-makers of Europe. To cater for a long-distance customer base, the Musschenbroeks developed advanced packaging techniques to ensure that complex instruments—for example, an air pump, survived shipping unscathed even when sent as far as St. Petersburg in Russia.[61] They also provided printed sales catalogues for customers across Europe, and Uffenbach picked up a copy at the store when visiting them in 1711.[62]

Local discoveries within the Netherlands also propelled forward natural history and medicine. Naturalists, pharmacists, and physicians painstakingly catalogued the flora and the fauna of the Low Lands, developed new techniques for preserving and representing plants, animals, and humans, and also invented advanced methods for marketing and selling specimens and representations at a distance.[63] The passion for collecting was not limited to exotic tulips, as naturalists were also eager to acquire, document, and picture butterflies, spiders, and aquatic animals hiding in the grass by the canals of the Netherlands. The medical author Stephanus Blankaart even found the time to collect some caterpillars while relieving himself in the backyard of a local teahouse.[64] Thanks to innovations in greenhouse technologies, moreover, oranges and pineapples were no longer strangers to the Dutch landscape in 1700, as some naturalists successfully grew them in their gardens, and then sold them to wealthy and hungry customers for a profit. In the field of anatomy, new preparation and preservation methods visualized hitherto unknown parts of the human body. Caught up within the culture of collecting, anatomists and *curiosi* began to sell and exchange illustrations and actual specimens of human organs. For the first time in history, anatomical specimens acquired a price.

DEBATING WITH IMAGES

This book focuses on the innovations, both scientific and commercial, of Dutch natural historians and anatomists. These practitioners not only served as brokers of *exotica* to European customers, but also invented new ways of visualizing plants, animals, and the human body, either by preserving a specimen or by creating an image of it in another medium. And, as they developed an infrastruc-

ture for turning visual images and material objects into mobile commodities, the very concept of representation underwent a transformation in the process. When seventeenth- and early eighteenth-century science became caught up in the culture of collecting, these naturalists and anatomists churned out various visual representations of plants, animals, and the human body that they were hoping to sell to *aficionados* of curiosities and scientific books, or simply to wealthy homeowners looking for novel ways of interior decoration. In collaboration with printmakers, painters, weavers, and other artisans, they produced illustrated encyclopedias, single-sheet prints, woven carpets, dried plants, wet and dry anatomical specimens, and wax models of fruits, flowers, and the human body. As such methods of representation proliferated, practitioners came to debate what factual information and scientific evidence they actually conveyed. Were curiosities and scientific illustrations visual facts, offering incontrovertible evidence over nature? Or were they artificial, and faulty, representations, marred by the hand and the imagination of their makers?[65]

Then and now, producers of scientific illustrations sometimes hope that their representations are visual facts—that is, they provide a mimetic depiction of nature as it really is.[66] Given their compact format, it is sometimes assumed that the significance and meaning of visual representations can be recognized at a glance. Yet, as scholars have argued extensively, facts and visual representations can never be fully extricated from the theoretical background and social context of their creation. They are bearers of complex visual epistemologies, reflecting the philosophical, gendered, and racial presuppositions of their creators.[67] Like twenty-first-century scholars, many early modern naturalists also harbored suspicions about a simplistic understanding of visual facts. One had to possess an attentive eye to decipher the factual content of an engraving of a plant. One needed advanced skills of interpretation to evaluate what particular perspective a dry or wet specimen provided over the nature of the human body. Indeed, as an early eighteenth-century museum guide remarked, the observation of *naturalia* required *more* time than art works or antiquities.[68] Visual facts were at least as difficult to digest and interpret as complex scientific theories, or artworks.

This book argues that commercialization played a major role in engendering a debate over the epistemological status of visual facts in natural history and human anatomy. In recent years, Harold Cook has argued in a book with stunning breadth that Dutch capitalism spurred the development of consensus in science by restricting practitioners' attention to empirically verified facts.[69] This book argues, in contrast, that mercantile capitalism only enabled the development of a unified infrastructure for circulating facts, images, and material objects. Com-

merce offered little guidance, however, once it came to assessing the intrinsic worth, significance, and financial value of facts and objects. It promoted the lack of agreement in these matters instead.

Commodification had a tremendous impact especially over visual culture for two distinct reasons. First, as later chapters will discuss it in detail, the production of visual representations was a costly process in the early modern period. As any published author can testify, images raise the price of a book to a considerable extent even in the twenty-first century. In the years around 1700, the engraving of images could double a book's value even in the case of moderately illustrated books.[70] Paintings, watercolors, and especially tapestries were even more expensive because of the high costs of material and labor. And, as Uffenbach recounted, wet anatomical specimens needed to be preserved in expensive alcohol, which made tight-fisted anatomists like Rau cringe. Given the high financial value of all types of visual representation, commercial thinking was predominant in their production and distribution.

Second, commercial competition resulted in the proliferation of divergent representational techniques in this period. Artisans, artists, and scientific practitioners competed with each other to invent imaging techniques that would offer a novel and better perspective over the visible world, revealing hitherto unnoticed details. The competition between the producers of these representational methods was not necessarily peaceful. Naturalists, anatomists, and printmakers often acted as entrepreneurs, fighting for the same customer base who would purchase their curiosities. In the Dutch Republic royal and aristocratic patronage were limited, and scientific practitioners and artists needed to earn their living by devising commodities that would sell on contemporary markets on both a domestic and an international scale. As a result, they held a vested, commercial and epistemological, interest in a particular imaging technique, and were highly suspicious of practitioners who were committed to another regime of representation.

Throughout this book, we will encounter several debates over the functions and the limits of imaging techniques that entrepreneurial practitioners engaged in. Was a prepared specimen a transparent, direct, mimetic representation of nature, or was it a decaying, fundamentally dead, and thereby faulty method of visualizing life? Or, did one need to follow Newtonian or Aristotelian color theory when producing color prints of anatomy? These debates touched on deep, philosophical issues that are still important for the visual studies of science today, but were also full of *ad hominem* attacks. The participants in these debates did not behave like polite gentlemen, or as honorable members of the Republic of Letters. To give only one example, the Leiden professor Bidloo argued that

anatomical preparations failed to show how the live human body really worked, and called Ruysch's cabinet of dead anatomical specimens simply a "cemetery."

Viewed from a broader context, one can often identify the commercial reasons behind these philosophical, and personal, debates. When scientific practitioners occupied a particular standpoint on visual representations, it was not only their professional integrity that was at stake. Their financial investment into the production of these representations also needed to be recouped. Winning a debate could mean scientific credit and financial gains.

Consequently, *Commercial Visions* argues, the modern, scientific, empirical culture of facts was riddled with contradictions from the beginning. While visual facts were available in large numbers, there were no commonly accepted protocols for the evaluation of their validity. The naturalists involved in the commerce of curiosities were not interested in a disinterested cooperation with each other to determine what counted as truthful knowledge. Instead of reaching agreement with their colleagues, they wanted to enlist customers who would be sufficiently curious about these arguments to make a purchase of their commodities. Consensus was not a concern for Dutch entrepreneurial practitioners. Their concern was to create a fashion and a market for their scientific products.

METHODS OF REPRESENTATION GALORE

Uffenbach himself was a witness of the proliferation of imaging techniques in the sciences, and also experienced how, driven by financial interests, scientific practitioners debunked each other's work in no uncertain terms. As we have seen, Uffenbach paid close attention to Johannes Rau's criticism of Ruysch's overly artistic methods of preparation. He also listened carefully when Rau recounted his affair with Ruysch over the scrotal septum. According to Rau, Ruysch falsely claimed priority for the discovery of the septum, which had been described by six other authors previously. Moreover, this septum did not even exist, Rau charged, it was a "figment" of Ruysch's imagination.[71] With his careful methods of dissection, Rau was able to visualize how the two chambers of the scrotum were not divided by a septum, but were actually two separate bags, each holding one testicle.

Besides hearing about novel techniques for dissecting scrota, Uffenbach also came across enhanced methods of preparing specimens, new optical instruments, prints, atlases, and hand-colored illustrations, and even *pietre dure*, a curious art of gluing together polished and colored stones to create an artwork that could withstand the ravages of time better than paper or canvas.[72] Indeed, Uffenbach's catholic taste for all modes of representation serves as a helpful corrective to the

focus of current historians of science, who tend to talk mostly about printed illustrations and paintings when discussing the visual culture of science. Because of market competition, scientific entrepreneurs in this period also invented various new methods of representation that ranged from tapestries to papier-mâché models.

From the Renaissance onwards, tapestries were frequently used as sumptuous showpieces of exotic nature. In the late seventeenth century, Dutch artists produced cartoons for tapestries of Brazilian nature for Prince Johann Maurits of Nassau and Louis XIV, and the French tapestry factory at Beauvais wove luxurious illustrations of the exotic animals at the royal menagerie.[73] While weaving was by no means an early modern invention, a later chapter will recount how the secretive Le Blon developed a new, scientific method for producing tapestries in the 1720s. Like her grandnephew, the naturalist Maria Sibylla Merian also experimented with various media. She did not only produce learned encyclopedias of exotic insects. Originally, some of her earliest work in entomology was also intended to serve as pattern books for embroidery.[74] In the field of printmaking itself, artisans recognized that engraving plates could print images not only on paper, but also on silk, and the Leiden publisher Pieter van der Aa produced such a printed, textile map of the Netherlands in 1734.[75] For natural history, nature prints were especially important. As the legend has it, this technology was invented by Leonardo, who inked the porous leaves of plants directly, and then pressed them against paper. The leaf's structure would be visualized directly, without the intervention of an artist's hand, a potential candidate for perfect mimesis.[76] During Uffenbach's lifetime, a host of other visualization techniques were enlisted in service of science. In England, Mary Delany's *Flora delanica* used the technique of paper mosaics—that is, the cutting and pasting together of colored paper to create stunningly naturalistic decorations where each leaf, petal, and other organ was represented by an individual slice.[77] The secret of Chinese porcelain was discovered in Meissen in 1708, and a few decades later, the Danish Johann Christoph Bayer used it to produce the *Flora danica,* a particularly impressive set of porcelain dinnerware designed for royal customers. Each cup, plate, or bowl sported an illustration of a particular species, identified by its Linnean, binomial name on the bottom.[78] In the field of anatomy, the eighteenth century saw the advent of wax models that provided colored, three-dimensional representations of the human body. Such models were produced by Ercole Lelli and Anna Morandi Manzolini in Bologna, and by Felice Fontana in Florence, and they were also used in anatomical education at the medical schools of the Hapsburg empire.[79] And, for the education of midwives, Angélique Le Boursier

du Coudray invented paper mannequin models of women in labor, which were printed in color.[80]

These new imaging techniques were supposed to earn a living for their inventors, and they also held the promise of reforming the visual epistemologies of early modern science. Particular scientific questions could now be answered through a particular, especially appropriate mode of visual representation. As Pamela Smith has argued, for instance, lifecast clay models were especially well-suited for the representation of amphibians in the sixteenth-century. According to contemporary theories of generation, these animals were born through the admixture of earth, fire, and other elements. In their kilns, artisans like Wenzel Jamnitzer and Bernard Palissy successfully recreated these natural conditions by heating up clay. The resulting lifecasts did not simply resemble the original specimens, they were produced in an analogous manner.[81] In a similar manner, Bert van de Roemer has recently shown that Frederik Ruysch, a major character of this book, found lacework and embroidery a particularly well-fitting allegory for his own anatomical work. Ruysch argued that the human body was composed of a dense network of interlacing vessels, just as textiles were created through the interconnections of fibers. Consequently, his anatomical installations featured objects that blurred the boundaries between textiles and the body—for example, napkins woven from the vessels of the human body.[82] The choice of representational technology often signaled a commitment, epistemological and financial, to a particular scientific theory.

COMMODIFICATION AND THE
CIRCULATION OF KNOWLEDGE

Commercial Visions studies through the example of Dutch scientific entrepreneurs how visual facts are produced, marketed, and contested through the commercial circulation of knowledge. The role of networks in the stabilization of facts has been studied extensively at least since the 1980s. Much of this historiography has focused on how local knowledge becomes universally accepted. The classic works of Harry Collins, Peter Galison, Mario Biagioli, Steven Shapin, and Simon Schaffer have explored the elaborate techniques by which scientists convince their colleagues about their knowledge claims.[83] They described a host of social, material, and literary technologies by which local knowledge was made accessible to the larger scientific community. In so far as it was applied to scientific practice, Latour's Actor-Network Theory also focused on how facts are crystallized and accepted to be true by the complete network. Epistemological closure,

or the blackboxing of facts, was the end result that needed to be explained. As Latour famously argued, science produced immutable mobiles—that is, bits of knowledge that were accepted to be true in widely divergent contexts.[84]

In the past two decades, however, the scholarly interest in reaching a consensus about scientific truth has been reformulated into the question of how knowledge circulates in widely differing contexts. Scholars have increasingly argued that epistemological closure is often ephemeral, and even facts might not have universal validity. As a result, they have turned to the question of how ideas and objects acquire new meanings as they travel from one cultural context to another.[85] Inspired by anthropology and, to a lesser extent, the classic works of hermeneutics, this trend investigates how one group's local knowledge becomes appropriated by another group to become a different kind of local knowledge.[86] Knowledge no longer has pretensions for universality, and only partial connections exist between local sites.

Such a move away from the focus on establishing scientific consensus may well have been connected to historians' lessened interest in scientific societies. Scientific academies often served in history as officially sanctioned, or self-appointed, arbiters of truth and consensus, or, again in Latour's terminology, as centers of calculation. Yet recent scholarship has shown that, outside their own walls, the power of such academies was limited. They could publicize and call attention to particular knowledge claims, but could not command assent from practitioners elsewhere. When Uffenbach visited Gresham College in London, he was astonished to see in what bad state the renowned Royal Society was, and remarked philosophically that

> but so it goes with all public societies. They bloom for a little time, the founder and the first members work as hard as they can, but then afterwards come all sorts of hindrances.[87]

Uffenbach found public academies and libraries not worth the attention they commanded, and reserved the right to disagree with the conclusions their members consented to. In a similar manner, scientific practitioners all around Europe paid close attention to what happened at the Royal Society or at the Académie des Sciences, and then made their own decision whether to agree with these societies' interpretations of their experiments. And, in the Netherlands, where no official scientific academy and society existed until the second half of the eighteenth century, no one felt entitled to even claim to have established scientific consensus.[88]

In this study of commercial exchange, I propose to focus on the processes of commodification as a way to resolve the tension between the earlier studies on the production of universal knowledge, and the more recent work on the instability of knowledge circulation. While individual Dutch scientific practitioners might well have believed that their visual facts should command universal assent, they made no collective effort to establish a mechanism to reach such a consensus. Instead, they focused their efforts on producing commodities that had universal purchase, and they collaborated with each other to maintain the infrastructure that made possible a long-distance trade in scientific commodities. These entrepreneurs designed their atlases, prints, and prepared specimens so as to reach customers across Europe and beyond. These representations could become successful only if their aesthetic and scientific appeal was appreciated simultaneously in London, Amsterdam, and St. Petersburg, and if pharmacists, wealthy burghers, and aristocrats in these cities agreed that they were valuable curiosities. In order to make their commodities universally available, naturalists developed elaborate marketing techniques that included advertising, "mail-order catalogues," preservation techniques to make commodities durable, and safe methods of shipping. Like the literary technology of "virtual witnessing," practiced by the early Royal Society, and the "inscription procedures" described by Latour, these marketing techniques served to make commodities universal in so far as the demand for them was concerned.

Yet the universal appeal of commodities did not translate into the universal acceptance of the knowledge claims of their producers. The protocols of marketing ensured only that scientific knowledge was turned into a commodity, but not that its validity would be accepted by all members of the scientific community. Arguably, the primary audience of scientific entrepreneurs was their customers, and not their fellow, competing practitioners. Consequently, commercial motivations could even force scientific entrepreneurs to withhold information that could convince others about the validity of their knowledge claims. Methods of production—for example, the imaging techniques used to produce visual representations, were a case in point. These techniques were considered trade secrets, whose open circulation would have endangered the producer's monopoly.[89] They were treated as intellectual property that could be exchanged only against hard cash.[90] Yet without knowing how visual representations were produced, the contemporary scientific community was unable to validate whether they distorted or were faithful to nature. As Steven Shapin and Simon Schaffer have shown, natural philosophers at the Royal Society attempted to provide detailed descriptions how their experimental procedures could be replicated by others, so as to enhance

their credibility.[91] Entrepreneurial practitioners, in contrast, were interested in preventing the possibility of replication and therefore lost some of their scientific credibility. Dutch practitioners were adept at making commodified knowledge and visual facts available for sale even at a distance; but, precisely because scientific knowledge was exchanged only in private, financial transactions, it did not gain universal acceptance in the public sphere.

The processes of commodification have long been studied by economic anthropologists, who have approached it from the perspective of other systems of exchange, most notably the gift system first analyzed by Marcel Mauss.[92] In this framework, the seemingly neutral transactions of money against goods turn out to be invested with social, political, and emotional meanings.[93] In this respect, commodification does not appear all that different from gift society. Converted to the discipline of science studies, commodification turns out not to be external to scientific research, to be done by salesmen after the scientists have finished their work. Rather, the commercial system of exchange becomes intrinsic to how scientists work, publish, and interact with their colleagues and the larger public. In recent years, the anthropologists of science like Warwick Anderson and Cori Hayden have shown in great detail how commodification and other systems of exchange transform the local, indigenous knowledge of communities in Papua New Guinea and Mexico into the mobile commodities of neoliberal capitalism (or, indeed, constitute local knowledge first in order to turn it into a commodity thereafter).[94] While these case studies have focused on how botanical and anatomical specimens from marginalized regions are appropriated by Western science, their insights can also be applied to the study of the birth of Western science itself. This book shows how natural history and anatomy have been imbued with the values of commodity culture since the scientific revolution.[95]

THE DUTCH CORRESPONDENTS OF UFFENBACH

Tapestries, *pietre dure*, porcelain, wax models, and papier-mâché models. Given the stunning variety of early modern imaging techniques, *Commercial Visions* can present the analysis of only a select few that exemplify the commodification of scientific knowledge. Illustrated encyclopedias, prepared specimens of anatomy and exotic animals, and color prints will reveal how two- and three-dimensional representations complemented and competed with each other in the early modern period. These curiosities were produced by a close network of Dutch scientific practitioners and artisans, a network that Uffenbach was familiar with. In the following chapters, we will repeatedly encounter Maria Sibylla Merian,

Frederik Ruysch, Govard Bidloo, Jacob Christoffel Le Blon, and Lambert ten Kate, who all knew each other, although they were not always on friendly terms. They competed for customers like Uffenbach, and we will see in further chapters how these practitioners engaged in commercial exchanges with England, France, and Russia.

The next chapter reviews how scientific practitioners, such as Petiver, Merian, and Rumphius, set up an infrastructure for the long-distance trade of specimens of natural history in the early modern period, a costly business because of the high price of shipping. Indeed, because of their small size, botanical specimens, seashells, and insects were exchanged much more frequently than larger quadrupeds or birds. Yet even small specimens could be exchanged at a distance only if one had an established system for identifying them in their correspondence. As this chapter argues, early modern encyclopedias of natural history came to serve as reference guides, or "mail-order catalogues," for naturalists who wanted to specify which exact species they wanted to order from their providers.[96] These encyclopedias' role in facilitating the commerce of specimens contributed to their transformation. The entries became shorter and the illustrations focused on classifying and identifying specimens by a few distinctive features. In other words, taxonomical works replaced the earlier, Renaissance histories of nature.

In the third chapter, the business of producing such encyclopedias of natural history is explored through the example of Albertus Seba's monumental *Thesaurus*. While Uffenbach does not mention a visit to Seba, he must have passed by his Amsterdam pharmacy on the Haarlemmersdijk, filled to the brim with curiosities, just a few blocks away from the German tourist's hotel. The *Thesaurus* offered an exhaustive overview of Seba's personal collection of *exotica* in four volumes, illustrated with four hundred plates. It was published over the course of thirty years between the 1730s and the 1760s. Seba himself died early in the project, and the completion of this work required the cooperation of a large number of workers: draughtsmen, engravers, writers, translators, printers, and publishers. Thanks to the surviving, extensive correspondence of the postmortem editors, one can recreate how, after Seba's death, their financial interests took over the publication project. These editors hired "ghostwriters" to complete the entries of the *Thesaurus*. Yet these hired writers no longer had access to Seba's original specimens, and, as a result, the finished work became a highly idiosyncratic and untrustworthy encyclopedia. The case of Seba exemplifies how, in the early modern period, the production of illustrated encyclopedias was a capital-intensive project. To attract customers, profit-seeking publishers often prioritized the aesthetic appeal of the engravings to the detriment of the entries' scientific accuracy,

which led many observant readers to develop a skeptical attitude towards any factual claim in natural history.

After two chapters on specimens and illustrated encyclopedias of natural history, the second half of this book offers a case study of three competing technologies for representing the human body: wax-injected preparations, engraved anatomical atlases, and color mezzotints. In the fourth chapter, I recount how Dutch anatomists invented a new method for preparing and preserving cadavers in the 1650s by injecting the circulatory system with wax. The inventor of this method was the minor nobleman Lodewijk de Bils; but its major proponent was Frederik Ruysch, the renowned physician whose cabinet Uffenbach much admired. For these anatomists, preparations offered the promise of a transparent representation of the human body where the self-inscription technology of wax-injection was supposed to eliminate human errors and let nature represent itself. To advertise the beauty and the scientific value of preparations, these anatomists turned to the world of publishing. Ruysch's printed works were not experimental reports, intended to help readers replicate his scientific findings. Instead, they served to increase sales by praising the author's scientific discoveries and the visualizing power of wax injection, and to offer a catalogue of all the preparations that customers might be interested in buying. Importantly, de Bils and Ruysch intended to maintain a monopoly over their method of preparations. None of their printed works ever disclosed how these specimens were produced. The circulation of these works did not contribute to the open exchange of useful knowledge.

In the 1690s, the Leiden professor Govard Bidloo launched a major attack against Ruyschian preparations, and argued that anatomical atlases offered a better way to represent the human body. He suggested that Ruysch's method introduced artefact into preparations because the injection of wax artificially enlarged the blood vessels. A correct image of the human body could be represented only in paper anatomical atlases, which allowed one to rationally reconstruct how the living human body looked. Although this debate might appear rather philosophical, the fifth chapter shows that it was also connected to the world of commerce. While both anatomists owned anatomical preparations, only Ruysch's specimens could be considered real commodities. Ruysch's collection was sold for 30,000 guilders in 1716, the price of six houses in Amsterdam. In contrast, Bidloo had only a meager collection of such specimens, because he invested his energies into producing a luxurious atlas, which he hoped to promote by denigrating the competing representational medium of preparation.

Finally, the sixth chapter turns toward the invention of mechanically reproducible color printing by Jacob Christoffel Le Blon, who would later publish

several anatomical illustrations in this medium. Le Blon conceptualized his own invention, and the art of printing in general, as the correct application of a set of communicable, mathematical laws, and not as a tacit, bodily knowledge.[97] This chapter argues that, since Le Blon believed that mathematical laws could easily be communicated, he resorted to trade secrets and patents to protect his own invention, which he was afraid others would pirate immediately. This was the reason the printmaker refused to share his secret with Uffenbach and his brother. Reviewing Le Blon's secretive strategies, and the arguments of Jacques Fabien Gautier d'Agoty, who eventually pirated this technique, I suggest that Le Blon's invention marked an important step in turning scientific imaging techniques into intellectual property. By the eighteenth century, not only visual facts, but also their methods of production became commodities.

In sum, these chapters offer an overview of the competing regimes of representation in the markets of early modern natural history. In each case, *Commercial Visions* illuminates how scientific entrepreneurs harmonized their epistemological claims with their commercial interests. This emphasis on the multiplicity of concurrent modes of representations is intended to serve as a corrective to recent scholarship that has attempted to encapsulate the visual culture of early modern science in one unified epistemology. Lorraine Daston and Peter Galison have argued that this period was dominated by "truth-to-nature objectivity"—that is, the tendency to create idealized and abstracted images of nature. In similar terms, Brian Ogilvie and David Freedberg have pointed to the second half of the sixteenth century when Dürerian naturalism was supplanted by the abstracted and idealized representations of taxonomy. Barbara Stafford, in turn, has argued that the transformation of early modern visual culture happened around 1700. As she wrote, the Baroque art of mostly Jesuit prestidigitation was eradicated by a rational, textualized Enlightenment in those years.[98] By focusing on large epistemological ruptures, these narratives do not sufficiently capture the multiplicity of competing visual regimes and, more importantly, usually ignore their commercial underpinnings. While this book does not dispute the presence of abstract, taxonomical images in the early modern period, it suggests that other modes of representation played an equally important role. In a culture of commerce, scientific entrepreneurs were loath to restricting their repertoire of imaging techniques. As long as customers were interested in it, anything could go on sale.

As *Leviathan and the Air Pump* has summarized the major claim of science studies since the 1980s, "the effective solution to the problem of knowledge [is] predicated upon a solution to the problem of social order."[99] A few years later, Mario Biagioli has shown as a corollary that, in the case of Galileo's work, uni-

versal consensus and epistemological closure could be achieved only through the intervention of an absolutist ruler.[100] Only the Medici duke, a real-life example of the Hobbesian Leviathan, could decide what counted as valid knowledge within his empire. It is therefore especially fitting that the processes of commodification are examined within the context of the Dutch republic. In the absence of a sovereign, the decision-making mechanisms of the republic depended on developing a minimal consensus necessary for the economic and political survival of the country, and the official toleration of dissenting views on topics that were centrally regulated in other European countries. Given this social and political environment, it might be less of a surprise that the imaging techniques of Dutch scientific entrepreneurs did not receive universal approval, and that their scientific debates did not receive closure. Instead, their visual representations and imaging techniques became commodities, traded like all the other consumer goods that made the Republic powerful throughout its Golden Age.

❊ II ❊

SHIPPING COSTS, THE EXCHANGE OF SPECIMENS, AND THE DEVELOPMENT OF TAXONOMY

Imagine you are a natural historian in St. Petersburg in the 1730s. You are fascinated with botany and hope to enrich your garden with some exotic plants from the British Isles. You write to your acquaintances in London to send you some seeds, especially from the species named . . . Well, yes, what is that species called? And even if you know its name, would your English correspondent call that British plant the same name? Or would he think that the name refers to another species? How can you make sure that you will receive the plant you were thinking of? In the period before the widespread acceptance of Linnaeus' binomial system, how do you establish a common system of communication that could ensure that your private identifications of plants are understood by your correspondents all around Europe?

Johannes Amman faced exactly these difficulties as professor of botany and natural history at the St. Petersburg Academy of Sciences. The Swiss natural historian came to Russia in 1733 at the bright age of 26. A cosmopolitan of the eighteenth century, Amman was typical of how early modern naturalists moved around during their careers and established multinational connections. He trained in Leiden during the 1720s under the famed physician Hermann Boerhaave. The early 1730s found him in London where he managed the private collection of the wealthy physician and Royal Society president Hans Sloane, which became the British Museum after the owner's death. Once in Saint Petersburg, Amman established the botanical garden of the Academy of Sciences, and married Elizabeth, daugh-

ter of Daniel Schumacher, who, as we shall see in future chapters, had arranged for the Russian czar's purchase of Albertus Seba's curiosities in 1713. To grow the botanical garden into a site of serious research, Amman needed to actively participate in the international exchange of seeds and plants. His earlier travels provided him with sufficient contacts. He was a regular correspondent of the Dutch Johann Frederik Gronovius, who owned a small private garden in his house in Leiden. He also exchanged letters regularly with the Oxford Sherardian professor of botany Johann Jacob Dillenius, and the English merchant collector Peter Collinson in London, among others. These correspondents provided Amman with seeds from their own gardens or from further contacts as far as Virginia. In return, they expected Amman to provide them with all sorts of curiosities from the vast expanses of the Russian empire.

For instance, Amman exchanged several letters with an ambitious Swedish scholar who resided in Holland in the period, Carolus Linnaeus.[1] Linnaeus was rather eager to acquire some plants from Russia. In 1737, he requested that Amman should send him some "Ceratocarpus Buxbaumi with dried flowers."[2] *Ceratocarpus Buxbaumi* might appear a standard Linnaean, binomial proper name of a species, but it was not. Linnaeus did not publish his *Species plantarum*, which introduced the binomial system for plants, until 1753. In Latin, *Ceratocarpus Buxbaumi* simply meant Buxbaum's *ceratocarpus*—that is, the *ceratocarpus* plant that was described and named by the St. Petersburg naturalist Johann Christoph Buxbaum in his *Nova plantarum genera*.[3] Linnaeus' communication with Amman thus did not depend on a commonly established proper name. Instead, Linnaeus was asking Amman in a kind of natural historical shorthand to go to his library, open up Buxbaum's book, search for the listing of the plant *ceratocarpus*, and then send a specimen corresponding to Buxbaum's description and depiction.

Amman performed the task without a hitch. In response to Linnaeus' letter, he sent parts of the *ceratocarpus* and also asked Linnaeus if he needed any more plants flowering in Russia. For those plants, Amman did not suggest that Linnaeus should identify them by a proper name either. He instructed Linnaeus to identify the specimens he wanted by referring to the relevant entries in Buxbaum's *Centuriae* or in Amman's own *Novi commentarii*, two works that described a large number of species in Russia.[4] If Linnaeus answered accordingly, Amman could again have opened these books at the right entry, read the description, and checked the illustration. Then he would have selected the corresponding plant in the Academy's garden and sent it in a package to Holland with the first available ship.

Amman did not correspond only with Linnaeus. Active in the early eigh-

teenth century, he was only one of the many naturalists, collectors, physicians, wealthy gentlemen, and apothecaries who actively participated in the international trade of curiosities. These curiosities included anatomical preparations, exotic fruits, curative plants, polished seashells, pinned butterflies, bezoar stones, Chinese costumes, and Ancient coins. They were the objects of natural inquiry that evoked wonder, charmed the eyes, and instantiated God's unbounded creativity in creating a glorious world. But these curiosities also served as status symbols, reflecting the collectors' high standing in society, and, moreover, they also had the potential to prove to be useful.[5] Rare and little-known natural objects attracted collectors by the chance that they would have an actual use in agriculture, medicine, manufacturing, or education. The exotic pineapple, for instance, turned from a wondrous curiosity into a rare but regularly cultivated fruit in early eighteenth-century Europe, which naturalists grew in their greenhouses and then sold to aristocratic customers for profit.

It was in search of such curiosities that Amman maintained a correspondence with Collinson in London. In these letters, he also relied on an encyclopedic publication to specify what species he needed from England. In 1738, Collinson offered to send some English bulbs to St. Petersburg but did not know exactly which ones Amman wanted. He presumed that Amman surely owned "Parkinson's *Flower Garden*—from Him you may Pick out, those that have English Names and Refer to folio and number possibly then it maybe in my power to help you."[6] If both Amman and Collinson owned the same volume, they could use it as a trustworthy coding system for identifying plants. Amman would look up a plant species in that volume, mark the folio number on which it was described, and send the reference to England. Once Collinson received Amman's letter, he would open his own copy of Parkinson. Looking at the relevant entry, he would be able to easily decipher Amman's reference. Although this coding system might appear cumbersome, Collinson clearly preferred it over Linnaeus' revolutionary taxonomy, which used the reproductive organs of plants to identify species. While the Linnean system might have been useful to class species into higher genera in theory, most collectors were unable to carefully observe the reproductive organs in their own specimens. As Collinson wrote, sexual identification was not practical enough, for "most people know plants by their leaves, shoots, size, bark, colour, but the Linnean systeme confines the essential characters to those parts least known and only to be seen att certain seasons."[7] While you could be sure that your correspondents would know the color and shape of the leaves, it was much less certain that they would also be able to correctly check the number of pistils and stamens in each specimen.

As Amman's exchanges of plants suggest, early eighteenth-century collectors relied on natural historical atlases and encyclopedias to facilitate the international commerce of *naturalia*. Indeed, many of them would end up writing a taxonomical encyclopedia themselves, using their own collection to devise a more ingenious system that could make communication and trade function ever more faultlessly in natural history. Throughout this chapter, I use the slightly anachronistic term *encyclopedia*, or atlas, to refer to printed works that contemporaries also called a *repertory* or simply a *catalogue*, containing brief, illustrated, morphological descriptions of a large number of species.[8] These repertories were designed for the purposes of identification and classification through a select number of external features, two key practices in long-distance exchanges. Indeed, these works were crucial to the development of Linnaeus' taxonomic, binomial system, which naturalists would treat as just another repertory well into the nineteenth century.

As I argue, these *repertories* first came to regulate the exchange of plants in the sixteenth century, and then, only in the seventeenth century, they also became widely used in the trade in seashells and in insects. Such repertories gradually replaced the earlier, Renaissance histories of nature, whose focus was not restricted to morphological description. As it turns out, this shift from *histories* to *repertories* can clearly be discerned in botany, conchology, and entomology, but not so much in other fields of zoology. The long-distance exchange of larger animals (birds, fish, and especially quadrupeds) was severely limited in the period, simply because it was too expensive to ship them. As a result, there was no clear-cut demand for classificatory repertories in these fields of zoology. In order to understand how commercial exchange brought about the development of taxonomical thought, we therefore need to investigate the material conditions of shipping specimens over a long distance.

NATURE IN THE MAIL

The exchange of natural historical specimens radically increased knowledge about the natural world in the sixteenth and seventeenth centuries, and played an important role in the development of the scientific culture of facts.[9] Yet it is hardly ever noticed that most of these exchanges involved small, botanical specimens, especially plants, fruits, and flowers. Renaissance physicians scoured the hills and valleys around their towns to collect plants with medical qualities. Universities, hospitals, and private collectors established botanical gardens where curative roots, pleasant flowers, or tasty fruits grew. Noblewomen, apothecaries,

and naturalists sent and received *simplicia* (simples), lemons, or oranges through-out Europe. As the sixteenth century drew to its close, exotic flowers, bulbs, and nuts flooded the markets of natural history from Turkey, America, or the East Indies.[10] The *tulipmania* of 1637 was not a unique event, and was followed by a somewhat less exorbitant hyacinth mania a good hundred years later.[11] By the age of Amman, Dillenius, and Collinson, plants, and knowledge about their curative and culinary qualities, had circulated widely for centuries.

The circulation of these plants was facilitated by their modest size and weight, an important concern for an age where the price of sending letters and parcels was considerable. At an international level, even sending a single sheet could cost significant sums, and naturalists did not fail to complain about this. Letters between the Netherlands and London cost 4 stuivers, and took four days for delivery in the best circumstances.[12] Correspondence with more distant locations was even more expensive. When Johann Philipp Breyne, the renowned natural historian and physician in Danzig, asked Collinson to forward his letters to Hans Sloane, Collinson did not fail to express his reservations about this request. Since postage was paid by the recipient in this period, he would have to stand the costs of the wealthy Sloane's international correspondence. He responded bitterly to Breyne that, for missives crossing the Baltic and the North Seas, "every letter inclosed in another, every cover on a letter, and the least scrap of paper in a letter, pays double postage near two shillings," a significant sum in the period.[13] Upon hearing these petty complaints, Breyne wrote back furiously and threatened to stop his correspondence with Collinson. The price of mail could break friend-ships and scholarly networks.

In a world where correspondence was costly, the pursuit of botany had a sig-nificant financial advantage over zoology and mineralogy. Since most plant seeds are tiny, they could be wrapped in a piece of paper and sent as regular mail. These seeds, as well as small pressed plants, flowers, and fruits, could be exchanged relatively cheaply across large distances. When the Dutch amateur naturalist Johann Frederik Gronovius wrote to Amman, then stationed in London, he did not hesitate to compile a long list of plants, domestic and foreign to England (102 in total!), of which he requested a branch for his own collection. A year later, Gronovius sent a letter of thanks to Amman: clearly, the request was not extraordinary and Amman complied with it. In return, once Amman was settled in Petersburg, Gronovius told him that

I have at present exceeding good correspondence in the Virginys from whence I get exceeding good seeds of rare plants, when they come up I

shall dry specimens for you: I recommend my self when you find in the country you are in, some plants which you did not meet here.[14]

The circulation of plant seeds was boosted by another consideration. They could be used to grow whole plants in the receiving naturalist's garden, a feat you could not repeat with animals. While some seeds became infertile when shipped across large distances, not all of them did. Gronovius was happy to report to Breyne that, while his seeds from Pennsylvania did not sprout, the Virginia seeds grew successfully and his garden was practically "infested" with these American plants.[15] Breyne himself could boast of similar results, and eventually ran a successful business producing and selling exotic plants to his customers in Russia. In 1759, he offered to the Russian court five sorts of pineapples, half a dozen cacti, and even an expensive Japanese camphor tree, all the products of his greenhouse.[16] Potentially useful curiosities turned into an actual botanical enterprise. And while some of Breyne's seeds never sprouted, other seeds sometimes managed to survive centuries without losing their ability to grow. In 2006, English botanists were able to grow a *liparia villosa* and other plants from seeds that were originally sent from South Africa to the Netherlands in 1806.[17]

Contrast this easy trade in plant seeds with the more cumbersome exchange of minerals and especially animals. In 1739, Amman requested two ounces of phosphorus from Collinson, a volatile and reactive compound discovered and first marketed by the secretive Hennig Brand in 1669.[18] Phosphorus required special care during transport, and Collinson was doubtful that he would be able to send Breyne the phosphorus, until he was able to report finally that

> it gives mee some pleasure that I can comply with your Request by an Unexpected Opportunity per Cap Tompson for I could not have sent the Phosphorus by Post, it is first putt in a Tinn Box directed for you, then I putt it in a Deal Box directed for Mr. Vigor, who is well known to the Capt he promises great care of it.[19]

If two ounces of phosphorus were cumbersome to transport across the North and the Baltic seas, zoological specimens posed even more problems. Animals, especially live ones, were much more difficult and expensive to transport than plant seeds or dried herbaria, and naturalists were unable to force most species to reproduce in Europe throughout the period. The English pharmacist James Petiver noted with sadness in his correspondence with colonial naturalists that, even for a substantially wealthy collector, it was too expensive, and therefore practically

impossible to ship large fowls across the Atlantic, but at least, "if we cannot have their cases whole, their Head, Leggs, or Wings, will be acceptable."[20] Costs of transportation made even fragmentary animals valuable in Europe. Because of these limitations, a significant long-distance trade in animals began only in the seventeenth century, lagging behind botanical exchanges.[21] Next to spices and silk, the ships of the Dutch and English India companies carried monkeys, parrots, or ostrich eggs.[22] Yet most animals reached Europe in a fragmentary form. While the Leiden anatomy theater possessed a full skeleton of a baboon and two meerkats by 1628, only bits and pieces could be exhibited of larger, exotic animals. Visiting travelers could see only the antlers and the hides of a reindeer and a Siberian roe deer, and, in the case of the rhinoceros and the elephant, only a head was available.[23] When a live beast was exceptionally brought to Europe, and even survived the arduous travel, it would be exhibited in a traveling show, bringing in paying audiences throughout Europe. In the sixteenth century, the elephant Emmanuel plodded through much of the Low Countries and the Holy Roman Empire before expiring on the road; and Hansken, the elephant commemorated by Rembrandt's drawing, followed in Emmanuel's footsteps in the 1620s. Even in the middle of the eighteenth century, the rhinoceros Clara was enough of a rarity to make a convincing one-animal show to the delight of viewers throughout Europe.[24]

The transportation of these large quadrupeds involved impressive sums. While even a naturalist of moderate means could afford to purchase an exotic seashell on occasion, elephants, rhinoceroses, and ostriches were reserved for royalty. The Hapsburg emperor Rudolph II ordered two ostriches from North Africa in 1604, and spent a small fortune in bringing the animals to Prague. The ostriches traveled to Venice by sea, and then spent eighteen days traveling by land and boat to their final destination, escorted by four servants. These eighteen days cost Rudolph 140 guilders, a sum that could sustain a peasant family for almost a year.[25] In the following two hundred years, transportation costs did not change significantly. When the French occupied the Netherlands in 1795, they promptly set to shipping to Paris the menagerie of the Prince of Orange, once supervised by Arnout Vosmaer. Transporting the elephants proved cumbersome. A special carriage needed to be constructed for the price of 15,000 *francs*, and the revolutionary government set aside another 60,000 *francs* for the elephants' travel within France.[26]

It was probably the enormity of the sums involved that led to the limited circulation of other exotic quadrupeds in early modern Europe. European natural historians knew only 150 species of quadrupeds in the late seventeenth century,

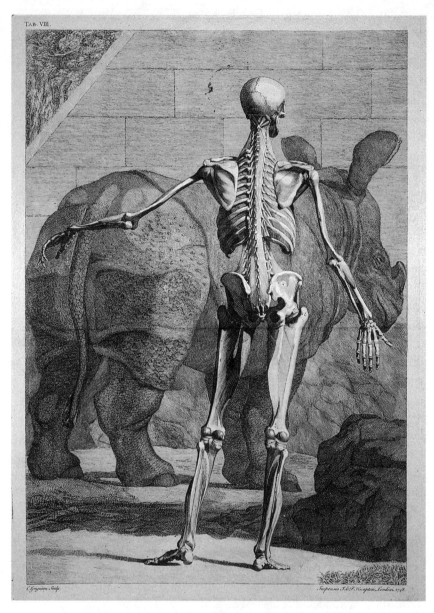

TAB. VIII.

Fig II/1. The rhinoceros Clara became so famous that it was even portrayed in Albinus' *Tabulae sceleti et musculorum corporis humani*, Tab. VIII.

and the number grew only to 300 by the time of Linnaeus, whose knowledge of plants was much more extensive. His *Species plantarum* classified around 6,000 plant species.[27] No giraffe visited the European continent between 1485 and 1827. The same period saw one hippopotamus at the Medici court in Florence, and two stuffed specimens in Naples, where they caught the interest of Peter Paul Rubens.[28] In fact, even the transportation of useful animals remained limited in this age. Obviously, the Dutch East India Company did not fail to stock its ships with swine to feed the sailors and horses to equip the soldiers, but they tended to economize on these costs whenever possible. Soon after the establishment of the Dutch colony on the Cape of Good Hope, for example, the governor Jan van Riebeeck sent repeated requests for European horses to the Amsterdam headquarters of the East India Company, without much success, and in the end resorted to having a few horses shipped from Java.[29] And while European courts regularly imported horses from the Middle East, and even crossed them with local breeds, these prize specimens could be afforded only by royalty or aristocrats. King James I paid over 150 pounds, for example, for the legendary Markham Arabian.[30]

Those curious quadrupeds that made it to Europe were often sold for a fortune, as a result. The rhinoceros brought to London in 1683 was sold for 2,320 pounds, although the buyer later defaulted.[31] Monkeys in seventeenth-century France could cost up to 480 *livres*, and even cockatoos, a species of a more modest size, were valued at fifty to sixty guilders in contemporary Amsterdam.[32] Given the high price of these specimens, naturalists and collectors with a zoological bent tended to specialize in smaller animals that could be transported and stored much more easily. Seashells and insects were especially popular. Since these animals are usually tiny, do not rot, and can be shipped without difficulty, they became one of the most important *exotica* of the seventeenth and eighteenth centuries.[33] It is true that rare shells could fetch exorbitant prices, and, in the 1720s, an Admiral seashell cost 1,020 French livres to a merchant in Amsterdam.[34] Yet most shells were cheaper and could be afforded by naturalists of moderate wealth. In the East Indies, one could even get nautilus shells for the price of a few guilders, a fraction of what a parrot cost, and prices were not much higher in the markets of Europe, either.[35] As a result, shells became the most frequent exotica in Amsterdam cabinets, and were also highly sought after in other countries. When visiting Paris in 1698, the English shell-expert Martin Lister did not only hear reports of the extraordinary collection of the late *Duc d'Orléans*. He could also personally visit and see the cabinet of Monsieur Buco, with sixty drawers of shells; the collection of Joseph Pitton de Tournefort, with its twenty drawers of shells, as well

as the smaller collections of Monsieur Morin and Father Charles Plumier.[36] By the eighteenth century, shells were one of the most fashionable curiosities in the French capital.[37]

If conchological collections had a competitor in the field of zoology, these surely were the insects.[38] The moderate size of these animals, and the relative ease with which they could be preserved, made them an ideal candidate for cheap transportation. In his letters, Petiver might have been worried about the shipment of larger birds and quadrupeds, but he was happy to inform his correspondents that most "Beetles, Spiders, Grasshoppers, Bees, Wasps, &c." could be

> drowned altogether, as soon as caught in a little wide Mouth'd Glass, or Vial, half full of Spirits, which you may carry in your Pocket: But all Butterflies and Moths, as have mealy wings, whose Colours may be rub'd off, with the Fingers, these must be put into any small Printed Book, as soon as caught, after the same manner you do the Plants.[39]

Sent across the Atlantic, packed in a bottle or pressed in books, insects approximated Bruno Latour's definition of immutable mobiles: easy to preserve, easy to transport, and even flattened into two dimensions when pressed in a book.[40] Little wonder, then, that late seventeenth-century cabinets were literally swarming with dead insects. As Maria Sibylla Merian wrote in her *Metamorphoses insectorum surinamensium*, all the major Dutch cabinets, including those of Frederik Ruysch, Levinus Vincent, and even Amsterdam burgomaster Nicolaes Witsen, exhibited countless insects.[41] Late seventeenth-century zoology centered on these minute animals because they were easy to exchange, and not only because of the development of microscopy.[42]

NEGOTIATING EXCHANGES

Shipping costs mattered to *curiosi*, and influenced the content of natural history collections, because of the commercial mindset of many collectors. Immediate profit might not always have been their primary concern, but they were loath to suffer financial losses when trading specimens. Historians have traditionally emphasized how knowledge was exchanged for honorific gifts in the international Republic of Letters. Yet, at least in the field of natural history, bartering and cash transactions played an equally important role in regulating the long-distance commerce of natural curiosities.

Take, for instance, the correspondence of James Petiver, who requested some plants from Breyne in 1706. Probably responding to a now lost letter of the latter, Petiver assured him, using a standard reference to Francisco Hernandez' natural history of Mexico, that if "the Contrayeerva is that Figured in Hernandez then I should be glad to see a sprigg of it."[43] In this letter, Petiver laid down explicit rules for trading natural curiosities and books:

> I am willing where money is not to be had, to exchange what I do for the like value, in other books of that kind, which Curious persons have often duplicates of, or at leastways can easily procure, and if they will or cannot do it, I am willing to traffic with the Booksellers in your parts, on the same Accounts, viz. Barter or Exchange for your Fathers acceptible works, your own or any others published in Dantzick or near you, or otherwise even for Collections of Naturall things, them selves or other Curiosities, if they value them not to dear.[44]

While the proposed barter probably suited well Breyne and the booksellers of Danzig, Petiver resorted to cash transactions with his correspondents in the Caribbean. At the first instance, Petiver proposed to reward his suppliers with the honor of mentioning them in his publications. But if they were not satisfied with purely honorific, scientific credit, Petiver was going to pay them five shillings for "every wide mouthed Quart Bottle filled with small Birds." He would also shell out the same sum "for every Oyster Barrel of Land, River, or Sea Shell," and for "each Hundred of Butterflies, Moths & such like insects."[45]

Indeed, although some curiosities circulated as gifts, many naturalists drew a significant income from selling them for money. As we saw in the introduction, when the German traveler Baron Zacharias Conrad von Uffenbach visited Amsterdam in 1711 he found there a thriving curiosity trade with specialized shops selling shells and other *naturalia* to tourists and other customers. Cornelis de Man's mid-seventeenth-century painting of *The Curiosity Seller* offers a rare glimpse into the world of these shops. A foreign-looking, mustachioed shopkeeper, wearing an earring, is shown attempting to sell various curiosities to two elegantly dressed ladies. The shop is furnished with a variety of objects. The obligatory dried crocodile, a monstrous fish, and antlers hang from the ceiling, while the walls and the shelves are filled with foreign ethnographic objects, swordfish, rare eggs, and shells, shells, shells. A young, male apprentice has just brought a basket full of conchs to the seated lady, who contemplates purchasing a

striped *nautilus*. Clearly, this curiosity shop specializes in those moderately sized objects that were easy to ship. Apart from the crocodile, a status symbol of the shop, all the other larger animals are shown in a fragmented state.

While most curiosity shops disappeared from Amsterdam without a trace, we are fortunate enough to put at least a name to some of those involved in this trade. Albertus Seba actively participated in this business, providing his customers in Germany and Russia with seashells, anatomical preparations, and other *exotica*. The naturalist Maria Sibylla Merian regularly sold specimens to customers such as Petiver, and even considered repaying the debts incurred during her voyage to Suriname by auctioning off her whole collection of insects and snakes.[46]

In this business of nature, correct identification was a must. Long-distance trade could work only if customers and salespersons agreed on what specimen was on sale. If you ordered a rare and expensive seashell, you did not want to receive another one that belonged to a more common, and less valuable species. Obviously, it was not always possible to correctly identify an exotic and potentially unknown animal, or to determine what plant will sprout from a packet of seeds. Collectors happily accepted these indeterminate curiosities as a gift, but they preferred to be more specific about their requests when they were expected to pay for them. Yet it was difficult to be precise when a common nomenclature was missing. Even in the twenty-first century, scientific nomenclature is far from perfect. In 2010, scientists estimated that, of the one million recorded plant species, 600,000 were duplicates or triplicates already known to science under another name.[47] In the years before Linnaeus' system became widely accepted (with the advent of international scientific organizations long after Linnaeus' death), the situation was much worse, and pragmatic solutions were sought that could bridge the distance between the pharmacies of Amsterdam and the Academy of Science in Petersburg. Aided by the naturalists John Ray and Francis Willoughby, the natural philosopher John Wilkins developed a new, universal language, including botanical and zoological nomenclature. The universal acceptance of the *Real Character*, or so Wilkins hoped, would result in "facilitating mutual Commerce, amongst the several Nations of the World, and the improving of all Natural knowledge."[48]

Yet Wilkins' *Real Character* never caught on, and natural historians had to content themselves with developing dictionaries that translated between the local languages of collectors in Russia, England, Italy, or the Indies. In the field of botany, where the demand for such works was especially pressing, Caspar Bauhin

published his *Pinax*, which performed this function, already in 1623.[49] Relying on his collection of plants, Bauhin looked through all the available botanical encyclopedias of his age and attempted to establish synonyms between these different works. Despite his Herculean efforts, the *Pinax* soon became obsolete and outdated. Botanists had to compile their own, personal dictionaries of plant names to ensure proper identification. In his own copy of Sebastien Vaillant's *Botanicon parisiense*, for instance, the Leiden professor Hermann Boerhaave, the editor of Vaillant's encyclopedic work, carefully noted in hand a large number of synonyms for each entry.[50] Some valiant naturalists also attempted to compose a new *Pinax* that could replace Bauhin in its entirety. William Sherard, erstwhile English consul at Smyrna, devoted no small effort to the project but died in the process. The task was left to the Oxford botanist Johann Jakob Dillenius, Sherard's protégé, who soldiered on for over a decade. Upon his death, the manuscript *Pinax* contained sixteen volumes and was still unfinished.

When universal languages and dictionaries both failed, natural historians had to find another solution to correctly identify the many species of plants and animals that they were dealing with. Realizing the limitations of using only names to identify species, they accommodated themselves to the multitude of illustrated encyclopedias as the best alternative for establishing successful, long-distance communication.[51] Early modern naturalists were hopeful, although not always justifiably, that everyone would be able to correctly identify plants and animals with the help of an illustration, especially if they were accompanied by a brief, descriptive note detailing the outlook of the species in a few words. When ordering specimens from their correspondents, they therefore turned to the method of identification discussed in the beginning of this chapter. Confident that every naturalist owned a copy of Parkinson's *Flower Garden*, Collinson told Amman to use this volume, and to specify the entry that described and depicted the plant he desired to have.

As we shall see, the hope and trust natural historians placed in illustrated encyclopedias had important consequences for the development of natural history. By and large, naturalists turned away from Renaissance *histories* to writing taxonomical encyclopedias. They developed an amazing variety of classificatory systems, with which they planned to order the living world. In these systems, each individual species could be identified with the help of a few distinctive features. Since plants were the first *naturalia* to be exchanged in large numbers, botany was the first to transform into a taxonomical enterprise. The disciplines of conchology and entomology followed soon, but the study of larger animals re-

sisted efforts at classification well into the eighteenth century. Yet to understand the shift to taxonomy, it is necessary to review how natural history functioned before classification became its primary concern.

TRANSFORMING A HUMANIST DISCIPLINE

Natural history became a humanist discipline in the years around 1500. In the first decades of printing, new editions of medieval herbals, such as the *Gart der Gesundheit* and the *Ortus sanitatis*, were regularly published, but scholars increasingly turned towards producing reliable, printed editions of the manuscript of the ancient naturalists Dioscorides, Theophrastus, and Pliny.[52] The first generation of humanist natural historians focused primarily on botany. Instead of simply cataloguing the known plants of contemporary Europe, they aimed at restoring the texts and the knowledge of the Ancients through the twin practices of textual philology and first-hand observation. When applying ancient knowledge to contemporary problems, botanizing humanists concentrated on medicinal plants in order to verify the Ancients' claims about their curative effects. In zoology, the first major humanist history, the Swiss Conrad Gesner's magisterial *Historiae animalium*, appeared only in the 1550s in five hefty volumes.[53] It was followed by Ulisse Aldrovandi's multivolume encyclopedia, posthumously published in the first half of the seventeenth century. These two zoological histories are often treated as the epitome of Renaissance scholarship. Gesner and Aldrovandi systematically compiled all the available information on most recorded animals throughout history, and provided an exhaustive, philological evaluation of the textual sources. As a result, entries on common species—for example, cattle or the horse, tended to run to hundreds of pages, as every Ancient author from Homer to Boethius had something to say about these animals. In his three-hundred-page entry on cattle, for instance, Aldrovandi reviewed all Ancient sources. He discussed how cows looked, what they ate, how they were used in agriculture, whether they were ever employed in a war, what ritual functions they fulfilled in different religions, and what monstrous cows were born throughout the ages, painstakingly assessing the available evidence. To give one example, Aristotle, Varro, and Sotion could not completely agree at what age it was best to castrate a bull, and Aldrovandi had a hard time deciding whom to trust.[54]

In such Renaissance *histories,* entries on exotic animals were shorter than the ones on common, domestic species. For curious animals, the authors had to supplement the scant evidence of the Ancients with new information gained from the accounts of learned travelers, printed broadsheets, and personal acquaintances.

Cap.32. proponerent, qua de re in Deuteronomio legimus : *Videns autem populus , quòd moram faceret Moyſes de-*
ſcendendi de monte Moyſes , congregatus aduerſus Aaron , ait : Surge , fac nobis deos , qui nos præce-
dant. Meyſi enim huic viro , qui nos eduxit de terra Aegypti , ignoramus quid acciderit ei . Dixitque
ad eos Aaron. Tollite inaures aureas , de vxorum filiorumque & filiarum veHrarum auribus , & affer-
te ad me . Fecit populus , qua inſſerat , deferens inaures ad Aaron . Quas cum ille accepiſſet , formauit
opere fuſorio ex eis vitulum conflatilem . Dixeruntque : Hi ſunt dij tui Iſrael qui te eduxerunt de
terra Aegypti. Quod cum vidiſſet Aaron , ædificauit altare coram eo , & præconis voce clamauit di-
cens : Cras ſolemnitas domini eſt. Surgenteſque mane , obtulerunt holocauſta & boſtias pacificas , &

Idololatriæ ſedit populus manducare & bibere , & ſurrexerunt ludere. De grauitate peccati huiuſce idololatriæ
peccati gra- ſic diſſerit Toſtatus : *Feceruntque ſibi vitulum conflatilem .* Hic (inquit) declaratur in ſpecie
uitas. peccatum , ſcilicet quod peccatum Iſraelitarum non fuit in aliquo paruo , ſed in maximo facien-
do contra primum mandatum fabricando deum , & fuit iſte deus vitulus conflatilis , ideſt , factus
conflatilem in forma fuſorio auro liquido immiſſo , de quibus omnibus rationes ſupra aſſignatæ
ſunt. *Et adorauerunt.* Hic explicat deus per ſingula grauitatem huius ſceleris , vt videatur Moy-
ſi magis dignum punitione. Fuit enim prima culpa ſiue gradus , quia fecerunt ſibi vitulum confla-
tilem : nam dato quod hoc ſolum factum fuiſſet , erat grauis culpa , & contra primum manda-
tum , ſed nec hoc ſolum manſit , quoniam ſecuta eſt alia culpa ſecunda , ſcilicet quia adorauerunt
eum , inclinantes ſe coram eo , tanquam coram deo ſuo vero : quod adhuc grauius culpæ genus
eſt : nam primum , ſcilicet fabricatio vituli , vel cuiuslibet alterius ſtatuæ non erat peccatum , ſed
ſecundum , quòd ad adorandum fiebat : ergo ipſa adoratio in ſeipſo grauior erat. Si ergo Iſrael
mox vt vitulum fabricauerunt pœnitentes de iniquitate ſua inchoatâ , & concepta eum non ad-
luiſſent comminuentes in puluerem , vel flammis exurentes , licet peccatum præcedens graue fue-
ret , remediabile tamen erat. Nunc autem quia adorauerant grandis erat effecta iniquitas. *Atque*
immolantes. Iſtud eſt tertium grauamen peccatum , ſcilicet quod immolauerunt illi vitulo : nam
adoratio erat quædam exhibitio reuerentiæ facta illi vitulo aureo iſta tamen aliquando fit homini-
bus , licet differat ab effectu exhibentis , vtrum ſit latria , vel dulia. Et ideo hoc exiſtente adhuc re-
erat

Aldrovandi based his eleven-page discussion of the rhinoceros on the travel accounts of Samuel Purchas, Martin Frobisher, Thomas Burton, Peter Martyr, and Jacques Chartier, among others.[55] These accounts usually centered on the animal's appearance, as most travelers did not spend enough time around them to learn much else about them. Yet Aldrovandi did his best to make the entries as complete as possible. He was happy to include reports on how one should hunt for ostriches, and, if the hunt was successful, how one could prepare a delicious meal out of them. Renaissance naturalists thus went beyond the concerns of identification, and made a concerted effort to provide an exhaustive account of each species.

The last volumes of Aldrovandi's zoological histories were published only in the 1640s. By this time, the discipline of botany had already seen the emergence of a new genre: the taxonomical encyclopedia. Since plants and their seeds, fruits, and flowers circulated in large numbers from early on, the collectors' demand grew for illustrated encyclopedias that facilitated the identification of plants by distinctive, external features. Such a development was also boosted by a growing consensus amongst scholars that the visually discernible features of plants were constant across a species, and could therefore serve as the basis for a proper definition.[56] As botanical commerce grew, collectors found the wide-ranging topics of humanist histories rather irrelevant for the purposes of reference "by folio and number." Instead, they turned towards newer atlases that provided succinct textual and visual information on the appearance and the geographical origins of a large number of species. Entries were much shorter than in Renaissance histories, usually not more than a few paragraphs, and discussed only a select number of external features, by which the species could be easily differentiated from related species. Long-distance exchanges of specimens were easier to perform with the help of these classificatory works. Taxonomy became a serious discipline.

For Michel Foucault, this transformation of natural history was an epistemic shift from Renaissance representation to Enlightened taxonomy, as discussed in his *Les mots et les choses*.[57] While historians are usually critical of Foucault's periodizations, they have come to agree with him on this particular point. In recent years, Brian Ogilvie, David Freedberg, Sachiko Kusukawa, and Laurent Piñon have refined, nuanced, and expanded the French thinker's original observations to the visual world of botanical and zoological encyclopedias.[58] Originally, Foucault simply postulated the concurrent emergence of Enlightened taxonomy across the disciplines as a shift in European mentality. Yet in recent years, scholars have debated extensively the causes of this development. Did taxonomy grow out

of a philosophical desire to establish the natural order of plants, or did it emerge from the more pragmatic concerns of having to catalogue a large number of newly discovered plants?[59] As this chapter argues, the long-distance, commercial, and gift exchange of specimens played an important role in effecting this shift. The commerce of *naturalia* would not have been able to function properly without the communicational help of the new, encyclopedic catalogues of nature.[60] Such a materialist approach does not simply offer a down-to-earth, basic explanation to an epistemic shift, but also explains why the turn to taxonomy did not happen simultaneously across the disciplines, as Foucault would have it. Because of the costs and difficulties of shipping, commercialization affected botany much earlier than zoology.

The earliest traces of this development are already present in the botanist Leonhart Fuchs' *Historia stirpium* from 1542.[61] Fuchs arranged the entries of his encyclopedia in an alphabetic order, suggesting that the ease of searching was more important for a reference work than a natural philosophical order. Compared to Aldrovandi's 300-page entry on cattle, Fuchs' entries were much shorter, usually taking up a few pages at most. Each entry was divided into the same subsections, first listing the various names of the plant and then discussing its shape and external features, the main interests of later taxonomists. An illustration also accompanied this description to facilitate identification. In the rest of the entry, Fuchs discussed where the plant grew, in what seasons, and in what temperatures. In the last section, Fuchs cited the opinions of Ancient authors, such as "Dioscorides, Galen, Pliny, and sometimes even Aetius, Paulus, and Simeon Seth." A good humanist and not a full-fledged taxonomist, Fuchs still retained an interest in the Ancients' opinions, even if this meant the swelling of his volume. The naturalist Valerius Cordus, a contemporary of Fuchs, paired differently his interests in the humanist and descriptive approaches to botany. The postmortem edition of his works, edited by Gesner, included both a volume of extensive commentary on Dioscorides, and a separate, illustrated repertory that provided brief, morphological descriptions of a large number of plants.[62]

Fuchs' and Cordus' attention to the external features of plants made each of them a potential candidate for managing long-distance communication. When, in 1564, Gesner received a package from the little-known Johannes Funck, he relied on Cordus to identify the plant as a *hepatica alba*, unknown to the Ancients, and wrote back that "the plant that you have sent me, is described by Valerius Cordus under the name *hepatica alba* in chapter 115 of the second book of the description of plants."[63] Yet in much of his correspondence, Gesner still hoped that one could simply rely on Greek names to identify a plant, and rarely found

c Stranguriæ & difficultati urinæ auxiliatur. Capiti admota calefacit, eiusq; humidi-
tates exiccat. Hinc est quod recentiores tantisper eius usum in frigidis cerebri &ner
uorum morbis, apoplexia, paralysi, & similibus cõmendent.

Sequentia duo capita, quoniam absoluto fermè opere ad nos uenerunt, & idcirco suo loco re-
poni non potuere, tamen ne lector ijs fraudaretur, in calcem potius reijce-
re, quàm omnino præterire, collibuit.

DE DIGITALI▸ CAP▸ CCCXLII▸

NOMINA.

Digitalis.

VOd appellatione tum græca tum latina herba hæc hodie destituta sit,
nulla alia de causa factum existimamus, quàm quod ueteribus incogni-
ta fuerit. Nos pulchritudine eius illecti, ἀνώνυμον esse diutius non sumus
passi. Appellauimus autem Digitalem, alludentes ad germanicam no-
menclaturam Fingerhūt / sic enim Germani hanc stirpem nominant, à florum si-
militudine, quæ digitale pulchrè referunt ac exprimunt. Hac appellatione utemur,
donec nos uel alij meliorem inuenerint.

GENERA.

Digitalis pur-
purea.

Digitalis lutea.

Duûm est generû. Vna enim purpureos obtinet flores, ideoq; Digitalem purpu
ream appellauimus. Germanis brauner Fingerhūt dicitur. Altera luteos habet flo
res, ob id Digitalis lutea dicta nobis est. Germanis geeler Fingerhūt nominatur.
In alijs per omnia similes sunt.

D

FORMA.

Herba est cubitalis, folijs latis & oblongis, Plantagini non dissimilibus, in extre-
mitatibus serratis, floribus à lateribus caulis ordine dependentib. digitalis formam
referentibus, purpureis aut luteis. Quibus decidentibus, semen in calycibus latum
& oblongum profert, Radix illi est exigua & capillata.

LOCVS.

Nascitur in montibus, umbrosis & saxosis locis.

TEMPVS.

Floret Iulio potissimû mense, atq; subinde cadentibus floribus semen producit.

TEMPERAMENTVM.

Impense amara est herba, perinde atq; Gentiana, ut hoc nomine calidã & siccam
esse euidentissimum sit.

VIRES.

Hæc herba hauddubiè quum opus est extenuatione, abstersione, purgatione,
& obstructionis liberatione, efficax admodũ esse solet. Nam, ut testatur Galenus li-
bro iiij. de simp. med. facul. cap. xvij. amari sapores abstergunt, expurgant, & quæ
in uenis est crassitiem incidunt. Quamobrē menses etiam quæ amara sunt mouere
possunt, & ex thorace & pulmone pus educere. Quid multa? potest hæc
herba ferè omnia quæ Gentiana, cuius uires suo in lo-
co inuenient studiosi.

DE OCIMA-

Fig. II/3. The text is divided into clearly marked sections, indicating the name, genus, shape, location,
time of flowering, temperament, and powers of the plant. Fuchs, *De historia stirpium commentarii*
insignes, 892–93.

DIGITALIS
PVRPVREA

Brauner Fingerhût.

it necessary to specify which encyclopedia contained a proper description and illustration of the species he was referring to.

By the end of the sixteenth century, such hopes were dashed by growing commerce and the ever larger numbers of available plants. Botanical language was mired in Babelian confusion, and botanists such as Carolus Clusius had to identify rarer plants in their correspondence by referring to an entry in an encyclopedia. When putting a packet of seeds in the mail for the Leiden anatomy professor Petrus Paaw, Clusius identified the better-known plants simply by their Latin names, but in the case of the *linaria alpina minima*, he specified that a description of this lesser known plant could be found in "Clus. in Pann. Obser."—that is, Clusius' own *Rariorum aliquot stirpium per Pannoniam observatarum historia*.[64] And once Clusius settled in the Netherlands, this bustling commercial entrepôt, other correspondents also sent him plants identified in this manner. When the Flemish physician Anselmus de Boodt reported to Clusius about his travels in Moravia, he informed the elderly naturalist, using the same bibliographical shorthand, that he would be ready to send him some bulbs of the plant "Moly, found in the mountains of Moravia, described by Matthioli." Using the classic work of Matthioli, de Boodt thus ensured that Clusius would be able to identify the plant and decide whether he wanted a specimen or not.[65]

Clusius did not only receive Moravian plants and Hungarian seeds: he also played a key role in introducing the Netherlands to the tulip, and the Dutch have been associated with this flower ever since. In the early seventeenth century, Dutch horticulturists grew dozens of colorful varieties, and rare cultivars changed hands for increasingly larger sums. This trade reached its height in the late 1630s, when collectors shelled out several thousand guilders for a *semper augustus* or a *viceroy*. Many of these transactions took place during the winter, outside the blooming season. Customers bought tulip bulbs on trust, uncertain of how the flowers would appear in the spring. It was therefore essential to develop a trustworthy system of identification by which one could distinguish between a white *Gouda* with red, vertical streaks, worth 1,500 guilders, and a white *Admiral Rotgans* with red, vertical streaks, worth 805 guilders.[66] To cater to these needs, tulip books appeared on the market both in print and in manuscript. The first harbinger of this genre might have been Emmanuel Sweerts' *Florilegium* from 1612, an advertising catalogue of various flowers, including tulips, which the author was offering for sale at the Frankfurt fair. Such catalogues and tulip books were usually sparse with words, and featured instead a large number of sumptuous illustrations, carefully detailing each variant's appearance. Textual

Fig. II/4. The inscriptions indicate the color of each tulip, in the absence of hand-coloring. Sweerts, *Florilegium*.

information was usually limited to a name, and could also include data on the weight and the price of the bulb that was sold.[67]

These tulip books might be one of the earliest examples of the new, taxonomic repertories of botany that came to facilitate the commerce of plants in the seventeenth century. The Renaissance interest in repeating all the Ancient sources on each species waned, and was replaced by the visual representation and the textual representation of the plant's outlook. Throughout the seventeenth century, naturalists developed a large number of classificatory systems to order and correctly identify plants.[68] For Petiver, Sloane, and Breyne, the most influential taxonomical encyclopedia was probably the *Historia plantarum* by John Ray, a common friend.[69] A generation older than these other naturalists, Ray played an influential role in the early Royal Society, sending frequent reports to London from his rural estate in Essex. A collaborator of John Wilkins' project of universal language, Ray hoped to stem botanical confusion by offering a cheap and trustworthy encyclopedia that every naturalist could afford. This work, the *Historia plantarum*, made every effort to be clear and understandable for a large audience of naturalists scattered around Europe. It started with a glossary where each term of description was defined. Ray then ordered thousands of plant species into a complex, taxonomical tree to facilitate identification, and devoted a separate entry to each of them. Using only words defined in the glossary, each entry offered a brief, methodical description of the plant's form, its place of origin, and its specific features that differentiated it from similar species. Ray hoped to publish the *Historia plantarum* with illustrations, but the lack of financial support prevented him from doing so. Even without images, Ray's work swelled to three volumes because of its treatment of such a large number of species. Nonetheless, it remained shorter than many of the earlier encyclopedias of the Renaissance.

Ray intended the *Historia plantarum* to replace earlier *histories* of botany with a cheap repertory, condensing their wide-ranging information into one book. As he explained to Sloane, his aim was not to "supersede the use of any approved botanic author," but to correct their mistakes, clarify their obscure language, and "alleviate the charge of such as are not able to purchase many books." A cheap repertory would then

> facilitate the learning of plants, if need be, without a guide or demonstrator, by so methodizing of them and giving such certain and obvious characteristic notes of the genera, that it shall not be difficult for any man who shall

but attend to them and the description, to find out infallibly any plant that shall be offered to him, especially being assisted by the figure of it.[70]

Ray's emphasis on the importance of identifying plants that one exchanged with correspondents stemmed from his own practice of borrowing, lending, giving, and receiving specimens. As he was a naturalist of modest income, the scope of his correspondence did not reach much further than England. The common, domestic plants that he sent and received circulated primarily as gifts. Yet Ray realized that international botanic networks functioned differently. When the physician Tancred Robinson visited Venice, he reported to Ray that the heirs of Giovanni Maria Ferro refused to sell him Ferro's herbaria, although he offered as much as twenty pistoles for them.[71] Robinson also informed Ray that, in order to maintain their monopoly, Arab traders sold only infertile coffee beans to foreign customers, and were "as careful in destroying the germinating faculty of the coffee fruit or seed, by boiling or burning, as the Dutch of the Moluccas are in their nutmegs."[72] Botany at a global level was serious business that did not work in a gift economy.

The *Historia plantarum* was not the only late-seventeenth-century systematic encyclopedia that aimed to become the *only* systematic encyclopedia, vainly hoping to replace older works and to gain universal approval. In France, Joseph Pitton de Tournefort was busily preparing his *Elémens de botanique*, whose illustrations showed only those parts of the plant by which it could be correctly identified, breaking with the tradition of showing each plant in its entirety. In England, Leonard Plukenet was about to publish his *Phytographia*, a strong competitor for Ray's own work especially because it contained hundreds of illustrations that featured almost three thousand plants. Each plate featured rather simplistic images of several plant species. Plukenet illustrated similar species next to each other on the same page, making it easier for readers to differentiate between them. As in Tournefort, Plukenet pictured fragmented plants, and focused on those parts that exhibited the distinctive features of the species, a helpful reduction in the size and cost of the book. The *Phytographia* was not a coffee-table book to entertain aristocrats with its beautiful images, it was a moderately priced, taxonomic visual aid. To facilitate visual identification, the illustrations were accompanied by brief, morphological descriptions with synonyms and references for each entry in the form of an inscription engraved on a copperplate.

One might expect that, with the proliferation of these taxonomic encyclopedias, the identification of plants became a simpler process in the years around

Fig. II/5. The plants are shown in a fragmented state only. Plukenet, *Phyto-graphia*, Tab. 66.

1700. And, in a sense, it did. If two naturalists could agree on whether they trusted Ray, Plukenet, or Tournefort, they could order plants from each other by referring to the relevant entry in the encyclopedia they had chosen to use. Yet it was hardly obvious how to make such a choice. No two encyclopedias agreed on where to draw the boundaries of species, and how to name and classify the ever increasing number of plants. For example, despite their mutual friendship, Ray was deeply dissatisfied with Plukenet's work, and wrote privately to Sloane that

I find in it many mistakes in the language, and in the composition of Greek names; and I doubt not but there are many in the matter. It is impossible but that a man who relies wholly upon dried specimens of plants (be he never so cunning) should often mistake and multiply.[73]

Ray, who studied botany by the first-hand observation of live plants in his orchard and through his extensive travels, suspected and found it deeply problematic that Plukenet relied only on his own herbarium, which showed dead plants flattened into two dimensions. Ray was especially troubled with Plukenet's classification of Jamaican ferns, and charged that Plukenet mistook each of his specimens for a separate, individual species. Sloane, who had recently returned from a prolonged stay in Jamaica, apparently concurred with Ray's criticism, but it was clear to both of them that it would be an uphill battle to bring up this topic with Plukenet. As Ray noted, Plukenet was "a man reserved, jealous of his reputation, and none of the best nature," and, as a result, Sloane and Plukenet, the two prominent naturalists of Jamaican flora, both living in London, could not come to an agreement as to what constituted a species in this field.[74] The different practices of plant observation, compounded by personality issues, led to what economists call a coordination problem.[75] Naturalists could not commonly agree to rely on one system of botanical nomenclature, and used several systems of taxonomy concurrently, turning long-distance communication and the exchange of information into a cumbersome business. Their choice of an encyclopedia was always context dependent, and could be revised when a new plant came under consideration.

Dillenius experienced this coordination problem when using taxonomical encyclopedias to identify plants during a herborizing trip to Wales in 1726. As we learn from his diary, a social manuscript that he circulated among his friends, Dillenius consulted both Leonard Plukenet's *Phytographia* and his own, recently published edition of John Ray's *Synopsis* throughout the journey.[76] On July 17, for instance, Dillenius noted that "upon Brent Down, which lyes over against Uphill, we searcht after Cistus humilis Alpinus durior, &c., Pluk. 342. [i.e., Plukenet] & found it in plenty on the rocks that lye South & West, after you are past the middle of the Down." The next day, they were less fortunate with Plukenet, but found some plants identified by Ray. As he wrote, they would "loock for 3 & more hours for Dr. Pluk. Polygonum folio circinato, mentioned grow near Weston supra mare, but could find nothing than Alsine 12, Syn. p. 351 [i.e., Ray's Synopsis] which may be Dr. Plukenet mistoock for a Polygonum."[77] In order to conveniently identify plants, Dillenius referred to two different botanical ency-

clopedias, and had to make his own judgment when these two sources disagreed on the identity of some plants.

CLASSIFYING SHELLS AND INSECTS FOR COLLECTORS

Botanical taxonomy emerged together with the growing commerce of plants in the sixteenth and seventeenth centuries. One can observe a similar, correlated development in the taxonomy and commerce of zoology, although with a significant delay. Because zoological specimens tend to be larger than plants (with the exception of trees), they were more difficult to ship in early modern Europe.[78] While broadsheets, travelers' reports, and encyclopedias widely circulated information about animals, actual specimens only rarely became the part of commercial exchange. There were two exceptions to this rule, however. As we have seen, seashells and insects were easy to ship because of their moderate size, and consequently became the favorite curiosity of seventeenth-century collectors. The first zoological taxonomical encyclopedias therefore focused on conchology, and to a lesser extent on entomology.

Shells and insects were already treated differently from the rest of the animals in Aldrovandi's monumental Renaissance encyclopedia. The Italian author discussed these species in his *De animalibus insectis* from 1602, and his *De reliquis animalium* from 1606.[79] While the illustrations on larger animals usually came from a variety of sources, the illustrations in these volumes were drawn after specimens either in the author's collection or observed during fieldwork. Aldrovandi obviously did not forget to include an elaborate philological, contextual, environmental, and historical narrative even in these two volumes. Yet his entries were generally brief, compared with the entries on birds, fish, or quadrupeds, and discussed primarily how to identify and differentiate similar species through the careful examination of external features. Contemporary readers did not only need to know what the Ancients thought about shells. They also had to be able to distinguish one shell from another in their own collections.

Taxonomical works on insects got an early start with Thomas Moffett's *Theatre of Insects* from 1634, which was ultimately based on Conrad Gesner, and received a significant boost with the English Martin Lister's extensive publications in the 1680s.[80] The heyday of conchological encyclopedias also came in the 1680s, when the Italian Jesuit Filipp Buonanni published his *Ricreatione dell'occhio e della mente* and the same Lister came out with his *Historiae conchyliorum*. Both of these works signaled collectors' and dealers' increased interest in correctly identifying the specimens they were exchanging. A student of Athanasius Kircher, Buonanni

was a Catholic Aristotelian who did not abandon the Renaissance interest in Ancient sources, and tried to vindicate them through the use of experimental evidence. The first and third books of the *Ricreatione* offered philosophical investigations of how seashells reproduced and lived in their natural habitat, and especially how they could produce dyes.[81] As Valerius Cordus did in his sixteenth-century botanical publications, Buonanni treated taxonomy separately from his philosophical work, in Books II and IV. Book IV published illustrations of more than 400 species that were described and identified in Book II. The entries of Book II were based on the specimens in Kircher's museum, where Buonanni served as a curator, and would later be reprinted, without the *Ricreatione*'s philosophical discussions, as part of the *Musaeum Kircherianum*, a catalogue of the museum.[82] This museum's holdings included shells from all parts of the world. Thanks to his extensive network of collectors, merchants, and Jesuit missionaries, Buonanni received shipments from the Netherlands, from Syracuse, from Portugal, from Brazil, and also from the Indies.[83]

From the outset, Buonanni made it clear that his intended audience was those *curiosi* who invested in the commerce of curiosities. As he wrote tellingly in his introduction, "the knowledge of nature and animals stimulates men's curiosity and desire for knowledge, and therefore many notable people decided to spend precious work, time, gold and expenses on it."[84] Buonanni might well have decided to write in Italian in order to reach out to local collectors without a strong command of Latin. He also encouraged readers to acquaint themselves with real specimens by visiting museums. At the end of Book I, he provided a list of collections that were worth a visit. And actual readers often paid special attention to Books II and IV, ignoring the controversial philosophical claims of the *Ricreatione*. The German collector Michael Bernhard Valentini, for instance, prepared a concordance that provided ancient and contemporary German nomenclature for these entries, further facilitating the *Recreatio*'s use in classifying and exchanging specimens.[85]

In the taxonomical books, Buonanni developed a simple classificatory system to facilitate identification. He arranged his entries into three major groups, according to the external features of seashells: univalves, bivalves, and turbinates. Each entry consisted of an image and a short text that focused on a few, additional distinctive features that helped easy identification at the species level. These features included color, shape, decorative patterns, and place of origin, and were contrasted with the features of similar shells. Among the turbinates, Entry 15 thus claimed that the shell was "not dissimilar from the other one described in Entry 1, indeed shaped like a pear." It came "from the Indian sea, hav-

ing a brittle and delicate shell, distinguished by an elegant, net-like decoration, having a wine- or flesh-like color and some disorderly, weasel-like spots." The next seashell, in turn, "imitated the candor of snow and appeared to be made of a paper-like, but not pliable substance." It could be "distinguished by small semi-circular grooves, and its almost flat hollows were decorated with golden spots."[86] As the constant repetition of the words "distincta" and "distinguitur" reminds us, Buonanni's taxonomical system served primarily to separate into distinct species a number of deceptively similar shells, a problem that came to trouble collectors once they have acquired a large collection of specimens. As a further aid for collectors, Buonanni also discussed on occasion how rare a particular seashell was so that readers could determine how likely it was that they could acquire a specimen.[87] Differentiation was the main concern of the illustrations, as well. The shells were uniformly lit from the upper right corner. Similar seashells were placed next to each other on each leaf so as to facilitate the appreciation of minor differences. As Buonanni claimed, the images were "deprived of any particular beauty" as extensive attention to detail was not part of his taxonomical project.[88]

Martin Lister's *Historiae conchyliorum* is an even purer exemplar of the taxonomical spirit of the age, radically departing from the traditions of Renaissance histories of zoology.[89] Lister's repertory opened with a short introductory note and a taxonomical tree, which also served to group the entries in the book. For the rest of the work, Lister provided several hundreds of illustrations of seashells with minimal textual content. Lister decided to engrave inscriptions directly on the plates, without the use of a letterpress. These inscriptions ran to one or two lines, and simply stated the Latin name, shape, color, and provenance of the shell. A focus on external appearance replaced the universal interests of earlier humanists.

In the absence of a textual commentary, it is difficult to establish Lister's precise aims with the *Historiae conchyliorum*. Yet he is more forthcoming in his other publications, which suggest that he designed his books to facilitate the identification and differentiation of specimens for collectors of natural history. As Robert Unwin has recounted, the visual regime of Lister's works was marked by a taxonomizing bent from early onwards.[90] When discussing snails, another type of small animal, Lister publicly avowed that the comparative method was the best for natural historical analysis. Ten years later, he echoed the same sentiment in his *English Spiders*, writing that he hoped to find "likeness and unlikeness of things," classifying and differentiating a large number of species. In the entries of the *English Spiders*, Lister found that the egg-sack and the eyes were especially important as distinctive features. For instance, the egg-sacks of the

Fig. II/6. Early modern shell illustrations did not always correctly represent shell chirality. Buonanni, *Recreatio mentis et oculi in obseruatione animalium testaceorum*, III/15–18.

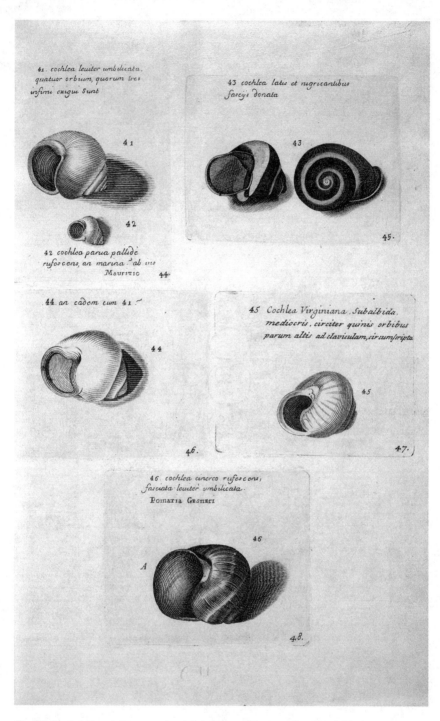

Fig. II/7. The brief inscriptions are printed directly from the copperplate. Lister, *Historiae sive synopsis conchyliorum*, Images 41–48.

eight-eyed spider in Entry 14 were "like a lentil and reddish in colour," whereas the one in Entry 15 had five eggs "in an egg-sac which is very small, shaped like a small lentil-seed, and made out of a very white membranous or linen-like material." The same spider also had "four middle eyes [. . .] arranged in a quadrangular plan, standing equidistant from each other, and on either side are two pairs placed more closely together"; while the eight eyes of the spider in Entry 16 "cannot be seen except with the help of the best microscope [. . .] and can be seen shining like amber."[91] In Lister's spider taxonomy, additional external features included the shape of the legs and the abdomen, the color of the body, and any particular decorative pattern.

When preparing the illustrations for the *English Spiders*, Lister paid special attention to the visual representation of these *differentia specifica*. In communicating with the draughtsman for the work, Lister pointed out "with my finger the characteristics of each species that I most particularly wished to have depicted," which would allow these objects to be "more readily and accurately recognized by other people."[92] When completing the illustrations, the draughtsman came back to the issue of representing these distinctive features. As he wrote in a letter, he planned the illustrations to be sufficiently large to "serve for your particular history and [to have] room enough to express the order of the eyes, a manner of the egg bagg," and enclosed a draft sketch for approval.[93] The illustrations of the *English Spiders* therefore uniformly concentrated on a select number of distinctive features, were grouped in *genera* to emphasize similarity and difference, and were less exactingly executed when insignificant details were concerned. As in Plukenet's *Phytographia*, Lister pictured the taxonomically important parts detached from the spider, but he also included images of the whole animal. Importantly, Lister's *Historiae conchyliorum* closely followed the visual principles established in the *English Spiders*. Both the original drawings and the final engravings focused only on a few distinctive features. The manuscript drawings were small, lacked coloring, and indicated shape with the help of just a few strokes. The final publication closely followed the manuscript and presented an abstracted version of each particular specimen. Taxonomy not only shortened the textual content of encyclopedias, it also changed their visual regime.

Obviously, even in the late seventeenth century, not all entomological and conchological works focused on taxonomy. The complex mechanisms of insect reproduction fascinated many naturalists, and resulted in the detailed microscopical studies of Marcello Malpighi, Jan Swammerdam, and Antoni van Leeuwenhoek, among others.[94] And in conchology, the German-Dutch Georg Eberhard Rumphius wrote his *Amboinsche Rariteit-kamer* to provide an extensive,

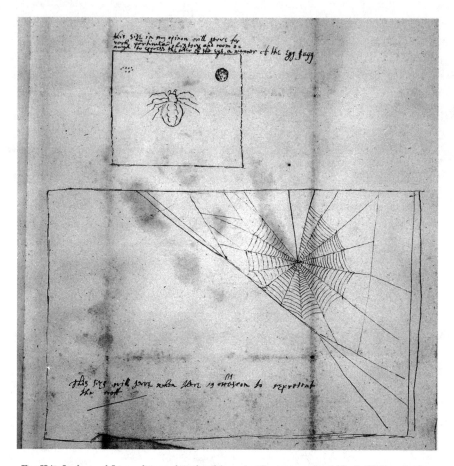

Fig. II/8. Lodge and Lister discussed in detail how the illustrations should look. William Lodge, *Drawing of a Spider*, 1674.

descriptive history of all aspects of the marine life surrounding the island of Ambon. The illustrated manuscript first circulated among the natural historical community of East Asia, and, after many hardships, it was posthumously published by Simon Schijnvoet in the Netherlands in 1705.[95] While the *Amboinsche Rariteit-kamer* did not restrict its focus to classification, some readers used it for the purposes of identification. When Seba sent a package of shells to Johannes Scheuchzer in Zürich, he intended to use Rumphius' work to identify them for his customer. Yet this task was lengthy and burdensome, and the busy pharmacist did not have enough spare time on his hands. Instead of tagging each shell separately, he simply told Scheuchzer to do the job of identification himself.[96]

Yet other readers found the bulky *Amboinsche Rariteit-kamer* less suitable for their own work, and decided to redesign it for the purposes of commerce. Lengthy

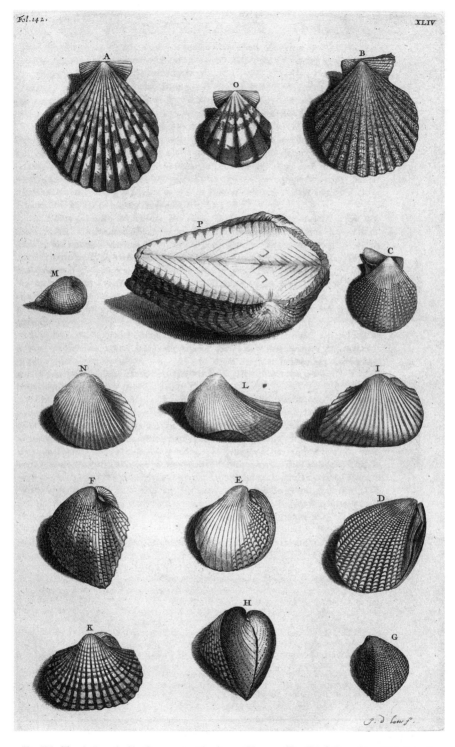

Fig. II/9. The shell marked by O was cut out by Arnout Vosmaer (Fig. II/10). Rumphius, *D'Amboinsche rariteit-kamer,* Tab. XLIV.

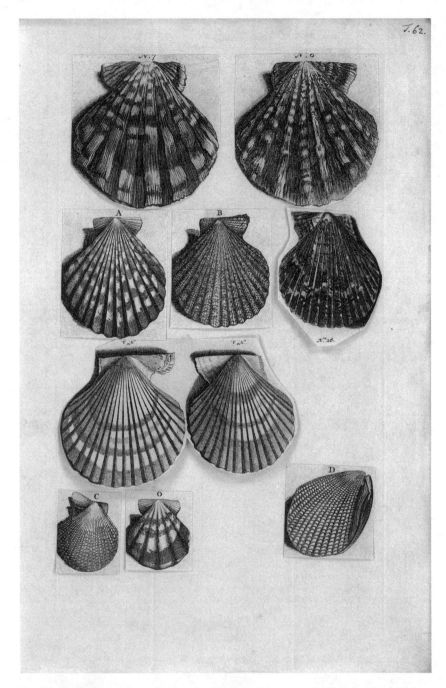

Fig. II/10. Vosmaer carefully cut up Rumphius' encyclopedia, rearranged their order, and glued them on blank sheets. Vosmaer, *Systema testaceorum*, Tab. 62, 18th century.

descriptions on the habitat of a shell were of little use when collectors desired only basic information on the external features of each species to facilitate their material exchanges. Collinson in London thus spent little time on Rumphius in his correspondence, and claimed that Lister's *Historiae conchyliorum* served as the universally accepted authority for those in the shell trade, writing that "ye Virtuosi att Paris rangge their Cabinetts by it."[97] And, although Petiver bought a copy of Rumphius during his travels in the Netherlands, he noted with regret that "the Figures are indeed very well done, contained in more then 60 Tables, but the misfortune is this, their History, and descriptions are printed in Dutch, a Language I very little understand."[98] He therefore decided to arrange for an English translation, and a fragmented manuscript of the *Amboina Rarity-Chamber* still survives, containing an English version of only the first 28 chapters.[99] Maybe his translator quit. But more probably, Petiver realized that Rumphius' text was not really useful for identifying and exchanging specimens. Instead of finishing the translation, Petiver therefore decided to publish a selection of the images from Rumphius with a minimum amount of text that only provided vernacular names for each specimen.[100] While Rumphius required re-edition for facilitating exchanges, Petiver did not think it necessary to perform the same editorial tasks with Buonanni's *Ricreatione*. When he noted that the shipment of "Father Bonanni's shells [was] rec'd march 27, 1704/5," he used the system of "folio and number" to identify his newly acquired specimens, and noted that the first shell was a "Pinna Ital. muricata Bon 101. fig. 24."[101]

A mercantile apothecary, Petiver also planned to publish his own guide to conchological commerce. As he wrote to Breyne in 1706, Petiver was in the process of preparing a catalogue of the molluscs of England. This treatise would not have been a stand-alone volume, as he was hoping to offer it "with the shells themselves."[102] Customers would have received a set of actual shells, collected from the shores of the British Isles. Petiver's publication would have been a companion volume to this collection, advising readers on how to identify and classify their newly acquired specimens. Shell taxonomy ceased to be an independent discipline, and became part of a commercial package.

Taxonomy did not aid the exchange of seashells only through the means of private correspondence. After the death of a wealthy collector, professional dealers of curiosities often organized auctions to dispose of the collection. These events played an important role in the curiosity trade, and were advertised internationally with the help of printed advertising catalogues, a genre that the next chapter will discuss in further detail. Potential buyers were expected to browse through these catalogues, and then ask a local agent to purchase the desired lots.

The Danzig collector Johann Philippe Breyne, for instance, sent Hans Sloane in London a sales catalogue of the late Dr. Christoph Gottwald's museum. Unfortunately, it was delivered to Sloane "long after the sale of the museum which was mentioned upon the title page of it or else I had sent to desire you to have bought me some of them," or so the English naturalist claimed.[103] The collection was instead purchased by agents of czar Peter the Great to enrich the recently established Kunstkamera in St. Petersburg. For these auction catalogues, the correct identification of items on sale was crucial. Buyers in distant countries had to be certain that they knew what they were spending their money on. Since it would have been exceedingly costly to print a detailed description and illustration for each entry, sales catalogues also relied on repertories. When in 1757 the Paris dealers Helle and Rémy organized the auction of the recently deceased M. le ***, they informed their readers that they identified those lots "that are figured in Monsieur Dargenville's *Conchyliologie* by mentioning the Plate and Letter, we have also cited Rumphius on occasion."[104]

It was in designing such an advertising catalogue that Rumphius' *Amboinsche Rariteit-kamer* underwent yet another transformation. As we have seen, this verbose, descriptive encyclopedia had an ambivalent reception among the mercantile collectors of the eighteenth century. While Seba was in principle eager to employ it, Collinson often preferred the more taxonomically oriented works of Lister and Buonanni, and, after the publication of Antoine-Joseph Dézallier d'Argenville's *La Conchyliologie* in 1742, French collectors increasingly opted for the encyclopedia of their countryman instead. Petiver went a step further, and published an abridged version for the purposes of identification. Rumphius' work underwent a similar metamorphosis in the hands of Arnout Vosmaer, an amateur naturalist and keeper of the menageries of the Princes of Orange. In the 1750s, Vosmaer developed his own system of shell classification, based on a few external features. In developing the system, Vosmaer created a handwritten folio album that described the distinctive features of the 32 classes of his taxonomy.[105] For each class, he provided one page of descriptive text and numerous illustrations of the species belonging to it. To illustrate this manuscript, Vosmaer did not make drawings after specimens in his own collection. Instead, he took the images from Rumphius, as well as from Michael Bernhard Valentini's *History of the Indies.* Ignoring the bulky textual apparatus of the *Amboinsche Rariteit-Kamer,* Vosmaer literally cut out the atlas' illustrations with the help of a pair of scissors. In Rumphius' edition, each leaf of illustrations contained several shell representations, and Vosmaer cut out each representation separately. Then, using his new system of taxonomy, he reordered these slips of images pasted them onto the

white sheets of his manuscript. Rumphius was again re-edited for the purposes of classification.

Vosmaer's new shell taxonomy was not a simple quest after the order of nature. It was a method to facilitate identification in the commerce of curiosities. Vosmaer published his treatise first in 1764 as part of an auction catalogue of an unnamed friend's shell collection.[106] This catalogue started off with Vosmaer's taxonomical tree and a short description of each of the 32 classes. A list of the specimens on sale followed, organized according to Vosmaer's system. Each shell was identified by name, a brief description, and a reference to the corresponding illustration in Rumphius. Clearly, the Dutch naturalist expected buyers to adopt his taxonomy. The customers would then look through the list of specimens, and identify them with the visual help of the *Amboinsche Rariteit-kamer,* ignoring its textual content. If they found any lot interesting, they could register their interest and make a bid.

WHEN CLASSIFICATION DOES
NOT MATTER: LARGE ANIMALS

While conchology and entomology quickly followed in the footsteps of botany, other fields of zoology lagged behind.[107] It is especially instructive to look at the study of quadrupeds, as most animals in this subgroup were rather large, and therefore expensive to ship. Exotic quadrupeds were consequently scarce in early modern Europe, and tended to be owned by royalty. They hardly ever entered the intensive commercial circulation that necessitated the development of taxonomy, and, as a result, the conventions of Renaissance natural history survived for long. As late as 1660, Robert Lovell's *Panzooryktologia* could offer detailed histories of numerous quadrupeds, birds, fishes, and snakes, relying solely on the writings of Gesner, Pliny, Nicander, or Plutarch without adding his own observations. Other authors, such as Wolfgang Franzius, turned to the Bible to cull evidence on the moral and theological significance of four-footed animals.[108] In the absence of actual specimens, one instead recounted the elaborate stories of the Bible and Ancients about them.

Limited circulation also influenced the development of new zoological genres as the century progressed. While taxonomy did not appear on the scene, monographic treatments on a particular quadruped flourished and complemented the Renaissance histories of animals. Happy to see even a single quadruped, naturalists wrote lengthy accounts of one case of first-hand observation, and discussed the specimen's external appearance, the behavior, and the anatomical structure,

but did not offer a generalized definition of the species. They also peppered their narrative with the *minutiae* of their observation to validate the credibility of their statements, following the conventions of "virtual witnessing" that Simon Schaffer and Steven Shapin have so painstakingly described. Trust was such an important issue in the study of quadrupeds because other naturalists could not verify the author's account by consulting their own collection, a somewhat less pressing problem in botany, conchology, and entomology.

An early example of this genre, Nicolaes Tulp's famous report of the orangutan was an anecdotal history of the rare and expensive ape that Prince Frederick Hendrick of Orange owned. Intriguingly, his account appeared as part of his *Observationes medicae*, an assortment of medical case studies that each described the peculiar course of illness in one individual, reminding readers that no two patients were exactly the same. Tulp offered stories of the Dutch physician Gosinus Hallius, whose toothache led to his death, or an Amsterdam captain whose lungs were in such bad condition that he coughed up large pieces of them.[109] Printed right after a report on a five-year-old boy from Gelderland, whose weight reached 150 *ponds*, Tulp's discussion of the orangutan employed the same stylistic conventions of particularism.[110] He entertained his audiences with the anecdote that, after drinking from a decanter, the ape wiped his lips like an experienced courtier, and failed to offer a synoptic definition of the species.[111] In the absence of further orangutans, Tulp rounded off his discourse in the Renaissance tradition, comparing his own observation with the accounts of the Dutch traveler Samuel Bloemaert, Pliny, Virgil, and Saint Jerome.

Such monographic treatises of a particular animal enjoyed their heyday in the late seventeenth century with the advent of comparative anatomy.[112] In the footsteps of Galen, many physicians believed that the dissection of quadrupeds could yield valuable information on the function and uses of human organs.[113] A part of the Royal Society's contingent of naturalists, Edward Tyson wrote a programmatic proposal to conduct a comparative survey of all animal species, revealing both the wonders of divine creation and the workings of the human body. Tyson hoped that the repeated observation and dissection of all species would propel the development of zoological taxonomy, as well, but his hopes were soon quashed.[114] While Vesalius had access to hundreds of human cadavers, the English naturalist had to content himself with cutting up only one porpoise. His proposal for comparative studies served as a preface to his monographic *Anatomy of a Porpess*, which, as he had to admit, was based on "a single Observation, and the first of the kind I had opportunity in dissecting."[115] The limitations of only one observation soon became evident. Tyson's porpoise weighed

96 pounds avoirdupois, which concurred with Johann Daniel Major's report of a 124-pound specimen, but could hardly be reconciled with Jan Jonston's account of a 1,000-pounder of a beast.[116] Such contradictory evidence made the definition and classification of species a utopian dream in most fields of zoology. Although Tyson attempted to develop a taxonomy of apes in his *Orangoutang sive homo sylvestris* of 1699, he could rely on the dissection of only one chimpanzee, again. To complement this observation, he confessed that he had to make

> use of the *Anatomy* which is given of *Apes* and *Monkeys* by other Authors; and very frequently have quoted their own words, which has render'd my Discourse much longer: for not having these *Animals* by me to dissect and compare, I thought it but just to let the Reader see, upon what Authorities I went.[117]

Unlike the brief, highly visual compendia of Lister and Buonanni that facilitated the intensive exchange of specimens, Tyson's treatise became a philological exercise in evaluating the evidence of two modern authors (Tulp and the Dutch traveler Jacob Bontius), and the authorities of classical Antiquity.

The conventions of reporting on quadrupeds using the first-hand narrative of the observation of a single quadruped soon became prevalent across Europe. Relying on the magnificent menagerie of Louis XIV, the French Claude Perrault and his colleagues were in a unique position to dissect a variety of quadrupeds at the *Académie des Sciences*, including multiples of the same species.[118] Yet, as Perrault came to realize in his *Memoir's for a Natural History of Animals*, the dissection of two or three specimens still did not provide enough evidence for making general statements about a species, or developing a complex classificatory system. As he wrote, the *Memoir's* were therefore "confined to the Narrative of some particular Acts, of which the Writer has a certain knowledge," and the author decided to "only expose things as singular; and instead of affirming, for instance, that the *Bear* has Fifty-two *Kidnyes* on each side, we say only that a *Bear* which we dissected had the Conformation thereof very *particular*."[119] He could not exclude the possibility that other bears would have fifty-one or fifty-three kidneys, instead. In the case of the lion, Perrault made a similarly motivated decision to not merge the results of his dissections of two lions into one chapter. He instead wrote two separate articles, titled *The anatomical description of a lyon,* and *The anatomical description of another lyon.* The *Memoir's* was filled with information to the brim, but did not facilitate the exchange of specimens through classification. Not that this was a problem. Naturalists did not trade in bears or lions.

THE
ANATOMICAL DESCRIPTION
OF A
LYON.

BEfore the opening of our Lion, we carefully examined all its external Parts, according to the Method which we propofed to our felves, to obferve in all the Defcriptions of the other Animals. We found that the greatnefs of the Head, which is remarkable in this Animal, confifted chiefly in the extraordinary abundance of the Flefh which covered it, and in the greatnefs of the Bones which compofe the Jaws. That the *Breaft* likewife, which appeared large, was only by reafon of the long and thick Hair which incompaffed it, the *Sternum* being compreffed, and much more pointed, than it is in moft *Horfes* and *Dogs* : And that by the fame reafon, the *Tail* feemed not to be of equal thicknefs from one end to the other ; but by reafon of the inequality of the Hair wherewith it was invironed, which was fhorter towards the beginning, where the Flefh and Bones are thicker, and which grew longer as thefe parts grow leffer and leffer, towards the end. And that this long Hair which is about the Neck and Breaft, did differ from that of the reft of the Body only in its length, having nothing refembling Man's Hair.

The *Claws* had no cafes, as *Pliny* reports they have, to keep them from being dulled by their walking ; but it appears rather, that thefe Animals, as *Plutarch* and *Solinus* obferve, do provide for that by retracting *them* between their Toes, by the means of the *particular Articulation* of the laft Joynt, which was fuch, that the laft Bone fave one, by bending it felf outwards, gives place to the laft which is articulated to it, and to which the Claw is faftened to bend it felf upwards and fide-ways, more eafily than downwards ; being drawn upwards by the means of a tendinous Ligament, which faftens together the two laft Bones in their fuperiour and external part only ; and which fuffering a violent diftention when the Toe is bent inwards, extends this laft Articulation, as foon as the *Mufculi flexores* come to flacken, and ftrengthens the Action of the *Mufculi xetenfores* : So that the Bone which is at the end of every Toe, being almoft continually bent upward, it is not the end of the Toes which refts upon the ground, but the Node of the Articulation of the two laft Bones ; and thus in walking, the Claws remain elevated, and retracted between the Toe, to witt, all thofe of the right Paws, towards the right fide of every Toe, and all thofe of the left Paws, towards the left

<center>A</center>

fide

Fig. II/11. Each dissected lion specimen needed to be discussed in a separate chapter. Perrault, *Memoir's for a natural history of animals*, 3 and 9.

THE
ANATOMICAL DESCRIPTION
OF ANOTHER
LYON.

THis *Lyon* was extraordinary large, though very young. It was seven
Foot and a half long, from the end of the Nose to the beginning of
the Tail, and four Foot and a half high, from the top of the Back to the
ground.

Our Observations were almost the same, with those which we have already made on the first *Lyon*, but amongst other things, the straitness and narrowness of the *Thorax*, which we have already remarkt, seem'd to us very considerable in this Subject : For in the inside, from the one side to the other in the largest place, it exceeded not seven Inches, of which the *Heart* took up four, so that there remained but three for the *Lungs*, *Pericardium*, *Mediastinum*, and Vessels of the *Heart*. The *Pericardium* was likewise without Water, and the *Intestines* short in Proportion to the Body, containing but Twenty five Foot in length, which was just three times the length of the Body. The *Cryftallinus* was more convex on the outside than the inside.

What we found different is, that the *Liver* which was of so dark a *Red* in the first *Lyon* that it appeared *Black*, was so pale in this that it had a *Feuil-le-morte* Colour.

That the *Annular Cartilages* of the *Larynx*, which were intire in the first *Lyon* which neverthelefs was not Old, were found imperfect in this which was Younger. And we were not able to resolve whether we ought to atribute to the difference of Age, that which we observed in the Paws, because that in those of the Young *Lyon* we found the Skin much lefs hard, and firm then the other, so that at the extremity of every Toe of the Young one, it was so loose and flaggie, that it might be made to extend and descend to cover half the Nail : Which seems to be the case of which *Pliny* speaks. But the Truth is that there is no probability that this can preferve its Nails, as this Author Reports, because that they use them only at the Point, which this Skin cover's not.

We likewise observed somthing new, *viz.* That the *Epiploon* which was as great and large as its internal Membrane, and which immediatly touched the *Intestines*, did invelope them, and came round even to the *Kidnyes*, having only the upper Membrane loose, as the Name of these Membranes
signifies.

B

Perrault's precepts for modestly presenting particular observations was also followed by Michael Bernhard Valentini's monumental *Amphitheatrum zootomicum* from 1720.[120] While Valentini strongly supported efforts to classify shells, he was less enthusiastic to raise above the level of the particular when it came to quadrupeds. The *Amphitheatrum zootomicum* offered an extensive overview of comparative zoology by bundling together reprints of Perrault, the Berlin Academy, the Royal Society, and countless other authors. Valentini refrained from adding any commentary that would have evaluated, compared, or synthetized the results of the other naturalists. Particular observation followed particular observation, through hundreds and hundreds of pages.

The situation changed only in the mid-eighteenth century, when increased commercial circulation made quadruped taxonomy a reality. Until then, not one taxonomic treatise had been exclusively devoted to them, although Walter Charleton and John Ray both included quadrupeds in their classificatory systems of the animal kingdom.[121] Contemporaries did not fail to realize that the lack of specimens lay behind this delayed development. Writing in the 1760s, Thomas Pennant complained that, for his taxonomic *Synopsis of Quadrupeds*, he could rely only on the Renaissance histories of Gesner and Aldrovandi, the earlier efforts of Ray and Linnaeus, as well as the recent work of Jacob Theodor Klein and Mathurin Jacques Brisson from the 1750s.[122] Discussing Ray's shortcomings in classifying especially quadrupeds, Pennant concluded that

living at a period when […] our contracted Commerce deprived him of many lights we now enjoy, he was obliged to content himself with giving descriptions of the few Animals brought over here, and collecting the rest of his materials from other Writers.[123]

LINNAEUS AND BUFFON

As this chapter has recounted, the development of early modern natural history was thoroughly influenced by commercial exchange. The circulation of botanical, conchological, and entomological specimens in contemporary Europe led to the development of taxonomy, while the lack of circulation in the case of quadrupeds led to the development of monographic treatments of particulars. These divergent paths long determined the course of natural history, and left their stamp even on those two giants of the eighteenth century, Linnaeus and Buffon.

When Linnaeus started his magisterial work on taxonomy, he was working in the company of the naturalists cited above. He corresponded and exchanged

specimens with Amman, Breyne, Dillenius, Gronovius, Sloane, among many others. There is no need to rehearse Linnaeus' interest in this commerce of naturalia. As Lisbet Koerner and Staffan Müller-Wille have recounted, Linnaeus spared no effort in importing foreign plants to Sweden in order to revitalize the nation's economy.[124] John Heller and Müller-Wille have also shown that the Linnean reforms of taxonomy and nomenclature were based on the Swedish author's practical involvement with the collection and close examination of specimens, as well as on his expertise in cataloguing and referencing books.[125]

The artificial system introduced in the *Systema naturae* thus followed in the footsteps of the botanical encyclopedias and conchological repertories, yet differed in important details. When discussing plants, Linnaeus did not identify them according to their external features. Instead, he relied on observing their sexual organs. While this system might have worked well for the purposes of taxonomy, some collectors found that it was ill-adapted for the practice of exchanging specimens. As we have seen, Collinson complained bitterly that many people could not correctly identify the pistils and stamens of a plant. The visual culture of Linnaean taxonomy was also an extension of the previous generation's reforms in botany and conchology. The conchological encyclopedias, however lavish they might have looked, primarily offered an abstracted, diagrammatic view of nature. Collectors used these images primarily for the purposes of identifying their specimens. The *Systema naturae* brought this tendency to its natural conclusion by appearing practically without illustrations.[126] After all, the determination of a species could best proceed by employing a short, textual description of the defining characteristics of a plant. According to Linnaeus, engraved images in encyclopedias—for example, the works of Buonanni, Lister, and Rumphius, were both superfluous and expensive for students of natural history.[127] The Linnaean system could be best expressed in language, and not through images.

Given its relationship to the previous generations' work, it is no surprise that some of Linnaeus' contemporaries interpreted the *Systema naturae* as one more work to facilitate the practices of collecting. Gronovius wrote to Amman that "since Linnaeus hath printed his Systema naturae, Dr Lawson and I were very curious to have the specimens belonging to the Regnum Lapidem," and requested minerals from his colleagues in St. Petersburg and in Danzig.[128] Yet Linnaeus' work was simply a useful addition to previously existing encyclopedias, and did not replace them as the one and only, universal system of classification. As curator of the botanical garden of the Royal Museum in Florence, for instance, Attilio Zuccagni arranged his collections according to a mixed system of classi-

fication, basing himself on the Swedish taxonomist, the garden theorist Antoine-Joseph d'Argenville, and many others.[129]

Linnaeus' taxonomical efforts were especially problematic when it came to larger beasts. Pennant remarked acerbically that Linnaeus changed his zoological taxonomy with almost every new edition of the *Systema naturae*.[130] When discussing animals in his long-distance correspondence, even Gronovius opted to use other works next to Linnaeus in the process of identification. When Breyne inquired about sea animals seen on the Dutch coast, he wrote the "vitulis marinus or walrus that was seen here recently, is the Rob, or zee hond that Linnaeus calls phoca dentibus caninis inclusus. You can find the same described and also illustrated in the *Acta Erud. Caesar. Norib. Vol. I. obs. 93.*"[131] To ensure that identification did not misfire, Gronovius decided to use Linnaeus, vernacular names, and a journal article in the *Acta eruditorum*. On its own, the *Systema Naturae* was not robust enough.

Perhaps, the different circulation patterns of plants, shells, insects, and larger animals might even have been a factor in the famous controversy between Linnaeus and George-Louis Leclerc de Buffon.[132] In his early years, the French naturalist heavily criticized the artificial system of the *Systema naturae*, and called into question the value of all earlier efforts at classification. The *premier discours* of his 36-volume *Histoire naturelle* famously derided the Linnean taxonomy of plants for paying attention to only the small, often microscopical, reproductive organs of pistils and stamens, and suggested instead to study in detail all aspects of every species, following the digressive style of Renaissance natural history and monographic comparative anatomy.[133] Such an approach worked best with large animals, and the *Histoire naturelle* consequently treated quadrupeds first, and then proceeded on to discussing birds and minerals.[134] Not a single volume was devoted exclusively to botany, entomology, or conchology. Placed at the *Jardin du roi* in Paris, Buffon had more opportunity to examine the rare and exotic beasts of Louis XV than Linnaeus in distant Uppsala, and less interest in maintaining the infrastructure for the extensive trade of plants, insects, and shells that moderately well-off naturalists pursued. Buffon's *Natural History* was excellent for the purposes of armchair travel in the case of animals that one could otherwise not see; Linnaeus' *Systema naturae* worked best when classifying plants that everyone had access to.

After a cursory review of three hundred years in one chapter, let us return to the early eighteenth century, the world of Rumphius, Petiver, and the young

Linnaeus. We will turn our attention from the exchange of specimens to the world of publishing. This chapter has argued that the commerce of plants and animals strongly influenced the transformation of encyclopedias; the next chapter examines how the economics of the book industry also shaped the format of these books. The focus will shift from a general overview to the case study of Albertus Seba's *Thesaurus*. As we shall see, this atlas was not a classic encyclopedia of taxonomy, yet its publication history offers rich lessons for studying all genres of illustrated books. It reveals how forgeries emerged in the world of eighteenth-century science, partly because natural history publishing was a highly risky, capital-intensive business, and partly because the modern concept of authorship emerged in this period.

❋ III ❈

IMAGE AS CAPITAL

FORGING ALBERTUS SEBA'S *THESAURUS*

PERISH AND PUBLISH

In 1736, the Leiden naturalist Johann Frederik Gronovius had sad news to send to Johannes Amman, his botanical correspondent in St Petersburg. The publication of Albertus Seba's four-volume *Thesaurus*, an illustrated, descriptive catalogue of the *naturalia* in Seba's cabinet of curiosities, would not go further.[1] The reason was simple: "Seba died in Amsterdam around three weeks ago, and saw that two volumes of his *Thesaurus* had been published, but left the third one in a rather imperfect state, and the fourth indeed only ready for beginning."[2]

Unmoved by Seba's demise, Gronovius focused on how his own finances would be affected if the *Thesaurus'* last two volumes were not going to be published. He had already shelled out 160 guilders for the four volumes in advance of publication, in a so-called subscription scheme, the early modern equivalent of pre-ordering your favorite author's novels. This was a lot of money in the period, but fortunately for Gronovius, he had already managed to get rid of his prepublication subscription before Seba's death. As he wrote with relief:

> I am very glad when I saw the second volume of his *Thesaurus* I sold the first volume and the subscription paper for five guilders' loss, and since they are sold at Lugtmans for 25 guilders there is no prospect of seeing the two last volumes printed, his heirs involve one another prodigious with lawsuits.

Gronovius also relayed the news to Richard Richardson, a distinguished physician and botanist in Yorkshire. As he recounted, "the executors and children of Seba [...] involved one another with so many lawshuts, that I believe that book will never come out."[3] He calculated that he saved "at least ninety guilders, or there about" by having sold his subscription to a work that would in all probability never see the light.

Seba's *Thesaurus* is arguably the most impressive work of eighteenth-century natural history, and has remained a favorite with readers up to this day. Christie's sold a hand-colored set of the original for $442,500 in 2000.[4] A year later Sotheby's sold another illuminated set for $511,750, and Taschen came out with a widely popular reproduction of the images in 2003.[5] Seba intended this monumental work to serve as a memorial for his celebrated cabinet of curiosities, which Linnaeus much admired. Its thousands of entries would offer an "accurate description" of Seba's specimens, based on "faithful observation through the senses," and its 449 etched plates would be made "accurately from the life."[6] Seba hoped that, after his passing, when his collection was dispersed, the *Thesaurus* would preserve his cabinet in paper for the delight and use of future generations. Yet he died before the completion of the *Thesaurus,* and his planned *magnum opus* threatened to remain a fragment. Although six years later, in 1742, Gronovius reported to Johann Philipp Breyne in Danzig that Seba's work "was again under the press," the excitement proved to be premature.[7] *Volume III* came out only in 1759, and *Volume IV* in 1765, thirty-one years after *Volume I* was published. By then, Gronovius, Breyne, and Richardson, the original audience for the *Thesaurus*, were all dead.

And even though the *Thesaurus* was eventually completed, it could no longer be called a paper mausoleum of Seba's cabinet. While Seba managed to prepare the illustrations for *Volumes III* and *IV* before his death, he left no textual content behind. His heirs therefore decided to secretly hire a group of "ghostwriters" to write up the descriptions, and sold the finished book as the priceless, original work of Seba. Instead of memorializing Seba's cabinet, the *Thesaurus* turned into a profitable sham.

The vicissitudes of Seba's *Thesaurus* reveal the changing patterns of how commercialization, and a desire for profit, shaped the illustrated atlases of early modern natural history. While the previous chapter focused on how encyclopedias came to regulate the commercial exchange of specimens, this chapter examines how the authors of natural history became involved in book publishing as a business. Printing and selling the illustrated works of natural history were considered a risky enterprise, and one could remain in the business only by closely focusing on reducing costs and maximizing profits. By the end of the seventeenth century,

the Dutch republic had a well-developed, entrepreneurial publishing sector that supported such capital-intensive projects. In addition, wealthy natural historians provided additional capital for the printing industry by frequently contributing to the costs of publishing their own books. As a result, the Netherlands saw more works of natural history published than ever before, sumptuously illustrated with engravings, etchings, and mezzotints.[8] As Seba's case exemplifies, commerce made luxurious atlases of natural history a reality.

Yet commercialization also raised numerous doubts about the reliability of printed works of natural history. What did the name of the (usually, but not exclusively, male) author on the title page signify? Could you trust that the author was indeed responsible for the contents of the book? Or could it have been an attractive brand name only, tagged onto the work by duplicitous publishers? How much work was an author expected to perform, anyway, and what dirty details could be left to invisible technicians? Who was expected to write the text, and who was expected to commission the illustrations?

By closely following the publication history of Seba's *Thesaurus*, this chapter offers some novel answers to these well-worn questions of the history and sociology of science. It argues that, by the eighteenth century, authorial originality had become an established norm in the sciences. Naturalist authors were expected to perform their own research, write the text, commission the illustrations, and even contribute to the costs of printing. When a book did not conform to these norms, publishers sometimes deliberately forged such an authorial identity, creating a fake aura of originality. This was a new development. Earlier, in the Renaissance, scientific authors did not have a high enough status to warrant forgeries, though, obviously, the Ancients were revered and forged plentifully.[9] Unscrupulous publishers instead plagiarized and re-edited successful books by their contemporaries, and then printed them under a new authorial name. But, as the early modern era progressed, modern authors could increasingly achieve a cult status, as well. Consequently, it began to make sense for publishers to hire a hack to write a book, and then falsely print it under the name of a well-respected author. When scientific authors became a brand, plagiarism was supplemented by forgery.

PRINTING FOR AN INTERNATIONAL AUDIENCE

The business of natural history publishing thrived in the Netherlands during the eighteenth century. The thirty-one years that it took to publish Seba's *Thesaurus* saw the appearance of many groundbreaking works on the market. Most of these

books took a long time to print. They were expensive, and would bring a solid profit only after a decade, but they would eventually change the course of botany and zoology. In 1736, the year when Seba died, Gronovius reported to Amman that Carolus Linnaeus' *Systema naturae,* the foundational work of modern taxonomy that Gronovius himself financed, had finally appeared in Leiden.[10] The Swedish Linnaeus was now busy publishing his *Flora lapponica* with a firm in Amsterdam, and twelve plates had already been engraved. Amman also learned that Hermann Boerhaave's edition of Jan Swammerdam's *Bybel der natuure,* this influential work in microscopical entomology, was just about to appear, some fifty-odd years after the author's death. In Amsterdam, at the same time, Johannes Burmann first published his *Thesaurus Zeylanicus,* a sumptuous account of the Asian island's flora, and then, as Gronovius related four years later, finally put into print the late Rumphius' monumental *Herbarium amboinense,* which had languished in manuscript for forty years because of the Dutch East India Company's censorship.[11]

The Netherlands played a prominent role in producing so many books of natural history for several reasons. Its global trading networks obviously provided Dutch naturalists with easy access to exotic plants and animals. But even more importantly, the Dutch Republic was the center of the European book trade in the period, and its publishers willingly invested into illustrated works of natural history. In the seventeenth century, the Dutch printed over 100,000 titles in all genres, and, according to the catalogues of the Frankfurt international fair, roughly a third of all European books published between 1650 and 1675 came from Holland.[12] The Amsterdam booksellers' guild had around 200 members in 1700, and more than eighteen bookshops catered for the desires of its reading public just on the Kalverstraat, the major shopping street of the city.[13]

The book trade also dominated the cultural life of other Dutch towns. The citizens of Haarlem took pride in claiming that letterpress printing had been invented there some three centuries earlier by the city treasurer Laurens Coster, before Gutenberg. The Hague, the political center of the Netherlands, could boast of over 70 printers, many of whom specialized in political news and pamphlets.[14] Thanks to their proximity to a famous university, the two dozen booksellers of Leiden published a large number of academic books, both for local students and the international audience of the Republic of Letters.[15] Thanks to the efforts of the medical professor Hermann Boerhaave, author's rights were first established as a legal category in Leiden, which was a marked departure from the traditional regime of awarding copyright to the publishers. From 1728 onwards, professors at Leiden University had automatic copyright over their manuscripts, which no

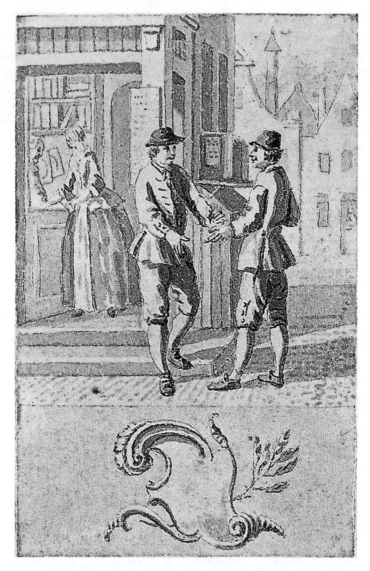

Fig. III/1. The bookshop has a female customer. Aartmen, *Two Men in Conversation in front of a Book Shop*, 18th century.

publisher could print without the explicit, written permission of the author.[16] Diligent students, carefully transcribing their professors' lectures, could no longer hope to cash in from selling their copies to unscrupulous publishers.

Dutch publishers could count on a strong, domestic market for books, as the majority of the population was literate, a rare achievement in the Europe of this period. They also vigorously exploited the international markets of the continent.

Amsterdam was second only to Paris in publishing books in French. Relying on the international networks of the Reformed church, many booksellers specialized in printing Bibles and religious treatises in the various local languages of the protestant populations of Eastern Europe.[17] Others ventured into publishing the seditious works of the radical Enlightenment. Dutch publishers were the first to print Pierre Bayle's *Dictionnaire* and Julien Offray de la Mettrie's *L'homme machine,* and then had these works smuggled into France and other countries under a false cover. Arguing for a materialistic interpretation of the soul, *L'homme machine* was banned even in the tolerant Netherlands, and the publisher Elie Luzac, a contributor to Seba's *Thesaurus,* received a hefty fine in 1748.[18]

Seba's *Thesaurus* and the other illustrated works of natural history were produced for the high end of these international markets. As the previous chapter has shown, by the eighteenth century, many botanical, entomological, and conchological encyclopedias turned towards taxonomy, facilitating the identification of specimens in the long-distance trade of *naturalia.* Whether living in St. Petersburg, Nuremberg, or London, wealthy collectors needed to purchase these works in order to successfully communicate across the linguistic barriers of natural history. They also eagerly bought other genres of natural history, such as regional studies that described and illustrated the fauna and flora of the East Indies, Africa, or the Carolinas. Stationed in Danzig, for example, Johann Philip Breyne purchased a subscription to Rumphius' *Herbarium amboinense,* the botanical description of the island of Ambon, from the Amsterdam publisher Janssonius van Waesbergen (and was given a small token as a proof of subscription); and received Johannes Burmann's ten-part *Rariorum Africanarum plantarum decades* from the author himself.[19] From London, Hans Sloane regularly sent him new installments of Mark Catesby's *Natural History of Carolina,* a work that was published in portions of 20 engravings (with the accompanying text) to spread over sixteen years the prodigious cost of printing.[20]

International distribution, the specialty of Dutch booksellers, was essential for natural history publishing because of the small size of this target audience. Botanical and zoological works were primarily bought by wealthy physicians, pharmacists, and collectors who could afford the oftentimes hefty price of illustrated encyclopedias. These customers were thinly spread all over Europe, and Dutch publishers were best equipped to reach them through their distribution networks. Thus, when Breyne proposed in 1712 a new edition of his father's *Exoticarum plantarum centuriae* from 1678, he pitched the work to the Amsterdam publisher Janssonius Van Waesbergen, and not to a local printer in Danzig.[21] The infrastructure of Dutch mercantile and scientific networks offered naturalist authors and their publishers the hope of earning a profit, or at least breaking even.

THE AUTHOR IN CONTROL

Well-capitalized publishers with international connections were not the only reason for the Dutch boom in illustrated publications in botany, mineralogy, and zoology. Early eighteenth-century natural history also saw the rise of a new concept of authorship. In a departure from the tradition, the new authors were charged with the triple task of making first-hand observations or performing experiments, writing up the text of their book, and then paying some of its publication costs. Many naturalists earned their living as physicians and apothecaries, two highly profitable professions in the era, while others were independently rich aristocrats who studied plants and animals as an expensive hobby. The wealth of these naturalists offered a helpful cash injection to the publishing industry, and encouraged booksellers to print risky, investment-heavy illustrated atlases. And, in return for their support, these authors could exercise strong control over all aspects of the production process. Originality emerged when the author was no longer financially dependent on the publisher.

This was a new development. In earlier periods, the authorship and financing of books were taken up by different persons. Impecunious authors usually could not cover the costs involved with publication. This was especially true for the illustrated volumes of natural history because of the high production cost of images.[22] It was usually the task of the publisher to oversee the financial aspects of printing the book. The consequences were obvious. Endorsed by the legal system, publishers considered the book their own property, and felt free to shape it according to their expectations of what the reading public was ready to buy. Driven by their concerns for profit, they frequently changed the textual and visual content of the publication.[23] In the late 1500s, for instance, when Carolus Clusius authored his *Rariorum stirpium per Hispanias observatarum historia,* his publisher Christopher Plantin used his woodcuts as illustrations to a book by Rembert Dodoens before proceeding to print Clusius' own work.[24] And while wealthy aristocrats could avoid the publisher's interventions by funding the publication of their works, they often considered it below their rank to be publicly associated with a literary or scientific publication. To secure their reputation, for example, noblemen in absolutist France usually published their works either anonymously or under a pseudonym. As an aristocrat (and especially as a woman), for instance, the seventeenth-century salonnière Mlle. de Scudéry published her poetic treatise on the chameleon without signing the finished publication.[25]

Renaissance authors were not only subservient to publishers. Their authorial persona was also weakened by the predominance of Ancient philosophers. As

the previous chapter revealed, in the years around 1500, the major interest of natural historians was to provide commentaries to the works of Theophrastus, Dioscorides, and other Greco-Roman authorities, creating a correspondence between the plants of the Ancient Mediterranean and the world they were living in. For these naturalists, originality was not a necessary precondition of scientific authorship. Fuchs, Gesner, and Aldrovandi became renowned for their excellent skill in managing and evaluating large amounts of previously available data on plants and animals, and not primarily for their own observations of plants and animals.[26] These Renaissance naturalists considered authorship as an incremental, editorial process, where new results could be reached only by the reconsideration and republication of earlier works. In this regime, editorship and authorship could hardly be distinguished. Renaissance natural history was a footnote to Dioscorides.

The fuzzy boundary between authorship and editorship led to bitter debates on what constituted plagiarism, the primary form of authorial misconduct in the sixteenth century.[27] If publishers brought forward a new edition of the Andreas Vesalius' groundbreaking anatomical works with some minor revisions, could the editors call themselves a new author, with their name proudly displayed on the title page? This did not happen to the renowned anatomist only once. His *Fabrica* was appropriated by Juan Valverde de Amusco, while illustrations from his *Tabulae anatomicae sex* were printed under the name of Jobst de Necker, Johannes Dryander, and Walther Ryff, among others. While Vesalius himself called such practices a clear case of plagiarism, his adversaries could successfully claim that their editorial interventions created a new work with a new author.[28] Contemporary law did not prohibit these practices, and the larger public did not condemn them, either. And even Vesalius himself could not wholeheartedly reject such an argument, since he had edited and reprinted Guinter's *Institutiones,* a commentary on Galen, under his own name only two years after the publication of the original.[29] Like the renowned anatomist, Renaissance natural historians were also plagued by plagiarism. The botanist Leonhart Fuchs was enraged to learn that the Frankfurt publisher Christian Egenolff republished his illustrations in Walther Ryff's commentary on Dioscorides, but, his diatribe notwithstanding, the pirate publisher died a happy and wealthy man.[30] Even at the close of the sixteenth century, the Dutch immigrant community in London could do little but loudly protest when John Gerard published under his own name a badly edited translation of Rembert Dodoens' *Stirpium historiae,* a book that, in turn, owed much to Leonhart Fuchs.[31] Readers did not necessarily demand the authentic works of a modern author. They were also interested in buying a revised and reworked edition of a book even if its title page paraded the name of the editor.

The Renaissance persona of the scientific author underwent a slow transformation from 1500 to 1750. The rising prestige of natural knowledge went hand in hand with the rising financial, social, and epistemological status of scientific practitioners. By the dawn of the eighteenth century, many scientific authors were wealthy enough to support the printing of their books, and also became well respected enough to become household, brand names in the world of publishing. This process has been documented extensively by historians in the past thirty years. As Mario Biagioli has shown, practical mathematics emerged from a lowly occupation to a respected and coveted profession by the early seventeenth century, culminating in Galileo's appointment as a courtly philosopher to the Medici. In a similar manner, Pamela Smith has argued that, once repackaged as natural philosophy, artisanal knowledge acquired a high status in the seventeenth century. By the time of the Restoration, English gentlemen such as Robert Boyle could be publicly engaged with scientific experiments, and indeed, it was arguably their high social status that lent credibility to their knowledge claims.[32] The wealthiest members of Dutch society were similarly active in the various fields of science. The Amsterdam burgomaster Johannes Hudde was highly conversant with mathematics, participated in the translation of Descartes' *La Géométrie* into French, and even invented a new microscope.[33] The millionaire Nicolaes Witsen, another Amsterdam burgomaster, began his career with the publication of the first Dutch treatise on shipbuilding.[34] And Constantijn Huygens Sr., the private secretary of the Prince of Orange, not only supported Cornelis Drebbel's microscopical investigations, but also educated his children to become expert astronomists.

The rising status of the scientific enterprise meant that, by the early 1700s, a number of practitioners were sufficiently wealthy to at least partially cover the publications costs, and they felt no compunction to obey earlier strictures on anonymous authorship. As a result, the book market for scientific publications received a strong boost, and the publisher's role was somewhat diminished, with the authors gaining an upper hand in controlling the shape of their books.[35] The Anglo-Dutch banker George Clifford offers the culmination of this development. Residing in the Netherlands, he decided to self-finance the printing of the *Hortus Cliffortianus*, a description of his garden written by the young Linnaeus. Clifford's wealth enabled him to remove the *Hortus* from commercial circulation; the book could not be purchased at a bookseller. Readers could acquire it only as a personal gift from the author.[36]

Well-established but not exorbitantly wealthy physicians and naturalists also experimented with self-financing and self-publishing their works, at least par-

tially, in order to have a close grip over both the intellectual and financial aspects of the publication. This was a complex business venture. Johann Philip Breyne's accounts for his *De Polythalamiis* reveal the careful calculations a naturalist had perform to ensure that, after investing into a beautifully illustrated book, he could still count on modest financial profit.[37] Breyne's treatise on the classification of fossilized shells was moderately expensive to produce because of its twelve engraved illustrations, and the author took pains to keep detailed records of his outlays for printing and the eventual returns from selling his book through a self-organized distribution network throughout Europe.[38] While the text, written by himself, was produced for free, Breyne had to shell out a significant sum for the images. His draughtsman charged 3 Danzig gulden (not much less than 3 Dutch guilders) for each of the illustrations. These drawings then needed to be engraved

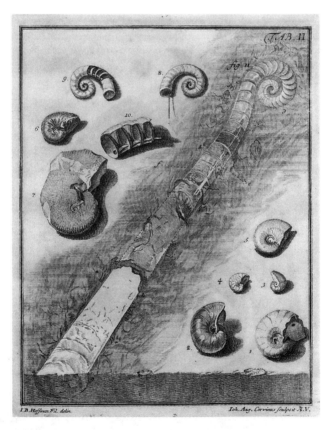

Fig. III/2. Each plate cost 3 Danzig gulden. Breyne, *Dissertatio physica de Polythalamiis*, Tab. ii.

Fig. III/3. Expenses are recorded on the left, sales and dispatches of books on the right. Johann Philip Breyne, *Accounts for de Polythalamiis*, 1732, Forschungsbibliothek Gotha, Chart A. 876, fol. 39v-40r.

on a copper plate for the hefty price of 19 gulden per plate, which included the cost of both manual labor and the expensive copper. Breyne then had to purchase paper for both the illustrations and the text. To reduce expenses, he printed only 110 copies on elegant paper, and used the cheaper, Dutch royal paper for the remaining 140 copies. After the pressmen had also been paid for the actual work of printing, and their apprentices adequately tipped, Breyne's expenses ran to almost 482 Danzig gulden. Setting the sales price at 3 gulden, Breyne now faced the formidable task of having to sell 160 copies of his book just to get even. He could do this only by arranging for the distribution of his book to the major centers of European science. While Danzig was a major city in contemporary Europe, its number of fossil enthusiasts was rather limited. Breyne thus sent thirty copies to the naturalist Johann Jacob Dillenius in England, who sold these in commission, and requested ten additional copies within a month. Another thirty copies were sent in commission to Amsterdam, ten to Leipzig, and, gauging the limited interest amongst Russian *curiosi*, only four to St. Petersburg. The judgment is still out whether Breyne managed to earn a significant profit. Authorial control meant, after all, responsibility for potential losses. Within the first two months, *De polythalamiis* sold 50 copies across Europe, bringing in a meagre 150 Danzig gulden. This was definitely not a financial disaster, though. In the scholarly book

trade, then and now, publications are expected to turn a profit only in the long run, in the matter of several years or even a decade. And even if Breyne ran short of selling more than 160 copies, he could count on his peers' approbation as an alternative form of credit. More importantly, he had also acquired twelve engraving plates in the process. They were solid, metallic capital that could be burnished, repolished, and sold to another publisher.

Self-financing meant that a naturalist was able to decide on the number of illustrations, the quality of the paper, and the distribution networks for selling the end product. Yet the high economic and social status of scientific practitioners had another consequence as well. They laid the grounds for the cult of the author. While the Ancients like Aristotle had always been well respected, one could now revere more recent luminaries, as well. The two late-seventeenth-century debates on the respective merits of Ancient and Modern learning, the French *Querelle des Anciens et des Modernes* and the English *Battle of the Books,* both ended with a victory for the Moderns in the field of the sciences.[39] While in poetry, one could debate whether Racine was superior to Sophocles, no one could doubt that Newton beat Archimedes to dust. Already famous in his lifetime, the English genius received a state funeral in 1728, and had a monument erected in Westminster Abbey in 1731. In a similar manner, the French Académie des Sciences began to issue its *Eloges* in the first years of the eighteenth century, an official obituary and memorial of each deceased member of the institution. Such a cult treatment was not lacking in the Netherlands, either, where Hermann Boerhaave's fame was so well established that, apparently, a letter from China, simply addressed to the "Illustrious Boerhaave, physician in Europe," reached its destination without a hitch.[40] Every mailman knew where the Leiden professor lived.

In an age of scientific cults, the boundary between editors and authors was no longer blurry. Working without the active interventions of a publisher, wealthy naturalists considered books their own intellectual property, and did not tolerate the publication of an edited, new version of their own work under a new authorial name. This new regime of scientific authorship went hand in hand with the waning of Renaissance natural history. By the early eighteenth century, authors of natural history were primarily expected to perform original research based on their individual observations and experiments. Instead of becoming experts in humanist philology, natural historians gained renown for their observational skills or novel instruments. Editing, compiling, and evaluating earlier authors became the first step in the career of a young scientific practitioner, not the crowning achievement of a lifetime's work.[41]

As a result, the Renaissance method of editorial plagiarism was supplemented

with another form of authorial misconduct: the forgery of recent and contemporary scientific authors. There was a market for brand name publications: the name of Descartes could turn any book a bestseller, even if the content was spurious. In the 1680s, for example, the English printer Joseph Moxon sold under the false authorial name of Descartes a set of playing cards that offered delightful instruction to players about the laws of mechanics.[42] By the eighteenth century, the scientific popularizer and *philosophe* Voltaire, the Enlightenment epitome of celebrity, had to explicitly warn his readers that "the *amateurs* of Letters should not pay any attention to [...] all these small works which are credited to my name, to these poems that are sent to the *Mercure* and to the foreign journals, these are nothing but the ridiculous effects of a vain and dangerous reputation." This was not a warning in jest: a contemporary sequel to the *Candide* was published under Voltaire's name well into the 20th century.[43]

Newton was similarly abused in the spurious *Isaac Newton's Tables for Renewing and Purchasing the Leases of Cathedral-Churches and Colleges*, a text probably authored by George Mabbut. Although the forgery was already denounced in 1731, *Newton's Tables* were so frequently reprinted that the publisher Thomas Astley had to issue a rather disingenuous warning in his 1742 edition that

> there being a spurious Edition of this Book very imperfect, as well as incorrect, and consequently a great Abuse and Imposition upon the Publick: The Proprietor Thomas Astley, thinks it necessary to distinguish such Copies as are Correct and Genuine, by subscribing his Name to this Notice on the Title-Page.[44]

Even lesser known authors could be subjected to such a treatment. The Dutch sailor Jan Struys may not have had a cult, but first-hand visits to foreign countries endowed him with a cachet of authorial credibility, which his publishers ruthlessly exploited when they printed under his name a heavily ghostwritten travel narrative, interspersed with a geographical description of Madagascar, East Asia, and Russia.[45]

The emergence of authorial rights in the Netherlands was a direct response to the dangers of forgery. As we have seen, the enormously rich Hermann Boerhaave and his colleagues were able to convince the government to grant automatic authorial rights for all professors at Leiden University in the 1720s, hoping to stem the flood of pirated editions of textbooks.[46] Importantly, the purpose of this legislation was not to circumvent simple reprinting. Rather, Boerhaave's contention was that pirated editions were inauthentic. They were corrupted and

filled with errors, and did not represent the views of the putative author. By the 1750s (when Seba's ghostwriters were at work), this abuse of authorship became such an accepted, though unwelcome, part of the scientific landscape that scientific practitioners began to hurl accusations of forgery at their enemies even in the absence of positive proof. When Pierre-Louis Maupertuis was challenged by Samuel Koenig about the priority of his discovery of the principle of least action (which Koenig justly attributed to Leibniz), the French mathematician successfully charged Koenig of making up his source. With the attestation of Leonhard Euler, the famous mathematician, the Royal Academy of Berlin condemned Koenig of forging Leibniz's letter with the incriminating passage.[47] In the nineteenth century, the cult of the modern scientist reached atmospheric proportions, and forgers did not neglect to exploit this niche. To boost national pride, Denis Vrain Lucas forged a correspondence between Blaise Pascal and Newton to show how the French philosopher developed a theory of gravity first, while the Italian historian Raffaello Caverni faked a Galileo manuscript to document how the Italian genius developed his ideas on projectile trajectories.[48] While plagiarism never fully disappeared, forgery became a legitimate alternative for those who wanted to earn a quick buck.

PRESERVING A CABINET

There were dragon-flies . . .

Seba's *Thesaurus* exemplifies well how the rising status of the scientific author changed the history of the book. The Amsterdam pharmacist kept both the intellectual and financial aspects of the publication under control, and also experienced the back side of the cult of the author: forgery. The surviving documentation offers a rich picture of the details and consequences of self-publishing in early modern Europe. It shows what the stakes were for wealthy naturalists who set out to print their own research, and what the motivations and concerns were for those who decided to forge similar works.

Initially, everything went smoothly. For the publication of the *Thesaurus*, Seba decided to form a consortium with two eminent publishing firms in Amsterdam. On October 30, 1731, Albertus Seba signed a notarized contract with the publishers Wetstein & Smith and Janssonius van Waesbergen (the firm Breyne also contacted). The contracting parties agreed to publish a four-volume work of natural history, with 400 engraved illustrations, titled *Locupletissimi rerum naturalium thesauri accurata descriptio et iconibus artificiosissimis expressio*. The parties further

agreed that each would pay one-third of the costs. The author, Seba himself, would receive twenty copies at a 20% discount, and a 10% discount on further copies. The publishers could keep 25% of all the revenues for the cost of distribution. The rest of the profit would be divided equally between the three parties.[49]

Such joint contracts were fairly common in all areas of early modern trade, and helped spread the risk of a large investment. At his death, for instance, Seba owned one-eighth of one ship, and one-fourth of another, sharing the risk of sinking with other merchants.[50] In the field of publishing, other booksellers also formed consortia to publish expensive, illustrated encyclopedias for which it was hard to calculate the market response. In the 1680s, four different publishers joined efforts to complete the twelve-volume *Hortus malabaricus* of Hendrik van Rheede tot Drakensteyn over the span of twenty years. The same team also successfully collaborated on Gerard Blasius' *De anatome animalium* and on Govard Bidloo's *Anatomia humani corporis*, disbanding only in 1721.[51] Even if one of these works turned out to be a flop, profit from the other books would compensate all of them for their losses.

Seba would therefore have been justified to think that, once the contract was signed over the *Thesaurus*, his financial investment would be secure, and he could look forward to a profitable, long-term collaboration with his partners. His choice of the firms was excellent. Both publishing companies enjoyed a solid reputation, and had a good record of publishing scientific works and illustrated atlases. The representative of Wetstein & Smith, Rudolph Wetstein, had previously published Cornelis de Bruyn's *Reizen over Moskovie* and Lambert ten Kate's *Nederduitsche sprake*, an early essay into historical linguistics.[52] He had recently bought a house on the busy Kalverstraat, and had just seen a new edition of Verheyen's *Corporis humani anatomia* through the press.[53] Janssonius van Waesbergen, in turn, was probably the best-known bookseller of Amsterdam in the period, so well established in scientific publishing that he had a separate trade catalogue for medical and pharmaceutical works.[54]

As for himself, Seba could boast of excellent credentials in the international commerce of natural history. Born into an impoverished family of Northern German farmers in 1684, he eventually became one of the wealthiest citizens of Amsterdam thanks to his pharmaceutical business.[55] His *Deutsche Apotheke*, opened on the Haarlemmerdijk in 1700, sold sal ammoniac, rose honey, bezoar tincture, Venetian theriac, and other drugs to local physicians and foreign customers alike.[56] By the 1710s, Seba became the chief pharmaceutical provider of the Russian court, handling requests at the scale of tens of thousands of guilders

annually. When he died, his inheritance was valued at 181,312 guilders and eleven stuivers, a clear proof of his business acumen.[57]

Among the curiosi, Seba was best known for his collection of curiosities, a large-scale intellectual and financial investment into natural history. His first cabinet contained American sloths, Surinamese and Asian anteaters, South African, East and West Indian crocodiles, parrots from the island of Ambon, European vipers, Italian salamanders, and a bird from Greenland, all preserved in large bottles of alcohol to prevent rotting. In 1714, Seba offered this collection to the Russian court, explaining that his business prevented him from maintaining it, and that he was afraid that the cabinet would be dispersed and sold apiece on an auction after his death. While the Russian court quickly approved of the purchase of the cabinet in principle, they disagreed about the price. Seba asked for 15,000 guilders, but the Russians were willing to disburse only 13,000 guilders, and the negotiations lasted for years even after the specimens had been shipped.[58]

The *Thesaurus* was supposed to commemorate Seba's second cabinet, established soon after the sale of the first. Despite the ravages of old age and his previous complaints about not having time for curiosities, Seba's second collection grew to be even bigger than the previous one. When this second collection was dispersed in 1752, confirming Seba's earlier fears, the heirs cashed in 24,400 guilders, a decent addition to the rest of the 180,000-guilder inheritance.[59] Just as the first collection was saved from dispersal by czar Peter's purchase, so would the second collection be immortalized in a printed publication. The popular preservation methods of the time—for example, Seba's animals kept in bottles of alcohol, might have been able to stop the biological decay of curious specimens, but only paper could forestall the deleterious results of human negligence.[60] Cabinets of curiosities were frequently subject to ruination, and not only because uninterested heirs auctioned them off after the owner's passing. Just a few years after Clifford hired Linnaeus to produce the *Hortus Cliffortianus,* an illustrated description of his renowned garden, all the plants perished in a fire by a negligent gardener, leaving only a paper trace behind.[61] And, ironically, parts of the *Kunstkamera* in St. Petersburg also burned down in 1747, together with some of the animal specimens.[62] We know about its original contents today thanks to the manuscript drawings that the administrators had presciently prepared for just such an eventuality.[63]

Seba's decision to assume control over the finances and the writing of the *Thesaurus* was a direct result of his insistence on preserving an accurate, paper copy of his cabinet. Once the *Thesaurus* was published, in the exact shape he designed,

Seba could rest assured that his cabinet's specimens were properly preserved at least in a paper copy, offering the possibility of a virtual visit to the international public, or at least to those who could afford to shell out 160 guilders for it. As Seba wrote,

> Since the majority of *curiosi* and the erudites live abroad, and do not have the possibility to travel, we nonetheless wanted to arrange a meeting with them and, so to speak, bring our cabinet, engraved from the life in printed images, to their lands and houses.[64]

As an authentic, paper copy, Seba's *Thesaurus* would conquer the distance separating London, St. Petersburg, and Danzig, and acquaint all present and future generations with Seba's *naturalia*, even after the dispersal of the original specimens.

THE BUSINESS OF PRINTING

Seba's aim to produce an accurate representation of his cabinet did not cloud his business sense. He did not want to sustain a financial loss because of the publication, and actually hoped for a moderate profit. This could be achieved only if a sufficient number of the "*curiosi* and the erudites abroad" actually purchased his book. He therefore needed to embark on a marketing campaign to convince potential customers that the *Thesaurus* was indeed an accurate representation of his cabinet, an atlas that they wanted to have in their library.

Marketing was especially important because the *Thesaurus* was first sold by subscription. In the early modern period, a subscription scheme meant that interested readers were invited to purchase a book for a discounted price before its publication. This practice could be beneficial to publishers for several reasons. A large number of subscriptions signaled real market demand for a book, and could also help determine print runs. By paying upfront, moreover, subscribers also provided cash to the publisher before the printing presses were turned on, reducing the considerable time lag between initial investment and the return from sales.[65]

In the case of the *Thesaurus*, the first advertisements for subscription went out in the 1734 January-February issue of the *Bibliothèque Raisonné*, a journal printed in the Netherlands, but written in French for an international audience.[66] For Seba, Janssonius van Waesbergen, and Wetstein & Smith, revenue from subscriptions was probably not essential for defraying printing costs. They wanted

to lock subscribers into buying all four volumes, and avoid having to deal with customers who bought only one or two volumes instead of the whole set.

Given the *Thesaurus*' exorbitant price, Seba and his publishers needed all their marketing skills to sell these subscriptions. They aimed at a wide audience, and printed this "extremely curious and magnificent work," as they called the *Thesaurus*, both in a Dutch-Latin and a French-Latin bilingual edition, to cater for the linguistic needs of well-educated readers across Europe. They addressed the problem of the price head-on. The advertisement predicted that some buyers might frown at the subscription price of 160 guilders, and went on to explain why it was a real bargain.[67] The first volume, for example, was printed on more than 33 quires of paper, which in itself was worth more than ten guilders. Readers would also receive 59 folio and the 52 quarto engravings as illustrations, a value of 45 guilders, not to mention the frontispiece, the title page, three vignettes and the portrait of the author. The publishers calculated that the first volume contained 59 guilders' worth of image and text, and that the four volumes, taken together,

Fig. III/4. One might take the claimed financial value of the *Thesaurus* with a grain of salt. Subscription advertisement for Seba's *Thesaurus*, *Bibliothèque raisonnée* 11 (1734), January-February, 236–39.

were worth 235 guilders. The discounted subscription price of 160 guilders was thus an irresistible offer, and they urged the reading public to subscribe before the deadline of September 1734, after which the *Thesaurus* was going to be sold for 225 guilders.

Yet who would buy a subscription to an expensive book that has not yet appeared? It was all too well known that booksellers sometimes put out advertisements for a projected volume, took subscriptions, and then failed to deliver the finished publication. Advertising a subscription for his *Naauwkeurige waarnemingen,* an entomological encyclopedia printed in four parts, the Dutch printmaker Jacob L'Admiral wrote plaintively in 1740 that "when it comes to subscriptions, the credit of booksellers is low because of their failure to complete their promised works."[68] L'Admiral promised not to disappoint his subscribers and offered them eight engraved illustrations in advance, but then, he could not avoid fate, either, and the *Naauwkeurige waarnemingen* was abandoned after the publication of the first part.

To allay similar fears, the publishers of Seba's *Thesaurus* stated forthright that "all the engravings have been cut already and the first volume has even been completed."[69] They promised to deliver within a few months the first volume, showing bulky and expensive mammals, such as a baby elephant, as well as cacti, exotic flowers, and paradise birds. This volume would also treat the curious specimens of apples, pears, and other fruits that were prepared according to Seba's own invention to visualize and preserve the anatomical structures of plants. The next volume, treating snakes, was slated to appear in February 1735, and the third and fourth volumes, on marine life and insects, respectively, were going to come out with the delay of one year each. To dispel any lingering doubt about the *Thesaurus'* high standards, the publishers reported that the renowned Boerhaave offered his personal endorsement of the enterprise, writing that

> in one word, the descriptions are so exact, and the engravings are so beautiful that Mr. Boerhaave, this illustrious professor at Leiden, offered a public testimony that no equal work had appeared in this genre before.[70]

And, if some were still uncertain about subscribing, even after such a glowing recommendation, the next issue of the *Bibliothèque Raisonné* published a rave review of the already published *Volume I*, which ran to 27 pages.[71] Only malicious critics would have caviled that the review's objectivity might have been compromised: the *Bibliothèque Raisonné* was edited by Wetstein & Smith, the publishers of the *Thesaurus.*

Marketing worked. The *Thesaurus* was on its way to reach out to customers across Europe, making Seba's cabinet accessible to armchair tourists and bringing profit to its author. Gronovius was only one of the many subscribers from London to St. Petersburg, and the rumor circulated that hand-colored copies were exchanging hands for around 500 guilders, a colossal sum in the period.[72] In 1735, *Volume II* appeared as scheduled. Everyone was waiting for *Volume III* and its assortment of marine animals.

And then, Seba died.

SELLING SPECIMENS, CAPITALIZING ON IMAGES

> *The circumstances that usually accompany the death of an author*
> *very often create obstacles to the final execution of a project*
> *that demands as much care and expense as this one does.*[73]

In literary theory, the "death of the author" signifies the author's loss of control over the interpretation of a text. Every literary work can be understood in myriad ways, and readers can form their own, diverging interpretations with little respect for the author's original intentions.[74] In early modern natural history, the literal death of the naturalist had similar consequences over the fate of a publication. Heirs and publishers usually had little interest in the original intellectual intentions of the dead author. If they decided to continue the project of publication, they often reshaped it so as to maximize their own financial profits.

The premature death of a still active author was a surprisingly common event in an era with high mortality rates and prolonged publication times. Almost all early modern naturalists left unfinished manuscripts or partially printed works on their desks when death took them away. The list included Conrad Gesner, Ulisse Aldrovandi, Jan Jonston, Francis Willoughby, John Ray, William Sherard across Europe, and Hendrik van Rhede tot Drakensteyn, Jan Swammerdam, Georg Eberhard Rumphius, Maria Sibylla Merian, and Louis Renard in the Netherlands and its colonies. Some of these interrupted works, such as Gesner's botanical manuscripts, never saw print, while others were published in a form that the original author would scarcely have recognized.

Seba's *Thesaurus* was no exception. In this case, the author's death first meant delays with the publication of the last two volumes. Before printing continued, the inheritance had to be divided between his widow and the three daughters' families, outstanding obligations needed to be paid, and the pharmacy needed a new apothecary. As a further setback, the widowed Anna Lopes died two years

later, throwing into renewed disarray the already complex negotiations about the legacy. The inheritance, and the *Thesaurus*, were embroiled in protracted legal disputes that lasted until 1742, when Seba's goods were finally unsealed and divided.[75] Yet the status of the *Thesaurus* was still unclear. As it turned out, the text of these two volumes was largely missing, with a few exceptions. While Seba had the copper plates engraved in his lifetime, the publishers needed to hire a natural historian to complete the text of the entries. The learned Jacob Marcus, the husband of Seba's eldest daughter, signed a contract in 1738 to finish these entries within three years, but could not get access to Seba's specimens until 1742.[76] And even then, Marcus did not exactly hurry to complete the entries for the volume. When he and his wife both died in 1750, Seba's work had not progressed an inch.

The *Thesaurus'* fate was now in the hands of two entrepreneurial heirs. Seba still had one daughter alive, Margaretha, married to the pharmacist R. W. van Homrigh, who now ran the *Deutsche Apotheke*. Another daughter, Elisabeth, was dead, but her children were represented by the father, the Alkmaar minister Willem Muilman. Seeing a commercial opportunity, Muilman and Van Homrigh resolved to publish the last two volumes of the *Thesaurus*.

The *Thesaurus* was a promising business venture despite all the delays because Seba left behind a practically complete set of engraving plates. As Breyne's accounts for *De polythalamiis* have already revealed, engraved illustrations were the major expense for publishers of natural history. For instance, Hans Sloane was rumored to have invested "neer 500 pounds for Engraving, and printing" in the first volume of his *History of Jamaica*. Similarly, the Dutch naturalist Adrian van Royen spent over 500 guilders on the 43 plates of his *Ericetum africanum* before abandoning all hopes of publication.[77] Seba and Van Royen employed the same engraver, Jacob van der Spijck, so one can reasonably assume that the 449 plates of the *Thesaurus* cost at the very least 5,000 guilders to produce.[78] This was not an amount any businessman would easily shrug off. Van Homrigh and Muilman were sitting over thousands of guilders of capital in the form of copperplates. They could produce the remaining volumes of the *Thesaurus* with a minor outlay of capital into paper and textual production, and then receive an impressive return on their investment once the completed volumes appeared in the bookstores.

These entrepreneurial heirs also made two controversial decisions that boosted their profits but compromised the content of the *Thesaurus*. First, Muilman and Van Homrigh decided to auction off Seba's cabinet, piece by piece, as the late naturalist feared. They contracted three brokers to run the sale, printed an auction catalogue, and set the date for April 1752. Yet the entries for *Volumes III* and *IV* were still missing, and, once the cabinet was gone, they could no longer be based

on the first-hand observation of the original specimens. Whoever was to write up these entries was going to have to rely exclusively on the engraved images to provide a description of Seba's curiosities.

Ironically, while the dispersal of the actual cabinet had disastrous effects on the textual content of the last two volumes, the first two volumes of the *Thesaurus* actively facilitated the sale. The auction catalogue used the first two, already printed volumes as a reference work for the specimens, referring to its entries through the 'folio and number' method discussed in the previous chapter. Whenever possible, the auctioneers directed potential customers to consult their copies of the *Thesaurus* to identify what exact specimen was on sale. Lot 105 amongst the *Insecta* [sic!] was "a young sloth from Ceylon, Tab. 33 N. 4," (i.e., Table 33, Fig. 4, of vol. I of the *Thesaurus*), lot 110 was an "American anteater, T. 37. N. 2," and lot 114 was a "Javanese weasel, T. 48 N. 4."[79] The customers followed these instructions, and consulted the *Thesaurus* and the sales catalogue together. In St. Petersburg, an unknown member of the Academy of the Science also wrote up a list of birds to purchase at the auction, omitting their names and indicating in shorthand only "Tab. 30. No. 5. Tab. 31. No. 10. Tab. 36 No. 6.," and so on.[80]

Fig. III/5. References are to the second volume of Seba's *Thesaurus*, buyers are recorded on the left.
———, *Catalogues van de uitmuntende cabinetten*, 1752, Catalogus van Insecten, 1.

The printed volumes of the *Thesaurus* supplemented the original cabinet: they preserved its contents in paper for eternity, but at the same time speeded up the dispersal of the original specimens.

GHOSTWRITING IN STYLE

After the sale of Seba's cabinet, Muilman and Van Homrigh made their second fateful decision. They commissioned a ghostwriter to finish the text, under the explicit obligation to write in the style and name of Seba, a highly debated decision. Interestingly, their issue was not where to draw the boundary between editor and author, as in the Renaissance. Instead, their question was whether a named editorial commentator would diminish the market value of a book sold for its authorial originality. Authenticity had a clear market value in this period, and Van Homrigh and Muilman believed that the *Thesaurus* would sell better if presented as written by Seba himself. With the original cabinet gone, they could not easily admit to having hired professional writers to complete the text. Their customers would surely realize that these writers had no access to the original specimens. And who would buy an expensive volume whose text simply told readers what the illustrations showed, and could not comment on those aspects of the specimens that were difficult to visualize? The only solution was to pretend that the entries had been written by Seba, during his lifetime, on the basis of his expert knowledge of each and every specimen.

Muilman let Van Homrigh handle the day-to-day business of publication, and Van Homrigh first hired the Leiden professors Hieronymus Gaubius and Adriaan van Royen to complete the part on marine animals. Once this part was nearing completion, Van Homrigh turned to the renowned naturalist Arnout Vosmaer, whose cut-and-paste version of Rumphius has already featured in the previous chapter, and asked him to complete *Volume IV*'s entries on insects, marine plants, and corals.[81] Unfortunately for him, and fortunately for us, Vosmaer kept a copy of his correspondence with Van Homrigh, revealing step by step how forgery compromised the reliability of the *Thesaurus*.[82]

A merchant by birth and training, Vosmaer was a good partner for the enterprise of Van Homrigh and Muilman. By the early 1750s, Vosmaer's passion for natural history had taken over his original profession, and he was employed as a director for the collections and the menagerie of the Princes of Orange in The Hague.[83] He had also just published a posthumous edition of Louis Renard's *Histoire des poissons*, where his role as an editor was acknowledged, which made him a perfect candidate for the complex job of finishing the *Thesaurus*. He was

even somewhat familiar with Seba's cabinet, having bought several of his specimens at the auction of 1752. Van Homrigh, Muilman, and Vosmaer came to a quick agreement about Vosmaer's financial compensation. For producing a text in Dutch (to be translated into French and Latin by others), he would receive 400 guilders in three installments, reimbursement for postal costs, and an uncolored exemplar of *Volumes III* and *IV*. Compared to the more than 5,000 guilders the copperplates cost, this was not much money.[84]

While he found his compensation adequate, Vosmaer was less satisfied with the stipulations of the publisher. Van Homrigh instructed him to write under a veil of secrecy, without revealing to anyone his role in completing the *Thesaurus*. He was supposed to be ghostwriting a forgery.[85] The naturalist of The Hague had to follow Seba's writing style as closely as possible. In Vosmaer's words, his entries were expected to be "short and to-the point, to simply describe the objects in the cabinet, without going into a natural philosophical discussion of them."[86] A few words on the specimen's name, shape, size, and color would suffice for each entry.

Vosmaer never broke his contract of secrecy, but he privately complained to Van Homrigh and the other collaborators in the project. In Vosmaer's previous experience, publishers did not usually bother to hide their editorial contributions to a posthumous publication. He suggested to explain in an introduction to *Volumes III* and *IV* "that the two last parts have been written after the man's [Seba's] death [...] and make sure that he is to be perceived as the author."[87] It was a commercially viable alternative to forgery to acknowledge the presence of editors, as long as their contribution was clearly separated from, and subordinated to, Seba's authorship. Echoing Vosmaer's concerns, fellow ghostwriter Gaubius also found Van Homrigh's and Muilman's concerns odd. He wrote to Vosmaer that the publisher did not "appear to follow the tastes of the public, but rather their own concept."[88] According to Gaubius, most readers would not have thought it unusual that the text of a (postmortem) publication was written by an acknowledged editor, as long as this contribution was not considered full authorship. On their own, the engraved illustrations lent sufficient authorial aura to call the *Thesaurus* a true work of Seba. Yet Van Homrigh vehemently disagreed with his employees, and told Vosmaer "the work must be published as a work of Albertus Seba and also not the slightest mention should be made that others have worked on it."[89] It would have been too risky to reveal that the entries were written after the sale of the specimens.

In practical terms, ghostwriting was a problem of stylistics, and Vosmaer had to work hard to maintain the fiction of a unique author. First, Seba was not solely responsible even for the descriptions published during his lifetime. The

Amsterdam anatomist Frederik Ruysch provided significant help for the entries on snakes, which took up much of *Volume II*, and Boerhaave supplied further observations on antelopes and other specimens.[90] While the learned public did not know of Ruysch's and Boerhaave's contributions, it was common knowledge that Seba asked the Swedish ichthyologist Petrus Artedi to write the entries on fish for the unpublished *Volume III*. After the ichthyologist's untimely death by drowning in an Amsterdam canal, Linnaeus publicized this fact in his biographic introduction to a posthumous edition of Artedi's *Ichthyologia*.[91] Vosmaer therefore had to imitate a style that was the collective product of at least four writers already in Seba's lifetime. And these writers did not even work according to the same standards. As Gaubius commiserated with Vosmaer, a ghostwriter faced the difficult decision whether to write his part "in accordance with those [entries] that were written, for instance, by the very skillful Artedi, or with the others." Did a good forger need to write purposely bad-quality entries, or was it permissible to aim for imitating only the best?

Vosmaer also had to coordinate his style with fellow ghostwriters Gaubius and Van Royen, whose attitudes were less than cooperative. In the middle of May 1756, Vosmaer asked Van Homrigh to send writing samples from them, "to see what directions they have followed so as to shape and direct mine accordingly."[92] Unfortunately, Homrigh did not have the requested texts at hand. Gaubius was still working on *Volume III*, and the completed entries were already in the hands of the printer Elie Luzac. Van Homrigh told Vosmaer to contact Gaubius for the proofs, although this was not even necessary. As he claimed, the text of *Volume III* would appear very similar to the previous parts. He wrote that

> you will see in what manner they are written, we have followed the intentions of Seba as much as possible, followed the same style very simply, and always paid attention not to diverge from its manners, as our intention was always to publish it as the work of the old man, and not to give any other idea to the curiosi.[93]

Vosmaer was not convinced, and wrote to Gaubius for a writing sample. Yet the Leiden professor would not release them without the publisher's explicit, written order. Vosmaer then turned to the printer Elie Luzac, who was able to send a few of the illustrations and descriptions. Then, despite Homrigh's written authorization, Gaubius refused to part with the rest of the text because he wanted to first "complete the remaining part of my work."[94] In order to gain time, he advised Vosmaer to write again to Van Homrigh, who might have had access to

those parts of *Volume III* that were being printed in Amsterdam. Having gone a full circle, Vosmaer again contacted Van Homrigh with his renewed request and reiterated that "I find it necessary to frequently use the already printed description of that part, in order to adjust my manner of writing and expressions."

Finding a common authorial style to imitate was not the only constraint for Vosmaer's writing. Soon enough, he realized that material constraints also had a significant effect on his work. In the absence of the original specimens, he could not say much in his entries, anyway. The illustrations showed the animal from only one side and lacked scale to determine the size. Even guessing the species could run into difficulties. As he wrote to Van Homrigh, he had to

> fit and direct my descriptions according to the hand-colored plates, and, since rather many specimens are unknown to all authors, I cannot give much more than a description of their color, and of what kind of animal it is, with a short remark according to the example of Seba.[95]

Fortunately, the constraints of the material overlapped with the constraints of the pseudo-Sebean style. Both necessitated that the descriptions remain short "to follow the directions of our predecessor." Even then, Vosmaer's entries in *Volume IV* tend to be shorter than the entries in *Volume I* and *II*. While Seba frequently included a short anecdote on how he acquired a specimen, Vosmaer could not provide such information to make the entries more personal.

AUTHENTICITY AS A SOCIAL PROBLEM

The problems with ghostwriting did not end with Vosmaer's adherence to a uniform style. He had to write as if the 1730s had never ended. This was especially problematic because the Linnean revolution occurred precisely during those twenty years that Vosmaer had to overlook. He could avoid discussing these developments only by restricting himself to terse descriptions of the specimens, as ordered by Van Homrigh. The publisher did not want to score points in the most recent scientific debates, he wanted to generate profit by selling an authentic work by Seba. Vosmaer, on the other hand, was a keen taxonomist who wanted to keep up to date with the latest developments in natural history. He finally gave in to Van Homrigh's orders, but not without expressing his concerns to Gaubius about having to omit "any theoretical considerations," in which he could have discussed philosophical problems related to the specimens.[96]

Erasing twenty years from a book's history also brought up issues of priority,

especially because Vosmaer could not reference any work published after Seba's death in 1736. Would he have to pretend that Seba's entry was the first to describe a previously unknown marine plant, if he was not allowed to mention "the name of an earlier observer, like Jussieu," who already described the species in an article in 1742?[97] If the illustrations were from the 1730s, yet the text only from the late 1750s, could one consider Seba as the true discoverer of the new species? By presenting his text as Seba's original, did Vosmaer unjustly strip Bernard de Jussieu from his claim for priority? Given the rarity of Seba's specimens, this was a pressing concern: ever since Linnaeus, the illustrations of *Thesaurus* have served as the iconotype for many species.

While Vosmaer did not shy away from ghostwriting, he drew a line at making a false claim in such priority debates. He told Van Homrigh that he wanted to include a short, explicitly posthumous note on the marine plants of Jussieu, suggesting that this commentary could be printed in a different font to mark its status as a later addition.[98] Van Homrigh probably did not protest too much about this request, since such a commentary could help establish the false boundary between authentic and inauthentic text, affirming Seba's penmanship of the rest of the work. In the printed *Thesaurus*, a footnote to Table XCV in *Volume III* gives proper credit to Jussieu's discovery.

Honoring priority claims was important for Vosmaer, because he slowly began to realize that, despite his best efforts, few would believe in the authenticity of the *Thesaurus*. Too many people were involved with the publication process, and not all of them kept their mouths shut. Gaubius warned Vosmaer that the publishers were foolish to

> abuse the public with a public untruth, pretending as if the whole work on the plates and the text was completed during the life of the late Mr. Seba to the extent that only the printing was left to do.[99]

Many naturalists with connections in the Netherlands already knew the truth. And even outside the Netherlands, careful readers would probably not be deceived about the *Thesaurus*' writers, either. When Vosmaer gained access to the finished text of *Volume III* in 1757, he realized that the other ghostwriters accidentally blew the whistle. One of them announced in the text that *Plates XXXII–XXXIV* were produced after the author's death. The narrator explained that Seba had intended to "fill [these plates] with other specimens of fish, as it appears clearly in his foreword to *Plate XXXV*," but never got to complete them.[100] If it could be admitted that three plates were designed, engraved, and described after

the author's death, Vosmaer could not understand why he had to pretend to be Seba so carefully, and complained bitterly to Van Homrigh.[101] Yet Van Homrigh paid little attention to this issue. By presenting these three plates as posthumous additions, he may have hoped to gain credibility for the claim that the previous thirty-one plates were all authentic, including an entry where the fictitious Seba accidentally referred to the postmortem sale of his own cabinet.[102]

While an anonymous ghostwriter did not have to worry a public reputation, Vosmaer began to fear that some readers would correctly guess that he was responsible for the text of *Volume IV*, and consider it part of his scientific oeuvre. The established naturalist could no longer consider ghostwriting a simple contract job because it could potentially have an impact on his reputation and career. He therefore needed to write the entries according to a higher standard, and informed Van Homrigh that

> as I have discovered that people made it clear that the work is put together and completed by others after the death of Mr. Seba, I have made more effort to describe the things clearly and eruditely.[103]

It was probably at this point that Vosmaer decided to include occasional references to the works of Nicola Gualtieri and John Ellis from the 1740s and 1750s.[104] If he might be held responsible for what he has written, Vosmaer had to update his references to deflect potential accusations of plagiarism and false priority claims.

AUTHENTICITY AS A SCIENTIFIC PROBLEM

The efforts at creating a fake aura of authenticity compromised the intellectual content of the *Thesaurus*, as well. Several specimens were incorrectly identified, some of the illustrations turned out to be copies from earlier prints, and the French, Dutch, and Latin versions of the entries did not match. Vosmaer discovered these errors only as *Volume III* neared completion. Although he was originally supposed to be involved with producing *Volume IV*, he was now sharing responsibility for this volume as well. The publisher had entrusted him with the task of preparing an index for *Volume III*, and also moved his entries on corals to this volume.

As Vosmaer came to realize, the premature sale of Seba's cabinet was a major problem. Even an expert natural historian could not always correctly identify a specimen on the sole basis of the engraved image. Browsing through Van Rooyen's entries, Vosmaer realized that the Leiden professor incorrectly identified sev-

eral of the marine species in *Volume III*. Vosmaer was able to correct these entries only because he had these specimens in his possession, having bought them at the auction of Seba's collection.[105] Comparing the imperfect illustrations with the originals, he could understand well why Van Royen went wrong. One wonders if, when he turned to writing his own entries on insects, he similarly wondered about the trustworthiness of the illustrations. Even today, expert herpetologists are able to identify only 50% of Seba's snakes at the species level, even though these entries were prepared under the original author's supervision. The illustrations and descriptions allow identification only at the genus level, or worse, for the other half.[106]

Vosmaer also disagreed with his colleagues' identifications even when he did not own Seba's original specimens. According to him, *Plate 94* incorrectly identified several specimens of *balanus,* a type of barnacle, as sea urchins. Vosmaer had a small collection of barnacles (unrelated to Seba's cabinet), and it was clear that the illustrations depicted the same species. Fearing that the page had already been typeset, he proposed to correct this mistake in an appended *erratum.* In response, Van Homrigh wrote that the text of *Plate 94* had not been printed yet. Changes could still be made and there was no need for an *errata* list, but he did not understand why those specimens could not be urchins. Vosmaer wrote back and referred Van Homrigh to Gualtieri's *Index testarum conchiliorum* from 1742. In that work, the Italian naturalist provided several illustrations of *balanus* specimens, dispelling any doubt about sea urchins.[107] Yet Gualtieri was hardly a decisive proof for Van Homrigh, who refused to consider the scholarly literature published after Seba's death. To maintain the illusion of Seba's authorship, it was probably better not to follow Gualtieri's system. When the final text of the Thesaurus was printed, the specimens on *Plate 94* were identified as urchins.

Even Seba's own illustrations lacked authenticity in some cases. The publishers told him early on that some illustrations in *Volume IV* were copied from an anonymous manuscript from the 1680s, but Vosmaer had other discoveries to make on his own. Browsing through the images, he noticed that several insects were taken from the early seventeenth-century prints of Wenceslas Hollar and Joris Hoefnagel. Vosmaer could not understand why Seba decided to include these illustrations in his description of the cabinet. They were badly executed and showed either monstrous or plainly fictitious specimens. They did not in the least resemble any insect that Vosmaer had seen before.[108]

Imperfect illustrations were not the only source of trouble. Good translators were essential to ensure that the *Thesaurus'* entries conveyed the same information in Dutch, French, and Latin, using the scientific terminology of the early

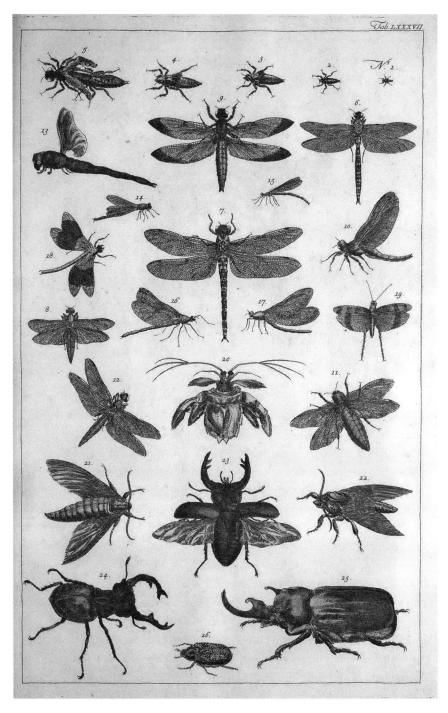

Tab. LXXXVII

Fig. III/6. Hoefnagel's beetle is on the bottom right. Seba, *Locupletissimi rerum naturalium thesauri accurata descriptio*, IV/Tab. 87.

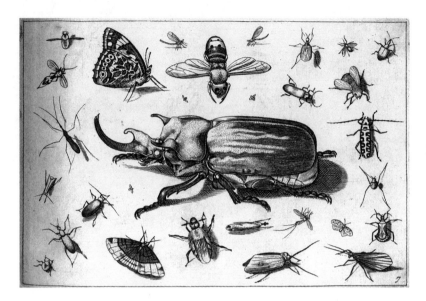

Fig. III/7. Stag beetles have been a hit with artists since Dürer. Jacob Hoefnagel, *Stag Beetle*, 1630.

1730s. This was not an easy task, and the French translator quit in the middle of *Volume III*. Van Homrigh was fortunate enough to hire Pierre Massuet within a few weeks. Massuet had already worked on the previous two volumes, and could therefore serve as a guarantee that at least the French version of *Volume III* would "follow the same style" as Seba's original.[109] As he soon discovered, the previous French translator did an atrocious job, skipping entire sentences in several entries.

Fanciful illustrations from the early 1600s, shoddy translations, incorrectly identified specimens, and an almost complete lack of reference to recent scientific discoveries. In Van Homrigh's and Muilman's hands, the *Thesaurus* was less and less the authentic work that Seba imagined it to be. Instead of providing a faithful, paper representation of Seba's cabinet, it became an inconsistent, inaccurate, and outdated work of natural history. Yet when in December 1759, *Volume III* was finally published, the book was selling well, with customers paying 130 guilders for a copy. Van Homrigh could lay back in his armchair. After long years of day-to-day management of the printing, and handling the constant complaints of Vosmaer and Gaubius, he was finally earning an income from the work. Afflicted by the death of his wife, he decided to retire from business. He sold the *Deutsche Apotheke* and moved to the countryside in Maarssen. He paid Vosmaer for his

work, and handed over *Volume IV* to the publishing firm Arkstee & Merkus. Van Homrigh forgot only Gaubius. The Leiden professor had to send repeated requests for payment before receiving his salary in the last days of 1761.

A HAPPY ENDING

A new publisher meant a new authorial regime. Arkstee & Merkus represented a new generation of publishers who came into business after Seba's death. Unrelated to the family, they were less interested in producing an authentic commemoration of the late author's collection. Not responsible for the sale of Seba's cabinet, they felt less pressure to pretend that the entries were produced in the 1730s. They thought that, thirty years after the author's death, the readers cared less about the authenticity of the *Thesaurus*, and preferred an up-to-date edition that took into account the latest developments in natural history. And it appears that they did not quite realize how different their approach was from that of Van Homrigh and Muilman.

Vosmaer learned about the changing expectations of the publishers in a rather abrupt manner. In November 1763, when Vosmaer had almost completely finished the text of *Volume IV*, Henricus Merkus happened to peruse Jean-Etienne Geoffroy's *Histoire des insectes aux environs de Paris*.[110] Forgoing issues of authenticity, Merkus suggested that Vosmaer should consult this work for his identifications and descriptions of the insects. Vosmaer was shocked to hear about such a turn in editorial intents. He filled several pages with his outraged response, emphasizing again and again that he had been ordered to write the "description as short and as simply as it was ever possible for me, and to keep myself from adding any signs of erudition to the work."[111] One could not tell Vosmaer offhand that, after seven years of writing in one style, he should shift to a new register. Yet after some further exchanges, the ghostwriter relented in the end, and included a reference to the *Histoire des insectes* in *Thesaurus IV*, as well as to August Johann Rösel von Rosenhof's recent entomological publications.[112] Priority and credit could now be given to works written after Seba's death.

According to the new publishers, one did not even need to pretend that Seba was responsible for writing the entries. His role in commissioning the illustrations was sufficient for claiming authorship over the finished work. Vosmaer therefore wrote up an introduction to *Volume IV*, making it clear that Seba did not write it. He mentioned that "the tireless Seba, as we have said in the introduction to the third part, had already prepared these copper plates after the

painted illustrations from the life [. . .] when he died in 1736," but avoided making such claims for the text. He even named Artedi as the writer of the entries on the fish in *Volume III.*

The introduction also admitted that the entries were written after Seba's cabinet was sold, and used this as an excuse for the brevity of the entries. Vosmaer posed the rhetorical question whether readers would prefer a "true and bare description, measured after the naked images of the objects that had truly existed," or a "more wide-ranging description, borrowed from others, or based on most uncertain reports."[113] The pseudo-Sebean style, forced on Vosmaer by Van Homrigh and Muilman, was presented as a straight constraint of the material.

Yet even the publication of *Volume IV* did not dispel all the mysteries surrounding the *Thesaurus*. It was still unclear who wrote the entries of this volume. Vosmaer's name was not mentioned once in the final publication, and readers were still left with the impression that the text of *Volume III* was prepared under Seba's supervision. Moreover, Vosmaer did not admit that even *Volume IV*'s entries on insects were written with the intention of creating the false aura of authenticity. Browsing through the entries, readers might have had an uncanny feeling of recognition. While they were consciously aware of the interventions of an anonymous writer in *Volume IV*, Vosmaer's style and mannerisms in this volume might have reminded them unconsciously of Seba's own writing in the previous volumes, especially because they thought that Seba was also the author of Vosmaer's entries on corals in *Volume III.* A curious memorial to Seba's literary style, but hardly a faithful paper copy of his erstwhile cabinet.

In tracing the tortuous publication history of the *Thesaurus* over thirty years, this chapter has revealed the curious effects of commercialization on natural history publishing. Only a well-capitalized, entrepreneurial network of publishers could sustain the finances of publishing the luxurious encyclopedias of early eighteenth-century botany and zoology. The formation of publishing consortia and subscription schemes reduced the risks of investment. Marketing and international distribution networks allowed Dutch publishers to find enough customers in all corners of Europe to earn a profit from natural history. And the naturalist author's personal involvement in financing a publication not only provided an additional source of funding, it also offered an added degree of authenticity to the finished work, deflecting accusations of crass commercialism. This increased emphasis on authorial authenticity went hand in hand with the transformation

of natural history. Gone were the days of the collective, piecemeal work of Renaissance naturalists. Wealthy natural historians based their observations on their private collections, and, as the following chapter reveals, performed their experiments using instruments and techniques that other practitioners did not have access to. Seba's *Thesaurus* was so appealing to subscribers because his financial investment kept the editorial desires of the publishers at bay, and his text offered a personal account of specimens that he had owned and studied through long years. His paper museum was supposed to be credibility exemplified.

The *Thesaurus*' protracted history has shown how profit-seeking publishers could exploit the emerging norm of authorial authenticity by developing new strategies of deception. Whereas in the Renaissance, editorial interventions served as a justification for claiming authorship over an earlier text, the eighteenth century saw editors separate their role in the production of a text from that of the author, in order to maintain an aura of authenticity. Or alternatively, as in the case of Seba, they turned into invisible contributors.

In this respect, Seba's *Thesaurus* could be considered the *Ossian* of natural history. Contemporaneously with the completion of the *Thesaurus,* the Scottish writer James MacPherson stunned the literary world with his putative discovery of the forgotten epic of the ancient Gaelic bard, and the extent of his forgery was not fully established until the mid-twentieth century. Indeed, the growing number of spurious scientific publications, from Descartes through Newton to Boerhaave, may well have been part of a larger eighteenth-century cultural trend. The strong demand for the authenticated writings of cult figures (including mythic heroes like Ossian) also resulted in William Ireland's celebrated forgeries of Shakespeare from the 1790s, in St. Jean de Crèvecoeur's vain decision to claim Benjamin Franklin as his textual source for parts of his *Voyage dans la haute Pensylvanie,* and in the various fake publications bearing the name of Rousseau.[114] Already well established in the fields of the Classics and the fine arts, forgery now also became part and parcel of everyday scientific and literary practice.[115]

As this chapter has argued, the increasing cult of the modern scientific author laid the condition of possibility for Seba's *Thesaurus* to become a ghostwritten fake. But there was another dynamic at play, as well: the differential production costs of image and text. Entrepreneurial publishers never forgot that illustrations were much more expensive to produce than the text. Seba's heirs continued the publication of the *Thesaurus* only because the engraving plates, already completed, were a powerful financial incentive. And they remained so well after *Volume IV* hit the bookstores in 1765. When the French publisher Didot Sr. acquired the original plates for the *Thesaurus* in 1801, he set to form a publishing con-

sortium to prepare a new edition, and advertised a subscription scheme.[116] While the Napoleonic wars put an end to this venture, Félix Edouard Guérin-Méneville successfully published a new edition, titled *Planches de Seba*, in 1827.[117] The illustrations were printed from the original copperplates, but a new commentary was prepared by Georges Cuvier and Geoffroy Saint-Hilaire, the leading natural historians of the age. Guérin-Méneville did this not because Seba's illustrations were more trustworthy than the text. As we have seen, Vosmaer frequently complained how these images failed to provide solid evidence on the identity of the original specimens. Guérin-Méneville's reasons were purely monetary. He could cheaply prepare an updated description, but would have had many difficulties with re-engraving illustrations. Financially speaking, an image was really worth a thousand words.

✦ IV ✦

ANATOMICAL SPECIMENS
IN THE REPUBLIC OF LETTERS

SCIENTIFIC PUBLICATIONS AS MARKETING TOOLS

*Such apply themselves very usefully to the business of anatomy, as are employ'd
in preserving the better and more rare preparations therein, that upon any occasion,
may be show'd and view'd: And for the purpose almost all has his own
peculiar liquor, and which he generally keeps secret.*[1]

When Albertus Seba's collection of *naturalia* was put on auction in 1752, the
printed sales catalogue prominently identified the erstwhile proprietor of the
collection on the title page, as if his ownership had turned him into an author
of these curiosities. The specimens would gain credibility and value in the eyes
of customers, or so the publishers of the catalogue hoped, because Seba had
"collected them through many years, not sparing effort or expenses." With its
prominent display of Seba's name, the catalogue also put under erasure the con-
tributions of those travelers, taxidermists, and merchants who caught, prepared,
and sold these specimens to the Amsterdam pharmacist.[2] They were not named
in the catalogue, which identified the lots only by the species or a more generic
name and omitted any information on their provenance. Thus, according to the
catalogue, *Chest 76* of the *Conchs* contained "diverse conchs," "ditto," "ditto,"
"ditto," and "ditto," while the section on *Diverse Animals* started with the lots
"two birds of Paradise," "two ditto," "two ditto," "two ditto," and so on. As au-
thorial authenticity gained a premium in the eighteenth century, its boundaries
were determined with growing precision. Ownership, and not taxidermic skill,
determined authorship over nature.

Seba's auction catalogue named the maker of a specimen only in two excep-
tional cases. Several of the nautilus shells were decorously engraved by Cornelis
Bellekin, and the catalogue acknowledged his artistic contribution, which clearly
raised the price of these specimens.[3] The catalogue also explicitly named Frederik
Ruysch, a wealthy physician, *praelector* of anatomy, and professor of botany in

CATALOGUS
Van de Uitmuntende
CABINETTEN,
Met allerley foorten van ongemeene
fchoone Gepolyfte
HOORNS,
DUBLET-SCHELPEN,
CORAAL- en ZEEGEWASSEN;
Beneveus het zeldzame en vermaarde
CABINET van
GEDIERTENS in FLESSEN
En;
NATURALIA,
En, veele RAARE
ANATOMISCHE PREPARATA
Van den Profeffor RUYSCH:
Als mede een Verzameling van diverfe
MINERALEN
Verfteende Zaaken, Agaate Boom-
fteenen, Edele Gefteentens,
En verfcheide andere
RARITEITEN.
Met veel moeite en koften in een reeks van
Jaaren vergadert.
En nagelaten dóor wylen den Heere
ALBERTUS SEBA,
Lid van de Keizerlyke Leopoldifche Carolinifche en Koningl.
Engelfche Societeit der Wetenfchappen, als ook
der Academie van Boloniën.
Dewelke Verkogt zullen worden door de Makelaars *Th. Sluy-*
ter, J. Schut en *N. Blinkvliet*, op Vrydag den 14. April
1752. en volgende dagen, 's morgens ten 9, en 's namid-
dags ten 3 uuren, te Amfterdam, ten huize van HUY-
BERT de WIT, Caftelyn in 't Oudezyds Heeren Lo-
gement.
Zullende alles des Woensdags voor de Verkooping
van een ieder kunnen gezien werden.
De CATALOGUS is te bekomen by de
voornoemde Makelaars.

Fig. IV/1. Ruysch is explicitly named on the title page of Seba's auction catalog.
———. *Catalogues van de uitmuntende cabinetten*, 1752, title page.

Amsterdam, as the creator of several of Seba's specimens. Across Europe, the *curiosi* praised Ruysch for his preserved anatomical preparations that presented the human body in its natural, lifelike form, and purportedly revealed its external features and inner structures in the state of perfect mimesis. Seba owned dozens of these specimens, which were listed under the headings *Preparations of Professor Ruysch* and the *Wet Preparations of Dito*, and were also singled out on the title page.

Why name Ruysch in Seba's catalogue, if his preparations showed the human body in its natural state, without any external sign of artistic intervention? Why not keep his preserved specimens anonymous, as it happened with the birds of paradise and the conchs? This chapter shows how, like a *trompe-l'oeil* painter, Ruysch claimed authorship over his specimens by emphasizing that he had discovered a creative and original method to uniquely preserve and faithfully represent nature. As he successfully argued, his preservation technique was a useful and novel invention for medical research, and not a common skill that countless artisans were familiar with. Thanks to his excellent marketing skills in promoting this method, Ruysch's name became a brand that Seba's catalogue could not omit from its listings. His authorship raised the financial value of these specimens and guaranteed their high quality.

Throughout his career, Ruysch argued vehemently in letters, pamphlets, and journal articles that maintaining a specimen in its natural state required a special and secret method of preparation, based on the expert knowledge of human (and animal and plant) anatomy. As Ruysch's publications reiterated time and again, death fundamentally altered the human body, and only his secret method could reverse this process. His trustworthy preparations revealed the true anatomical structures of the body better than any other specimen, engraved atlas, or, indeed, any illustration in the numerous letters, pamphlets, or journal articles that he himself had penned. Students and scholars of anatomy had to consult these preparations to investigate the body, because engraved illustrations, educational textbooks, and even public dissections offered only faulty evidence.

To convince the contemporary public about the primacy of specimens, Ruysch needed to have excellent skills of preparation, a compelling visual epistemology, and a successful marketing strategy. Focusing primarily on the aspect of marketing, this chapter examines how Ruysch exploited the print culture of his time to promote his anatomical preparations, and, consequently, to call into question the value of print publications in anatomy. As a medical entrepreneur, he was active both in the marketplace for curiosities and in the marketplace of printed works. Yet, for Ruysch and many of his contemporaries, the market of print culture was subsidiary to the world of curiosities. As a producer of specimens, he considered

journals and books as vehicles for advertising the superiority of his preparations, but not as objects of value in themselves. Like the previous two chapters, this chapter thus again focuses on the complex relationship between the world of curiosities and print culture.[4] Seba's *Thesaurus* has revealed how printed atlases could commemorate a cabinet, and the correspondence of Breyne, Gronovius, and Amman has shown that printed encyclopedias could facilitate the exchange of specimens. Ruysch's case lets us discover how cheap but well-placed publications could function as free advertisements for more expensive curiosities.

Such a functional approach to early modern print culture calls into question whether publications are necessarily valuable objects that embody intellectual property and financial value. Historians tend to view early modern print culture as if it had operated as an independent, closed marketplace with its own value system. As the previous chapter on Seba has exemplified, scholars have focused on how authors and booksellers made careful calculations to turn a profit on a publication. They have also investigated how the transfer of a literary work's intellectual property is negotiated between the author and the publisher, and how eventual profits and credit are shared between these actors. Yet, for Ruysch, profit on the book market could be neglected as long as his publications helped him earn more in the marketplace for preparations. His publications had little intrinsic material and intellectual value when compared to his specimens. Printed works were not commodities *per se*, but rather tools to commodify his specimens. By closely following the career of Ruysch and a few other entrepreneurial practitioners, we can gain a better picture of how print culture and curiosity culture interacted in the seventeenth and eighteenth centuries. As I argue here, an integrated view for the marketplaces of print works and curiosities can even help us call into doubt traditional claims that posit a strong correlation between the growth of print culture and the development of the public sphere.

THE DEVELOPMENT OF PRESERVATION TECHNIQUES

Anatomical preparations were a novelty in the markets of early modern Europe, during a period of growing demand for innovative methods of visualizing the human body. They were the offshoot of early modern Europeans' expertise in preservation methods. Before the invention of the fridge, fish and meat quickly became unsafe for consumption and turned into powerful sources of disease. Pickling and smoking were part of the culinary apparatus of all European cuisines, keeping food from rotting. Fish were salted right after capture, and, as herrings migrated southwards to the North Sea during the early modern ice age,

the Dutch became an important source of salted fish for customers across Europe.[5] To store food at low temperatures, cellars cooled with ice were widespread in warmer climes, keeping meat fresh and making ice cream a possibility even during the summer time.[6] In more northern regions, the 1680s saw the invention of the heated tropical greenhouse, which kept exotic plants in a constantly warm environment, allowing pineapples and the Brazilian *hibiscus mutabilis* to grow in the Netherlands.[7]

Culinary delight was not the only reason that natural historians and *curiosi* were invested in the development of preservation techniques. A cabinet of curiosities could not survive long if its specimens began to stink, were eaten by moths, and slowly disintegrated. With the exception of seashells (without the live mollusk, obviously), all plants and animals needed some treatment. Plants were pressed and kept in books, and insects were pinned and then stored in a hermetically sealed box to keep live insects away. Taxidermists could preserve animal hides with the help of pepper and tobacco dust, and smaller animals could be bottled in jars filled with alcohol.[8] Collectors frequently exchanged recipes for such preservation techniques to ensure that their correspondents could send them specimens in a good condition. Many of these recipes relied on culinary ingredients that even common sailors could have easy access to, as in the case of James Petiver, who told his contacts that

all small Animals, as Beasts, Birds, Fishes, Serpents, Lizards, and other Fleshy Bodies capable of corruption, are certainly preserved in Rack, Rum, Brandy or any other Spirits; but where these are not easily to be had, a strong Pickle, or Brine of Sea Water may serve; to every Gallon of which, put 3 or 4 Handfulls of common or Bay Salt, with a Spoonful or two of Allom powderd, if you have any, and so sent them in any Pot, Bottle, Jarr, &c. close topt, Cork'd and Rosin'd.[9]

Vinegar, salt, and pepper were essential for turning dead animals into both delicious dishes and delightful curiosities.

Efforts at preserving human remains originally relied on techniques and ingredients also used in natural history and cooking. Balsaming had been practiced since Egyptian times to preserve the body of renowned statesmen by removing and destroying the viscera, and then treating the remains with a mixture of myrrh, aloe, cinnamon, and other spices.[10] With the rise of the relic industry in Catholic Europe, a new market opened for keeping in good condition the various body parts of potential saints.[11] Yet such relics performed miracles even if they

retained only an indexical relationship to the original saint, and therefore did not necessarily need to look lifelike. The visualization of internal and external structures became the goal of preservation techniques only in the early modern period. With the growing interest in anatomy, new methods were sought to offer a trustworthy representation of the living human body. Balsaming, with its removal of internal organs, would no longer do.

Visualization became an increasingly important element of studies in human anatomy from the early sixteenth century onwards. Spurred by the Renaissance editions of Ancient medical authorities, the Flemish Andreas Vesalius published his masterly *Anatomia humani corporis* in 1543. Executed by master woodcutters under the author's close supervision, this atlas offered a stunning visual survey of the human body in its hundreds of plates. Vesalius' work became hugely successful, earning him the position of imperial physician to Charles V in the process.[12] An abbreviated version for students was published in the same year, and reprints, updated editions, and pirated copies soon flooded the market.[13] The interested public could also learn about human anatomy from public dissections in anatomy theaters, which displayed the human body's workings to medical professionals, students of medicine, or any interested person who was willing to pay a modest entrance fee. The first anatomy theater was opened in Padua in the 1580s, soon followed by other such institutions throughout Europe. By the 1650s, over a dozen such theaters had been established all over the Netherlands, and the popularity of dissections is attested by the emerging genre of the anatomy lesson in Dutch and Flemish art.[14] The early seventeenth century also witnessed Harvey's discovery of the circulatory system, which revived debates about the function and the use of the heart, the arteries, and the veins.[15] By the 1650s and the 1660s, Dutch, Danish, Italian, and English anatomists actively competed with each other in figuring out how the glands, the nervous system, the brain, the liver, and the kidneys looked and worked.[16]

Anatomical preparations arrived as a new imaging technique into the bustling world of anatomical research in the 1650s. Despite his claims to the contrary, Ruysch was not the inventor of this new technique. In 1659, a certain Lodewijk de Bils came forward with a novel method of preparation. De Bils believed that bodies produced in this way would offer a novel look at human anatomy. Preservation would ensure that the same object could be used in research and teaching repeatedly for decades.[17] De Bils began the preparation process by injecting the vessels of the human body with a wax-like material that visualized the circulatory system. The cadaver could then be laid in a special bath, optionally, which protected the organs from decay. Although this method of wax injection was a

strong departure from earlier, culinary methods of preparation, its practitioners never completely shed their associations with the artisanal cultures of preservation and taxidermy.

A minor nobleman from Flanders without a proper training in medicine, de Bils was only one of the many medical entrepreneurs who thrived in the contemporary Netherlands. In such a competitive marketplace, good marketing was crucial to distinguish a medical professional from the crowds of competitors. De Bils therefore set to widely advertise his new method of preparations through printed publications. The medical world learned of de Bils' discovery from a short pamphlet, the *Kopye van zekere ampele acte van Jr. Louijs de Bils,* published in Dutch and in Latin to reach both university-trained physicians and less well-educated *curiosi*.[18] In this work, de Bils announced his plan to establish a museum of prepared cadavers in Rotterdam that would lay the foundations of a reformed anatomy. The purpose of the *Kopye* was to advertise his project and seek investors for this new project. Like the publishers of Seba's *Thesaurus,* De Bils intended to finance the preparation of cadavers by public subscription and expected to raise 20,000 pounds to cover the costs of this rather expensive process. Although the preparations were not yet made, the pamphlet nonetheless offered a detailed description of the future museum. But first, it catalogued the preparations that De Bils had already donated to the anatomical theater in Leiden, which included "dried human skin with hair, beard and eyes on the head, three human skeletons, the skeletons of an ox, a horse, a donkey, a hound, a pig, a ram, a monkey and a young child, as well as an aborted embryo, the head of a seahorse, a lion, a wolf, and the skull of a man."[19] These curious objects served as a material proof of the anatomist's expertise, and also offered evidence of the scholarly context in which he was hoping to operate. The planned museum would be even more impressive. Cadavers would be shown with "all the Veins, Arteries, Sinew and Fibres severed from one another, but remaining fast, both where they first arise, and where they end."[20] The "Liver, Lungs, and Entrals, Eyes and Brains" would be shown separately to facilitate research. Reflecting the contemporary research trends in anatomy, other exhibits would visualize Harvey's system of blood circulation, and the peculiar, semilunular shape of the valves of the veins. Anatomical preparations not only served as moralizing lessons over the power of death, they also brought forward a revolution in medical research.

The rhetorical structure of De Bils' *Kopye* was surprisingly similar to Seba's auction catalogue. It offered a small, virtual tour of the future collections to acquaint potential investors with what they were about to finance. Each specimen was described briefly, as the pamphlet's short size did not allow de Bils to offer

a full description of all exhibits that could sufficiently emphasize their scientific importance. And just as Seba's catalogue referred readers to the *Thesaurus* for more detailed descriptions of the specimens, de Bils instructed his potential investors to consult his *The true use of the Gall-bladder, etc.,* which offered an extensive, illustrated account of the exhibited veins with their valves.[21] De Bils' pamphlet thus enlisted a prior scholarly publication in the service of advertising, using it as a reference for a specimen in his future museum. Read through the lens of the *Kopye, The true use of the Gall-bladder* did not simply offer an abstract description of the generalized human body. Its referent now shifted to the future, three-dimensional specimens in Rotterdam. And, if the *Kopye* and *The true use of the Gall-bladder* did not convince potential investors to contribute, they were also invited to visit de Bils' house in Rotterdam where they could behold four prepared cadavers for the entrance fee of 2.5 guilders.

The *Kopye* was a museum catalogue of the future, and not an experimental report. It revealed what de Bils' anatomical specimens would show to visitors, but it did not offer an explanation of how these specimens were to be produced. In a period when many natural philosophers emphasized the importance of giving detailed, accurate descriptions of how a natural fact was established, de Bils refused to disclose the method by which his specimens were prepared and preserved. His reasons were commercial. He promised to reveal his secret only to those who underwrote his project. Investors above 25 guilders would receive a written description of the method of preparation, as well as an option to train with the master. The divulgation of the secret was tightly connected to the overall success of the project, however. If de Bils failed to collect 20,000 pounds in total (and he did fail), de Bils would keep his method secret and return the investors' money.

The museum would forever remain a project of the future, but de Bils made a career none the less. His museum became a topic of conversation even in England, where Samuel Hartlib and Robert Boyle had the *Kopye* translated into English. Then, in 1663, the money started flowing. The University of Louvain offered him the astronomical sum of 22,000 guilders, and a permanent position with the annual salary of 2,000 guilders, in exchange for five prepared cadavers and the secret of preparation.[22] De Bils gladly accepted the offer, arrived in Louvain, and soon after left again, allegedly because of religious disagreements. A sinecure in 's-Hertogenbosch offered financial relief, however. He was appointed as a canon, and the local illustrious school named him honorary professor of anatomy.[23] In July 1669, he advertised his first public anatomy in the *Haarlemsche Courant*, a newspaper that was published a good hundred kilometers away from the city. Had anyone taken the trouble to take a barge to Den Bosch, however,

they would have been disappointed. De Bils died soon after posting the advertisement, and the dissection did not take place. His body would not be preserved.

Despite de Bils' untimely death, anatomical preparations quickly became a vogue in Dutch scientific and gentlemanly circles. A generation of Leiden graduates, including the renowned Jan Swammerdam and Reinier de Graaf, perfected the wax injection method of preparation without having access to de Bils' secret. By the end of the seventeenth century, almost all medical doctors of quality—for example, the professors Anton Nuck and Govard Bidloo, were acquainted with one or another form of anatomical injection technique. Among the curious public, anatomical preparations were also quite fashionable and commerce flourished. In 1710, the English traveler John Farrington saw in the anatomy theatre of Groningen a 15-day-old fetus that was worth 250 guilders, as well as other anatomical preparations.[24] As we have seen, when the German traveler Uffenbach visited the cabinet of Johannes Rau, he immediately assumed that Rau was attempting to sell his preparations to him.[25] Yet Rau, Nuck, and all other anatomists paled in comparison to Frederik Ruysch. Ruysch's injection techniques were far superior to any of his contemporaries because of his own secret method that he refused to share. His commercial enterprises and advertising techniques were also better developed than those of his fellow anatomists.

THE RHETORICS OF ADVERTISING

If therefore there is any one Duke, Marquis, Earl, Viscount,
or Baron, in these his Majesty's dominions, who stands
in need of a tight, genteel dedication, and whome the
above will suit [. . .]—it is much at his service for fifty
guineas;—which I am positive is twenty guineas less than
it ought to be afforded for, by any man of genius.[26]

Ruysch was born in 1638 into a family of civil servants in The Hague.[27] He graduated in medicine from Leiden University at the relatively old age of 26, and never received an appointment at a university. From the beginning, he needed to earn his salary on the urban markets of medicine. In The Hague, he even had a brush with the local authorities because he opened a pharmacy without proper licensing. His career took off after his move to Amsterdam in 1666 where he occupied an impressive number of posts. He worked as *praelector* of the surgeons' guild, supervised the education of midwives, and was later appointed as professor of botany at the local *hortus botanicus*. His municipal responsibilities did not distract

him from research, however. His discovery of valves in the lymphatic vessels and of the structure of the bronchial artery, his description of the cortex's circulatory system, and his work on the role of the placenta in childbirth might have contributed significantly to his fame in the Republic of Letters. In his old age, several honors were bestowed upon him. He became a member of the Leopoldine Imperial Academy in 1705, was chosen as Fellow of the Royal Society in 1720, and was elected *associé étranger* to the Académie des Science to the place of Isaac Newton in 1727.[28] He died at age 92 in 1731.

Anatomical entrepreneurs like Ruysch and De Bils operated on the well-developed markets of curiosities and medical and scientific instruments of the Netherlands. In this emerging capitalist country, Ruysch and other scientific practitioners earned a living primarily through commerce, and less through patronage or sponsorship by the state. In recent years, historians have paid special attention to how patronage has been a major source of funding for early modern scientific practitioners.[29] From the late Middle Ages onwards, sovereigns and wealthy aristocrats retained scientific practitioners at their courts, to provide both symbolic justification of their rule and practical knowledge about building mills, mines, and fortifications. A court appointment offered a quick elevation of status for scientific practitioners who were able to tailor their research to the needs of a sovereign. Yet the sociopolitical structure of the Netherlands differed from countries in which patronage had been traditionally strong—for example, Italy, France, or the German princely states. As in Reformation Nuremberg and Augsburg, or in seventeenth-century London, the scientific practitioners, artisans, and artists of the highly urbanized Netherlands often focused on commercial venues to capitalize on their scientific products. With the potential exception of the members of the Orange family, the Dutch Republic did not engage in large-scale operations of patronage.[30] As Klaas van Berkel has suggested, the wealthy bourgeois of Dutch cities preferred to be seen as a *mercator sapiens,* but not as a courtly patron who would expect a scientific publication tailored to fit their persona.[31] *Mercatores sapientes* supported commercially exploitable inventions and Dutch cities provided various incentives to lure foreign artisans to the Netherlands.[32] Once these practitioners arrived in the Netherlands, they became part of a flourishing market economy and did not adjust their production to the requirements of a court.[33] As Dutch commerce operated at a global level, connecting the various corners of the world with other European countries, Dutch scientific practitioners also began to produce for an international market. Similarly to the booksellers who published Seba's *Thesaurus,* inventors, artisans, and medical entrepreneurs increasingly faced the problem of establishing a market

presence at a distance.[34] For them, science had to be universal not only because its abstract laws applied everywhere. It also had to sell everywhere.

Anatomical practitioners were also active on the domestic and long-distance medical markets of seventeenth-century Europe. Dutch anatomists could pursue various careers, and, like Ruysch, many of them held multiple positions at the same time. Social stratification was present among their ranks but commercialization affected all. Among the highest ranks were professors of medicine at the universities of Leiden, Utrecht, Harderwijk, or Franeker, who complemented their salaries with private seminars, and could also work with instrument makers to exploit some of their inventions. Ruysch never gained a university post, and worked instead as a town physician, like the majority of his contemporaries. These doctors actively sold medical knowledge and advice to city dwellers. The Delft physician Reinier de Graaf, for instance, was the inventor of an injection syringe that was marketed by the instrument maker Musschenbroeks.[35] Others doubled as apothecaries (Ruysch's initial job was in a pharmacy, too) and came in close contact with the mercantile, colonial trade of drugs. And last, some anatomists, such as Lodewijk de Bils, had no university education and few connections to guild-regulated urban medical markets. Nonetheless, some of them could gain respectable status positions during their career, and de Bils was invited to teach at illustrious schools and universities.

For market-oriented medical and scientific entrepreneurs, advertising in its various guises provided a much-needed means to reach out to potential customers at home and at a distance.[36] These advertisements often functioned similarly to publications that aimed at securing patronage for the author. Yet in publications for patronage, the text and the author's identity were usually shaped according the exigencies of one particular reader, the patron.[37] In a system of advertising, on the other hand, the intended audience was *anyone* with sufficient financial means to purchase the products on offer. Even when practitioners worked with the high nobility as their customer base, they did not customize their products for one particular aristocrat. To give an example, flower painter Rachel Ruysch, daughter of the anatomist, agreed to send a painting to Duke Johann Wilhelm of the Palatinate annually but requested to be exempt from her *Residenzpflicht,* the requirement to stay at the ducal court.[38] Jan Swammerdam, Ruysch's fellow student in Leiden, similarly rejected Cosimo III de' Medici's offer of 12,000 guilders for his collection. Cosimo stipulated that Swammerdam move to the Florentine court and convert to Catholicism, which the Dutch naturalist refused because of his deep-seated religious convictions. These scruples did not prohibit him from offering his collection for sale, however. He wrote up a catalogue in 1676 and

sent it to his Parisian friend Melchisédec Thévenot with instructions to find *any* potential buyer. At the same time, he also contacted the Royal Society about the upcoming sale.[39] Although their customers were highly ranked, Rachel Ruysch and Swammerdam refused to adapt their work and personal identity to the desires of a particular patron. Instead, they attempted to sell their products to any interested customer in Europe. And advertising offered the means to reach out to this potential clientele.

Scientific advertising could come in various formats, and it often relied on the same strategies that Seba's publishers employed. Scientific entrepreneurs exploited the widespread advertising sector of the early modern Netherlands, but also modified the meaning and form of traditional commercial advertisements. Just as any other early modern newspaper, the Dutch journal *Amsterdamsche Courant* regularly published advertisements on sales of paintings, curiosities, and occasionally, pickled, prepared animals.[40] These ads were a few lines long at most. They were printed at the edges of the news sheet, usually in smaller font than the main stories of the paper. The Ruysch family itself was involved with such advertisements. Frederik Ruysch Pool, grandson of the anatomist, had an advertisement published in the *Amsterdamsche Courant,* and sales of Rachel Ruysch's paintings were also marketed in a similar way.[41] The dissections of Ruysch were also advertised there, captivating the crowds with the claim that he also anatomized preserved cadavers that still looked fresh although they had been prepared two years earlier.[42] And after Ruysch's death, the *Amsterdamsche Courant* printed an ad on the sale of his collection as well.[43]

Dutch scientific and medical practitioners, artisans, and especially instrument makers also used other advertising tools to gain potential customers. Trade catalogues, such as those published by the Musschenbroek workshop in Leiden, could acquaint customers with the stock of their scientific instruments.[44] Unlike in the case of newspapers, advertisement was the *sole* content of trade catalogues. They reached a larger audience than local newspapers like the *Amsterdamsche Courant*. Musschenbroek's catalogues initiated contact and facilitated further discussions with customers in Marburg and St. Petersburg, although personal contacts and meetings were occasionally still crucial at later stages of the transaction. Catalogues acquainted customers with what was on offer; they could later double check the quality of the products during a personal visit.[45]

Advertising did not stop with newspaper postings and trade catalogues. Full-fledged books could be published with the intent to publicize and market the usefulness of certain scientific products and inventions. Scientific "content" and "advertising" formed an amalgam and the whole work could be interpreted both

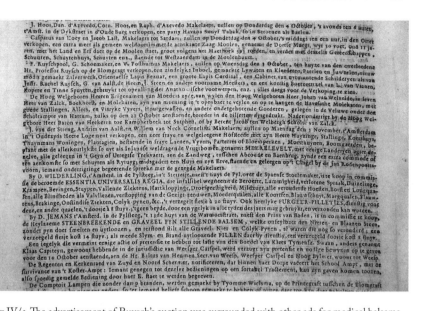

Fig IV/2. The advertisement of Ruysch's auction was surrounded with other ads for medical balsams, English toothpaste, the Dutch translation of the *Philosophical Transactions*, and the lectures of Desaguliers. *Amsterdamsche Courant*, September 25, 1731, 2.

as a scientific report and as a marketing device. The Amsterdam doctor Stephanus Blankaart, for instance, gained international fame for his *Anatomia reformata,* a standard textbook for university students. While this work significantly contributed to the wider circulation of anatomical knowledge, Blankaart also used it to advertise his own commercial enterprises. At the end of the *Anatomia reformata*, he informed readers that scientific instruments for anatomical investigations were sold at shop of instrument maker Johann Musschenbroek.[46] On the same page, Blankaart also mentioned that he would be available to give further lessons in anatomy, should anyone be interested. In his treatise on the podagra, he also claimed that, despite his many publications, he was still in possession of countless secrets that he would divulge through instruction only against payment.[47] Blankaart wore the persona of a natural philosopher in search of academic rewards, but also of a secretive medical entrepreneur in search of financial profit. His publications revealed and disseminated some of his expertise, but much of it still remained private knowledge.

The Van der Heyden family's *A Description of Fire Engines with Water Hoses and the Method of Fighting Fires now used in Amsterdam* illustrates well the rhetorics of advertising practiced in such works. The Dutch painter and inventor Jan van der Heyden and his family invented a new fire engine in the 1670s, and first

secured local support for selling these engines without the help of publications.[48] They received a patent for 25 years in 1677, and soon became the fire masters general of Amsterdam. Their entry into the world of printing, the *Description of Fire Engines*, coincided with their first attempts to sell their engines internationally. In this work, the Van der Heydens described in graphic detail the numerous fires that Amsterdam underwent in the previous fifty years. Imitating and rivaling the details of the experimental reports of Robert Boyle, they gave a minute-by-minute analysis of how each fire broke out, spread over many houses, and got extinguished. The publication emphasized that, whereas fires before the introduction of the Van der Heyden engine tended to be devastating, they were easily contained once the new invention was put to use. The reports were accompanied by a large number of illustrations that showed in gory details the destructive power of fires and how the Van der Heyden fire engines could extinguish them. After dozens of pages of narrative, though, the book ended with a one-page notice that the promised chapter 4 on the fire engines' internal mechanism would not appear in the book. The authors feared that the publication of this information would lead to the reproduction of the engines by amateurs.

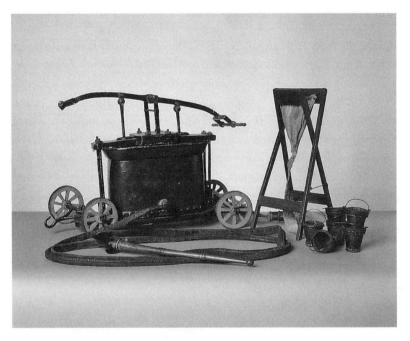

Fig. IV/3. The inventors never discussed publicly the internal workings of their engine. Van der Heyden, *Fire Engine*, c. 1700.

The replicas of the Van der Heyden engines would never equal the quality of the original machines and would lead to terrible disasters, which could only be prevented by withholding the secret of the engine.

In shaping the rhetorics of their volume, the Van der Heydens adopted and modified one of the publication strategies of early modern science that served to make spatial distance disappear. As Steven Shapin and Simon Schaffer have argued, virtual witnessing's function was to allow observers at a distance to participate and vouchsafe for the credibility of an experiment.[49] Similarly, the role of advertising was to conquer distance and allow customers to virtually visit the shop. Despite a common aim to make distance disappear, the rhetorical structures of virtual witnessing and that of long-distance advertising were quite different. Virtual witnessing aimed to create the illusion of a transparent observation of the experiment and the experimental apparatus. The inclusion of minute details served to ensure readers that they could replicate the experiment and therefore assign credit to the authors. The rhetorics of advertisements, in contrast, aimed to create a virtual spectacle in which readers watched with wonder the magnificent workings of an engine, an instrument, or an anatomical preparation, and then desired to purchase the given product from the showman. Wonder could be replicated only when the reader bought the product because the advertisements did not explain how such instruments or machines could be built. The Van der Heydens wrote detailed histories of Amsterdam fires, but did not describe the workings of their engine. Just as early modern shops started featuring shopwindows to showcase their products, the Van der Heydens allowed readers to participate in "virtual window-shopping" but excluded them from the private chambers of the workshop where engines were fabricated.[50]

The long-distance advertising effect of the rhetorics of *A Description of Fire Engines* was considerable. In 1690, the year of publication, an English MP from Staffordshire bought a Van der Heyden engine, and soon afterwards King William III also made use of the firemen's services. In 1697, czar Peter the Great visited the Van der Heyden factory, had the book translated into Russian, and ordered a number of fire engines for Russia, which he personally showed to the Dutch traveler Cornelis de Bruyn who visited Moscow in 1702.[51] The strategy of advertisement through publications ensured commissions all throughout Europe but did not breach the family's monopoly in the market of fire engines. Their trade secret remained untouched. It was probably this secretive feature of the rhetorics of advertising that made it popular with the entrepreneurial anatomists de Bils and Ruysch.

THE COMMERCE OF SPECIMENS: FREDERIK RUYSCH

As we have seen, the rhetorics of De Bils' publications were not all that different from the book of the Van der Heydens. In the *Kopye,* he offered an elaborate catalogue of objects in his future museum of anatomy in Rotterdam, and also enlisted *The true use of the Gall-bladder* in order to provide further detail. Readers could see the future fruits of their investment in advance, but they were kept in the dark about the technical details of de Bils' method of preparing cadavers. Ruysch adopted even more intricate marketing strategies during his long career as a medical entrepreneur. An analysis of his publications shows how the rhetorics of advertising could bring significant financial gains to an endeavoring, if secretive, anatomist.

Nowadays, Ruysch is mostly renowned for his artistic installations of specimens that combine skeletons, kidney stones, and dried arteries and veins in a moralizing, *vanitas* tableau. Yet in the early decades of his career, he mostly produced dry preparations for anatomical research: specimens that were injected by a wax-like material but not bathed in an alcohol-based liquid. It was only in the 1690s that his attention turned to wet specimens that were kept in bottles. Even then, most of his specimens exposed the internal structure of the human body. Artistically decorated specimens made up only 22% of his collection in 1691, and the percentage further decreased in the following decades.[52] From the beginning, Ruysch was justly proud of his preparation method, which he developed in Leiden in the company of Swammerdam and De Graaf. He claimed that, using this method, his specimens would appear "very beautiful, well-shaped, and full of lively color" and would not decay for decades or even centuries.[53] Scholars have long debated why Ruysch's specimens were more valuable than those of his contemporaries. Some have argued that it was his manual skill, his long years of experience, and his attention to detail that made all the difference. In one word, Ruysch's preparation method was an art. The anatomist himself explained his success differently, however. According to him, his preparations used a particular recipe, mixing ingredients that no other anatomist was familiar with. Anyone could produce such high-quality preparations if they came into possession of this recipe. His method of preparation was a secret, not an art.

Ruysch's exquisite and unrivalled specimens provided him with a significant income. He opened a museum dedicated to these preparations in 1671, and Swammerdam promptly reported to his correspondent in Paris that "Ruysch has founded an anatomy room and shows it for money."[54] It was this collection that

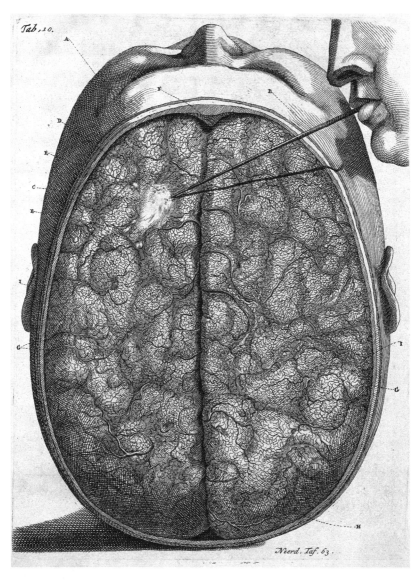

Fig. IV/4. This illustrations shows how air is blown into the brain. Ruysch must have used a similar syringe for his injections, as well. Ruysch, *Epistola anatomica, problematica nona*, Plate X.

brought Ruysch most of the attention he received throughout Europe. From the outset, it was both a scientific showcase of Ruysch's anatomical discoveries and a commercial institution. By the 1710s, the museum contained thousands of specimens.[55] Ruysch claimed that the museum was not simply a touristic attraction, it was a locus where the dead human body became alive and transparent again. Just by seeing the preparations, visitors would learn more about anatomy than through reading books or attending public dissections. The epistemological primacy of the museum was best expressed in Ruysch's motto that he repeated in his publications over and over again: *venite et videte,* come and see.

Ruysch's numerous publications always emphasized the priority of anatomical preparations over textual descriptions. They were not stand-alone books, and served only as an advertisement for the museum. To give one example, his *Observationum anatomico-chirurgiarum centuria* from the 1690s appeared together with a catalogue of his museum. The *Observationum centuria* contained a hundred particular observations of curious illnesses—for example, the case of a merchant whose heart valves became completely ossified and led to the patient's death. Actual objects in Ruysch's museum attested to the truth of the anatomist's claims, such as the merchant's preserved heart, which could be examined by those who doubted the book's claims. Pathological deformities were not only described in a publication, they could also be seen during a visit.

Fig. IV/5. An idealized illustration of Ruysch's cabinet. Ruysch, *Opera omnia anatomico-medico-chirurgica,* frontispiece.

The dissemination of knowledge about his museum soon became an obsession for Ruysch. He started publishing a series of *thesauri* in early 1700s, each of which described the contents of a particular cupboard in his museum. He also printed his correspondence with other physicians on various case studies that featured specimens in the museum. For the last three decades of his life, Ruysch kept on publishing newer and newer *thesauri,* epistles, and case studies. We can best picture these books and pamphlets as a complex network of interconnected references between his secret of injection, the exhibited cadavers, the activities he organized around the museum, and the exhibition catalogues. His published books are, figuratively speaking, *paratexts* to a particular preserved object that Ruysch studied and examined in the presence of credible witnesses.[56] Ruysch repeatedly mentioned that the truth claims of printed anatomical texts and illustrations could be taken seriously only if backed up by the actual, visual presentation of supporting material objects. Otherwise, engravings were just "fictitious figures." As he argued, he decided to preserve and exhibit his specimens "with much cost and difficulty" only to avoid the charge that his "engraved illustrations were not well-done and not after the objects themselves."[57] Ruysch's publications did not count as proper scientific proofs. Only anatomical specimens did.

Importantly, Ruysch's publications employed the rhetorics of virtual window-shopping. For some travelers, the *thesauri* might have served as preparatory reading for an upcoming tour, or they might have offered the chance of revisiting the collection after a visit. For other readers, they would have served the purposes of armchair tourism. Priced cheaply at less than half a guilder, each *thesaurus* described and depicted one cabinet in Ruysch's museum in painstaking detail. The different objects within the cabinet were enumerated in the strict order they were found on the different shelves. Scientific information was provided in the same manner as a conscientious visitor would have jotted down the remarks of a tour guide. Marked with a clear *Nota Bene* sign, Ruysch ensured readers realized the primary scientific importance of each particular object. Once a reader has read all the *thesauri,* he has also performed a virtual tour of the whole museum, although female readers had to cut short their visit at certain moments. The Dutch version replaced the text with asterisks where the Latin revealed how the male reproductive organs worked.[58]

Twenty-first-century museum visitors rarely get to see the conservation lab. Similarly, the virtual tours of Ruysch's museum conveniently skipped over how the anatomist prepared his specimens. He hoped to convince his public that one could determine the quality of a specimen simply by looking at it, and not by examining how they were made. In the early 1700s, Johannes Gaubius (uncle to

the Leiden professor Hieronymus Gaubius) asked Ruysch in a published letter about his method of preparing the scrotum so that its inner structure could be seen so perfectly. This was not an innocent question. As Uffenbach recounted, Ruysch and Rau engaged in this period in a heated debate over the existence of the scrotal septum, and whether one could visualize this organ with preparations. Yet, despite the attack on the value of preparations, Ruysch was reluctant to discuss his secret. As he wrote, he was afraid that others would have claimed to have invented the same secret once it became known. He sent Gaubius "an accurate illustration of the arteries in the frontal part of the scrotum" instead, which he hoped would convince those who disagreed.[59] Unwilling to part with the *method* of production, Ruysch disseminated images of the prepared specimens, whose aesthetic perfection was to guarantee his truth claims. And to aid the visual interpretation of these specimens, he even offered nine criteria for judging their quality. For instance, the preparations had to retain their lifelike color and shape, no artificial wrinkles could appear on the skin, and the lymphatic vessels had to be clearly visible. Eminently, only Ruysch's preparations fulfilled these requirements, but no one was told why.[60] While many natural philosophers of the period preferred to present their experimental reports in the form of virtual witnessing, he circulated only illustrations of the end results of his work: the specimens on show in his museum.

The rhetorics of advertising worked well, and visitors flocked to see Ruysch's specimens. An abbreviated version of his exhibition catalogue was even reprinted in Michael Bernhard Valentini's *Musaeum musaeorum*, an early travel guide for scholarly tourists.[61] Uffenbach consulted the *Musaeum musaeorum* several times during his travels in the Netherlands and England, and one may well imagine that his reason to visit Ruysch's museum was because he learnt about it from Valentini. Apart from providing publicity for the museum, Ruysch's *thesauri* also served as an advertisement for the collection on sale. *Thesaurus X* was subtitled *Thesaurus magnus et regius,* suggesting that this cupboard of specimens would be especially appropriate for a princely purchase. Ruysch achieved his aim soon as the Russian czar Peter the Great quickly made moves to purchase this cabinet for the sum of 2,000 guilders, only to later extend his offer to Ruysch's whole collection.[62] And when Ruysch's heirs sold his museum at a postmortem auction, they relied on the last two *thesauri* (published shortly before the author's death) to prepare for the auction. The line was thin between exhibition catalogue and sales catalogue.

The *Thesauri* also promoted Ruysch's other commercial activities. One of the

exhibition catalogues, *Thesaurus IV,* contained an ingenious idea how to turn the method of preservation into a lucrative business. In a discussion over hearts embalmed according to his method, which ensured that they "could be preserved for hundreds of years, with lively colors and a very pleasant odor, without any corruption," Ruysch recalled that Englishmen often preserved a lock of hair of their deceased lovers in a ring.[63] He suggested that as a similar act of memory, the heart of a dead lover could also be embalmed and kept in a silver or golden box, which would ensure the eternal memory of the beloved and "the flourishing of our art."[64] While I am not aware of any lover's heart thus preserved, I strongly suspect that the heart of Nicolas Bourgeois, giant to the Russian czar Peter the Great, was embalmed upon the czar's order according to Ruysch's method.[65] Ruysch also preserved whole bodies upon request, and received high honors from the Dutch government when he successfully embalmed the body of the English admiral Berkeley.[66]

Private lessons to medical students were Ruysch's major source of regular income, and his *Thesauri* did not fail to advertise these lecture series, either. *Thesaurus VI* announced a daily course of lectures in 1705. Lectures were held every day at noon and lasted for an hour or an hour and a half. It took four or five weeks to cover the human body. The rest of the course was devoted to the analysis of fish, shells, birds, and many other rarities.[67] During these lectures, Ruysch offered a short discourse on each specimen and ensured that his teachings became deeply imprinted onto the mind of the students. In 1715, an eight-week course cost roughly 15 guilders per person and eight students were subscribed, mostly Englishmen. Johannes Rau, Ruysch's competitor and opponent, asked his three students for 50 guilders for a lecture series of two months.[68]

RUYSCH'S FINANCIAL GAINS

We tend to judge a scientific practitioner's success by the scholarly approval of his peers and by the honors scientific societies bestow upon him. Ruysch was clearly much esteemed by many of his contemporaries, as his memberships in the various scientific societies of Europe attest. Yet, in the case of this entrepreneurial anatomist, his financial gains might offer an alternative, and equally useful, estimate to judge his career.

One can get a pretty accurate picture of Ruysch's cumulative income from his preparation-related activities. We do not know how much he charged for the entrance to his museum, and one doubts whether his idea to embalm the hearts

of deceased lovers ever captured the attention of customers. Yet, as we have seen, his private lessons of anatomy were lucrative. If Ruysch's students paid around 120 guilders for an 8-week course in total, this amount in itself was comparable to the official salary of a young university professor at an annual level, although somewhat less than Ruysch's own professorial salary in Amsterdam. If more students subscribed on average, Ruysch could have earned the equivalent of star university professors just from his regular, private courses of anatomy.

But the preparations were not just educational tools. They were expensive commodities that one could sell at a profit. In the early 1700s, Ruysch almost sold his collection to Emperor Leopold for the impressive sum of 20,000 guilders, or so he claimed, had it not been for the emperor's untimely death. He was luckier in the mid-1710s when czar Peter the Great arrived in Amsterdam for a second visit. Thanks to the groundbreaking research of Jozien Driessen-van het Reve, we can now reconstruct in great detail how the czar and the anatomist did business with each other.[69]

The Russian czar was not your typical courtly patron. During his first visit to the Netherlands in 1697, he despised courtly mannerisms and almost fainted when he had to go through the elaborate ceremonies that the States of Holland organized for his reception in The Hague.[70] Instead of acting as a patron of scientific entrepreneurs, he behaved like a commercial customer with a bottomless purse. In Amsterdam, he visited Ruysch's museum and called Ruysch his own teacher. And, as a contemporary engraving reveals, when Peter visited the numismatic collection of the Dutch regent Jacob de Wilde, both of them sat down by the same table to discuss the coins. The artist, de Wilde's wife herself, decided to maintain the illusion of equality between collector and visitor, and did not highlight the difference between their status in the social hierarchies of patronage. Peter approved of the image and thanked de Wilde's wife for it.[71]

Peter's second visit to Amsterdam was preceded by a flurry of negotiations between Dutch entrepreneurs and the Russian court. Long-distance marketing strategies, including the use of sales catalogues, helped the Dutch raise the czar's interest before he left St. Petersburg. Albertus Seba, who had supplied the Russian court with pharmaceuticals, alerted Peter years in advance of his trip that one could easily buy a few cabinets of curiosities in Amsterdam.[72] As we have seen in the previous chapter, the czar actually purchased Seba's own collection of *naturalia* (345 specimens in total) before leaving Russia, although the two parties fought over the sales price for years.[73] Seba was also responsible for signaling to the court Ruysch's interest in selling his collections. To offer a sample of the collection, he bought a few items from Ruysch and sent them over so that the

czar could decide about the purchase.[74] Later that year, when Peter came to Amsterdam again, he visited Ruysch's museum again, and, a short time later, the Russian court decided to buy the whole collection.

Ruysch treated Peter like a customer. In his letters to St. Petersburg, he stressed his personal relationship with Peter from 1697, but only to show his own importance to Peter's agents, and not to tailor his offer to the desires of the czar.[75] Ruysch offered his collection for a meager 30,000 guilders, a very cheap deal in his opinion. Yet this price was clearly profitable to him. He had easy access to human cadavers through his municipal responsibilities. Although wax and the alcohol-based liquid of preparation might have been more costly, a comparative price analysis of Dutch anatomical preparations will reveal in the next chapter that Ruysch's specimens were more expensive than any of his competitors. Since the material costs were comparable, Ruysch's work and secret recipe clearly multiplied the value of his specimens.

Peter did not buy only specimens. Ruysch also put on sale his secret of preparation, which "only he knew," for the additional price of 5,000 guilders.[76] This was not negotiable. If the czar found the price too high, Ruysch suggested that he could go and ask someone else for an alternative, cheaper, and probably useless preparation method.[77] The Russians agreed and paid. No wonder then, that Ruysch would not reveal his secret to Gaubius, and the rest of the literate world. Like the specimens, the preparation method was also a commodity, and a rather expensive one at that. The entrepreneurial anatomist strongly believed in intellectual property, and asked a hefty price for sharing it with others. And even 5,000 guilders did not suffice to make the secret entirely public. The contract specified that neither party would discuss the secret of preparation with anyone else.[78]

Ruysch's decision to consider his preparation method a secret recipe clearly paid off. Had he considered his preparation method an embodied, artful skill, gained through years of experience, he would not have been able to write it down on a piece of paper that he could sell to the czar. He would have had to travel to St. Petersburg, and spend years in training his apprentices. By reducing his preparation method to a recipe, on the other hand, he could sell it much more easily, exchanging a brief document for an astronomical sum. Ironically, Ruysch was probably mistaken in downplaying the role of experience in preparing specimens. When his secret recipe was leaked to the learned world in 1735, three years after his passing, the resulting preparations paled in comparison with Ruysch's original specimens. The published text did not help enough those who wanted to replicate Ruysch's experiments. Ruysch was an artist, after all, and his monopoly remained with him even after his own death.

After his sale of the collection, life went on for the octogenarian anatomist. He was soon busy assembling a new collection and published other *thesauri* to advertise them all around the world. By the early 1730s, his second museum had grown bigger than the first collection, and Ruysch was ready to sell again. In arranging the sale, the aged anatomist again emphasized that he was not seeking the patronage of any particular prince. Wealthy customers were welcome from all corners of the world. When authorizing his son-in-law to act as his agent, Ruysch told him to sell the cabinets to "whoever it be at the court of His Majesty of Great Britain, at the Royal Society of London, or any other particulars who had desires for it."[79] Price was the only barrier. Ruysch's son-in-law could not sell for less than 22,000 guilders, excluding transportation costs. Conveniently, Ruysch had two printed catalogues available for the sale (probably *Thesauri XI* and *XII*), and a manuscript catalogue listed the latest specimens. Print culture was still ancillary to the market of curiosities. But then Ruysch died before any sale could be perfected, and was buried in the Nieuwe Kerk. His heart was not preserved, and the collection soon dispersed. The heirs organized an auction that they advertised with the help of the printed catalogues.

PRINTING AND OPENNESS

When Seba's heirs printed the sales catalogue of the late naturalist's collection, Ruysch was still a household name in the world of curiosities. His specimens were in circulation (and many of them still survive in Saint Petersburg today). His preparation method was unsurpassed, and his name became a synonym with good specimens. The Amsterdam anatomist Abraham van Limburg, for instance, advertised his own anatomical specimens by stressing that they "emulated the preparations of Ruysch." Clearly, it would have been foolish to omit Ruysch's name from Seba's catalogue. By naming the deceased anatomist, the heirs also commemorated the friendship of Seba and Ruysch, the two scientific entrepreneurs who conquered together the Russian markets for curiosities.

From sales catalogues to printed correspondences, this chapter has traced how Dutch scientific entrepreneurs shaped their publications in order to market their curiosities, cabinets, and associated instructional technologies to an international clientele.[80] Throughout their career, Ruysch and de Bils published pamphlets, collection catalogues, scientific articles, and books. These works praised the epistemological value of preparations, and also acquainted the public with the author's latest discoveries in anatomy. At the same time, Ruysch and de Bils did not use these publications to disclose their method of production, and worked

hard to ensure that other anatomists could not replicate their discoveries nor make similar anatomical preparations on their own. While the dissemination of their discoveries could help establish the scientific credit of these anatomists, the nondisclosure of their working methods also allowed them to monopolize the scientific and curiosity markets. Printed texts alerted customers that the preparations and corresponding technologies were available for sale from the author.

Ruysch and de Bils operated in a period that arguably saw the emergence of the public sphere.[81] For historians of science, the development of the public sphere refers not only to the disinterested political discussion of male bourgeois citizens, but also to the free conversation and increasingly open flows of knowledge between natural philosophers across Europe, manifest in the burgeoning of scientific journals, societies, and academies. At least since Robert Merton, many scholars have argued that the institutions and communication networks of seventeenth- and eighteenth-century science appear to have favored the free disclosure of scientific facts and experimentation techniques.[82] Recent historical work has provided an elaborate analysis of this Republic of Letters, which underlined that, despite its rhetorical flourishes, it was a reward-oriented, hierarchical sociocommercial system that offered tangible material benefits and social credit to its members.[83] Some have gone as far as to call this system an open market for academic knowledge, with a clear emphasis on the exchange of private information for public rewards.[84] Another major system of reward was the courtly system of patronage, which also pressed scientific practitioners towards openness and publications.[85] The dedication of a scientific text resulted in financial remuneration and potential appointment at the patron's court.

From the analyses of the Republic of Letters through recent work on patronage, this historiography sometimes presumes a simplified correlation between publication and openness. After all, the model of exchanging social and material rewards for publications works properly only if publications are the source of open, useful knowledge for the scholarly community. In the framework of this exchange system, the invention of printing, the growing number of journals, and the increase of scientific books might be too easily identified as vehicles for the transmission of knowledge. In some cases, insufficient attention can be paid to claims that early modern printing was in fact quite unstable and did not result in fixed, easily accessible knowledge, or that at least some sorts of scientific knowledge are inherently connected to bodily practices and can be transmitted through print only to a limited extent.[86]

In this chapter, a third alternative was proposed as to why printed works might not necessarily promote the open exchange of knowledge. Advertising is a genre

where much ink is spilled in order to create public awareness of certain products or activities without the dissemination of the scientific and technological know-how involved in the production process. If, in a metaphorical and sometimes even concrete sense, advertising was one of the functions of Ruysch's and De Bils' scientific publications, then these publications were not exclusively or necessarily intended to openly disseminate knowledge. The anatomical discoveries described in these works served only to underline the usefulness and scientific promise of anatomical preparations. These publications provided limited openness at best, and were counterbalanced by the lack of information on the anatomists' methods of producing these discoveries. Philosophical claims about human anatomy could be discussed openly, but one had to remain silent about experimental technique and research methods. While even such limited openness resulted in significant social recognition in the Republic of Letters, Ruysch's and De Bils' publications were not simply part of an exchange system of rewards for public knowledge. They rather facilitated the commodification of anatomical preparations. Like Martin Lister's and Filippo Buonanni's encyclopedias, the printed works of Ruysch and de Bils became tools for the commerce of curiosities.

In 1717, when Ruysch sold his collection to Peter the Great, Albertus Seba and the Russian physician Laurentius Blumentrost were responsible for examining, packing, and transporting the anatomical preparations to Saint Petersburg. On several occasions, Seba and Blumentrost went to Ruysch's house with their helpers, but could not find anybody at home. The building was closed and they could not inspect the anatomy preparations. In an official letter of complaint, they requested that Ruysch hand over the keys and allow them to finally have a look at the objects that the czar bought. A notarial act made Ruysch cooperate and finally open his doors.[87] But even today, it remains unclear whether Seba managed to pack all the preparations, or whether some of them stayed in Ruysch's possession. The scene of Seba and Blumentrost standing in front of the door to Ruysch's house provides an appropriate coda for this chapter. Scientific practitioners in the Netherlands, and probably elsewhere as well, operated at the borders of public and private science. They were gatekeepers who opened their doors only against a fee. The doors of science opened when it served the interests of scientific practitioners, but only to a select number of customers. For the general reading public of the early modern Republic of Letters, the secrets of science remained firmly under lock. The publications of Ruysch and de Bils allowed readers and customers to visit the authors' museums, and to do their shopping from a distance, but did not permit them to enter the laboratory spaces themselves.

COMMERCIAL EPISTEMOLOGIES

THE ANATOMICAL DEBATES OF
FREDERIK RUYSCH AND GOVARD BIDLOO

The year 1713 was sad for Hendrickje Dircksz. Her husband, the Leiden anatomy professor Govard Bidloo, died on April 20, and she had to devote the rest of the year to consolidating the household's finances. Her late husband's library and museum had to go, and she asked the publisher Samuel Luchtmans to organize a public auction for the last days of October. The books were sold on the 23rd, the 24th and the 25th, and brought in almost three thousand guilders.[1] On the afternoon of the 25th, the museum was also sold with its 131 anatomical preparations, for the much less impressive sum of 177 guilders. While Bidloo's books would have provided Hendrickje with enough money to manage for a couple of years, had she not had other assets (and a well-to-do son), she would probably have spent the 177 guilders by the end of the winter.

If one compares this income with the price of Ruysch's cabinets, the shock is inevitable. Bidloo's specimens are outright cheap. As we have seen in the previous chapter, Peter the Great spent more than 30,000 guilders on Ruysch's preparations just three years after Bidloo's death, an amount equivalent to the price of several elegant houses on one of the more fashionable canals of Amsterdam.[2] While we might be shocked about the contrast between the sales prices, contemporaries would not have been so surprised. While Ruysch's fame rested on his anatomical specimens, Bidloo decided to launch his career by publishing the *Anatomia humani corporis,* arguably the most impressively illustrated anatomical atlas since Vesalius. These two anatomists despised each other, and spent the

Fig. V/1. The inscription compares Bidloo to Vesalius. Abraham Blooteling, *Govard Bidloo*, 1685.

better half of the 1690s on a bitter pamphlet war on the role of preparations and atlases in anatomical research. Ruysch claimed that his anatomical preparations offered a faithful representation of the body, while paper representations could never be trusted. Bidloo countered that the specimens offered deceptive evidence, and atlases were better equipped to visualize anatomical structures. No wonder

then that Bidloo's preparations did not fetch a high prize: he set his epistemological and financial stakes on atlases. For him, printed works did not necessarily function as tools for managing the exchange of curiosities. His *Anatomia humani corporis* became a valuable commodity with scientific import.

This chapter analyzes the respective roles of preparations and atlases in anatomical research through the debates and working practices of these two Dutch anatomists. In their struggles to depict living organisms with the evidence of dead specimens, they hit on philosophically novel concepts of objectivity. Their debates thus echo historical controversies over methods of visualizing the body—for example, the pre-Galenic arguments between the rationalists' reliance on (animal) cadavers and the empiricists' emphasis on wound observation, or recent debates on the comparative advantages of fMRI and PET scans.[3] Yet the significance of Bidloo's and Ruysch's research went beyond the realm of philosophy, and also had direct relevance for the material value of anatomical specimens. Their pamphlet war played out in early modern capitalist Netherlands, where visual representations were busily traded commodities. The problem of the representation of the human body therefore became linked to the question of what imaging techniques could produce valuable commodities. For anatomical preparations, price and epistemological status went hand in hand.

ANATOMICAL PREPARATIONS AS TRANSPARENT REPRESENTATION

Anatomy and first-hand observation do not go well together. The human eye cannot see the internal structures of the living human body, hidden behind the skin. Refraining from the vivisection of humans, early modern anatomists needed to consider various other options to peek into the body of humans. The observation of animals was one solution. Vivisected beasts offered comparative evidence about the living human body, and, as William Harvey pointed out, one could even see the beating of the heart in shrimp without making an incision because the minuscule animal's skin was transparent.[4] Yet such model animals did not exactly mirror human anatomy, and ever since Vesalius, medical professionals routinely condemned research done exclusively on animals because it gave only partial evidence about how humans looked. While the *rete mirabile*, a branching of the carotid arteries, was clearly visible in sheep, its existence in humans was up for significant debate.[5]

Human cadavers could stand in for the living human body much better than animals, and they were the preferred method for examining the secrets of life

and disease. In the Netherlands, medical doctors and their students regularly attended dissections. From its foundation, Leiden University regularly requested suitable cadavers from state authorities to hold anatomy lessons.[6] Within the guild system, apprentice surgeons and midwives also relied on practical anatomy to acquaint themselves with the human body's structures. The larger public could benefit from public dissections in the anatomy theaters of various Dutch cities, which were advertised in newspapers and commemorated in paintings and ivory sculpture. Despite their popularity, public anatomy lessons often had a limited role in education and research. Because the performance was frequently geared towards the entertainment of authorities and paying visitors, students could not discuss controversial issues at length. They were also seated at a considerable distance from the dissecting table, behind the rows of professors and municipal officials. Rowdiness only exacerbated the situation, and strict rules needed to be established to regulate the audience's behavior. The finer details of the human body remained hidden from the public view.

While one could take a better look at cadavers in a private dissection, performed in a hospital or at one's own lodgings, even these investigations could not bring conclusive evidence about the nature of the human body. As Ruysch claimed, once the blood and other bodily fluids seeped out of the body, the delicate vessels that carried them collapsed, and it was impossible to observe how they circulated all the liquids that were necessary to nourish the body. This was a tremendous hindrance because, as Ruysch argued, vessels were the basic building blocks of the whole organism, carrying blood, lymph, milk, sperm, tears, sweat, and the various other excretions of glands. All organs could be reduced to these vessels; the human body was nothing but an assembly of various circulatory systems. Once the fluids in them were gone and the vessels collapsed, the cadaver held precious little information for the anatomist.

Anatomical preparations circumvented precisely this shortcoming of human cadavers, as Ruysch was happy to point out to everyone. Wax injection could preserve the shape and position of all the body's vessels in their natural state, serving as a substitute for the missing blood and lymph. And if vessels were the only building blocks of human anatomy, this meant that wax could faithfully capture the entire structure of the body. While Ruysch's theory was controversial, it had more appeal than one would expect in the aftermath of Harvey's discovery of blood circulation. To give only one example, many physicians agreed that the nerves were also hollow vessels, which carried the liquid *spiritus* that connected body and mind.[7]

Anatomical specimens also had practical advantages over other methods of

observation. Because they did not decay, the number of preparations in circulation was also expected to steadily increase. This was no small advantage in an era when cadavers were hard to come by. While the Leiden anatomy theater remained unused for years because of the lack of available bodies, Ruysch's museum contained thousands of specimens. Ruysch also considered wax-injected preparations superior to other methods of investigation because they could bear solid evidence about the human body. Unlike fresh cadavers, they could be examined repeatedly, an increasingly useful feature in an era when the replication of experiments became a norm of scientific research. Without preparation, a human cadaver decomposed within days, and one needed to trust the experimenting anatomist and his witnesses about the veracity of their observations. Moreover, dissections could only be communicated in paper reports and represented in engraved illustrations. Guided by the imagination, anatomists could always embellish the narrative of their experiments, and the engraver's hand was prone to introducing fictitious elements into paper representations. Scientific texts and illustrations, on their own, had no guarantee that they were truthful; one needed to trust the makers of these reports. The belief in the evidence of dissected cadavers was a social act.

Not so for anatomical preparations. To rephrase Ruysch's words in modern terminology, wax injection was an auto-inscription technology that worked according to notions of mechanical objectivity. The historians Lorraine Daston and Peter Galison have argued that nineteenth-century scientists embraced the medium of photography because it offered them the promise of representing nature without the judgmental intervention of a scientist.[8] Mechanically produced, photography could not lie (until the intervention of Photoshopping), or so hoped the scientists who relied on it. Led by the body's own vessels, wax-injected preparations were similarly trustworthy, because they were not made by human hands. They were auto-icons, representations of themselves in their live forms. As the previous chapter has shown, Ruysch's published works relied precisely on this form of objectivity.[9] They discussed anatomical discoveries made with the help of wax injection, and were always supported by the evidence of a prepared specimen. If critics disagreed with these claims, Ruysch invited them to visit his museum where the specimen was exhibited. Available for public viewing, the preparations could serve as the ultimate arbiter for bringing a controversy to closure, a clear advantage over corpses that decayed.

For Ruysch, therefore, wax-injected specimens were medical wonders that restored life to the human body, and not only objects for moral reflection on inevitable death. As wax replaced blood in the circulatory system, the cadaver's

collapsed organs were restored to their natural state of life. Ruyschian prepa-
rations vanquished the power of death and they even looked beautiful.[10] The
wrinkled skin of a dead person became smooth again, the red tint of the wax
restored rosiness to the cheeks of the wizened head, and, bottled in alcohol,
the cadavers emitted no strong smell of putrefaction. As Ruysch recounted on
countless occasions, when Peter the Great visited his cabinet, and was shown the
body of a young girl, the czar thought that she was only asleep and kissed her.[11]
The Amsterdam anatomist was so enamored of his own preparations that his
printed *oeuvre* became a *paean* to the art of preparation. A malicious contempo-
rary, potentially Govard Bidloo, took the pains to count how often Ruysch used
the word *mirum* [wonder] and its cognates in his relatively brief *Epistolae* and
Observationum centuriae: they appeared 96 times in the text.[12]

PROBLEMS WITH WAX-INJECTION:
JOHANNES RAU AND HERMANN BOERHAAVE

Despite the fame and material value of Ruysch's specimens, the medical profes-
sion remained divided about the theoretical underpinnings of the art of prepa-
ration. Taking up the vacated chair of Bidloo at Leiden University in 1713, the
lithotomist Johannes Rau gave an inaugural lecture that offered only a moder-
ate endorsement of Ruyschian preparations. Discussing the best methods for
learning anatomy, Rau urged students to read the texts of the Ancients and the
Moderns frequently, attend the lectures of the professors, and participate in pri-
vate dissections.[13] Anatomical preparations were supposed to play only a second-
ary role to these activities. They could offer some guidance in research, but the
method of wax-injection unfortunately also distorted the structures of the hu-
man body. As wax filled the veins and the arteries, it distended the walls of these
vessels beyond their normal state and made them appear bigger than in reality.
No longer transparent, preparations offered only an approximate representation
of the human body.

Rau's reserved attitude towards Ruyschian preparations was shared by his col-
leagues. In a letter published in the early 1720s, his Leiden colleague Hermann
Boerhaave repeated the claim that preparations enlarged the circulatory system.
When wax was injected into the liver's portal artery, the vessel expanded to the
extent that the neighboring anatomical structures were suppressed. This short-
coming was decisive for Boerhaave. On the basis of theoretical arguments, he
had already surmised the existence of glands in the human body, where bodily
fluids were mixed and separated like chemical substances in a retort. It was nec-

essary that such structures should exist. Otherwise, the blood would circulate in the body without undergoing any modification in its composition. Since wax injection potentially suppressed these glands and only visualized the circulatory system, its anatomical use was heavily limited.[14]

While recent studies have emphasized the theoretical underpinnings of Boerhaave's criticism, it is important to note that the concept of visual evidence was also under debate.[15] The existence of glands simply could not be detected with the Ruyschian preparation technique. Boerhaave instead suggested an alternative technology, recently dubbed by Domenico Bertoloni Meli as the *microscope of disease*.[16] Originally invented by Malpighi, this method exploited the fact that certain illnesses caused the glands to grow into an abnormally large tumor. These tumors magnified the shape and structure of healthy glands so that they became visible to the human eye. Unlike preparations, the *microscope of disease* confirmed Boerhaave's claims. Yet Boerhaave's reliance on disease to draw conclusions about the healthy body could also be contested, as Ruysch bitterly retorted. Instead of trusting the auto-inscription of preparations, Boerhaave mistakenly used reason to theorize and diseased tumors to visualize the glands.[17]

PAPER EPISTEMOLOGIES: THE DEBATE BETWEEN BIDLOO AND RUYSCH

Throughout his career, Ruysch's most vociferous opponent was the anatomist and playwright Govard Bidloo, born in 1649. As a surgeon apprentice in Amsterdam in the 1670s, he became acquainted with the higher echelons of society. He was briefly associated with *Nil volentibus arduum*, a literary society that aimed at modernizing Dutch culture with the precepts of French classicism, and became a medical doctor in 1682. While Ruysch established his career with a museum of anatomical specimens, Bidloo put his stakes on books.[18] He published a Dutch translation of Corneille's *Pompée* in 1684, ridiculed the rigid classicism of the *Nil* in 1685 in a satirical pamphlet, and wrote the libretto for *Ceres, Venus and Bacchus*, the first Dutch opera, in 1686.[19] His monumental *Anatomia humani corporis* came out in 1685, cementing his fame as a medical professional. This atlas contained over a hundred folio engravings on human anatomy, designed by Gérard de Lairesse, the most-praised classicist painter of the period. Thanks to these publications, Bidloo became a client of Prince William of Orange, soon to become William III of England. After serving in a variety of positions, he was appointed professor at Leiden University at the instigation of the king in 1694. William later also hired him as a personal physician, and he had the dubious honor of

Fig. V/2. Note how the putti hold up a print as if it had been nature printed from the dissected arm below. Bidloo, *Ontleding des menschelyken lichaams*, title page. The original Latin edition sports the same title page.

assisting to the king's fatal illness in England. Left without a patron, Bidloo returned to Leiden where he taught until his death in 1713.

Bidloo flourished in the world of publishing. He authored luxuriously illustrated atlases, engaged in multiple pamphlet wars with his enemies, fought vehemently against his plagiarizers, and eagerly protected his copyright. When William died in 1702, for instance, Bidloo offered a detailed account of the king's last days and defended his own actions in a brief pamphlet that became one of the earliest examples of celebrity death news.[20] He was also instrumental in publicizing major events during the king's life. The king was treated to a triumphal entry in The Hague in 1691, when he returned to the Netherlands after the Glorious Revolution. Bidloo quickly capitalized on this event by publishing an illustrated account of it together with the eminent engraver Romeyn de Hooghe.[21] He secured an exclusive privilege for his *Komste van zyne Majesteit Willem III in Holland* just three days after William's entry to The Hague, and, when Barent Beek prepared an alternative publication of the triumphal entry, Bidloo successfully petitioned for an injunction against him, delaying Beek's time-sensitive publication by six months.

Turning first-hand observation into print was the shared aim of both the *Komste* and the *Anatomia humani corporis*. As Bidloo explained in the introduction of his account of the triumphal entry, historians' accounts were usually untrustworthy because they could not rely on their own experiences or on trustworthy "ear- and eye-witnesses."[22] Fortunately, the *Komste* was an exception from this general, and reprehensible trend, as Bidloo himself was present during the day's events, and also had access to the original designs of the triumphal entry. These personal experiences granted the *Komste* a superior status when compared to other accounts. Not that first-hand observations necessarily resulted in straightforward representations on paper. While the king and the regents of The Hague officially met on the Westenderbrug, for example, Bidloo's engraver situated these figures in front of the bridge to make the composition clearer and better.[23]

The *Anatomia humani corporis* opened with a similar emphasis on Bidloo's expertise in committing first-hand observation to print, stating that "the truths of anatomy are discovered only through *autopsia*." Bidloo proudly claimed to have dissected over 200 cadavers while preparing the book. It was not that Bidloo was not familiar with the art of preparation, or that he was unaware of the shortcomings of relying on dead cadavers to make a judgment about the living body. His decision to commit his dissections to print was based on a complex epistemology of paper representation. Three distinct arguments supported the superiority of atlases over specimens. While preparations were frozen in time, sequential

Fig. V/3. The city magistrates met the King on the bridge, and not in front of it. Bidloo, *Komste van zijne Majesteit Willem III.*

images could represent on paper the changing shape of an active, living organ. Paper also offered the possibility to juxtapose and compare representations produced with various observation techniques—for example, microscopy or even wax-injection. Third, engraved images had a higher resolution than anatomical specimens. They could visualize microanatomical structures that not even microscopes could detect.

We are in a privileged position to scrutinize Bidloo's paper epistemology and contrast it with Ruysch's preference for preparations. The two anatomists spent the better part of the 1690s dissecting each other's discoveries. In the early 1690s, Ruysch printed a part of his extensive correspondence with other anatomists. These essays on the internal structure of the spleen, on the branching of the aorta, or on the *arachneal mater* often criticized the plates in the *Anatomia humani corporis*. Bidloo did not take these charges lightly and responded in a pamphlet titled *Vindiciae quarundam delineationum anatomicarum contra ineptas animadversiones Fred. Ruyschii.* The counter-response came almost immediately. The *Responsi ad Godefridi Bidloi libellum* argued that the *Vindiciae* had misrepresented Ruysch's original criticism of the *Anatomia humani corporis*.[24]

Some of Bidloo's arguments foreshadowed the ideas of Rau and Boerhaave. Like the other Leiden professors, Bidloo also found it problematic that

Ruyschian preparations looked alive. Cadavers were dead and no art could bring them back to life. Although colored wax could make the cheeks of humans rosy again, the underlying structures were corrupted beyond repair. The reason for this should by now be familiar: injected cinnabar, scarlet, and ceruse made blood vessels appear larger than life. The *mimesis* of preparations was no scientific proof but only a "meretricious art" to entertain the masses.[25]

Yet the criticism of the *Vindiciae* went beyond standard quibbles over distending the vascular system. At stake was the tangled representational relationship between cadavers and animate organisms. For Bidloo, no simple correspondence could be established between the two because the organs of the living body were in motion. External and internal pressure constantly changed the shape of the heart, the lungs, and the skin. Since anatomical preparations, in contrast, were static and rigid, they could not represent temporal change. The preservation of the heart was especially problematic in this respect. In life, the four chambers regularly contract in a well-determined rhythm. Wax injections, on the other hand, filled, distended, and froze the chambers in the state of diastole. The function of the heart was rendered incomprehensible through the art of preparations. Observers would not be able to understand the principles of the circulation system.

The rigidity of anatomical preparations was both a philosophical and a physiological problem for Bidloo, who considered variety and change key constituents of human nature. In 1685, the same year the *Anatomia humani corporis* appeared, he ridiculed the *Nil volentibus arduum* because of its adherence to the artificial and rigid rules of Francophile playwrights. His satire pleaded for a more relaxed interpretation of the rules of poetics. Similarly, if a preparation was preserved and kept in the same shape for centuries, it could not properly mirror the changing world of life. In this respect, Bidloo concurred with the French classicist art theorist André Félibien, who claimed that wax death masks could not represent the beauty of a person, despite their apparent faithfulness to nature.[26] Frozen at a determined point in time, they showed the face devoid of movement. One needed an artist's hand to bring life back to the motionless, dead body.

The *Vindiciae* consequently charged Ruysch of too rigid an understanding of the shape of papillary glands in the human skin. Bidloo had originally claimed that these glands looked like a cone, or, in his own terms, had "the shape of a pyramid with a round base." When Ruysch disagreed, Bidloo misread his opponent's argument and came to believe that their disagreement hinged on the definition of *pyramidal*. According to him, Ruysch understood *pyramidal* in a strictly mathematical sense and expected the glands to conform exactly to this

well-defined shape. Ruyschian representations of the glands' openings at the cone's base (their *foramina*) created the impression that these glands were rigid, inflexible, and immobile, or, in Bidloo's words: "just like marble."

As for himself, Bidloo wrote that "it was never my opinion that these nervous-glandlike organs were mathematically pyramidal, but only comparatively."[27] The varied shapes of the papillary glands more or less approximated the shape of a cone. Nonetheless, each gland and its opening had a slightly different form that could also change in time as a result of motion, disposition, external pressure, and flaccidity. Consequently, Bidloo preferred to depict a large number of papillary glands next to each other in a highly particularistic manner so as to show variability. Image *No. VI* in *Fig. V/4* could be interpreted as a particularistic representation of neighboring glands whose shapes were all subtly different. Image *No I.* offered a diagrammatic cross-section of the openings at the bottom that again accentuated the variability of their forms. Yet I argue that this figure could

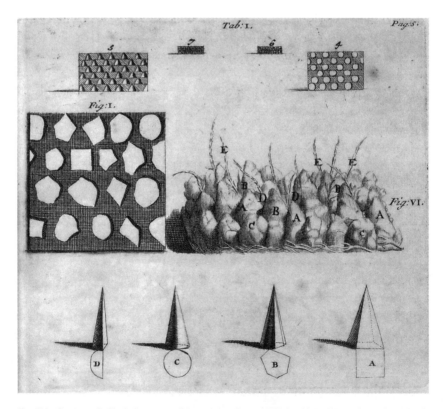

Fig. V/4. Compare Bidloo's depiction of the strict geometry of Ruysch's understanding of the glands with his naturalistic illustration. Bidloo, *Vindiciae quarundam delineationum anatomicarum*, 5.

also be read in another way. It could be interpreted as a cinematic representation of how one opening changed its shape with the passage of time.[28] As the human skin was pressed and twisted, the opening grew, shrank, and shifted in succession. Bidloo offered a rational explanation why these organs were so fickle. If the papillary glands could not change their form, the sense of touch would not be able to differentiate between the perception of various materials that brushed against the skin.

As it happens, Bidloo misunderstood the debate. Ruysch's main problem was not with the definition of *pyramidal*, but with the definition of papillary glands. He considered *papillae* and glands two separate organs. For him, *papillae* were pyramidal but glands had a globular shape. Definitions were of little importance to Ruysch when Bidloo conflated two separate organs into one. Yet Bidloo's misunderstanding is helpful to us in that it revealed his thoughts about the visualizing power of preparations and paper. He surmised that Ruysch's preparations and epistemology were connected. Since the preparations could not change their shapes, their maker also had to imagine the body's organs to be rigid. The surface of paper, in contrast, allowed Bidloo to set things in motion. He could represent changes to the shape of a papillary glands in a chronological order. Atlas images reflected the variability of nature better than three-dimensional specimens.

Paper had another advantage over preparation. It could accommodate different methods of visualization on the same page and provide the reader with the composite result. In *Table XXII* of his *Anatomia humani corporis*, Bidloo provided a large number of competing representations of the heart, each of which visualized and emphasized different aspects of the same organ. While image *No. 1* in *Table XXII* attempted to represent the heart as *it appeared to the eye,* this image could not show its building blocks and structure. In order to visualize the structure of the muscles, tendons, and their fibers, the heart needed to be boiled first. *No. 2* and *No. 3* thus showed the front and back of a boiled heart. Yet boiling was not the best method for the investigation of the ventricles. These chambers could be best seen with the help of desiccated specimens. *No. 7* and *No. 8* consequently depicted a dried heart from different perspectives to show the cavities. *No. 9* then aimed to show the connections between the chambers of the heart. Bidloo inserted several quills into a desiccated heart that pierced through the barely visible valves. Thanks to these quills, the connections between the atria and the ventricles were adequately shown. Finally, *No. 11* visualized the coronary arteries and veins on the surface of the heart with the injection of mercury and wax. While *No. 11* offered a good picture of the elaborate structure of these vessels, it also emphasized the distortions of wax-injections when compared to *No. 1* on its left.

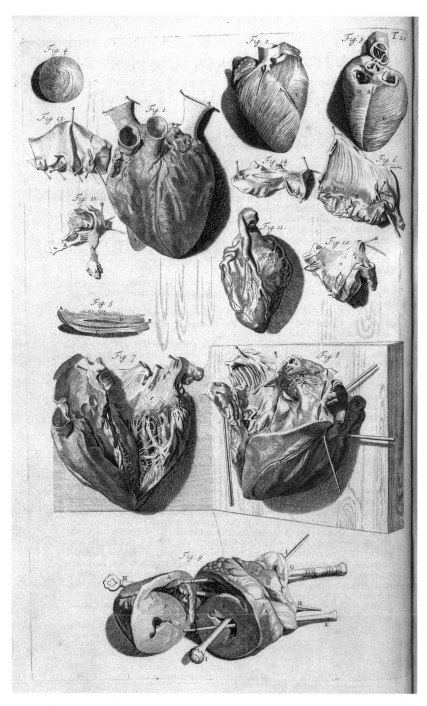

Fig. V/5. For Bidloo, there was no single correct representation of the human heart. Bidloo, *Anatomia humani corporis*, Tab. XXII.

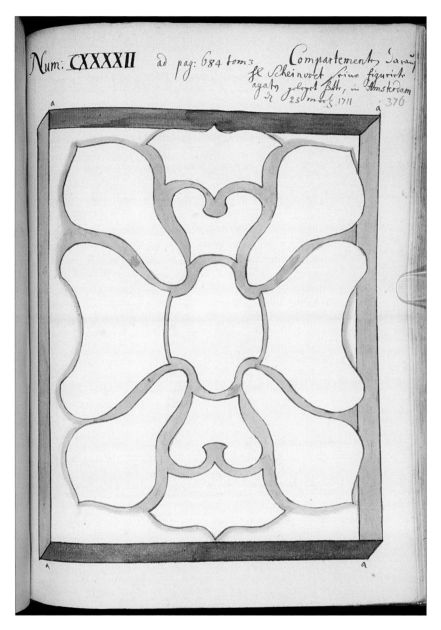

Gal. 1. The Uffenbachs visited Schijnvoet on March 23, 1711. Uffenbach, *Drawing of a Drawer from Simon Schijnvoet's Cabinet of Curiosities.*

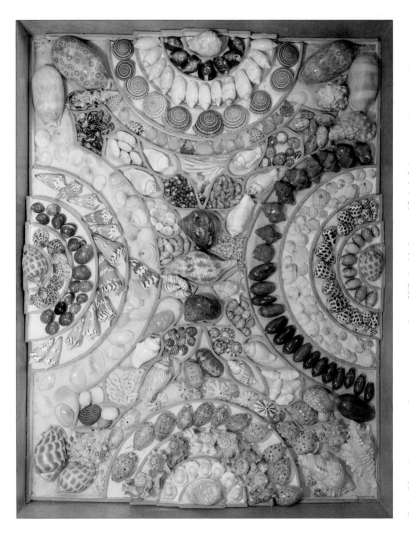

Gal. 2. Note the geometrical arrangement, similar to Uffenbach's drawing (Gal. 1). Schijnvoet, *A Drawer of Shells*, c. 1725.

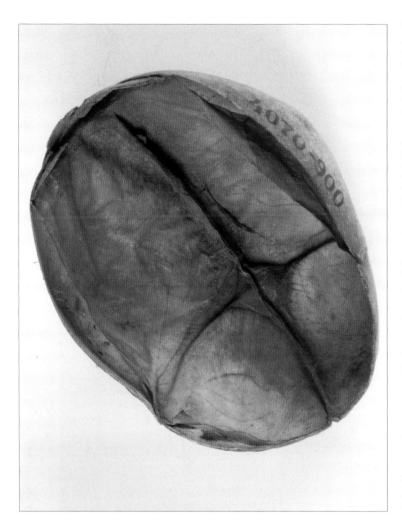

Gal. 3: Compare this specimen with the two-dimensional illustrations of Ladmiral (Gal. 27 and 28). Ruysch, *Injected Skull Cap of Newborn*, c. 1700.

Gal. 4. The Bourse was located on the Dam, and the Uffenbachs visited it, as well. Berckheyde, *The Interior of the Bourse*, 1670–90.

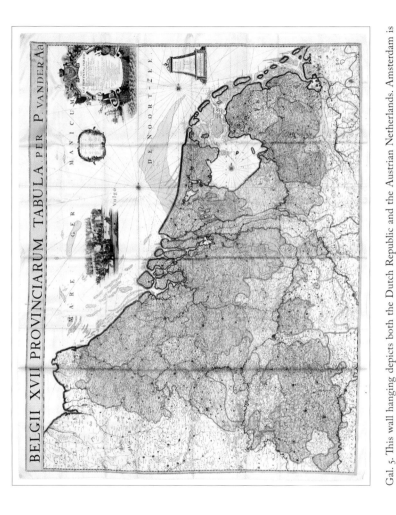

Gal. 5. This wall hanging depicts both the Dutch Republic and the Austrian Netherlands. Amsterdam is marked with a red dot. Van der Aa, *The Seventeen Provinces of the Netherlands*, 1734.

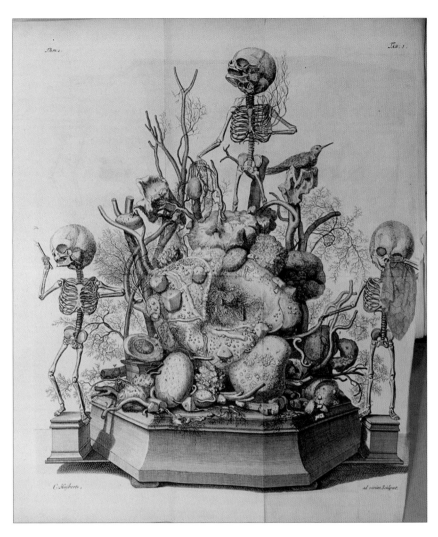

Gal. 6. Compare the texture of the vessels with the texture of the napkin. Ruysch, *Thesaurus I* from *Opera omnia*, Tab. 1.

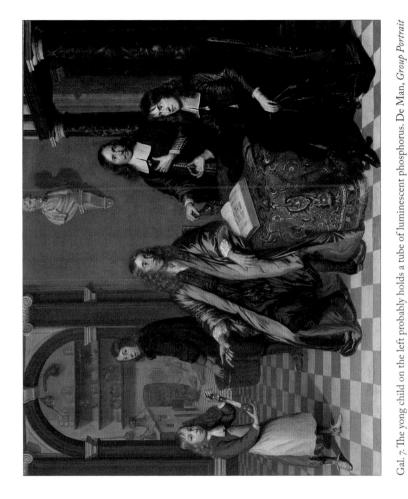

Gal. 7. The yong child on the left probably holds a tube of luminescent phosphorus. De Man, *Group Portrait in the Chemist's House*, c. 1700.

Gal. 8. The transportation of elephants necessitated novel designs for a special wagon. *Dessin du chariot qui a servi au transport des Eléphants*, c. 1800.

Gal. 9. Note the omnipresence of shells, and the obligatory crocodile on the top. De Man, *The Curiosity Seller*. 1650–1700.

Gal. 10. Seba holds a specimen in his hand, and points at the paper version of his museum. Seba, *Locupletissimi rerum naturalium thesauri accurata descriptio*, frontispiece.

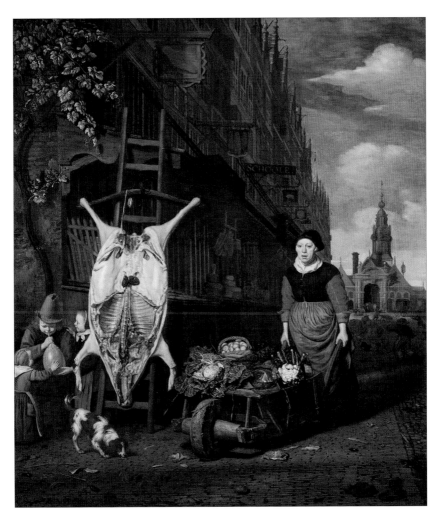

Gal. 11. Seba's pharmacy was on this street. The butchered pig reminds viewers that the anatomy of common animals was an everyday sight in early modern cities. Van Musscher, *A Pig on a Ladder with the Haarlemmerpoort in the Background*, 1668.

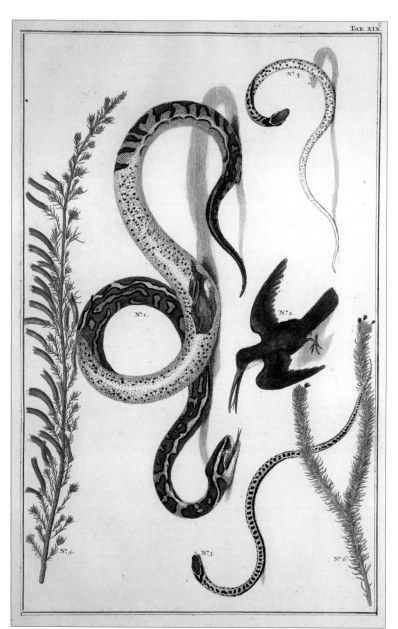

TAB. XIX.

N°.4.

N°.2.

N°.1.

N°.5.

N°.3.

N°.6.

Gal. 12. The *python Sebae*, preserved in Berlin (Gal. 13). Seba, *Locupletissimi rerum naturalium thesauri accurata descriptio*, II/Tab 19.

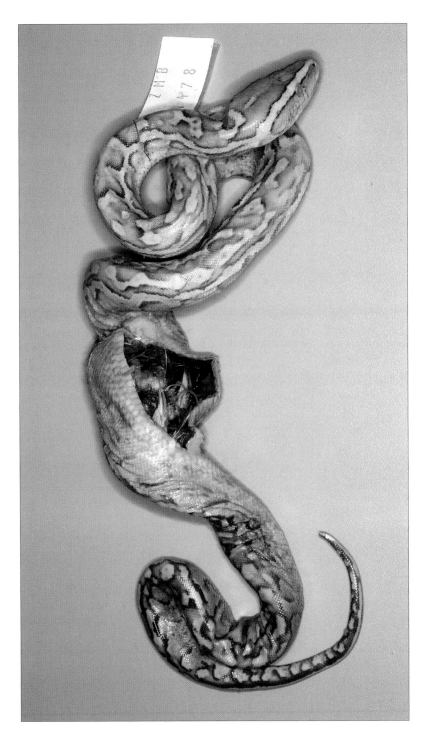

Gal. 13. Compare with the paper illustration (Gal. 12). *Python Sebae*, original specimen.

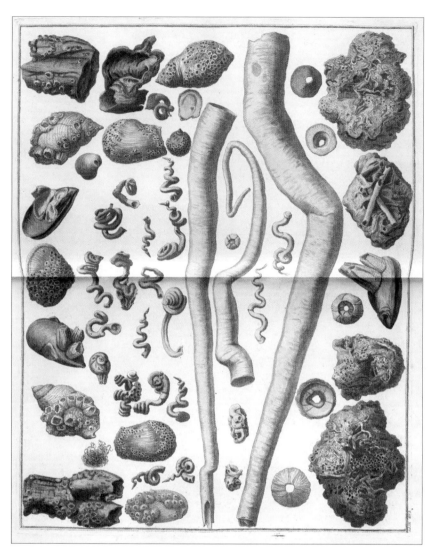

Gal. 14. Balanus illustrations. Seba, *Locupletissimi rerum naturalium thesauri accurata descriptio*, III/ Tab 94.

Gal. 15. Note the authorial signature on the bottom, C. B. f[ecit]. Bellekin, *Shell with a Mythological Subject*, 1650–1700.

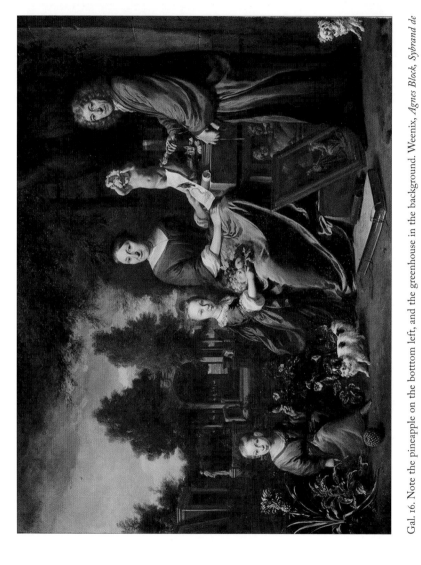

Gal. 16. Note the pineapple on the bottom left, and the greenhouse in the background. Weenix, *Agnes Block, Sybrand de Flines, and Two Children at the Vijverhof*, 1684–1704.

Gal. 17. This fugitive sheet ironically shows Vesalius himself subjected to dissection. *Anatomical Fugitive Sheet, Male, with the Head of Vesalius*, 1573.

Gal. 18. A visual comparison of the efficiency of Van der Heyden's engine with older con-traptions. Van der Heyden, *Beschryving der nieuwlijks uitgevonden en geoctrojeerde Slang-Brand-Spuiten*, Plate 2.

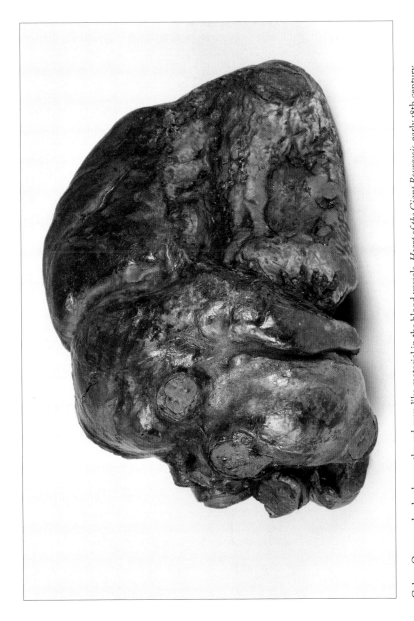

Gal. 19. One can clearly observe the red, wax-like material in the blood vessels. *Heart of the Giant Bourgeois*, early 18th century.

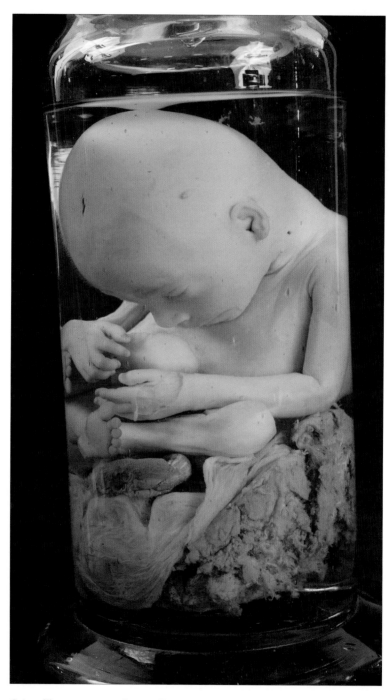

Gal. 20. The specimen is still in excellent condition. Ruysch, *Foetus (ca. 5 months old)*, early 18th century.

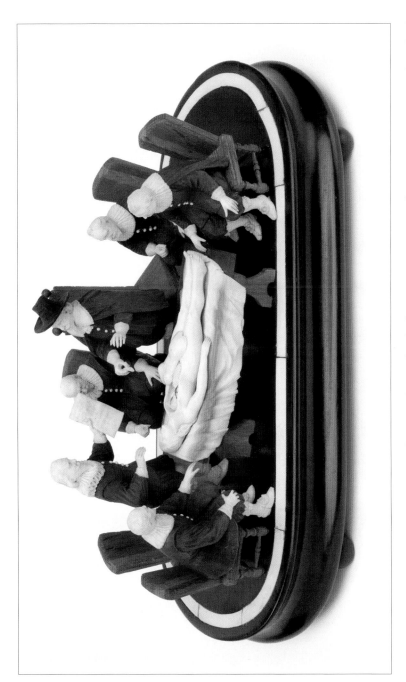

Gal. 21. While ivory models of dissected women were frequent in the period, such a figure group appears extremely rare. *Wood and Ivory Figure Group, based on Rembrandt's Anatomy of Tulp*, 18th century.

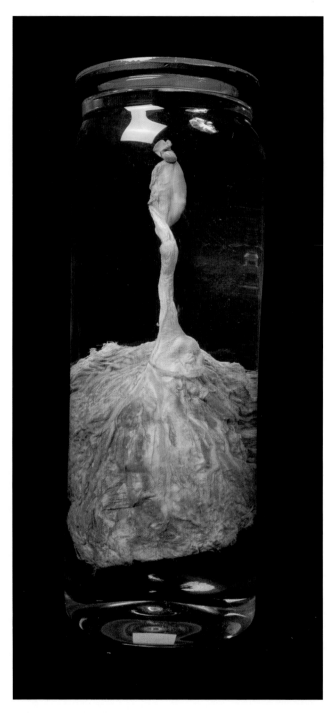

Gal. 22. Red wax has dyed portions of the placenta. Rau, *Preparation of the Placenta*, c. 1700.

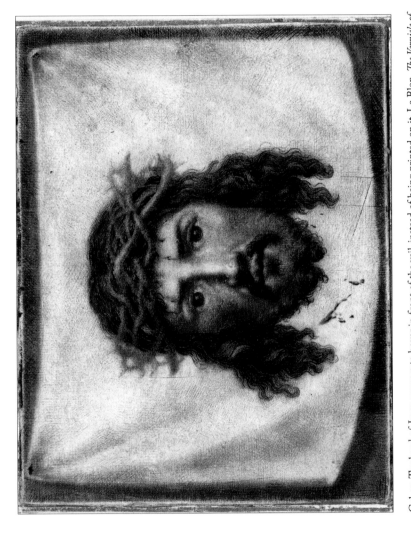

Gal. 23. The head of Jesus appears to hover in front of the veil, instead of being printed on it. Le Blon, *The Vernicle of Veronica*, c. 1710–20.

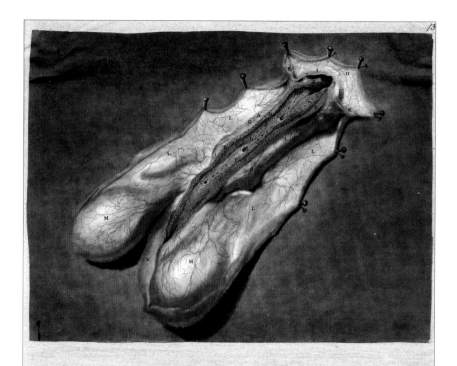

Préparation Anatomique des parties de l'homme, servant à la generation, faite sur les découvertes les plus modernes.

AA L*E Sujet disposé dans un Point de Vuë, où toutes les Parties qui en dépendent se voyent au naturel.*

BB *L'Uretre ouverte dans sa longueur, pour decouvrir les lacunes.*

CC *Les lacunes demontrées par Morganéus.*

DD *Un autre ordre de lacunes placées dessous les premieres, jusques à present Inconnuës.*

EE *Plusieurs petites lacunes parsemées dans l'Uretre, sur tout deux ouvertures fort prés du gland, toutes nouvellement decouvertes.*

F *Toutes les petites lacunes communiquant avec les plus grandes.*

G *Les Veines de l'uretre remplies par l'injeBion, & paroissant sur les Corps Caverneux.*

H *Le Prepuce.*

I *Le Gland.*

K *Le Frein.*

L *La Peau.*

M *Les Testicules.*

N *Le Muscle accelerateur.*

 N. B. Que toutes les lacunes, le corps spongieux, les veines, &c. ont eté injeBées par l'Aorte.

Apparatus Anatomicus G. Cockburni Libello, super Gonorrhæâ virulentâ, inserviens.

AA P*Enis ad apparatum perspiciendum rite dispositus.*

BB *Urethra in longitudinem secta, quó pateant lacunæ.*

CC *Morgagnii lacunæ.*

DD *Lacunarum inferior ordo Morgagnio incognitus.*

EE *Lacunæ plurimæ ad vesicam usque urinariam pergentes; aliæque duæ, ab alterutrâ urethræ parte una, in glande conspicuæ.*

F *Lacunulæ perplures rorem suum in Lacunas deponentes.*

G *Urethræ Venæ injectâ in majorem lacunam cerâ plenæ.*

H *Præputium.*

I *Glans.*

K *Frenum.*

L *Cutis.*

M *Testes.*

N *Musculus Accelerator (Acceleratores vulgò Musculi.)*

 N. B. Lacunas has cum lacunulis, corpus spongiosum, venas, &c. cerâ in Aortam injectâ fuisse repletas.

Gal. 24. A color mezzotint of an injected specimen. Le Blon, *Anatomical Preparation*, c. 1710–1720.

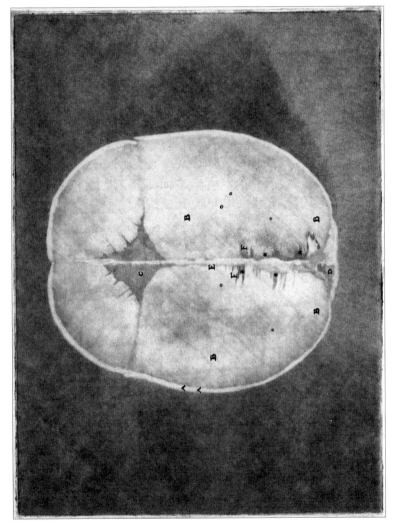

Gal. 25. Note the subtle tonal variation. Ladmiral, *The Human Brain seen from Above*, proof state with blue plate, 1738.

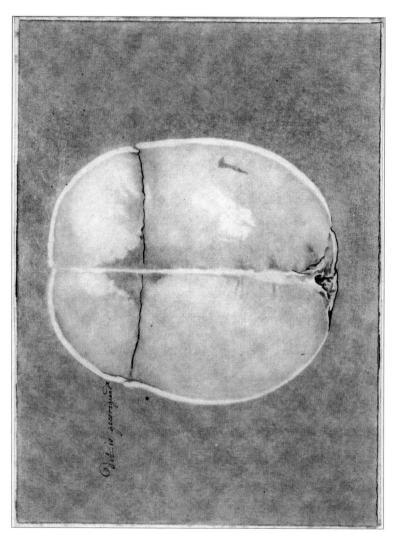

Gal. 26. The inscription reveals that the yellow plate needed some correction. Ladmiral, *The Human Brain seen from Above*, proof state with yellow plate, 1738.

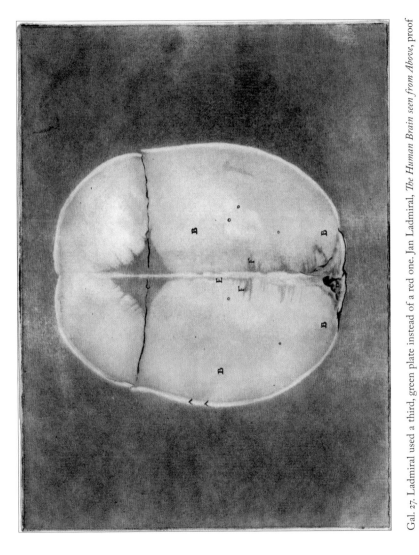

Gal. 27. Ladmiral used a third, green plate instead of a red one. Jan Ladmiral, *The Human Brain seen from Above*, proof state with green plate, 1738.

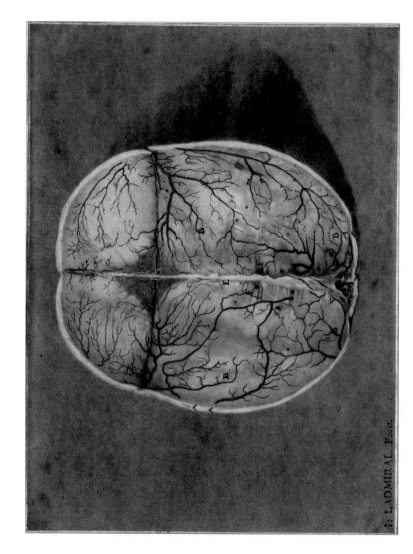

J: LADMIRAL. F.^{cir}.

Gal. 28. The red is probably added by hand. Jan Ladmiral, *The Human Brain seen from Above*, first state, 1738.

Gal. 29. A variety of optical experiments, Newton's prismatic experiment is the second from the left. Gautier d'Agoty, *Observations sur l'histoire naturelle, sur la physique, et sur la peinture*, 1752, I/Tab. 2.

Gal. 30. The inscriptions offer short instructions how to reengrave the plates. Jan Ladmiral, *Anatomical Study of a Human Heart*, proof state, 1730–40.

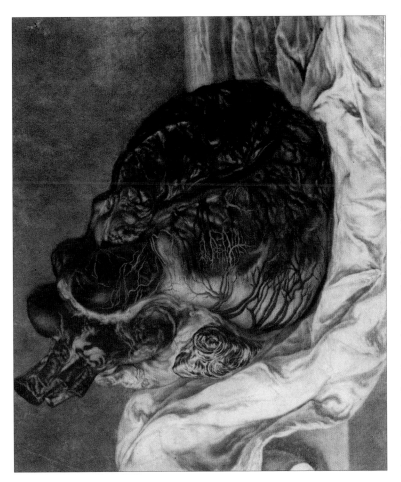

Gal. 31. Compare the colors with the proof print. Ladmiral, *Anatomical Study of a Human Heart*, first state, 1730–40.

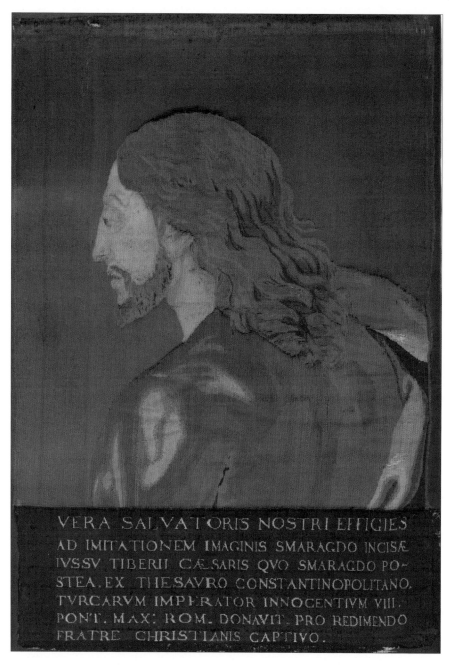

VERA SALVATORIS NOSTRI EFFIGIES
AD IMITATIONEM IMAGINIS SMARAGDO INCISÆ
IVSSV TIBERII CÆSARIS QVO SMARAGDO PO-
STEA. EX THESAVRO CONSTANTINOPOLITANO.
TVRCARVM IMPERATOR INNOCENTIVM VIII.
PONT. MAX: ROM. DONAVIT. PRO REDIMENDO
FRATRE CHRISTIANIS CAPTIVO.

Gal. 32. Le Blon's weaving factory did not succeed. Jacob Christoph Le Blon, *Woven Tapestry Panel with a Figure of Christ*, 1723.

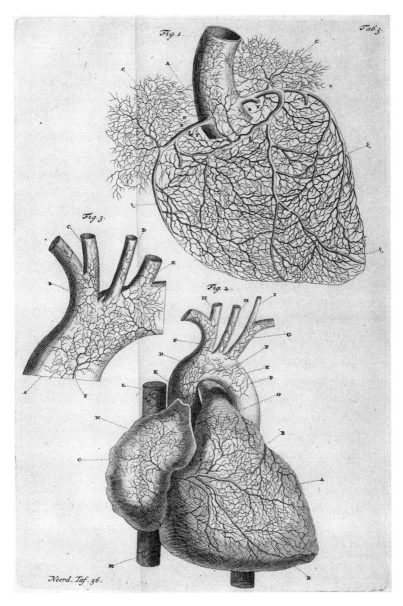

Fig. V/6. For Ruysch, wax injection was the only way to correctly visualize the heart. Ruysch, *Alle de werke*, Illustration of the Heart.

Table XXII on the heart thus offered a functional theory of representation. There was no single method that could transparently depict all building blocks of the heart. The muscles, chambers, valves, and blood vessels each required a specific mode of visualization. *Table XXIII No. 15* on the infant circulatory system employed the same approach and emphasized that the art of wax injection was only one, imperfect method of representing the body. The blood vessels were shown in the state when they were filled with wax. Yet this representation was only approximate, as Bidloo admitted explicitly, because wax could not reach some blood vessels that were hidden in the muscles and around the bones. In order to highlight potential distortions, he even offered a detailed explanation how his method of wax-injection worked.[29] This way, readers could judge for themselves how this method could produce artefacts.

Bidloo's visualization of the heart and the blood vessels was therefore a direct attack on Ruysch. The response did not wait long. In his *Third Letter to Gaubius*, Ruysch argued that Bidloo did not correctly display the infant circulatory system on *Table XXIII*. The heart's coronary arteries were especially problematic. Having read Bidloo's recipe for the wax-injection method, Ruysch could only repeat that he and his son were the only anatomists who knew the true secret of preparation. Bidloo's arguments for the imperfections of preparations held true for his own specimens, which were truly awful, but not for Ruysch's specimens. Ruysch now understood why Bidloo's anatomical museum was not open to the public.[30] He must have been afraid that visitors would see how useless they were. In fact, some specimens in Bidloo's museum "were not [even] prepared by himself but acquired elsewhere."[31] The doors of Ruysch's cabinet, in contrast, were always open to everybody.

Bidloo's defense of his depiction of the coronary arteries of infants introduced a third argument for the superiority of paper over preparation. While wax-injection was an auto-inscription technique that blindly followed the arteries, paper allowed for the intervention of authorial reason in making a faithful representation. And only authorial reason could correctly see these coronary arteries. Unlike the proponents of mechanical objectivity, Bidloo believed that it was permissible, and sometimes necessary, to retouch illustrations of the human body. At first sight, Bidloo's claim might appear to conform with the recent historiography of paper epistemologies. Since Bruno Latour's classic article, many authors have claimed that paper is the best medium to simplify and standardize the chaos inherent in the outside world.[32] The intervention of reason allows scientists to control and represent nature in the form of abstracted paper diagrams. From a historical perspective, Lorraine Daston and Peter Galison have argued

that, in the epistemic culture of truth-to-nature objectivity (before the advent of mechanical objectivity), enlightened anatomical atlases retouched images of the body to make them better accord with the idealism of mathematics and the Classics.[33] Many of these analyses thus ally the use of paper and reason with an abstracted or idealized representation of nature.[34]

This historiographical interpretation presumes that scientific practitioners believe in the lawlike behavior of nature. They employ paper as a technology to represent natural laws that are not immediately apparent in the world outside. Yet early modern scientific practitioners heavily contested such a rule-based understanding of the world. While some natural philosophers clearly believed that the universe followed the rules of mathematics, others argued that nature was fickle, playful, and ultimately unpredictable. Miracles, wonders, and chance events could disrupt the regular course of nature. A creative playwright, Bidloo was not immune to formulating such ideas. As a result, he did not use paper to depict an abstract, idealized image of the human body. Rather, paper allowed him to correctly depict chaotic nature in all its whimsical particularities.

The infant coronary arteries were a case in point. They showed that the human body was infinitely variable, and could not be reduced to an abstracted image. Bidloo claimed that the smaller branches of these arteries could be seen properly neither with a microscope nor with the help of a preparation. They were too minuscule to be visible to the human eye. Yet reason postulated the existence of these branches because, together with the capillaries, they were needed to connect the arteries to the veins. How could one then visualize these invisible structures? One option would have been to present an abstract diagram that showed a rough sketch of the coronary arteries' branchings without any claim to naturalism. Bidloo's solution was radically different. He offered a particularistic representation of the blood vessels with a plethora of idiosyncratic detail. For instance, the artery below the engraved letter B meandered downwards and then branched into two. Of the two branched vessels, the right one disappeared inside the heart. The left one, in contrast, again branched into four smaller arteries. Reason on its own could not have vouchsafed for these details' necessary truth. Why did Bidloo depict four of these small, practically invisible arteries, and not three or five?

I would suggest that Bidloo's decision was based on the chaotic nature of the human body. At and beneath the microscopical level, the structure of the circulatory system continuously varied from person to person. Some coronary arteries meandered to the right, others to the left. In some people, certain arteries branched into four capillaries. In others, the same arteries branched into two, three, or five. Because of this limitless variability, Bidloo's particularistic depiction

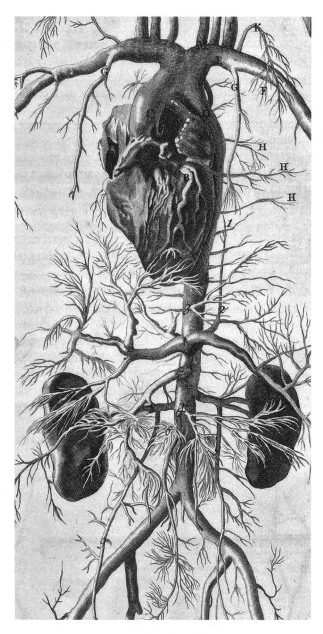

Fig. V/7. The aorta's symmetrical branching was much criticized by Ruysch. Bidloo, *Anatomia humani corporis*, Table XXIII.

of the arteries simply could not go wrong. Whether he depicted three or four smaller arteries, some people in a sufficiently large population must have featured a configuration that matched this exact representation. The law of large numbers ensured that at least a few people in the world had a coronary artery that meandered to the right, branched into two and then again into four.

Unlike later Enlightenment atlases, Bidloo's *Anatomia humani corporis* therefore did not represent an ideal or average human body. But by all probability, it corresponded to at least one specimen among the millions of people. Bidloo dubbed this mode of naturalist depiction the "mind's eye" and exclaimed happily: "Is there anyone of sane mind, who does not gladly agree that it is possible to see the coronary arteries with *the mind's eyes* and to understand in what way they should spread out in the heart?"[35]

Bidloo expounded his theory of rationally naturalist representation when he discussed his illustration of the infant aorta's branchings on the very same *Table XXIII*. Ruysch was very critical of this image and claimed that the positions of the branchings were incorrect. Bidloo's defense was eloquent. He first affirmed that variability was essential to these structures, and wrote that "nature often plays with the origins of the bronchial artery."[36] The aorta of many humans might have branched in accordance with Ruysch's observations. Yet the fickle and continuous variability of nature also ensured that other people's circulatory systems conformed to Bidloo's illustrations. Bidloo's representation might not have been typical but it referred to an extant configuration nonetheless.[37] His image of the aorta's branching actually relied on the dissection of a cadaver. Yet the same laws of probability could represent the coronary arteries without recourse to visual evidence. Variability ensured that naturalism could be objective even in the absence of first-hand observation. Refuting Ruysch's qualms about the potential fictionality of printed images, Bidloo argued that the illustrator's hand could never lie because imaginative, playful nature would always produce at least one corresponding original.

Bidloo's justification of the representational strategies of the *Anatomia humani corporis* thus offers another alternative to the regimes of truth-to-nature and the mechanical objectivity that Daston and Galison have proposed for pre–twentieth-century science. Both of these epistemes impose a regime of regularity on the observer. Mechanical objectivity relies on an automated, trustworthy representational technique that works by eliminating human intervention. Enlightened, truth-to-nature objectivity, in turn, can function only because the scientist's desire for rational order creates an archetypal, characteristic, or abstracted image of nature. In contrast, Bidloo accepted that fickle nature obeyed no rules, within

certain limits. As a result, he suggested that the draughtsman should have a relatively free choice in representing the aorta's branchings or the coronary arteries. The artist's hand only imitated nature's own whim. Judgment was supplemented by creativity.

To sum up, Bidloo's visual epistemology and stance towards preparations were therefore based on three fundamental points. First, anatomical preparations could not capture the temporal, sequential changes that the organs of the human body underwent. Second, anatomical preparations offered only one, and moreover distorted, image of the human body, and not a transparent representation. Third, anatomical preparations had a low power of resolution whereas the technique of the *mind's eye* could offer particular representations of microscopical organs inferred with the help of reason. Anatomical preparations were therefore only of limited use for Bidloo's anatomical research. Ruysch's museum turned into a "Ruyschian cemetery" where distastefully decorated dead bodies were paraded as true representations.[38]

The debate between Bidloo and Ruysch is thus an important step towards understanding how an anatomist could turn towards a functionalist interpretation of images. Bidloo did not simply break with the tradition of Ruyschian preparations, but also disposed of the idea of transparent representation. For him, no single image could present a faithful image of an organ in the human body. Anatomists first had to decide what they wanted to learn about a particular organ and only then could they choose a proper way of imaging the body. Paper's great advantage was to allow for the juxtaposition of various modes of representation within the borders of a single page. Instead of establishing a world-class museum, Bidloo decided to publish a luxurious atlas.

THE MATERIAL VALUE OF
ANATOMICAL PREPARATIONS

Epistemological debates do not take place in a purely intellectual space. By the late 1690s, when the debate between Ruysch and Bidloo erupted, the two anatomists had already invested significant time, energy and money in their chosen media of representation. Ruysch had spent over two decades with decorating his anatomical museum with wax-injected preparations. His first museum catalogue came out just a few years earlier, in 1691, and promoted his art of preparation to larger public. Bidloo had also been committed to his chosen medium for almost two decades. The writing of the *Anatomia humani corporis* took up several years of his life in the early 1680s, and he was still engaged with promoting it

to the wider public. While Bidloo was printing his *Vindiciae* against Ruysch, his publishers were busy selling the English publication rights of the *Anatomia* to Samuel Smith and Benjamin Walford in London. The debate between the two anatomists thus had important financial consequences for them. They would probably impact the English sales of Bidloo's *Anatomia*, and the reputation and value of Ruysch's museum. No wonder, then, that their epistemological standpoints closely mirrored the commercial interests of these medical practitioners. Ruysch was a proud defender of specimens; his anatomical museum was the most important repository of anatomical curiosities in the Netherlands, while his publications were usually sold for cheap. A promoter of atlases, Bidloo had only a few anatomical preparations, but amassed an impressive library to facilitate his study of human anatomy.

The Ruyschian museum was a major financial enterprise, and its sale elevated Ruysch into the highest echelons of Amsterdam society. As we have seen, his first anatomical collection, which also included some animal and plant specimens, was sold to Peter the Great in 1717. Ruysch received 30,000 guilders for roughly 2,000 specimens. Established soon after the sale, Ruysch's second cabinet was similarly valuable. When he began to think about selling this new collection of 1,300 specimens in 1730, Ruysch specified that it could not be sold for less than 22,000 guilders.[39] These data suggest that Ruysch's preparations were rather expensive. In 1717, a single specimen cost 15 guilders on average. On the basis of Ruysch's estimation from 1730, his preparations were worth roughly 16 guilders apiece then.

Fifteen guilders were an impressive amount of money. That was two weeks' salary for a skilled worker, the price of a decent painting by an acceptable guild master, or the value of an illustrated atlas of natural history.[40] A Ruyschian specimen was, on its own, an expensive commodity that held its price relatively constant. As we have seen before, when Seba's second collection was put on auction in 1752, it included wet and dry specimens by Ruysch. These 73 preparations sold for more than 560 guilders. Two decades after the anatomist's death, the price of Ruysch's anatomical curiosities went down slightly. Wet preparations fetched roughly 10 guilders on average, whereas dry specimens were worth slightly over 4 guilders apiece. These prices were still quite high. At the same auction, Seba's other *exotica* were sold for less than even the dry preparations. Pickled snakes and birds cost almost 1.5 guilders on average. Preparations of fish went for just below 2 guilders, while chests of exotic insects could be purchased for 5 guilders apiece. Other animals were priced at roughly 4 guilders.[41]

Bidloo's collection of specimens could not be mentioned on the same page as Ruysch's magnificent museum. Bidloo might have attempted to create an

**Tab. 1. Summary Price List of Albertus Seba's Curiosities,
based on the *Catalogues van de uitmuntende cabinetten*.**

Type of Object	Total Price (Guilders with decimals)	Number of Lots	Average Price / Lot (Guilders)
Shells	12772.25	253	50.48
Corals	1682.5	72	23.37
Petrified specimens	418.5	39	10.73
Minerals	2236	484	4.62
Agates	1723	312	5.52
Fossils	71.5	20	3.58
Diverse Rarities	166	20	8.3
Animals	579.5	150	3.86
Ruyschian Preparations	127.75	30	4.26
Ruyschian Wet Preparations	436.5	43	10.15
Exquisite Cabinets	643.5	10	64.35
Insects	2433	487	5
Snakes	573	422	1.36
Wet Bird Specimens	75.75	51	1.49
Wet Fish Specimens	402	214	1.88
SUM TOTAL	24340.75	2607	9.34

expensive anatomical cabinet early in his career, but he soon turned away from producing luxurious specimens. In the 1670s, Bidloo's preparations were much praised by the pharmacist and poet Johannes Antonides van der Goes, a member of the *Nil volentibus arduum*. Van der Goes' poem described these specimens in the terms of the culture of curiosities, not unlike the way Ruysch praised his own preparations. It claimed that Bidloo's museum contained "anatomical wonders, where art and nature competed" and this charming art "gave life to the dead themselves."[42] Yet it also already pointed towards the practical, research-oriented aspects of the museum. According to Van der Goes, Bidloo's cabinet contained

dry, wax-injected preparations of the blood vessels, livers, lungs, and reproductive organs. His poem remained silent about wet specimens, embryos, and complex body parts. Unlike Ruysch's universal collection, Bidloo's preparations probably served to visualize only the circulatory and the respiratory systems.

While Van der Goes was quite adulatory of Bidloo's collection, other accounts offer a more qualified assessment. When Leiden University was about to purchase Bidloo's herbarium, the curators appointed a certain Dr. Cosson and the pharmacist Taurinus to evaluate the collection on offer. Cosson and Taurinus reported that both Bidloo's plants and the university's own herbaria were of mixed quality, and some specimens were in a deplorable condition. The integration of the two herbaria, however, would have resulted in a good collection. The university curators therefore decided to purchase Bidloo's plants to complement their own for the moderate amount of 250 guilders.[43] Bidloo also possessed some exotic animals and presented the English collector and pharmacist James Petiver with a snake. Characteristically, he was the source of only one specimen. Petiver received more than a dozen *exotica* from Ruysch.[44]

In addition, Bidloo's anatomical museum was not advertised by printed publications during the anatomist's lifetime, and visitors had limited access to it. It also lacked a stable environment. In the 1700s, Bidloo did not even keep all his cabinets at home, but deposited some of his preparations at the anatomical theater of the university. The traveler John Farrington saw these during his visit to Leiden in 1710, and mistakenly claimed that the theater was "now made much more considerable by the large addition of Professor Bidloo's curiosities."[45] Bidloo in fact did not donate his collection to the university but simply used the anatomical theater for the purposes of storage. Gerard Blanken, the anatomical servant, complained much about the fact that Bidloo did not keep an order among the preparations. Whenever he needed a particular specimen for the purposes of research or education, Bidloo took it out from the cabinet and did not necessarily return it to the same place afterwards. As a result, the servant could no longer ascertain which preparation belonged to Bidloo, and which one to the university. The professor was therefore ordered by the curators of the university to make a list of his own preparations and then move them back to his own house. He did not immediately comply with the request, and the curators had to remind him a year later.[46]

Without a fixed physical location, Bidloo's collection functioned as a research tool. It was not a showcase of luxurious preparations that revealed the secrets of the human body. Bidloo's functional approach to these specimens was reflected in their financial value. His museum consisted of only 131 preparations valued at

177 guilders and 8 stuivers. He also owned 149 wet specimens of animals worth 276 guilders 14 stuivers, 24 kidney stones at 18 guilders 15 stuivers, and 62 bones, skulls, and skeletons at 117 guilders 9 stuivers. Altogether, these specimens were worth just over 590 guilders.[47] Remember, Ruysch's collections were worth tens of thousands of guilders.

Bidloo did not just have fewer specimens than Ruysch. He also devoted less care and attention to them. His specimens were not intended to last for centuries and, in principle, they could be thrown away after use. The financial record bears out this claim well. On average, Bidloo's anatomical preparations cost only 1.35 guilders, while Ruysch's specimens were originally priced at 15 guilders a piece. This price difference was the result of two different factors. First, most of Bidloo's specimens were dry, which were (and still are) significantly less expensive to make than wet preparations because they do not require the expensive alcohol that makes part of the preservative liquid. Even Ruysch's dry preparations were worth only 40% of the price of wet specimens.

When one compares similar items in the two collections, it becomes clear that issues of quality also had a bearing on the price of Bidloo's museum. Bidloo's preparations were clearly inferior to Ruysch's. For instance, a customer at Seba's sale purchased a lot that contained a "piece of a penis, artfully prepared" by Ruysch, a preparation of intestines, a book, and a mole skeleton for the sum of 23 guilders. In 1713, Bidloo's "most charming mole skeleton" was sold for 4 guilders 10 stuivers. Human intestines "decorated with wax and mercury and a corium humanum" were also available for 1 guilder 10 stuivers. A "penis siccatus" fetched 1 guilder and 2 stuivers together with "two testicles injected with mercury." As part of a separate lot, several "penes viriles et canini" were purchased for 14 stuivers, even though a dog's *baculum* was also added. Adding together Bidloo's mole skeleton, intestines, and penis, the total amount is 7 guilders 2 stuivers, and it also includes an extra *corium humanum* and the two testicles. In 1752, Ruysch's specimens were still worth three times as much as Bidloo's, even though Seba's auction prices already reflected a slight depreciation of Ruyschian preparations.

Preparations of fetuses offer another opportunity for a comparison. At Seba's auction, four Ruyschian fetuses were on sale. Three were worth roughly 12–13 guilders. A fourth one, probably in worse condition, sold for only 7 guilders. In comparison, Bidloo's best fetus was worth 8 guilders. Another one sold for 6 guilders, and three specimens fetched only 2 guilders each. These numbers suggest again that Bidloo's preparations were worth one-third of the price of comparable Ruyschian specimens. Clearly, Bidloo's museum was cheap because it contained only a few specimens, most of which were dry and of low quality.

THE COLLECTIONS OF TEN KATE, LIMBURG, AND RAU

Bidloo and Ruysch were not the only producers of anatomical preparations in the period. Many Dutch medical professionals and *curiosi* produced and owned such specimens. A cursory glance at these collections affirms the exceptional status of Ruysch's museum and reveals that Bidloo's cheaper and smaller cabinet was typical of the age. As we have seen with Seba's catalogue, Ruysch's name guaranteed high quality in the world of collecting. At the sale of the amateur philosopher Lambert ten Kate's cabinet, Ruyschian preparations were singled out in a similar manner. The catalogue of his collection did not mention the makers of his specimens, except for the ivory models of the auditory organs "from the Cabinet of Professor Ruysch" and a "book of Professor Ruysch" with prepared specimens of plants.[48] Like Fahrenheit thermometers and Hartsoeker microscopes, Ruysch's preparations became a brand. When the Amsterdam physician Abraham van Limburg died in 1720, his postmortem sales catalogue remarked that Limburg's specimens were produced according to Ruysch's method. Nonetheless, these preparations sold for much less than the originals. Out of the forty specimens on offer, only 33 were sold in the end. They fetched 2.77 guilders on average, twice as much as Bidloo's specimens.[49]

Dissatisfied with the visualizing power of preparations, Ruysch's other critics also failed to assemble luxurious collections. Like Bidloo, Rau did not produce expensive showpieces for the market. When Uffenbach visited his cabinet, the German aristocrat could not fail to remark that it was "not for decoration, but for use."[50] Uffenbach also complained that several bottles of wet specimens were only partially filled with alcohol, conjecturing that the anatomist wanted to save on the expensive liquid. Although somewhat larger than Bidloo's museum, Rau's collection still lagged behind the Ruyschian enterprise. It contained 476 specimens, stored in one small and two large cabinets. Rau left this collection to Leiden University without specifying its financial worth. While the university was certainly grateful for this donation, the surviving records indicate that they considered the preparations to have limited value. When the trustees of the university appointed Bernhard Siegfried Albinus to make a catalogue of the collection, he was ordered to throw away worthless duplicates and triplicates.[51] According to Albinus, most specimens directly related to Rau's anatomical work on the bones, the eyes, and the testicles. More than 20% of the collection consisted of skulls: 52 skulls of adults, children, and fetuses, 42 skulls of aborted fetuses, and 9 fragments. Fifty-two bottles, or 10% of the collection, contained parts or a complete set of the auditory bones. Sixteen bottles of adult teeth, 38 eyes or eye

Tab. 2. The Price of Select Anatomical Collections in the Early Modern Netherlands.

Anatomist	Total Price (Guilders with Decimals)	Number of Lots	Average Price / Lot (Guilders)
Ruysch (1717 est'd)	30000	2000	15
Ruysch (1732 est'd)	22000	1300	16.92
Ruysch Wet Specimens in Seba's Collection	436.1	43	10.14
Ruysch Dry Specimens in Seba's Collection	127.73	30	4.26
Bidloo (anatomical preparations)	177.4	131	1.35
Bidloo (wet animal specimens)	276.7	149	1.86
Bidloo (kidney stones)	18.75	24	0.78
Bidloo (bones, skeletons)	117.45	62	1.89
Limburg	91.4	33	2.77
Rau	Donation	471	N/A

parts, and 33 preserved testicles were also listed. In contrast, the catalogue did not mention any wet preparations of embryos, or larger parts of the human body. Instead of offering a faithful representation of the body, Rau's specimens served his particular research interests.

Some of Rau's preparations are still extant today at the Leiden University Medical Center's Anatomical Museum. Most of the specimens are exquisitely preserved bones, but their arrangement does not facilitate careful observation. The bottles hold so many bones that they occlude each other. The largest and most impressive specimen is a wax-injected placenta. In comparison with Ruysch's specimens, this exhibit certainly appears botched. Unfortunately, the wax has escaped from the blood vessels at several points. It has flooded and dyed large parts of the placenta indistinctively.

BIDLOO'S BOOKS

If Ruysch's philosophical preference for the art of preparations was mirrored by his increased production of luxurious specimens, Bidloo expressed his paper epistemology through his investment in the book trade. He was both an avid

book collector and a prolific author whose output ranged from occasional pamphlets to luxury atlases. At his death, his library contained over 1,800 items that were worth almost 2,900 guilders, as the postmortem auction catalogue reveals. Although cheaper than Ruysch's cabinets, the library was nonetheless ten times as expensive as Bidloo's own preparations. The folio volumes on medicine, or on natural history, on their own brought in more money than all the anatomical specimens. An average folio volume was worth more than a preparation. Compare the prices of 5.07 guilders for works of anatomy, 4.38 guilders for natural history, and 5.4 guilders for the Classics, to 1.35 guilders for an average specimen.

Bidloo did not only buy books. He also authored them in prodigious quantities. While he did not despise pamphlets, he also produced luxurious volumes for the same high-end market that Ruysch dominated in the field of preparations. The *Anatomia humani corporis*, for instance, was arguably the first major anatomical atlas published since Vesalius. The images were drawn by Lairesse and then cut by Abraham Blooteling, one of the leading engravers of Amsterdam. An anecdote about Bidloo's intended readers might enlighten the social stakes involved in the printing of the *Anatomia*. King William III dislocated his shoulder during a fall from a horse in 1702, an accident that contributed to his death a few weeks later. Upon hearing about this event, Bidloo rushed to the King, holding the *Anatomia humani corporis* in one hand and a skeleton in the other, in order to explain what exactly happened during the fall.[52]

The price of the *Anatomia* was appropriately high for a royal audience. It cost roughly 30 guilders, and was one of the most expensive one-volume, illustrated encyclopedias in contemporary Europe. At the auction of Bidloo's library, the English translation of the *Anatomia* sold for 27 guilders, higher than any other book. It was also among the most expensive works that the English bookseller Samuel Smith received from his European correspondents during his long career.[53]

Like Seba's *Thesaurus*, Bidloo's atlas cost a hefty sum to produce, financed by four different publishers, including Hendrick Boom. Although it is unknown whether it has brought a profit, the appearance of translations in several languages hints that printers in other countries considered the *Anatomia* a potentially good investment. The original publishers came out with a Dutch translation in 1689. A few years later, a Russian edition was planned and a manuscript translation was executed for Peter the Great, and a new Latin edition was published in 1735.[54] Yet it was the English translation that stirred up most heat in the contemporary Republic of Letters. The booksellers Samuel Smith and Benjamin Walford contracted with Boom in 1695 to publish an English version of the atlas. They

Tab. 3. Summary Prices of Bidloo's Library, based on the *Bibliotheca et Museum Bidloianum*.

Book Type	Total Price (Guilders with Decimals)	Number of Books	Average Price / Book (Guilders)
Anatomy Folio (F)	218.05	43	5.07
Medicine (F)	208.1	67	3.11
Natural History (F)	249.8	57	4.38
Philosophy and Maths (F)	72.15	24	3.01
Greek and Latin (F)	232	43	5.40
Misc (F)	613.85	86	7.14
FOLIO SUBTOTAL	1593.95	320	4.98
Anatomy Quarto (Q)	111.8	74	1.51
Medicine (Q)	221.5	174	1.27
Natural History (Q)	70.95	28	2.53
Philosophy and Maths (Q)	86.45	66	1.31
Greek and Latin (Q)	69.95	30	2.33
Misc (Q)	129.45	135	0.96
QUARTO SUBTOTAL	690.1	507	1.36
Anatomy Octavo (8)	86.7	104	0.83
Medicine (8)	93.8	225	0.42
Natural History (8)	64.55	55	1.17
Philosophy and Maths (8)	21	50	0.42
Greek and Latin (8)	77	67	1.15
Misc (8)	207.6	212	0.98
OCTAVO SUBTOTAL	550.65	713	0.77
DUODECIMO SUBTOTAL	46.7	257	0.18
PROHIBITED SUBTOTAL	4.7	7	0.67
TOTAL	2886.1	1804	1.60

ordered three hundred copies of the illustrations from Boom, and hired the English surgeon William Cowper for the translation. This was an impressive print run for a luxurious atlas in English if one considers that it would have circulated almost exclusively on the British Isles. Importantly, Boom had to print new impressions off the original plates, which suggests that he no longer had a sufficient number of remaindered engravings from the Latin and Dutch editions.[55]

Unfortunately, the British interpreted the concept of translation rather widely, in the vein of the pre–eighteenth-century tradition of conflating editorship with authorship, discussed in the chapter on Seba. Cowper added nine extra plates to the *Anatomia*, emended the text with some of his own commentaries, and published it as his own work, without mentioning Bidloo's name on the title page. The Dutch author was enraged, published an accusatory pamphlet, and sent a letter to the Royal Society, asking for Cowper's condemnation.[56] But authorial credit was not the only stake in this affair. Bidloo's publisher was more concerned about the loss of potential profit than about Bidloo's fame. As he complained, Cowper's corrected edition with its extra illustrations would probably even take a share of the European market. A simple English translation would not have sold well on the Continent, but an updated edition could easily lower the value of the original version.[57]

One is tempted to cite Cowper's appropriation of the *Anatomia* as an example of the apparent instability of early modern print culture. While Ruysch was able to preserve his secret of preservation throughout his life, Bidloo could not prevent piratical editions in the world of publishing. But such an interpretation actually misses the point. As the chapter on Seba has shown, the publication of luxurious atlases hinged on the production of engraved copperplates. Unlike cheap textual editions, such illustrated works could not be reproduced without a significant investment from the publisher of a new edition. They either had to engrave a new set of copper plates, or get access to the originals. Yet publishers tended to keep such copperplates under lock, and refused access even to the original authors. As Boerhaave remarked, copper plates

> are always yielded to the buyer [publisher], so that neither the seller [author] nor anyone else can use them to the detriment of the buyer, who has bought all the books simultaneously with the purpose of selling them. And certainly herein he has a right not to bear the matter lightly.[58]

Bidloo's booksellers were safe as long as they could keep the engraving plates to themselves. The *Anatomia* could be published under another name only after

the new publishers had actually bought the illustrations from the original book-sellers.

The popularity, and potential profitability, of Bidloo's *Anatomia* can also be gauged by looking at the response of the contemporary medical market. Like Ruyschian preparations, the illustrations of Bidloo were imitated by others. The second edition of Stephanus Blankaart's pocketsize *Anatomia reformata*, an af-fordable textbook sold at 14 stuivers, reprinted many of Bidloo's engravings in a smaller format.[59] Blankaart's work was well-known and affordable in all corners of Europe, and even the Transylvanian physician Ferenc Pápai Páriz placed an order for it in the 1690s.[60] Importantly, Bidloo did not start a copyright debate with Blankaart after the images' republication. This octavo edition was not a financial competitor for the original folio, but helped spread the author's fame among medical students throughout the world.

The story of Bidloo's *Anatomia* thus reveals a circulation pattern that rivals Ruysch's preparations. While his specimens were few in number, and inferior in quality, his *Anatomia* was highly sought after and copied by authors in the Netherlands and abroad. It might well have brought an impressive profit to its publishers, and definitely earned Bidloo a position at the court of the Oranges. Looking at the scientific half-life of Bidloo's works, the same pattern can be observed. While none of his preparations survive today, a simple Web search reveals more than 100 copies of the *Anatomia humani corporis* in libraries all around the world.

CONCLUSION

This chapter has examined how commercial considerations stirred philosophical debates on the nature of representation at the close of the seventeenth century. Although Bidloo and Ruysch differed on almost any topic, they shared the same entrepreneurial attitude towards making a career. They both agreed that one needed to produce expensive curiosities to become a successful anatomist with a respected social status, and only disagreed on whether to turn preparations or atlases into a lucrative commodity that they would sell on the booming medical markets of contemporary Europe.[61] It was this disagreement that led to their pamphlet war in which the two sparring anatomists offered philosophical expla-nations for potential customers about the value of their commodities on offer.

Studies on the transmission of knowledge and material objects have already explored how information and objects need to be made durable to enter global systems of exchange. Marc Ratcliff, for instance, has argued that Abraham Trem-

bley's strategy of generosity hinged on his ability to keep microscopical specimens alive when sent from The Hague to Paris.[62] Harold Cook has argued, in turn, that techniques of preparation were originally designed to ensure that commodities would withstand the ravages of time.[63] In similar ways, durable preparations allowed Ruysch to become a successful scientific entrepreneur in the long-distance markets of *naturalia*.

Yet, as Bidloo argued, the art of preservation might also be interpreted as the objectification of human life. Anatomical preparations could not capture the variability of nature. They were rigid and static and could not simulate temporal change. Paper, in contrast, was mobile. It also allowed for the juxtaposition of multiple representational techniques. Wax-injected, desiccated, and boiled hearts could be displayed on the same page. Moreover, the variability of nature allowed paper to visualize the particular details of the circulatory system, whose existence was only inferred by reason. While opposing the mechanical objectivity of anatomical preparations, Bidloo therefore did not subscribe to the abstracting and idealizing tendencies of other Enlightened atlases. Instead of relying on learned judgment, he embraced the naturalism of the *mind's eye*. When nature itself was fickle, the creative imagination of the draughtsmen was unable to lie.

Because of all these reasons, Bidloo decided not to market and circulate his preparations as expensive commodities. His specimens functioned well only within the walls of the laboratory, where they served as disposable tools in the production of more trustworthy paper atlases. Outside the private research of the anatomist, Bidloo's preparations had little epistemological and financial value. The larger public could not trust them as faithful representations of the body, and would not consider them as worthy investments. Bidloo's museum was not visited by aristocrats and did not elevate his social status. The Leiden anatomist instead invested in the publishing business to produce valuable and curious scientific atlases.

Ruysch concurred with Bidloo that not all products of anatomical research needed to turn into commodities. While Bidloo praised books as the ultimate commodity to represent the body, though, Ruysch proposed printed publications as disposable tools to advertise and disseminate the evidence of preparations. For Ruysch, illustrations on paper were not a proper method of representation, and, therefore, not a proper consumer object. But they could serve as a supplement to preparations. His museum catalogues and other pamphlets circulated widely, but they did not bring in a significant income. They were produced only to advertise his museum.

One can thus observe a dialectical relationship between paper and prepa-

ration. For Ruysch, anatomical preparations had both an epistemological and financial primacy. They were prized curiosities for collectors in England, in the Netherlands, in Germany, and in Russia. They promised transparent representation for centuries, and around a thousand of these preparations indeed survive to this day in St. Petersburg. Ruysch's publications served primarily to advertise his preparations and had no epistemic function on their own. For Bidloo, in contrast, preparations were cheap, disposable tools used locally in the process of making expensive atlases. It was the publication of *Anatomia humani corporis* that spread his fame in the Netherlands, in England, in Russia, and in the rest of Europe. Yet preparations and engraved atlases were not the only media to represent the human body. In the 1710s, just when Ruysch successfully sold his collection to Peter the Great, another, new medium appeared on the market: color mezzotints.

KNOWLEDGE AS A COMMODITY

THE INVENTION OF COLOR PRINTING

Sometime in the early 1720s in London, the German-born printmaker Jacob Christoph Le Blon wrote up a list of the mezzotints he had published with the help of his new invention: mechanically reproducible printing in color.[1] For centuries, printmakers had had to content themselves with producing black and white images that could be illuminated only by hand. This novel technology, which Le Blon deliberately veiled in secrecy, seemed to offer a means to transcend this limitation. It reproduced all the hues of the color spectrum by the ingenious application of color theory to the technology of printing. Le Blon started off his publications list with what may appear oddly juxtaposed items: "the Veil of St Veronica with the head of our Lord, at the size of 4 ½ by 3 ½ inches," for one shilling, "an anatomical preparation according to the method of Doctor Cockburn, from the nature, prepared and injected by St André" (5 shillings), and "the portrait of the King of England" (5 shillings 6).[2]

Each of these prints made an intensely charged, symbolic claim about the aesthetic worth and financial value of Le Blon's invention. In offering a version of *Veronica's Veil*, Le Blon suggested that color mezzotints offered a transparent, unmediated representation of the world. As the Catholic legend has long averred, when Jesus ascended the *via dolorosa*, he cleaned his face with a cloth borrowed from Veronica. Thanks to a mixture of sweat and miracle, the cloth preserved his image. This was an iconic image, more than a simple representation, a *vera icon* that partook of Jesus' divinity. First recorded in the eleventh century,

Veronica's veil soon became an artists' favorite. Countless painters copied the image of the *vera icon* to emphasize art's ability to faithfully picture the visible world and embody the invisible sanctity of Christ. After the Reformation, protestants heavily contested the iconic status and miraculous power of the veil, but felt no compunction about continuing to use it as a powerful allegory of perfect visual representation. By including this image among his first prints, our printmaker symbolically asserted that, by adding color in this mechanical way, he turned imperfect representations into images that brought nature back to life.[3] Whereas previous illuminators had relied on their hands, imprecise and prone to errors, Le Blon offered the perfection of mechanical technique—perfection that merited the attention of the highest circles. With the portrait of George I, Le Blon signaled that color printing was a royal technology—and, of course, he also made a bid for the King's patronage.

With the third print, an illustration to William Cockburn's *The Symptoms, Nature, Cause and Cure of Gonorrhea*, Le Blon asserted that color mezzotints not only served the fine arts, but also could enhance the representational repertoire of the contemporary life sciences, as well. Color printing had connections to science because it could bring to life the dappled petals of flowers in bloom, the piebald plumage of exotic birds, and the various shades of red that dominate the internal organs of the human body. The scientific practitioners agreed. Back in Danzig, the naturalist Johann Philipp Breyne noted in his diary, after reading a treatise by Le Blon, that "this invention could find the greatest use in natural history."[4] And indeed, the new technique garnered much interest in the early years of the 1700s, when microscopical anatomy was in its heyday and strange animals from the Indies proved wrong all the traditional knowledge about zoology.

Le Blon's print for *The Symptoms* was an especially strong bid to enter the market for scientific illustrations because of Cockburn's renown. A graduate of Leiden University, the physician not only treated Jonathan Swift, but also became a well-known member of the College of Physicians and a fellow of the Royal Society, and his treatise on gonorrhea enjoyed much success and frequent reprintings in the period. In addition, Le Blon's image was associated with the renowned physician Nathaniel St. André, whose patients included King George and the poet Alexander Pope. The mezzotint claimed not to show the organ in its live state. As the inscription explained, it pictured an "anatomical preparation" by St. André, and "all the cavities, the *corpus spongiosum*, the veins, etc. were injected with wax through the aorta," no small feat given the high density of veins in the reproductive organs. A representation of a representation, Le Blon's print reminded viewers about the tangled relationship between image and reality.

It also emphasized that the latest, fashionable, three-dimensional visualization technique of preparation could now be adequately reproduced in two dimensions, in color. Le Blon must have felt a moment of pride when he finally pulled off the press his successful imitation of a specimen that only the most skilled anatomist could prepare. His manual skill in engraving now was equal to the preparer's skill in injecting.

Yet color printing related to science not only because it could brilliantly picture the objects of natural history and anatomy. Le Blon also believed this technique to be the practical result of his decade-long, theoretical investigations of mathematics, optics, and color theory. As he emphasized repeatedly, his artisanal knowledge of printmaking, and the fine arts in general, was founded on theoretical considerations gained from scientific study. He claimed that his mastery of printmaking had nothing to do with the *je ne sais quoi* of the genius, or the tacit knowledge involved in skilled work that Pamela Smith has explored in great detail.[5] In recent years, Smith has argued convincingly that early modern artisans understood their knowledge to be the result of their active, embodied engagement with matter, which could not be fully codified in simple rules or recipes. Le Blon's career signals the decline of this earlier artisanal epistemology, indicating how a number of eighteenth-century, enlightened practitioners turned towards the theoretical rhetorics of Newtonian science, in the Pyrrhic hope of reducing every type of knowledge to mathematical laws.

What practical consequences resulted from such a sea change in artisanal self-understanding? This chapter argues that the modern intellectual property regime emerged from this conceptual and rhetorical shift, which was not necessarily accompanied by the transformation of artisanal practice itself, though. As long as practitioners considered printmaking, and inventions in printmaking, as a kind of bodily or tacit knowledge that cannot be verbally communicated, they did not think it likely that outsiders would appropriate their working methods.[6] After all, one needed to carefully observe and imitate the bodily movements of the printmaker for long years in order to acquire this knowledge, a heavy investment in time. On the other hand, if one believed that techniques of representation could be reduced to simple mathematical laws, it naturally followed that inventions in this field could be poached without much effort by one's competitors.[7] Piratical entrepreneurs would only need to steal a formula that could be written down on a single sheet of paper. In this new regime of artisanal self-understanding, the role of inventors became precarious unless they employed trade secrets or gained legal protection from the state.

Objects turn into property when there is a chance others can take them away

from you. Similarly, knowledge turned into intellectual property when scientific practitioners began to believe that it was alienable, communicable, and mobile. In the wake of Newton and the mechanical revolution, many artisans adopted the language of theoretical, mathematized science to describe what they knew and did, and this is precisely when the first formulations of modern patent law appeared on the scene.[8] Artisanal know-how became an immutable mobile; artisanal know-how became a commodity. Or so they believed, at least. The story of Le Blon thus illustrates larger trends in the history of intellectual property.[9] This chapter offers a detailed account of how Le Blon conceived of color printing as the product of a scientific theory, and then recounts how he immediately applied for patents and privileges to protect this new invention from piratical entrepreneurs. This was not pure paranoia. Soon after Le Blon's death, his patented method of color printing was illegally appropriated by a French artisan, Jacques Fabien Gautier d'Agoty, and Le Blon's heirs needed to turn to the French courts of law to maintain their monopoly in the field.

INNOVATIONS IN PRINTING:
THE MEZZOTINT AND THE INKPOT

Printmaking was an industry bubbling with inventions throughout the early modern period. While traditional narratives treat the discovery of color printing as a minor development during the uneventful technological stagnation that dominated the field from Gutenberg to lithography, a closer look reveals a bustling field of piecemeal innovation throughout the centuries.[10] Throughout the period, artisans worked hard on developing new printing presses and more efficient inks, and also invented techniques to reproduce images on textile, leather, and glass. The historiography has tended to ignore these discoveries especially because many of them did not use the medium of paper. Scholars of early modern scientific illustrations have traditionally focused on book illustrations, and, until recently, art historians restricted their attention to painting, sculpture, and paper prints.[11] Yet, if one overcomes the urge to concentrate on paper, color printing suddenly becomes part of a larger set of imaging techniques brought to life in the years around 1700.

Printing revolutionized European culture in the fifteenth century, and not only because of Gutenberg's discovery of movable type. Woodcuts began to be printed in Europe around 1400, soon after paper mills spread across the continent. They were printed by carving the surface of a woodblock to leave a relief of the image, which was then inked and pressed against paper or vellum. Intaglio

prints (engravings and etchings) were also perfected in the same century, and provided the first stepping stone for Le Blon's invention. In the case of engravings, one scraped the image into a copperplate with the help of a V-shaped tool, the burin. The whole plate was then inked, the artist removed the excess from the surface, and ink remained only in the crevices carved out by the burin. Finally, the plate was pressed against paper with so much force that the ink was transferred. Etchings were produced in a fairly similar way. In this case, the copperplate was covered with acid-resistant wax, and the artist used a needle to draw the image by removing wax and exposing the copper. The plate was then washed in an acid bath, which burned the image into the exposed crevices of the copperplate. Finally the wax was removed, and the copperplate was inked and printed like an engraving.

By 1500, all these techniques were well known in all corners of Europe, and used for producing playing cards, block books, religious imagery, illustrations of natural history, and, obviously, masterful works of art. Because of the ubiquity of woodcuts, etchings, and engravings, scholars have not considered printmaking a hotbed of invention. While historians have explored how exceptional masters like Dürer and Rubens turned their signature into a protected trademark and copyrighted their works in multiple jurisdictions to prevent piracy, it has been presumed that the legal protection of patents held little interest for printmakers in this period.[12] Yet even a cursory glance at the patent rolls of the Dutch States General and the English Crown reveals a more complicated picture. Clearly, Gutenberg's famed printing press was not a finished invention, as a certain Arnold Rotispen secured a Dutch privilege for his improved model in 1634.[13] Paper also needed to be perfected, especially because its color was subject to widespread variation. In London, Nathaniel Gifford received a patent for "making all sorts of blew, purple, and other coloured paper" in 1692, heralding the glorious era of blue paper for the fashionable letter writers of Enlightenment Europe.[14] Ink and pigments were subject to improvement, too. To prevent ink from drying before it was applied to paper, for instance, the Dutch bookseller Adriaen Bockaert received a patent for a glass inkpot that ensured that it would not become dirty or thick.[15] And in England, as Zacharias Conrad von Uffenbach learned, King James II had granted Charles Holman a patent for powdered ink that would not dry, thicken, freeze, or spoil, and could be used simply by adding water. Just a few years and a Glorious Revolution later, Holman's commercial competitor Thomas Harbin also obtained a patent for his "shining Japan Ink" that had similarly marvelous qualities.[16]

One did not necessarily need paper to print images on. Entrepreneurial arti-

sans exploited the cravings of wealthy Dutch burghers and English aristocrats for interior decorations, and patented methods for printing decorative patterns on textile, gilt leather, and other types of wall coverings.[17] Already in 1611, the Dutch Jan Andriesz. Moerbeecke received a patent for his tapestries "with beautiful and diverse figures very decoratively printed and painted," as well as for similar items made from silk, linen, and wool.[18] Similarly, Jacob Dircxz. de Swart from The Hague was awarded a privilege for printing "people, histories, forest birds, hunts, wild animals, birds and others, with gold and silver, as well as with all their colors [..] not only on leather, but also on satin, Ormuz silk, linen and other materials," as well as a separate patent for printing "all kinds of flowers, garlands, persons, animals, birds" on gilt, silver, and colored leather.[19] Just a few years later, Jacob Verstegen Stevensz. received another patent for printing in color on a wide variety of textiles.[20] Many of these techniques elicited the interest of contemporary scientific practitioners. In the 1670s, for instance, when the printmaker William Sherwin turned to staining calico, a method of dying or printing on muslin, Robert Hooke expressed keen interest in learning more about this technique.[21]

White paper, blue paper, silk, linen, and satin were all the rage in the period, but the new printing method of mezzotinting overshadowed all these other inventions. The early history of mezzotint reveals how entrepreneurial artisans and natural philosophers shared a common interest in imaging techniques. Representation was a scientific, artistic, and entrepreneurial problem at the same time. The novelty of mezzotints lay in their heightened ability to represent tonal variation. The copperplate was first turned into a consistently rough surface on the engraving plate with the help of the rocker, a sharp, spiked instrument. If printed at this stage, the resulting image would have turned completely black as ink was lodged in the cracks of the surface throughout the plate. In order to create white or gray areas lighter than the black background, the printmaker had to burnish the rough surface to create smooth areas to which less ink adhered. Because one could delicately control the degree of smoothness, mezzotints were renowned for their subtle tonal variation and shading, unlike engravings and etchings where similar effects could only be achieved by hatching.[22]

From early on, mezzotinting was considered a secret technique that could bring financial and honorific rewards to its possessor.[23] Its inventor, the German Ludwig von Siegen, started off production with a portrait of Princess Amelia Elizabeth of Hesse-Kassel in the 1640s, an obvious attempt to find a patron.[24] The legendary Prince Rupert then acquired the secret from von Siegen, improved it significantly by developing a hand-held rocker, and made steps to prevent its further dissemination. According to the Dutch biographer Houbraken, he "made

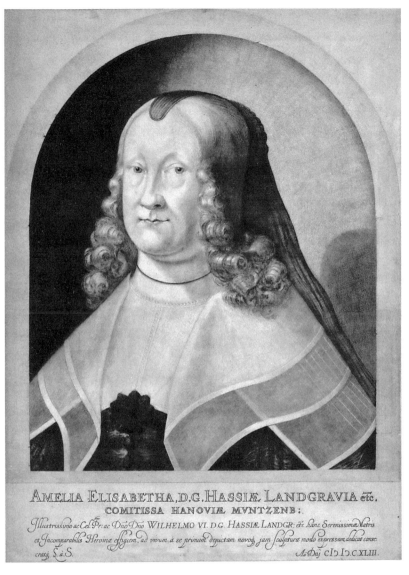

Fig. VI/1. Mezzotints allow for a high degree of tonal variation. Von Siegen, *Princess Amelia Elizabeth*, 1642.

[his servant] Vaillant swear never to divulge the secret"; the servant nonetheless accidentally shared it with some printmakers in Paris.[25]

When the Royal Society of England was established with the Restoration, its fellows immediately turned to studying representational techniques.[26] In 1662, the English virtuoso John Evelyn, a founding member, published his *Sculptura* on technologies of print. Printmaking could reform the study of natural knowledge, or so Evelyn claimed, and would prove especially useful to those "addicted to the more noble mathematical sciences," who "may draw, and engrave their schemes with delight and assurance."[27] It could also further the Baconian project of collecting facts, as the author exhorted his fellows to devote themselves to "making the most exact observations, and collecting the *Crayons, Prints, Designes, Models* and faithful *Copies* of whatsoever could be encountered through the whole *Circle* of the *Arts* and *Sciences*." Yet the scientific study of printmaking did not turn it into public knowledge. Evelyn called the technique of mezzotint a "Mystery [. . .] altogether rare, extraordinary, universally approv'd of [. . .], which (as yet) has by none been ever publishd," and let it remain so.[28] The English virtuoso was reluctant to publish this "mystery" not because he thought that one could learn about printmaking only by years of experience with bodily engagement. Rather, Evelyn was afraid that his publication would allow "all ingenious Persons" to appropriate the technique and employ it for their own purposes. He would never have forgiven himself if the art of mezzotinting were "to be prostituted at so cheap a rate, as the more naked describing of it here, would too soon have expos'd it to."[29] To resolve the conflict between public disclosure and the vulgarization of art, Evelyn decided to deposit his report on mezzotints at the archives of the Royal Society, where it would be available only to a select few. Despite the democratizing rhetorics of the Royal Society, commercially oriented printmakers could not have access to its exclusive, honor-bound network to extract the necessary secrets.

For the next fifteen years, the technique of mezzotinting was successfully limited to a select few in England.[30] Prince Rupert shared his knowledge with Evelyn, the diary-writer and scientific *amateur* Samuel Pepys, the court engraver William Sherwin, the architect and Royal Society fellow Christopher Wren, the Dutch natural philosopher Christiaan Huygens, and Francis Place, the draughtsman for Martin Lister's work on spiders. Yet the less well-established printmaker William Faithorne had no access to the secret, and did not discuss it in his *Art of Graveing and Etching* in 1667.[31] The first description was published only in 1669 in Alexander Browne's *Art pictoria*, and even then, the author refused to disclose the shape of the rocker, which he promised to reveal only in person.[32] Prince Rupert's monopoly was finally breached only when Dutch artisans familiar with

the technique arrived in London in the spring of 1672, fleeing the French invasion of their home country. Abraham Blooteling, who would later etch the illustrations for Bidloo's *Anatomia,* became especially well known for his work and skill in this field.[33] Even then, the Dutch were unwilling to share their secret with British artisans without connections to Rupert. A consortium of British printmakers therefore decided to approach one of Blooteling's servants, about to return to the Netherlands, and pay him a handsome sum in exchange for the method of mezzotinting.[34] The new invention spread slowly because owners of the process had little interest in disclosing it, and became public knowledge only when a large number of printmakers pooled together to buy out one of those already in the know.

WHEN ART BECAME THEORY

If mezzotints successfully garnered the interest of both scientific practitioners and entrepreneurial artisans, the same was even more true for color printing. Le Blon, the inventor of this technique, was a subscriber to the Enlightenment belief in the lawlike behavior of nature, the arts, and technological invention, and claimed throughout his career that color printing relied on Newton's laws of optics. As historians have long argued, the seventeenth and eighteenth centuries saw the mathematization over large swaths of the scientific enterprise, oftentimes but not always coupled with a commitment to corpuscularian, mechanical philosophy.[35] While the mathematization of nature did not begin with Newton, many eighteenth-century adherents adopted him as the standard-bearer of this idea. Thanks to the work of historians like J. B. Shank, Margaret Jacob, and Larry Stewart, we are now largely familiar with the complex history of the reception, selective adoption, and often mind-boggling transformation of Newton's ideas in the hands of his fans in Britain and on the continent.[36] Dutch *amateurs* and artisans, French *philosophes,* and English engineers often profoundly disagreed on what Newtonian philosophy embodied, and what kinds of mathematics it entailed. Yet it seems clear that there was a widespread Enlightenment agreement, including many of those who opposed Newton, that simple, oftentimes mathematical laws could describe much of nature, the arts, and technological innovation, although there was an active debate about just how far such an approach could be taken.[37]

The clearest triumph of mathematics came in astronomy and physics, but other fields were not unaffected, either. The Dutch physician Hermann Boerhaave, for instance, maintained that mathematics could ultimately provide the

means to transform medicine, even if his discipline was not yet mature enough to wholeheartedly embrace this approach.[38] Others were even more enthusiastic. The colonial physician John Mitchell argued, for example, that racial variation in skin color could also be resolved by the straightforward application of Newtonian optics to anatomy.[39] Turning theories of human and animal nature into materiality, to give just one more example, Jacques de Vaucanson produced his renowned flautist automaton, ingeniously applying the laws of mechanics and acoustics to the complex task of music-making.[40] Though Vaucanson did not argue that all aspects of life could be subjected to the laws of mechanics (his defecating duck automaton, for instance, was based on a chemical model of digestion), he clearly believed that a much larger part of human and animal nature could be described by such laws than it had been thought before.[41]

Mathematics ruled not only the starry sky and the human body. As art theorists argued across Europe, beautiful paintings could be produced and analyzed with the help of numbers. The French writer Roger de Piles famously graded the masters along the four axes of composition, drawing, colors, and expression. Out of a maximum of 18 points, Rembrandt received 15 for composition, 6 for drawing, 17 for coloring, and 12 for expression, while Raphael got the scores of 17, 18, 12, and 18 for the same categories.[42] Other art writers believed that numbers not only helped evaluate artists in a beauty contest, but also determined how the perfect image must be drawn. In the Netherlands, classicist authors like Willem Goeree attempted to established ground rules, often based on mathematics, to guide the artist in determining the proportions of the human body and positioning it in an illusionary, three-dimensional space. As the Dutch journalist Peter Rabus claimed, the one task left for these theorists was to study the mixing of colors, and the interplay of light and shadows, which "no one could demonstrate mathematically up till now."[43] Apart from color theory, or so Rabus believed, aesthetics had successfully been reduced to a well-defined set of rules.

Artisanal technique underwent a similar reconceptualization in the years around 1700. While the dominant artisanal epistemology of the early modern period focused on the embodied and tacit nature of knowledge-making processes, the late seventeenth and eighteenth centuries saw the increasing portrayal of technological invention and artisanal labor as "mechanick exercises." As the British printer Joseph Moxon wrote, "mechanick exercises" were practices governed by universal "Rules, that every one that will endeavour to perform them must follow."[44] And a good hundred years later, Vaucanson relied on the same ideology when he designed an automated loom, which replaced the human weaver with a mechanical machine.[45] Even more emphatically than Moxon and

Vaucanson, Le Blon and his fellow printmakers also tended to diminish the importance of the ineffable qualities of the genius, the *je ne sais quoi* of embodied, tacit knowledge, or role of experience when they discussed artisanal or artistic work and inventions. Instead, they came to view art as the application of a set of easily communicable, mathematical or linguistic statements. This knowledge could easily be acquired by anyone, or so they believed, and, if the rules of art were sufficiently disseminated, everyone could become a successful artist or artisan.

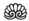

Le Blon, the main character of this chapter, was born into the entrepreneurial world of printmaking in 1667, when mezzotints were still a little-known secret, and had important connections to the contemporary world of natural history. His father belonged to the Merian dynasty in Frankfurt, the most influential printmaking family in the century. The engraver Matthaeus Merian was Le Blon's great-grandfather, and his other relatives included the engraver and diplomat Michel Le Blon, the art historian Georg Sandrart, the naturalist Maria Sibylla Merian, and the publisher Theodor de Bry, whose editions and re-editions of travel books flooded European markets at the close of the sixteenth century. The young Le Blon therefore probably grew up in the best environment that seventeenth-century Europe could provide for the education of an innovative printmaker.

After studying with Carlo Maratti in Rome, as Johann Friedrich von Uffenbach noted, Le Blon settled in Amsterdam in 1704 and decided to "research the application of the theory of the great Newton to the colors of painting."[46] It was during this period that Le Blon also developed his new invention in printing. While there have been numerous explorations in color printing in the centuries before Le Blon, including *chiaroscuro* woodcuts and Johannes Teyler's *à la poupée* prints, the Amsterdam artist was able to develop a new technique that relied on mezzotints' ability to carefully control for tonal variation. Instead of using one copperplate, Le Blon engraved three plates of mezzotints, and then printed all of them on the same sheet of paper.[47] First, each plate was worked with a rocker, scraped and burnished to control for intensity, and then inked with one of the primary colors: blue, yellow, and red. If printed separately at this stage, the plates produced a monochromatic image. Yet if the inked plates were pressed against the same sheet, the three colors merged and produced a variety of colors that represented the whole spectrum. It is possible to trace step by step how such a technique worked thanks to the Dutch artist Jan Ladmiral, an apprentice of Le Blon.

Instead of inking his plates with the three primaries, Ladmiral relied on blue, yellow and green, as shown in the monochromatic proofs to his illustration of an anatomical preparation of the *dura mater* by Ruysch. When Ladmiral applied all three plates to the same sheet (and added some red by hand), the final result offered a stunningly beautiful and colorful representation of the human brain. Since the technology of mezzotint offered the possibility to control the intensity of each pigment, even the smallest variation of hue, the complex interplay of light and shadows, could be printed properly. While the technique was supposed to work well in theory, it was riddled with difficulties in practice. Ladmiral had to add red to his print of the *dura mater* by hand, and Le Blon was also accused by his contemporaries, and by more recent art historians, as well, of embellishing his prints by hand-coloring. Yet, even if Le Blon did not succeed in completely mechanizing color printing in his lifetime, he remained convinced that his theory was right, and that it would ultimately lead to the desired outcome.

Amsterdam provided Le Blon with a rich scientific environment to discuss the theoretical underpinnings of his work. The printmaker was closely associated with the grain merchant Lambert ten Kate, an *aficionado* of Newtonian optics and an amateur theorist of aesthetics, whose collection of *exotica* and anatomical preparations already made an appearance in the previous chapter. Ten Kate was also one of the many Dutch thinkers of that era who wanted to counter the radical ideas of Spinoza by showing that the study of mathematics did not lead to atheism, but to a deeper appreciation of God. During the first decade of the eighteenth century, while Le Blon was developing his method of color printing, ten Kate and the classicist painter Hendrik van Limborch collaborated with him on establishing a universal, Pythagorean theory of proportions that could be applied to sculpture, to optics, and to the new art of color mezzotint.[48]

Ten Kate, Van Limborch, and Le Blon worked together on the development of a comprehensive theory that would explain seemingly disparate artistic practices in a unified, scientific framework. The *spiritus rector* of this group, Ten Kate was the most vocal proponent of the idea that art could be reduced to a set of universal laws.[49] As Le Blon wrote later about him, the Dutch theorist apparently discovered the "Analogy of the ancient Greeks, or the true Key for finding all harmonious Proportions in Painting, Sculpture, Architecture, Musick, etc. brought home to Greece by Pythagoras." Ten Kate's work could have led to a revival of the Dutch leadership in technological innovation and arts, as Le Blon believed that this "theoretical science" "was one of the most considerable and useful [...] discoveries and improvements" that helped the Greek "excel other Nations in Sciences and Arts." Ten Kate's inspiration came from aesthet-

ics, where he argued that, in every painting, "a particular Harmony reigns, and a certain Union of the Whole, just as in a fine Piece of Musick, the Key or Tone reigns upon which the Musick is composed." For those who learned the rules of this harmony, the art of painting, which was previously a "real Je ne sçai quoi to most People," could now become a scientific theory, easily communicated in linguistic statements.[50]

Ten Kate's first exploration of the Pythagorean law of analogy revolved around the proportions of human anatomy. In this study, ten Kate was closely assisted by Le Blon, who printed a summary of ten Kate's results under his own name in 1707, and later translated ten Kate's own publication on the topic into English.[51] The Dutch amateur believed that the ideal, aesthetically pleasing human body could be described by using the mathematical language of proportions. It might seem odd to call Ten Kate an innovator, or a discoverer of lost knowledge in this domain, as art theorists had endlessly discussed precisely these questions since the Renaissance. Italian and German authors had drawn upon the writings of Vitruvius to claim that the length of the adult body could be expressed as an integer multiple, usually seven, eight, or nine, of the head's length. The size of other body parts could also be expressed as a fraction of the head/body ratio. Albrecht Dürer's elaborate tables in his *De symmetria partium* epitomize the maddening precision of these studies, as the German artist painstakingly computed the proportional length of the tiniest body parts, including the knuckles of the fingers, for male and female bodies that were seven, eight, nine, ten, or even eleven times as tall as the head.[52] The art theorists of the Dutch Golden Age continued in Dürer's footsteps, and improved upon his measurements by attending dissections. While serving as a draughtsman for Bidloo's *Anatomia,* for instance, Gérard de Lairesse carefully measured the cadavers at his disposal, and then published his results in a chapter on proportions in his *Groot Schilderboek,* a practical guide for training painters.[53] In a letter to Ten Kate, Van Limborch heavily criticized Lairesse, stressing that his system was "truly not any better than the measurements that Albrecht Dürer used."[54]

Ten Kate's own system was innovative precisely because it offered a new solution to an age-old problem in a lively field of study. The Dutch amateur found distasteful Lairesse's examination of the unsightly corpses of those sickly Dutchmen that Bidloo had access to. Only the beautiful statues of the Ancients revealed the true proportions of the ideal body, and, consequently, ten Kate began his research by acquiring plaster casts of the Laocoön group and the Medici Venus. These works presented an almost, but not quite perfect image of the ideal human, providing more satisfactory results than modern sculptures, such as Michelangelo's

Fig. VI/2. Audran's measurements of Ancient statues, including the Laocoön group, shown here, were probably a major source of inspiration for ten Kate. Audran, *Les Proportions du corps humain*, Tab. 2.

David, whose head was too small. Ten Kate measured the proportions of these casts with extreme precision, often to the third of a millimeter, and was elated to realize that his findings suggested a new basis for Pythagorean harmonies.[55] Renaissance theorists were mistaken to take the head as the basic unit, or module, for their measurements. The natural choice for a module was instead the chest, the least variable segment of humans. The ideal human body was always nine times the length of the chest.[56]

Not that all beautiful humans had to look the same. Ten Kate did not forget that short, midsized, and tall people could all be beautiful, even if they had somewhat different bodily proportions, a well-known tenet of Renaissance theory. According to him, the legs, abdomen, and chest of all three types had the same proportional height, but the head/neck ratio varied between them. The head of tall people was one module high, the equivalent of the chest's length, and the neck ½ a module. For mid-sized people, the head was 1⅛ modules long and the neck ⅜ modules; while the shortest had to make do with a 1¼-module head and a ¼-module neck. Consequently, the head/body ratio was no longer necessarily an integer, a radical departure from the Renaissance tradition.

At this point, Pythagorean harmonies entered the picture, and revealed that the human body functioned like a musical instrument. As it is well known, Pythagorean musical theory claims that each interval can be expressed as the fraction of two integer numbers: the fifth is 3:2, the fourth is 4:3, and the major second is 9:8. To his amazement, ten Kate found that the relationship between the heads of tall, middling, and short-sized humans could also be expressed as a fraction that corresponded to a musical interval in Pythagorean theory. The proportion between a tall and a middling head was 1 : 1⅛, which was equal to 8 : 9, the major second. When he compared middling heads to short ones, the result was 1⅛ : 1¼ = 9 : 10, that is, a minor second. And last, the tall/short head ratio was 4 : 5, the equivalent of a major third. With the help of further comparisons of the necks, Ten Kate was also able to arrive at proportions that corresponded to fourths, fifths, and the octave. This perfect correlation of music and anatomy allowed one to formulate simple laws that could govern the practice of artistic anatomy. Satisfied with his findings, ten Kate exclaimed enthusiastically about the significance of his discovery:

> Thus the whole foundation of musick, all that is marvellous therein, admirably corresponds with these agreements and proportions of ideal beauty. What admirable harmony, what charming airs does beautiful nature sing to the praise of its divine author![57]

Ten Kate did not stop at putting artistic anatomy on a new footing. Pythago-rean theories could also be applied to the field of optics. In a lecture in 1716, ten Kate expanded and corrected Newton's findings as to how sunlight was diffracted into various colors through a prism.[58] In his *Optics*, Newton had let sunlight into a dark room through a small hole in the wall.[59] He put a prism in the way of the light, which cast a rectangular band of the color spectrum on the opposite wall. Like a rainbow, this band consisted of patches of violet, indigo, blue, green, yel-low, orange and red, and Newton noticed that the width of these patches varied. Rather surprisingly, this variation followed the rules of Pythagorean harmonics. If one took twice the total bandwidth as the basic unit of measurement, the width of the red patch (with the addition of ½ unit) was 9/16 units long, a minor seventh. When Newton added the orange patch to this 9/16, the sum was 3/5 units, a major sixth. Further iterations of this procedure led to the ratios necessary for fifths, fourths, and thirds and seconds.

One can easily understand the Dutch theorist's enthusiasm for Newton's find-ing. The English scientist discovered an optical system that was uncannily similar to his own laws of human proportions. Ten Kate's improvements on Newton aimed at reconciling optical theory with the harmonious underpinnings of Py-thagorean music theory. Based on the equivalence between musical intervals and the prism experiment's color patches, Ten Kate equated the whole color spectrum on the wall with one musical octave. But then, how could one explain that you could play several octaves on a harpsichord, and hit the C key in several registers, while the prism experiment produced only one optical octave, and the color red appeared only once on the wall? What was the optical equivalent of a musical register?

The answer was soap bubbles.[60] Ten Kate blew a thin membrane of soap over the opening of a wineglass, and then, like a curious toddler, carefully observed the reflection of light on this surface. At first, the membrane appeared colorless, but soon a band of the color spectrum appeared on its surface, not unlike a rainbow. So far, soap appeared to work just like the prism, turning white light into the one octave of the color spectrum, But then, as a few additional seconds elapsed, the color spectrum multiplied, as in a double rainbow, and one could soon observe six, seven, or even eight series of the spectrum next to each other, before the membrane dissolved into thin air. The new spectra appeared gradually, and had a larger width and a lower light intensity than the original one. Soap membranes were the optical keyboard of nature. Color and sound were discrepant no more.

Le Blon's contribution to ten Kate's scientific project on proportions was to develop an appropriate color theory, and to revolutionize the technique of print-

ing mezzotints with the help of these theories.[61] From the beginning, Le Blon was enthusiastic about the creative and commercial potential of such a philosophical invention, and wrote that his "spirit was so much occupied with the possibility of being able to print with *harmoniously arranged* colors, that I could not stop thinking about it."[62] With this new invention, if he was able to keep it secret, Le Blon could establish a lucrative monopoly in the booming and competitive markets of early eighteenth-century print culture. As we have seen, his method of color printing exploited how the mixing of the three primary colors could reproduce the whole color spectrum. Curiously enough, the stated primacy of red, yellow, and blue appeared inconsistent with Newton's belief in the seven elementary rays of light produced through prismatic diffraction. In his 1716 lecture, Ten Kate himself discussed this apparent paradox, and was fortunately able to resolve it through a sleight of hand that relied on the laws of *analogy*.[63]

So far, Le Blon's invention of color printing does not appear to need the complex theoretical apparatus of ten Kate's theory of proportions, or, indeed, the use of mathematics. Yet Le Blon faced an important practical problem in printing high-quality mezzotints, which he decided to resolve through the application of mathematics. In order to reproduce the color spectrum by the mixture of the three primaries, Le Blon needed to carefully decompose each hue into its components. This is a relatively easy process in painting. After applying red, blue, and yellow to the canvas, one can immediately see whether the pigments have blended into the desired color. In printing mezzotints, however, errors become more difficult to eliminate. The intensity of each primary color is controlled through burnishing, but the result becomes visible only after printing. An anatomical print of a prepared heart from Ladmiral exemplifies how proofs needed to be printed to correct for errors. On this proof, the printmaker marked with A where more yellow had to be added, and letter G showed where a more powerful red was necessary. With the help of these instructions, the plates needed to be burnished again, and then printed anew, a rather cumbersome process.

To speed up production, and to put it on a theoretical footing, Le Blon and his circle therefore attempted to determine the exact mathematical proportions of pigments necessary for producing particular colors. They especially focused on the effects of shadows and reflections on human skin, a topic also extensively studied by contemporary French painters and art theorists.[64] In 1709, Le Blon performed an experiment in his studio to determine the "scales and series of the harmonious tempering of shadows."[65] While this experiment focused on oil paint, he must have hoped to extend these investigations to the field of printing, as well. The printmaker positioned a white sheet of paper near his source of

light, three feet away from the observer. He placed another white sheet a further three feet away from the light source and the observer, and then another sheet a further three feet away. Obviously, these white sheets appeared darker and darker with the growing distance from the light source. How could one represent these varying degrees of shadow in a painting? Le Blon set up a canvas painted in pure white two feet away from the observer, and started applying black paint to it until the observer judged its color equal to the first sheet of paper near the light source. He then added more black paint until the observer judged its color equal to the second sheet, further away from the light source, and even more black to match the color of the third sheet. This experimental technique helped Le Blon carefully measure how much black pigment was needed to recreate the effects of shadows on white color, and he found that white could be "tempered in an arithmetic proportion." The increasing amounts of black pigment needed to recreate the three degrees of shadow formed a recursive series.[66] This was also true for other colors, and Le Blon explained that, to make red color lighter, he mixed 15 units of white with one unit of red pigment, and to make it even lighter, 31 units were necessary.[67] Using an anachronistic twenty-first-century terminology, but faithfully to Le Blon's mathematical orientation, his original table with its numerous measurements can be reduced to the following recursive series:

$$F_{(n)} = 2 {}^{*}F_{(n-1)} + 1 \text{ (n= degree of lightness; F= amount of white pigment)}$$

Like artistic anatomy, prisms, and soap bubbles, the mixing of pigments followed harmonious, scientific laws. Laws that could be expressed in statements. To produce beautiful and colorful paintings or prints, artists need only memorize the simple rules of mathematical proportions. This knowledge was declarative and could not be supplanted by long years of artistic experience. Le Blon acknowledged that, on occasion, artists could produce "wonderful artifices [...] only by the stroke of their brush, without knowing the reason for it," but this was usually an accident.[68] In order to create consistently good work, one needed to be aware of the rules established by Le Blon.

THE OWNERSHIP OF PYTHAGOREAN ANALOGY

Le Blon's experimentation with shadows and lighting turned the theoretical investigations of ten Kate to practical use in printmaking. Pythagorean harmonies not only revealed the divine workings of nature to the contemplative mind, they could also revolutionize artistic and artisanal practice. As Newton established

Fig. VI/3. Le Blon's table for tempering pigments reveals how four different tints (marked with A, B, C, and D on the left) can be made progressively lighter by the addition of white pigment (Witt, or W), in a strict recursive series. Le Blon to Van Limborch, 1711.

laws for mechanics and optics, so would ten Kate and Le Blon establish the laws of aesthetics and printmaking. And just as Newton hoped that his mathematized, experimental science of optics would be universally understood and replicated by scholarly communities around the world, so did ten Kate, and his circle, believe in the dream that their laws of art could be fruitfully used by artists through-out Europe.[69] But, unlike Newton, they were not overly enthusiastic about this prospect. While the spreading of theoretical ideas was in itself a laudable ideal, entrepreneurial artists like Le Blon could lose their living when their inventions were appropriated by a large community of artists.

Consequently, Le Blon shrouded his inventions in secrecy, hoping that it would protect his monopoly in the novel art. Indeed, Le Blon's recorded conver-sations, his publications, and his legal debates with competitors reveal how his concern with secrecy was related to his belief in the theoretical foundations of color printing. Remarkably, not a single member of the ten Kate circle published any of their researches into Pythagorean harmonies for over twenty years, and even their later publications remained cryptic. In 1711, the same year he cor-responded with Van Limborch on the representation of shadows and light, Le Blon received a visit from the German traveler Baron Zacharias von Uffenbach, and his brother, and showed them some color mezzotints. As we have seen in the introduction, the Uffenbachs were curious to learn more about this new in-vention, but could not get an answer from the printmaker. As Zacharias Conrad wrote, "Mr. Le Blon made a great secret about it; he said it would be for great gentlemen who would have to pay him handsomely before he made his invention public."[70] For Le Blon, his invention was already a commodity with a financial value attached to it.

And indeed, even if Le Blon was not paid by great gentlemen, he did receive a privilege from King George in England in 1718, soon after he had migrated to London, "for a new method of multiplying of Pictures and Draughts by naturall Coloris with Impression."[71] He had applied for a patent in the Netherlands even earlier, but his application was rejected, probably because of an earlier patent by Johannes Teyler on his *à la poupée* method. Once armed with a patent in England, Le Blon engaged in several large-scale enterprises in printing, but failed to estab-lish a successful long-term career. In the mid-1720s, for instance, he advertised a series of anatomical tables, printed in color under the supervision of Nathaniel St. André. Riding the wave of interest in anatomy (Ruysch had been elected a fellow of the Royal Society only a few years before, and William Cheselden was about to publish his renowned *Osteologia*), Le Blon hoped that these color prints would "confirm the Usefulness of the said Imprimerie beyond question."[72]

Unfortunately, St. André lost his reputation soon afterwards when he publicly gave credence to a sham report about a Surrey woman who allegedly delivered a rabbit, and the promised publication never appeared.[73]

To advertise this anatomical project, Le Blon published his *Coloritto,* a short pamphlet that introduced his printing method to the larger public, and offered a glimpse on his views on art and science. Our printmaker revealed his belief that, thanks to ten Kate, he was able to turn artisanal knowledge into a scientific theory, a theory that could be communicated and exchanged among practitioners, or, alternatively, could be kept a secret to maintain one's monopoly. In an epistle dedicatory highly reminiscent of Ten Kate's jargon, Le Blon claimed that

> the Ancient Grecians did certainly understand the Harmony of Colours, or Colouring, and some great modern Colorists were not ignorant of it; only the Moderns in hiding their Knowledge as a mighty Secret, have depriv'd the Publick of a great Treasure. It was in pursuit of this Art that I fell upon my Invention of Printing Objects in their natural Colours, for which his Majesty was graciously pleas'd to grant me his Letters-Patent.[74]

As Le Blon explained shortly thereafter, this knowledge was not "some peculiar incommunicable Talent, or Inspiration, which cannot be learn'd, or a Sort of Skill that must be brought to Maturity only by long practice."[75] Le Blon thus diverged from those artisans whose epistemology relied on the embodied, ineffable nature of productive knowledge. He was not a believer in romantic genius, either. For him, artisanal knowledge was communicable, in principle; except that in practice no self-preserving artisan wanted to communicate it. And, despite his ownership of a patent, Le Blon himself was reticent to discuss the exact rules of the harmony of colors. The *Coloritto* offered only vague descriptions of how to mix colors in painting, but did not even mention Le Blon's recursive series for mixing red and white paint. The author relied on imprecise terms, such as "a little black," or "some of the principal tincture," keeping the real secret of coloring to himself.[76] While successfully promoting Le Blon's planned anatomical prints, the *Coloritto* did not deliver its promise.

Le Blon's second publication, his translation of ten Kate's *Beau Ideal* from 1732, was similarly infused with the rhetorics of secrecy. This time, Le Blon was hoping to promote another new invention, his novel method of weaving tapestries based on the principles of Pythagoras. While other artisans produced tapestries using yarns of all colors, Le Blon's patented technique imitated his method of color printing by using only yarns dyed with the three primary colors. If red,

blue, and yellow yarns were tightly woven together, their colors blended and could reproduce the whole spectrum for viewers at a distance. Unfortunately, this project also failed, because, as the surviving *Head of Christ* attests, when the three yarns were woven together, the surface of the image became uneven and lost its aesthetic appeal. In his introduction to the *Beau Ideal*, Le Blon emphasized the theoretical foundations of his weaving technique in the Pythagorean laws of universal harmony that ten Kate rediscovered. Rediscovered, because the Ancient Greeks had already known it, but "cared not to communicate their Secret of the Analogy," and, among the Moderns, so did Raphael and Bramante, who failed to have "the Secret communicated" to their apprentices.[77] Ten Kate was therefore the third discoverer of Pythagorean harmonies, but modesty had prevented him from publishing it for a long time. After such an introduction, readers were probably rather shocked to realize that the English version did not reveal the laws of universal harmony. While the original edition contained a summary of ten Kate's idea about anatomical proportions, Le Blon omitted this section from his own translation, which now offered only an art historical narration peppered with statements of personal preference. Titian had a "certain Majesty and Spanish Gravity," and Annibale Carracci's work was known for its "great Vigour, and a florid Nature joined with a modest Gravity."[78] As William Hogarth complained harshly, he expected to learn the "secret of the Ancients" from Le Blon's translation, "but was much disappointed in finding nothing of that sort, and no explanation, or even after-mention of what at first agreeably alarm'd me, the word *Analogy*."[79] To appease readers, Le Blon promised them that he would publish the Pythagorean law of analogy "as soon as my Business will permit me," but for the time being, the success of his tapestry factory was more important than everlasting fame.

Pythagorean theory mattered for weavers, or so Le Blon claimed, because the best tapestries were based on the cartoons of Raphael and the Ancients who had known and closely followed the rules of universal harmony. As our printmaker pointed out,

> Raphael and the best Grecian Antiques cannot be copied but either by Themselves (which is now impossible) or else by such Moderns as are possess'd of their Principles or Theoretical Science, even tho' much inferior to Them in the Spirit of Invention.[80]

Consequently, no contemporary weaver could claim to produce a tapestry based on Raphael's designs. Le Blon singled out Raphael's Hampton Court car-

toons for a tapestry cycle of Biblical scenes, now kept at the Victoria and Albert Museum. Artists ignorant of the laws of analogy could produce only "unhappily executed" tapestries of this work. The only exception was Le Blon himself, obviously, thanks to his intimate knowledge of Ten Kate's writings and thoughts. And, by a fortunate coincidence, as he explained in his epistle dedicatory to the text, he had just "obtain'd the great Privilege of a Warrant to copy the Cartoons of Raphael at Hampton-Court, in Order to be woven in Tapestry, after my Invention."[81] By not disclosing the secret of analogy, Le Blon was able to remain the only authentic executor of Raphael's designs, and he could keep his weaving factory afloat. The publication of the *Beau Ideal* was thus a shrewd piece of marketing, not unlike Frederik Ruysch's printed catalogues of his anatomical cabinet. By hinting at the secret of analogy, Le Blon could alert readers to his own exceptional ability to produce exquisite tapestries of the Hampton Court cartoons for interested customers. The nondisclosure of the actual secret, however, ensured that no other entrepreneurial artist could take advantage of Ten Kate's method. In order to further protect himself, moreover, Le Blon also acquired a privilege for his invention of weaving. Now, even if particularly inventive craftsmen again rediscovered the Pythagorean laws of harmony, they were nonetheless unable to provide competition for Le Blon. He had legal protection from the King of England.

THE DEVELOPMENT OF PATENTS
AND INTELLECTUAL PROPERTY

While Le Blon's and Ten Kate's fascination with Pythagorean harmonies might not have been shared by many scholars in the Enlightenment, the mechanization of artistic work, and its relationship to regimes of intellectual property, was a topic much discussed in contemporary Europe. When the Royal Society's secretary Cromwell Mortimer reported on Le Blon's work in printmaking and weaving in the *Philosophical Transactions*, for instance, he approvingly confirmed that Le Blon "hath reduced the Harmony of Colouring in Painting to certain infallible rules." The author claimed that "the most considerable, [...] Theoretical Part of the Invention" of printmaking was the expression of the "natural Colours" of real-world objects by the proportional mixing of the three primary colors, the topic of Le Blon's own research on shadows. Once the color spectrum was so subjected to analysis, the rest of the printmaking process was simple "mechanical Practice."[82]

As Mortimer explained in somewhat utopian terms, the analysis of natural

colors could revolutionize artisanal practice by reducing it into easily communicable, theoretical knowledge. Turning to tapestries, Mortimer enthused about the prospects of this revolution. Before Le Blon, one needed to hire expensive artists at the loom, whose experience allowed them to look at a design, guess what yarns would reproduce its colors, and then use those yarns to reproduce the design in the tapestry. Thanks to Le Blon, this guesswork was now replaced by computation. His scientific analysis of colors determined mechanically how one needed to combine a select number of yarns to reproduce the drawing. His weavers no longer looked at a drawing, but followed the instructions of a pattern book that told them when to use what yarn. The mechanization of yarn selection allowed Le Blon to replace expensive artists at the loom with "any common Draft-Weaver." Pythagorean harmonies could result in the subsumption of ineffable experience into mechanized, repetitive work practice.[83] But not just yet, because the *Philosophical Transactions* did not disclose Le Blon's touted laws of color analysis, which remained the secret property of the printmaker.

The English were not the only ones to muse over the emerging, novel constellation between theoretical knowledge, artisanal epistemology, and secrecy. In France, where Le Blon moved in 1734 after his projects failed in London, Enlightenment philosophers, artisans, and royal authorities similarly discussed whether technological inventions could be reduced to communicable knowledge, and if so, whether they should be protected from pirates and appropriated by the state.[84] By and large, we are mostly familiar with the *philosophes'* perspective on this debate thanks to their prodigious publication record. The editor of the *Encyclopédie*, Denis Diderot expressed the opinions of many philosophers when stating that artisanal inventions needed to be made public. As Liliane Hilaire-Pérez has shown, Diderot understood invention to be the application of the scientific method to technology, and contrasted it with the genius of literature and the arts.[85] In literature, copyright was needed to protect the ineffable quality of the genius' work from the piracy of publishers. The mechanical application of scientific laws, on the other hand, did not merit official protection. In the absence of genius, artisans had no right to claim property rights over their own inventions. A writer by profession, Diderot stood to benefit from the publication of technological knowledge, but had no personal interest in rewarding the work of industrious artisans.

But government bureaucrats had taken a different stance, well before Diderot appeared on the stage. They agreed that artisanal knowledge was communicable and had to be shared with others lest it disappear with the inventor's death. Nonetheless, they also realized that communicable knowledge was a commodity

with a price attached to it, and artisans had to be protected and compensated for the losses they might suffer for disclosing their knowledge to others. To stimulate industry, the royal administration therefore established reward funds and sponsored contests that remunerated inventors who shared their knowledge with the public, or at least the government, and also issued increasing numbers of nonexclusive and exclusive privileges, the precursors to the modern patent.[86] Le Blon's career in France unfolded in this context, where he relied on the French government's legal support to revive his printing enterprise.

The French recognized the scientific stature and importance of Le Blon's invention from the beginning. Charles François du Fay discussed it in a lecture at the *Académie des Sciences*, and the Jesuit *Journal des Trévoux* reviewed the *Coloritto* in 1737.[87] The review's author, most probably Louis-Bertrand Castel, called Le Blon's work "a completely new science, a completely new art." Fueled by national pride, Castel explained that Le Blon's project did not succeed in England because it had not been sufficiently supported by his British patrons. The English were not well versed in color theory, and therefore could not gauge the importance of his work from the terse remarks in his pamphlets. In contrast, the French were sufficiently advanced in the sciences to understand Le Blon's ideas even from a few cryptic remarks. In England, Le Blon could freely explain

without consequence that he produced all the variety of colors for a finished painting with three plates, each inked with only one color, one with blue, the other with yellow, and the third red, which he applied successively on paper, or on taffeta, or on satin.[88]

Neither potential patrons nor competitive printmakers would have understood the theoretical basis of this invention. Yet, in France, his words were immediately understood by all those "who heard his talk for the first time," and patrons would soon be forthcoming to support Le Blon. At the same time, Castel realized that an extensive discussion of Le Blon's results could have been perilous for the printmaker. In a country where patrons were capable of understanding the secret of color printing, competitors might well have done the same, as well. As a result, he cut his review short so as not to arouse "more attention than it is appropriate for the Author's secret."[89]

Given the mixed blessings of an attentive audience, Le Blon soon applied for an exclusive privilege. This was granted in November 1737, three months after the appreciative, but potentially too informative, review appeared. Signaling the increasing belief in the communicability of inventions, the King specified that

Le Blon should share his knowledge with the government. A scientific advisor, probably Du Fay himself, wrote that

> the only way to preserve this secret, which would be very useful, would be to accord Le Blon a privilege on condition that he present his secret to the people that his Majesty appoints to him.[90]

The aged artist was compelled to "work and state all his secrets, and the practice of his art" to a select group of associates at his studio.[91] The disclosure of the secret was an illustrious event with several high-ranking scientific professionals in attendance, including du Fay himself, Mlle. Basseporte, the draughtswoman for the Jardin du Roi, Gautier Montdorge, who would later publish an article on color printing for the *Encyclopédie*, and another *académicien*. The best audience for the evaluation of artisanal work was a group of scientific practitioners, a standard practice in eighteenth-century France. And if Le Blon was afraid that these associates would exploit their knowledge of his invention for their own purposes, the King's final memoir specified that they "will not be allowed to claim any part of the profit that could result from the implementation of the privilege."[92] Competition after the expiration of his privilege probably bothered him less; he was already seventy years old.

The French administration's response to Le Blon's patent application followed codified standards that were indicative of the eighteenth-century transformation of the concepts of artisanal invention, intellectual property (an eighteenth-century coinage), and patents. In earlier centuries, when artisanal knowledge was considered a tacit skill, early modern technology transfer and innovation were spurred by facilitating mobility of craftsmen. Unlike today, sovereigns primarily used patents as a tool to lure foreign artisans with innovative skills to their territory.[93] The Dutch States General, for instance, granted a patent to an Italian immigrant in 1660 for bringing the culinary secret of making macaroni to the Netherlands.[94] Because their knowledge was understood to be embodied, these mobile artisans did not have to disclose their inventions upon receipt of the patent. They were instead required to share their knowledge by training apprentices in their workshop.[95] Such a training had little in common with the single session that Le Blon had with the French king's *académiciens*. Apprenticeship was a long-term process of experiential learning, and not the quick communication of textualized, declarative knowledge.

Mario Biagioli has argued that this early patent system underwent a transformation with the emergence of the patent bargain in the new, democratic regimes

of revolutionary France and the United States.[96] In these new systems, patents were no longer issued at the whim of the sovereign to bring in foreign skilled labor. They were codified as a legal contract where the inventor deposited and shared a specification of his new and original invention with the public, in exchange for a limited monopoly for its exploitation. The contractual status of the new patents, however, worked only if artisanal invention could be reduced to a textual patent specification. In order to disclose and exchange knowledge, it had to be mobile and communicable. To make knowledge a public good, it had to be possible to share it.

As Le Blon's case signals, this precondition of the modern patent system had emerged already in pre-revolutionary, Enlightenment Europe. Scientific practitioners and bureaucrats both agreed that artisanal knowledge could be reduced to texts, mathematical formulas, or diagrams.[97] A sign of this growing belief, a brief description of the invention became a standard, necessary condition for receiving a patent in England in 1734. The legal definition of the description had to wait until 1778, though, when Lord Mansfield judged in *Liardet v. Johnson* that it had to be detailed enough to permit others to reconstruct the invention.[98] In France, the Académie de Sciences, which vetted all inventions submitted to the state, entrusted Jean-Gaffin Gallon with the publication of illustrated patent descriptions in 1735. As Gallon explained, his *Machines approuvées* aimed to stimulate the larger public to improve that nation's economy by perfecting the published inventions. Even brief descriptions could fulfill this task, because technological knowledge was not all that difficult to disclose. Gallon supplied illustrations of all the inventions to ensure "that one could understand them perfectly, and also have them reproduced, if it was necessary," and his text served "to offer an understanding of each machine with its parts, to reveal its construction method, and to indicate its use."[99] Perhaps, Le Blon's invention was received so well by the *Académie des sciences* because both parties agreed that brief printed works could reveal the secret of artisanal work to the larger public.[100]

Traditionally, historians took it for granted that eighteenth-century science was characterized by increasing openness and the free exchange of knowledge. This chapter has offered a rather different view, suggesting that, in the wake of Newton, Le Blon and similar Enlightenment artisans developed a new conceptualization of technological invention and practice, and believed that their knowledge could easily be circulated and communicated to the public. Not that this conviction was necessarily right. As we saw earlier, the Russian court purchased a recipe of Frederik Ruysch's preparation method for thousands of guilders, only to realize that the text did not allow them to reproduce the anatomist's high-

quality specimens. Yet the belief in the mobility of artisanal knowledge (which Ruysch himself shared) did have a result. Reacting to the perceived threat of open circulation, artisans began to treat their inventions as an expensive commodity, exchanged only for cash or legal protection in the form of patents. Instead of public science, intellectual property was born.

ARTISANAL COMPETITION IN THE
AGE OF ENLIGHTENMENT SCIENCE

The new conceptualization of technological know-how did not only help propel a new regime of intellectual property. It also changed how artisans competed with each other. They had to emulate each other's products within a regime that was increasingly dominated by patent law, and not guild regulations. In addition, their customer base expected them to develop their inventions with the help of scientific theory. Le Blon's competitors had to distinguish themselves from the original artist not only by creating a superior product. They also had to explain to their potential consumers why it was based on new and better theoretical foundations. Scientific argument and debate became part and parcel of how artisans marketed their inventions and products.

During his lifetime, Le Blon faced little competition. Apart from his erstwhile apprentice Jan Ladmiral in the Netherlands, no one else challenged his monopoly over color printing. The situation radically changed when Le Blon died in 1741. Le Blon's former apprentice, Jacques Fabien Gautier d'Agoty, quickly applied for a privilege to continue his former master's business. At the recommendation of the *Bureau de Commerce*, he was granted a nonexclusive privilege for thirty years. Le Blon's daughter and estate Marguerite quickly attacked the decision, arguing that she still possessed the exclusive privilege of her father.[101] As the law specified, patents were transferable property that could be inherited. This argument found favor with the royal authorities, and d'Agoty's enterprise was seized by government officials in early February 1742.[102] In the following months, a bitter legal debate ensued in which D'Agoty attempted to regain his lost privilege in the art of printing. After losing his lawsuit, the French artisan finally decided to acquire the exclusive privilege through another method. On May 12, a certain Monsieur Desprez, a straw-man, purchased the patent from Marguerite Le Blon, and then transferred it to a company of investors that included d'Agoty.[103] This company was not without its own problems. The investors frequently changed, and a host of legal arrangements were written up to determine who could own and use the secret of color printing. The situation became especially dire in 1747

when D'Agoty was in the process of publishing a series of anatomical prints. The investors were reluctant to pay the artisan's salary, and complained about his treatment of the company's property. Eventually, these rough beginnings were followed by decades of modest prosperity. In the 1750s and 1760s, d'Agoty launched the first ever color-printed periodical, titled *Observations sur l'Histoire naturelle, sur la Physique et la Peinture*, and also printed various anatomical atlases and botanical treatises.[104]

Next to his legal and financial campaign for Le Blon's privilege, d'Agoty also waged a pamphlet war to convince the French public about his moral right to print in color. In his first published work from 1742, he still hoped to prove his right to a privilege by disputing Le Blon's priority. D'Agoty argued that the Jesuit Castel, Le Blon's reviewer in the *Journal des Trévoux*, was the true inventor of color printing. According to him, Le Blon himself acknowledged his debt to Castel in his publications, and consequently had no right for a monopoly over this technique. Since d'Agoty also relied on Castel's writings for his process, he had every right to produce color mezzotints, as well.[105] Given Le Blon's prior career in England and the Netherlands, however, the French artisan managed to convince neither the royal authorities, nor the larger audience.

Once he had purchased Le Blon's exclusive privilege, d'Agoty changed tack. To denigrate the deceased printmaker's mezzotints, he decided to promote himself as a scientifically inclined artist whose philosophical expertise guaranteed a higher quality of print production. In his publications, d'Agoty repeatedly argued that scientists could not observe nature without training in the arts, and artistic genius without a scientific mindset was blind. Anatomists, for instance, had to be expert draughtsmen, because their observations and illustrations would otherwise become untrustworthy:

> It is like the observers of the microscope, if they do not know the effects of light and shadows, and the shape and contours of bodies, they will mistake the bubbles for molecules, and the animalcules for the springs.[106]

Conversely, even historical paintings of the body needed to rely on an extensive knowledge of anatomy. Painters had to follow in the footsteps of Michelangelo, and pick up the dissecting knife. D'Agoty turned to his fellow artists, and asked whether "they explored the intestines, if they injected the vessels, and if they knew the joints and the mechanical movement of the muscles."[107] How could you picture Hercules, or the Holy Trinity, without being familiar with Ruysch's preparation methods? Needless to say, d'Agoty claimed to be the only

practitioner who combined the best qualities of both professions, and he proposed to establish a drawing academy where artists and scientists would happily mingle and learn from each other.

Color printing was similarly an art and a science at once. Or rather, it was two arts and two sciences. D'Agoty argued that his method of printing fundamentally differed from Le Blon's earlier, and imperfect, technology. Le Blon was not a bad artist, he was a bad philosopher. The difference between the two printmakers lay in the scientific theory they employed; like Le Blon, d'Agoty also believed in the theoretical foundations of artisanal knowledge. While Le Blon relied on Newtonian color theory, which was inadequate, d'Agoty offered a completely new, anti-Newtonian philosophy. In his *Chroa-genesie,* a two-volume, thousand-page condemnation of Descartes, Gassendi, Hartsoeker, and every other philosopher who ever existed, the French printmaker also destroyed Newton's *Optics* and, consequently, Le Blon's Newtonian printing technology.[108] To give only one example, D'Agoty repeated and printed a color illustration of the prismatic experiment, so much praised by Ten Kate, only to show its failure to prove the laws of diffraction. Newton was wrong to state that there were seven primary colors, but Le Blon and ten Kate were also wrong to claim that these seven could be reduced to three. In fact, there were two primary colors (white and black) and three secondary colors (red, yellow, and blue), or so d'Agoty wrote. Surfaces that completely absorbed light appeared black, and opaque objects that reflected all light appeared white, while the three secondary colors of blue, yellow, and red were produced by the co-presence of black and white substances in one object. All other hues were produced by the admixture these five primary and secondary colors.

D'Agoty's revolutionary color theory revealed him as the proper inventor of color mezzotints. Le Blon's method was defective, or so d'Agoty charged, because it was impossible to reproduce true black with three engraving plates inked with blue, yellow, and red pigments. To remedy this shortcoming, the accusation continued, the German-Dutch printmaker secretly hand-colored his prints with a black paintbrush. Clearly, this was a sham and not an invention. Armed with his new optical theory, d'Agoty instead prepared four plates inked with Prussian blue, ochre yellow, cinnabar, and German black, and pressed them on white paper, the fifth color.[109] This was the only scientifically sound and technologically viable method to mechanically reproduce the color spectrum on paper, and that is why d'Agoty deserved praise, patents, and profits galore. Interestingly enough, modern inkjet printers still operate with four pigments. Whether or not we accept the arguments for his convoluted optical theory, the French artisan was ultimately

right when it came to technological practice: it is very difficult to produce faithful representations of nature by using only three inks.

SECRETS, ART, AND ARTISANAL KNOWLEDGE

Remember the debate between Ruysch and Bidloo. The two Dutch entrepreneurial anatomists made a career from producing high-end representations of the human body. In their competition for the same consumer base, they developed two highly complex and opposing philosophies of visual representation to gain an edge over each other. One could observe the same dynamics between Le Blon and d'Agoty. In order to distinguish himself from Le Blon, d'Agoty branded his printing method anti-Newtonian, and promoted his mezzotints by publishing journal articles, pamphlets, and lengthy volumes about the scientific novelty of his artisanal work. D'Agoty's commercial interests stimulated scientific and philosophical debate, bringing forward new arguments that were closely followed throughout Europe. In Frankfurt, Johann Friedrich Armand von Uffenbach read with interest an account of d'Agoty's printing method in the *Hamburgisches Magazin*, and even excerpted it in his diary.[110] Johann Friedrich might also have played an important role in introducing d'Agoty to Goethe, who cited the French artisan's work with approval in his *Farbenlehre,* this curious scientific masterpiece of the renowned German poet.

The story of Le Blon and d'Agoty also revealed how artisanal work and invention were reconceptualized as scientific theory in the early Enlightenment. Artisans and art theorists like Le Blon, ten Kate, and d'Agoty believed that the production of beautiful images was dependent on the proper application of the laws of science. While they disagreed about the importance of Newton, they were all committed to performing experiments that would reveal the regularities of nature in optics, the human body, and artistic work itself. As d'Agoty wrote eloquently, "the real artists are scientists because their actions are always grounded in some science, and they are only called artists because they join handywork to their knowledge."[111]

Le Blon and ten Kate, as well as Prince Rupert and his circle of mezzotint *aficionados,* also argued that the transformation of artisanal knowledge made it communicable, and therefore prone to piracy. As this chapter has suggested, the ideas of Le Blon and ten Kate were also taken up by government bureaucrats in the course of the eighteenth century, turning artisanal knowledge into a commodity protected by intellectual property rights. D'Agoty encountered this new regime during his protracted battles with Le Blon's estate and the royal

administration in the 1740s, and tried to exploit it to his advantage. Yet belief in the communicability slowly began to work against him in the following decade. His exclusive privilege was about to expire, knowledge about color printing had spread widely since Le Blon's death, and Gautier de Montdorge was just about to publish a detailed description of the method.[112] He was losing ownership of the technology that he so desperately wanted to have invented. There was only one way out: to reverse the rhetorics of communicability, and to return to the earlier concept of artisanal epistemology. In a debate with an art conservator, d'Agoty therefore drew an important distinction between secrets and arts. As d'Agoty argued, "secrets can be communicated instantaneously, but several years are needed to acquire an art."[113] The conservation of paintings was a secret because it relied on one simple idea, and it could be communicated easily. But real artistic knowledge was different, precisely because it relied on science. D'Agoty's color prints were valuable objects because the artisan had studied medicine, anatomy, geometry, and optics for long years, and gained a scientific expertise unlike any-one else.[114] This was especially true for anatomical illustrations, as he immodestly explained, because "I want to make it clear that, in the world, only I am able to produce anatomical tables and to observe the objects, because I am anatomist, physician and painter at the same time."[115] Good artists may no longer have relied on ineffable qualities or on bodily experience, but they still needed to undergo a thorough education in the laws of science—an education that lasted decades.

As this chapter has argued, if there was an epistemic shift in early Enlighten-ment Europe, it was the reconceptualization of artisanal work in communicable, mathematical terms. Yet d'Agoty's eventual return to the belief that all knowl-edge, even when theoretical and mathematical, required a thorough education, and was therefore not immediately communicable, signals the fragmentary and limited nature of such epistemic shifts. The mathematization of natural knowl-edge might have created the preconditions for the emergence of the modern pat-ent system. Yet the losers in this new system immediately set to dismantling the theoretical underpinnings of the Enlightenment ideas of communicable science. Pitted in commercial competition against the beneficiaries of the new patent system, d'Agoty re-introduced the concept of tacit, artisanal epistemologies to claim his superiority in the markets for scientific prints.[116]

So can knowledge be communicated efficiently and quickly, or is it by its nature ineffable, tacit, and hard to acquire? Maybe the answer does not depend on the usual distinction between artistic and scientific knowledge. As this chap-ter has argued, the answer you get depends on the historical context in which scientific and artistic practitioners operate. As inventors of a new technique in

the wake of the Newtonian revolution, Le Blon and ten Kate considered their knowledge a mobile commodity, ready to be appropriated by pirates. They turned to secrecy and the emerging intellectual property system of Enlightenment Europe to protect their art. A pirate himself, d'Agoty tried out the same strategy for a while. He claimed to be the inventor of his method and guarded his business with a purchased exclusive privilege. And when the secret of his technique nonetheless became public, d'Agoty changed tack. To protect his market share, he argued that the essential ingredient of his technique was experience, a type of knowledge that could not be transmitted instantaneously. As long as Enlightened artisans could claim ownership of their knowledge, they tried to present it as a mobile commodity that they could trade with. Their individual expertise came to the fore only when they had already lost their monopoly rights.

❈ VII ❈

PETER THE GREAT
ON A SHOPPING SPREE

Let us take a last look at the entrepreneurial landscape of Dutch science in the last years of its Golden Age, this time from the perspective of a czar. In 1716, the Russian czar Peter the Great embarked on a trip to visit the Netherlands. After almost eleven months on the route, stopping in the city of Danzig and a variety of German towns, he reached Amsterdam on December 17, 1716. He had already visited that country in 1697. Back then, he had primarily been interested in enlisting the support of the Dutch in a war against the Ottomans, and also in establishing a modern navy on the Black Sea. Not too convincingly disguised as a manual worker, he learned shipbuilding technologies in the wharves, and also made an official request for two hundred ships from the Dutch. In 1716, the political purpose of Peter's visit was to engineer an alliance against Sweden in the ongoing Northern war. Like twenty years earlier, his diplomatic efforts were not fully successful. Yet his visit bore another fruit. It helped develop strong scientific, cultural, and artistic ties between Russia and Central and Western Europe. Peter and his entourage visited the studios and workshops of countless artists, artisans, and scientific practitioners. He was eager to become acquainted with the latest artworks and inventions that the Dutch Republic could offer.[1]

Throughout his reign, the enlightened monarch vied to create a reformed Russian state by adopting the most recent scientific, technological, and cultural fashions and achievements of Western countries. From the 1710s onwards, Peter programmatically purchased the most recent and available scientific knowledge

from his Dutch suppliers. Much of this knowledge was to serve utilitarian needs by creating a strong military and economy. Dutch artisans were lured to Russia to establish tobacco factories to reduce the country's reliance on foreign imports.[2] Ships and technologies of shipbuilding were purchased from England and the Netherlands to create a powerful navy. And, to provide for the army's health, officials ordered their annual supplies of pharmaceutical goods from no one else than Seba in Amsterdam.[3]

Other scientific commodities were imported rather to create a scientific ethos and increase familiarity with the world without an immediate utilitarian benefit.[4] In 1725, the Russian Academy of Sciences would be established where scholars, primarily from the Germanic and Dutch lands, would study planetary vortices, graph theory, and the anatomy of the elephant. Next to imported scholars, curious objects and illustrations of *exotica* were also brought to Russia to educate locals about the wonders of nature. These were first stored in Peter's personal collection of curiosities. As the collection grew, however, it became a site of public exhibition, housed first in the Kikin Palace near the Smolny monastery, and then at the Kunstkamera on the Preobrazhensky island. Since the 1720s, the collection has stayed on the same site, and many of its original exhibits are still available for viewing in the heart of the city.[5]

Natural history and anatomy, the focal points of this book, occupied a pride of place in the Kunstkamera. In the 1740s, anatomical specimens, animals, herbaria, and minerals filled half of the printed catalogue of the museum, while the other half was taken up by scientific instruments and the numismatic collection.[6] Many of these objects came from the Netherlands. As we have seen, Frederik Ruysch supplied the anatomical preparations, which were complemented with impressive anatomical atlases, including a manuscript Russian translation of the Bidloo's majestic *Anatomia humani corporis* from 1685. Exotic animals, preserved in alcohol, were purchased from the celebrated museum of Seba on the Haarlemmerstraat. The seashells came from the cabinet of the Dutch architect Simon Schijnvoet, and entomological and floral drawings were bought from the renowned artist Maria Sibylla Merian. Even the scientific instruments were of Dutch origins: they were made by the Leiden artisan Jan Musschenbroek and the Danzig immigrant Daniel Fahrenheit, who specialized in the production of thermometers. Antique coins, finally, could also be traced back to the cabinets of Nicolas Chevalier and Jacob de Wilde, two Dutch merchants with a penchant for history.

Many of these curious exhibits were purchased during Peter's visit to Amsterdam. On January 3, 1717, for instance, Peter authorized the payment of

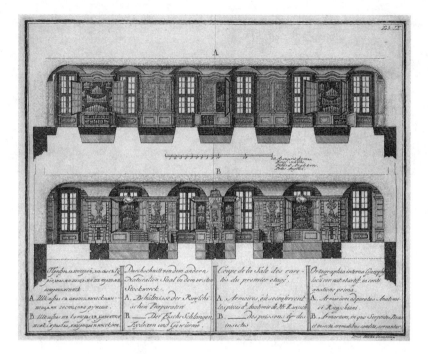

Fig. VII/1. A cross-section of the Imperial Library and the Kunstkamera. Schumacher, *Gebäude der Kayserlichen Academie der Wissenschafften*, Tab. IX.

3,000 guilders for two volumes of watercolors of flowers, butterflies, and insects by Merian. Other curiosities were bought in 1720, when Johann Daniel Schumacher, the court librarian of the czar, traveled through Europe to recruit scientists. Schumacher's "to-do list" included orders for him to "make drawings of the models of machines that are found in the observatory" of Paris, "to send here the gardener who used to work for Mr. De la Court in Leiden," "to get people from England who can perform experiments and make the necessary instruments," and, importantly, "to visit the museums of learned men, both public and private, and to find out how these differed from the collections of his Imperial Majesty."[7] Schumacher could also make further purchases if he found some curiosities in these collections that Peter had not yet possessed.

Yet the Russian court had already arranged to buy many scientific curiosities before Peter embarked on his trip to Europe. Seba sold and shipped his collection of *naturalia* to Saint Petersburg in 1716, months before the czar arrived in Holland. Discussions about the purchase of Ruysch's anatomical cabinets also began that year, although the sale was finalized only during Peter's stay in the

Netherlands. Clearly, these transactions were made possible because Ruysch and Seba had already established contacts with the czar's personal physician and other scholars in Petersburg, and supplied the Russian court with information on what was trending in Amsterdam. The fame of Dutch science had reached Russia before the czar embarked on this voyage, and not only because of Peter's earlier visit.

As this book has argued, the infrastructural innovations of Dutch merchants greatly facilitated the Russian czar's purchases.[8] With the rise of the Dutch colonial empire, mercantile networks connected the various Dutch cities with Deshima, Batavia, the Cape of Good Hope, New Amsterdam, and Moscow. From the early seventeenth century onwards, the Dutch maintained an active trade with the Russian Empire through its merchant port in Archangel. In 1664, the wealthy Nicolaas Witsen visited the Russian capital as part of an embassy, the starting point of this virtuoso's fifty years of research into the geography, natural history, and curiosities of Russia and the Far East.[9] By the time of Peter's childhood, many Dutch merchants had settled in the Nemetskaya Sloboda in Moscow, where the young czarevich could satiate his desire for the knowledge of foreign lands by learning Dutch.[10] Ruysch and Seba relied on these networks when shipping specimens and transferring money between Russia and the Netherlands.

Dutch scientific entrepreneurs also developed their own innovations to facilitate the commerce of natural knowledge. They exploited the growing print culture to advertise their valuable curiosities through private correspondence and printed pamphlets, journal articles, and books. Seba advertised his *Thesaurus* in the *Bibliothèque Raisonnée* in advance of publication, had a positive review of the work placed in the same journal, and offered a discount for subscribers to all four volumes. The Dutch print networks also informed the Russian elite of what products Seba and Ruysch had on offer. Ruysch printed catalogues of his museum, where all his specimens were listed, and Seba wrote up a manuscript trade catalogue of his stock of exotic animals. Peter's court had simply to wait in St. Petersburg, because Dutch tradesmen would approach them with their scientific wares, anyway.

To identify what objects they wanted to order, the Dutch and their trading partners did not rely only on sales catalogues. The blooming trade of plants profited from the proliferation of illustrated encyclopedias of natural history. As an earlier chapter recounted, Johannes Amman at the Petersburg Botanical Garden did not treat these works only as the description of nature's bounty. He considered them a universal catalogue of what one could potentially purchase on the markets of natural history. The correspondence of Amman and other natu-

ralists in the period is peppered with orders of plants, shells, and insects that are identified by reference to an entry in a repertory. Because all naturalists tended to own copies of the most renowned treatises, it was assumed that referencing these works could facilitate scientific communication across borders. Entrepreneurial naturalists turned the luxurious products of the scientific book trade into tools of trade, a transformation that coincided with the move away from Renaissance histories of nature to the era of taxonomical encyclopedias like Martin Lister's and Filippo Buonanni's conchological works.

Preservation was the third innovation that played a crucial role in the international trade of natural history. How would you be able to sell and ship your scientific wares if they rotted halfway through their journey to the customer? All natural specimens are subject to decay, and it is hard to overestimate the importance of De Bils' and Ruysch's inventive methods of preparation. Even three hundred years after the czar's purchase of Ruysch's cabinet, one can admire the specimens in Petersburg in their full beauty, with only a few signs of deterioration. For the scientific trade, distance was just as much a problem as the passage of time—both because it was costly to transport bulky items like elephants and other animals, and because of the fragility of many curiosities. How could you ensure that your objects do not break during a storm on open seas? When the Musschenbroeks, the authors of the first Dutch sales catalogues of scientific instruments, filled an order of the Russian court for an air pump, they carefully wrapped its parts in paper, cased it in four boxes, specified how the boxes needed to be carried and opened, and enclosed detailed instructions for assembly. As they specified, the glass container of the air pump needed special care when handling because it was extremely brittle.[11]

CIRCULATION

Because of their entrepreneurial behavior, Ruysch, de Bils, Seba, Breyne, Bidloo, Le Blon, and ten Kate do not quite fit our image of honor-bound, gentlemanly natural philosophers who considered the fray of business below their status. For long, historians used the concept of the Republic of Letters to describe international scholarly communication within early modern Europe. Scholars in this Republic were apparently bound together by their subscribal to the common ethos of the disinterested pursuit of science, and exchanged knowledge and specimens in a gift system. Yet this book argued that the circulation of knowledge was a mercantile occupation throughout the period. Postal service was a luxury: to put letters, specimens, and people in motion, one needed to expend consid-

erable amounts of money. Naturalists had to have an astute eye for finance to maintain the international networks of science, and a familiarity with the commercial world of transportation and shipping. The entrepreneurial practitioners studied in this book not only relied on the mercantile infrastructure of the Dutch Republic, but also adopted its commercial ethos. They balanced their interest in furthering knowledge with a desire to keep their accounts in the black. They used scientific exchanges to turn a profit, not only to maintain the social fabric of an intangible Republic of Letters.

How did objects and knowledge travel in the commercial world of these entrepreneurs? Historians who study the circulation of knowledge often focus on how the local context changes the nature of scientific information in motion. In this vein, scholars have argued that cacao beans from Jamaica received new meanings when arrived in eighteenth-century London, and Sufi mysticism facilitated the welcome reception of Copernican theories in Ottoman Turkey.[12] This book instead analyzed how commercial circulation itself changed the nature of scientific knowledge, regardless of the local conditions at the place of origin and destination. Whether they acquired curiosities in Suriname, Batavia, or Den Bosch, Dutch practitioners turned them into objects of trade, and sold them to any interested customer from Russia, England, Germany, or France. It required a lot of transformative work to turn knowledge into a universal commodity, and the Dutch put a lot of efforts into creating an infrastructure for making objects mobile.

At a theoretical level, it is probably best to picture the circulation networks of Dutch science as operating at three different scales of value. These multiple networks of circulation were tightly connected. While monetary considerations played a different role at each level, the ultimate aim of this system was to produce commercial gains. At the bottom rung of circulation, free or cheap objects facilitated the production and sales of commodities. Advertisements in the *Amsterdamsche courant* or museum and trade catalogues exchanged hands for free, as gifts, or, in the case of Ruysch's *Thesauri*, for a few stuivers. This book argued that even the other printed publications of Ruysch could be interpreted as practically free advertising materials, as their price was a fraction of the cost of a specimen. Some anatomical preparations could belong to this category of objects, as well. For his anatomical publications, Govard Bidloo prepared some specimens that helped him design better illustrations. These specimens were experimental tools, not commodified representations of the human body. Consequently, most of them cost a few guilders at most. Johannes Rau's specimens were similar, disposable tools with little financial value. When Bernhard Siegfried Albinus

cataloged Rau's donation to Leiden University, he discarded the duplicates without organizing an auction for them. For entrepreneurial and well-to-do scientific practitioners, such advertisements and disposable tools were the necessary by-products of their business that could circulate freely because there were of little inherent value. Obviously, such a valuation did not reflect the opinions of all their customers. Poor students visiting from Transylvania might well have considered such a catalogue the most they could afford to buy as souvenir, and cherished them dearly when they returned to teach or preach back home.

Ruysch's preparations, Bidloo's and Seba's atlases, and even Le Blon's color mezzotints belonged to the second tier of value. They were the prime commodities that scientific entrepreneurs were trading with, ranging in value from a few to several dozen guilders. Le Blon's mezzotints were sold at roughly 3 guilders a piece, Ruysch's specimens cost 15 guilders on average, Bidloo's atlas was 30 guilders, and a single volume of Seba's *Thesaurus* cost almost 60 guilders. Such commodities could be bought in the curiosity shops that Uffenbach visited, in a bookshop on the Kalverstraat in Amsterdam, in pharmacies like Seba's, or at the auctions of deceased collectors. Selling one such specimen did not change an established scientific practitioner's financial status to a measurable degree, but a steady trade in such objects could provide a continuous flow of income to successful entrepreneurial practitioners. Not that every entrepreneur succeeded. While Seba amassed a fortune from his pharmaceutical business, which included a vigorous trade in curiosities, Le Blon never managed to stay afloat financially despite his numerous ventures in Amsterdam, London, and Paris. Ruysch's, Bidloo's, and Seba's commodified specimens and atlases were too expensive to enter free circulation, but were cheap enough to be exchanged as valuable gifts on occasion. In such cases, both donor and recipient were acutely aware that the gift was costly and a counter-gift was expected. Ruysch sent several specimens as a gift to Petiver in London, who acknowledged these donations in his *Gazophylacium naturae et artis decades*, but the Amsterdam anatomist charged for similar specimens when sending samples of his collection to Petersburg. And in sending such gifts to Petiver, Ruysch probably expected specimens of equal value in return. When the English collector turned out to offer only cheap and common insects in his exchanges, for example, Maria Sibylla Merian told him outright to send cash, and not unworthy counter-gifts. When valuable commodities circulated as gifts, one still kept accounts with credits and debits clearly marked with a price.[13]

At the third tier of value, no gift exchanges were possible. Exotic quadrupeds, whole collections, the complete print run (or copyright) of an atlas, trade secrets,

and patents were too valuable to be exchanged for anything else than money, with the amount specified in a notarized contract. Seba's collection of *naturalia* was worth over 24,000 guilders, and Ruysch's first cabinet cost even more. As we have seen, the investment costs into Seba's *Thesaurus* were in the ballpark of tens of thousands of guilders, and, given the involvement of four publishers in printing Bidloo's *Anatomia,* it must have been an expensive enterprise, as well. Once artisanal invention was turned into a commodity, it was traded for similarly high amounts, as well. Ruysch's secret of preparation cost five thousand guilders to the Russian court, and d'Agoty needed to purchase Le Blon's exclusive privilege for money when starting his own enterprise. One could not acquire these trade secrets during polite conversation, as the Uffenbachs hoped when visiting Le Blon in Amsterdam. They were simply too valuable. Selling a cabinet or an invention was a lifetime event in one's financial career, securing one's financial well-being for decades to come. No wonder that Ruysch obsessed over the details of his contract with Peter the Great for months, that Bidloo and his publishers began a campaign against Cowper's improperly credited edition of the *Anatomia,* or that Seba's heirs spent more than a decade with sorting out who inherited the late pharmacist's *naturalia.* At this level, the customers of Dutch scientific practitioners were sovereigns, aristocrats, wealthy merchants, or consortia of rich entrepreneurs: the czar, Hans Sloane, and d'Agoty's financial backers.

The commercial culture of the Netherlands thus supported three different circulation networks: the free exchange of marketing materials and disposable research tools, the cash and partially gift economy of individual specimens and books, and the occasional sale of a whole cabinet, an invention, or the right to publish an encyclopedia. When anthropologists study such multiple networks of circulation, they often consider them mutually exclusive. In Western medicine, kidneys, blood, and other body organs circulate in strict exclusion from the omnipresent cash economy; it is legally forbidden to buy a new kidney for yourself. The Polish anthropologist Bronisław Malinowski argued similarly a century ago, claiming that the Melanesian Kula exchange of armshells and necklaces to gain social status was conducted outside the regular barter of commodities with a use value.[14] Yet within the triple exchange system of Dutch science, free materials, frequently traded commodities, and precious secrets were not incommensurable.[15] No one banned the exchange of museum catalogues for the collections themselves, and the monetary economy helped establish the relative financial value of such objects. While Ruysch's museum catalogues mostly exchanged hands for free, they sold at library auctions for less than half a guilder, raising the distant, but distinct possibility that one could exchange them for a specimen: you only

needed to have fifty of them at hand. Similarly, the sale of Bidloo's preparations could have supported his widow for several months, even though their value was dwarfed by Ruysch's cabinets. At the other end of the spectrum, the boundary between individual specimens, cabinets, and trade secrets was even more porous. A collection was nothing more than a large number of curiosities stored together; and mechanical invention is nothing more than the ability to produce, or reproduce, thousands of identical specimens. The commercial circulation of Dutch anatomy and natural history can therefore be best pictured along a continuum with three markedly different but not incommensurable price ranges.

Anthropologists often contrast gift exchanges, which serve to build a society, with cash economies that tend to reduce the accumulation of social capital into impersonal exchanges with no emotional ties established between salesperson and customer. By and large, this book supports this claim. Financial transactions did not turn Ruysch into a client of Peter the Great. His sale of the cabinet was not the beginning of a meaningful relationship between the two, it was its desired endpoint for both sides. Similarly, the commodification of technological knowledge promised to reduce the importance of personal contact between artisans. Le Blon and his fellow artisans strongly (and falsely) believed that it would ultimately become possible to communicate Enlightenment technology by exchanging impersonal pieces of text, and not through passing on embodied knowledge via apprenticeship. The international orientation of Dutch practitioners might at least partially explain their emphasis on such a monetary economy. Exchanging information and objects with their long-distance colonial correspondents and their European customers, they could not rely on the honor system of a traditional, closely knit society. They were not out there to build a nation, or to establish an intangible, learned, or civil society across the borders of fragmented Europe and its colonial world. They invested into a commercial infrastructure that only facilitated earning a profit.

REPRESENTATION

Take a look at the frontispiece of Levinus Vincent's *Wondertooneel der Natuure*.[16] It brilliantly summarizes the commercial and transnational orientation of Dutch scientific practice. A contemporary of Seba, Ruysch, and Le Blon, Vincent was a damask merchant and amateur *virtuoso*, whose collection of *naturalia* was praised in equally high terms by Peter the Great, the Uffenbach brothers, and James Petiver.[17] The *Wondertooneel* provided an illustrated account of Vincent's curiosities, and its frontispiece offers an allegorical representation of his cabinet (and,

Fig. VII/2. An allegorical representation of Vincent's cabinet. Vincent, *Wondertooneel der nature*, frontispiece.

synecdochically, of Dutch collections in general), displaying the intricate connections between commerce, natural history, and visual representation. Vincent's collection is shown in a classicizing, oval room with an open ceiling revealing the sky and the sun above. As the designer Romeyn de Hooghe explained in a short, interpretive essay, the room is framed by two allegorical women on the

side, and four allegorical persons on the bottom. At the bottom left stands the male personification of Research with a butterfly net to catch exotic insects, busily uncovering the numerous breasts of Isis, the bountiful goddess of Nature. The globe under the arm of Isis, and the personifications of America and Africa on the frieze, indicate the global reach of natural history. Vincent did not only collect and study the plants and animals of Europe, his interests encompassed *exotica* from all corners of the world. Turning to the bottom right, viewers of the frontispiece can encounter *Liefhebberij* (the personification of Collecting or Curiosity), pictured with a bottled specimen and Mercury's staff in his hands. A pen behind the ears signifies *Liefhebberij*'s desire to describe and depict the crabs, corals, seashells, pinned butterflies, bottled snakes, and Surinamese toads in illustrated atlases, and a folded letter in his right hand reminds viewers of the importance of postal networks.[18] The frontispiece leaves no doubt that description and correspondence are the bread and butter of anyone with a serious interest in collecting natural history. And, as the personified Navigation reminds us, with a nautilus shell helmet and an oar in her hands, seafaring provides the necessary infrastructure for sending and receiving specimens, letters, and information across the globe.

Vincent's frontispiece reveals how Research, Nature, Collecting, and Navigation were all connected in the global pursuit of knowledge. A pursuit that was inherently commercial, as Mercury's staff reminds the viewers. Vincent not only acquired his specimens through the global networks of trade, he also engaged in the active business of brokering scientific transactions and selling curiosities. Profit from this trade was of essence to Vincent, who took a 50% commission on any book ordered through him, as we learn from Merian's complaints to Petiver. Similarly to Ruysch, Vincent's publications could also be understood as a sales catalogue of the author's collection. In 1725 Vincent sent an uninvited letter to Hans Sloane, offering his collections on sale. Referring to his recent publication on the Surinamese toad, which Sloane had already received, Vincent wondered whether British collectors would perhaps "decide to purchase the two small cabinets, described in the new description, inserted in the book on the frog at fols. 86 and 87, numbers 8 and 6."[19] Nature collected was nature on sale.

As this book has argued, Dutch natural history and anatomy were a visual enterprise. The two allegorical figures flanking Vincent's cabinet are reminders of this fact. The ancient art of Painting is portrayed on the right, in the act of sketching a water color of East and West Indian flowers in a pot. On the left, one can see Embroidery, the pastime Vincent's wife indulged in, imitating nature with a needle, thread, and beads. Painting, Embroidery, *Liefhebberij* with a pen,

atlases, and bottled specimens emphasize how imaging techniques were at the heart of natural history, or, indeed, all facets of natural inquiry. One learned about the world by collecting and producing visual facts.

The omnipresence of images in Dutch Golden Age science should not be taken as self-evident. In recent years, historians have offered powerful evidence of the complex, and by no means straightforward, sixteenth-century debates that led natural historians and anatomists to embrace visual methods. It was not necessarily true that pictures were the best way to study, represent, and teach all of nature's secrets. As the sixteenth-century naturalist Sébastian Monteux argued, for example, the medicinal value of a plant could not be distilled from a picture, because its shape could be subject to variation without substantially changing its pharmaceutical effect.[20] By the end of the seventeenth century, however, such doubts dissipated into thin air, and would be only briefly revived by Linnaeus. The Dutch fully embraced images in all branches of scientific practice. Instead of pitting visual methods against a tradition of textual exegesis, Dutch scientific practitioners focused on developing new imaging techniques to better and better represent nature. In astronomy, Christiaan Huygens was just as famous for his improved telescope as for his mathematical discoveries, and Dutch readers devoured Newton's *Optics* with no less interest than his controversial theory of gravitation in the *Principia*. In the life sciences, Leeuwenhoek's powerful microscopes, Ruysch's preparations, and Le Blon's color prints were only the tip of the iceberg when it came to the proliferation of scientific imaging techniques. During his visits to the Netherlands, Peter the Great also caught the infectious obsession with images, as his purchases of preparations, dried specimens, globes, and watercolors evince. The Kunstkamera in Petersburg could be fairly described as a storehouse of scientific representations, especially when one learns that the Russian court even ordered that drawings should be made of each and every exhibit in the collection. The real museum was replicated in a paper museum in case the original specimens decayed or burned.

We might think that the two- and three-dimensional representations of Dutch practitioners had an easy purchase to factuality. Early modern prints— for example, Bidloo's *Anatomia* or Ruysch's illustrated museum catalogues, often bore the caption "ad vivum" or "from the life," claiming to truthfully mirror nature.[21] Shorn from the theoretical flourishes of language, visual facts could be expected to capture the look of a particular plant, animal, or human organ without the distorting effects of the unbridled imagination. Yet, as it has been argued most forcefully by Lorraine Daston and Peter Galison, claims to factuality and objectivity can come in many different guises.[22] The visual facts of early modern

science encompassed complex and powerful theoretical presuppositions about the world in a condensed format. As Daniela Bleichmar has argued, for instance, they reflected the social, cultural, racial, and gendered "blind spots" of naturalists.[23] The creators' philosophical commitments and professional training, in the arts or in the science, could also leave their stamp on the image.[24] The creators of images were often committed to a particular scientific theory, which they then used as a guide in producing a truthful representation. It fell to competing artists and naturalists to point out that such presuppositions and theoretical foundations brought into question the factual value of images.

As this book has argued, the commercial culture of the Netherlands played a hitherto unappreciated role in the formation and shaping of visual facts. Financial concerns mattered so much because the production of representations was expensive. One needed to have a mercantile attitude to successfully manage the heavy financial investment that etchings, color mezzotints, or anatomical preparations required, and considerations of profit could even lead to the falsification of authorship, as the contorted publication history of Seba's *Thesaurus* revealed. In addition, new types of visual facts were developed to facilitate the commercial exchange of specimens. The seventeenth-century encyclopedias of botany, conchology, and entomology moved away from the Renaissance genre of *historia* to a more taxonomical approach in order to help collectors identify specimens in their long-distance exchanges. Taxonomy, this abstracted mode of representation so eloquently analyzed by Foucault, did not simply make a general statement about how the essence of things could be visualized. The new encyclopedias of natural history were designed as tools to perform certain tasks for an audience of collectors in a commercial environment. Representation was, after all, a functional, performative act.[25]

The most important effect of commerce was to engender an active debate about the nature of visual representation. Entrepreneurial practitioners constantly competed with each other to develop more advanced, and marketable, methods of visualization that offered an edge over existing technologies. Their vocal dissatisfaction with previous and competing imaging techniques might have been couched in philosophical terms, but was ultimately fueled by the desire to gain customers in a highly competitive environment. As the debates of Bidloo, Ruysch, Le Blon, and d'Agoty exemplified, marketplace competition engendered complex epistemological debates over how one could best picture the human body, and what optical theories lay behind the technology of color printing. Etchings, mezzotints, and preparations did not peacefully coexist to reveal in various *media* the same face of nature. They offered representations that were

mutually incompatible and relied on divergent metaphysical assumptions of what were the basic buildings blocks of human life or light. The scientific marketplace prevented the development of a unitary visual epistemology.

In *Objectivity*, Lorraine Daston and Peter Galison have argued that the early modern period was marked by truth-to-nature objectivity, a regime of abstracted and idealized images. While nineteenth-century scientists were wedded to the unadulterated, mechanical representation of particular events, the erudite scholars of earlier periods found it advisable to correct and improve upon single observations on the basis of their learned judgments. Yet, as Sachiko Kusukawa pointed out, at least for the sixteenth century, Renaissance naturalists actively debated whether to use idealized or particularistic images, or no images at all.[26] This book has taken Kusukawa's argument further by showing how commercial considerations led to the development of a plethora of conflicting visual epistemologies. While taxonomical encyclopedias followed the principle of truth-to-nature objectivity, Frederik Ruysch's specimens could be best described in the terms of a particularistic, mechanical objectivity that Daston and Galison find typical of the nineteenth century. Moreover, Bidloo's *Anatomia* revealed a new type of representation that blurred the boundaries between objectivity and subjectivity. As the Leiden professor argued, nature was inherently playful and did not strictly follow any regularities. There was a large amount of variation in human anatomical structures at the microscopical level. As a result, scientific illustrators did not have to slavishly follow any particular observation of a cadaver, or establish a new, idealized model of the human body. They could freely rely on their creative powers in drawing the minutest details of the body. Given the degree of variation within the human population, even if the illustrator invented some of the particularities of an anatomical structure, without relying on first-hand observation, at least a few specimens would most probably conform to that constellation. Nature's playful creativity would always trump the imagination of the artist.

DEBATE

Petrine Russia was an absolutist empire, and the czar took a direct interest in running the country as his personal enterprise. In Russia, what counted as a scientific fact was ultimately determined by imperial *fiat*. The czar himself was a scientific practitioner. He learned dentistry, and practiced his skill by pulling the teeth of his courtiers. Throughout Russia, he ordered that all live and dead monstrous humans should be brought to the Kunstkamera where they could be exhibited. Within Russia, imperial reform and scientific endeavors were closely

intertwined. Peter's case is part of a larger pattern. Sociologists of science have long realized that the formation of scientific consensus is dependent on political context. In tracing Galileo's career in the Medici court, Mario Biagioli found that the duke Cosimo played an important role in creating scientific consensus, not unlike the situation in Russia.[27] Simon Schaffer and Steven Shapin argued that, concerned by the possibility of a new Civil War, the aristocrats of Restoration England avoided creating unnecessary disagreement, and considered a scientific consensus the equivalent of gentlemanly civility.[28] Yet not all political constellations foster the development of such a consensus. The early modern Dutch Republic has long been recognized for its active culture of political disagreement and political debate without an absolutist court to resolve political matters at once. As Maarten Prak has observed, the mystery of the Dutch Golden Age is that the country prospered despite its decentralized and highly conflicted structure of government.[29] Did such a relative vacuum of political influence lead to the dissolution of scientific consensus in the Netherlands? Not necessarily so, claims Harold Cook.[30] Cook has argued eloquently that the commercial culture of the Netherlands fostered the development of a scientific environment that placed value on verifiable, empirical knowledge. Trading at a long-distance is only possible when the contracting parties trust each other, and, as a result, Dutch merchants actively promoted agreement on scientific facts that they then could trade with. For Cook, modern science emerged from this trade of natural knowledge where every actor had a deep-seated interest in reaching a consensus, and sealing a contract of sale.

This book took an opposing view of the impact of commerce on science. The mercantile culture of the Dutch may have driven them to desire to found their knowledge on trustworthy, universally accepted, empirical facts, but I don't think these utopian dreams were ever realized in the commercial practice of the day. The Dutch were willing to cooperate on developing a commercial infrastructure for long-distance exchange, but had little incentive to agree on what scientific objects were the most valuable to trade with. All merchants in Amsterdam held an account in the *Wisselbank*, international money transfer was no longer an issue for businessmen and travelers, and insurance companies lessened the risks involved in shipping across the seas. Merchants were able to trade with each other thanks to these innovations, but did not agree with each other. Commercial competition fostered scientific debate. While entrepreneurial practitioners had incentives to convince their customers about the veracity of their scientific claims, they did not need to come to an agreement with their competitors. Instead of selling the same knowledge, each scientific practitioner hoped to have

a monopoly on his or her own, special product. Ruysch, Seba, Bidloo, Le Blon, d'Agoty, and even Vincent branded their commodities as novel, revolutionary, and fundamentally incompatible with other classes of scientific objects. Interestingly, their internecine debates were never resolved. Instead of reaching a consensus, Dutch scientific practitioners remained locked in what economists call an unresolved *coordination problem.* No sovereign or scientific academy ever issued a resolution of the fight over the relative values of preparations, engraved atlases, or any type of color print. As we have seen, when Bidloo asked the Royal Society to issue a judgment over William Cowper's rather straightforward plagiarism of the *Anatomia,* the British institution refused to engage in the two fellows' argument. Even today, there is no agreement whether two- or three-dimensional representations are the best medium to study and memorize the numerous structures of human anatomy.

Was the presence of a commercial incentive for entering into scientific debates a bad thing? Scholars of late modern technoscience often justly decry how some companies artificially promote ignorance for the purposes of commercial gain, and have shown masterfully how certain industries intimidate scientists and falsify data to undermine the consensus over the causes of lung cancer or manmade climate change.[31] The Dutch Republic did not lack similar cases of ethically problematic behavior. The Dutch East India Company ruthlessly exploited its monopoly and censored books that challenged its incorrectly benevolent interpretation of its colonial rule of the Spice Islands. And, as we have seen, Seba's wealthy heirs hired ghostwriters to fool their publics into buying a forgery of the *Thesaurus.* Yet, arguably, commercial competition did not only have negative effects over the scientific culture of the day. The commodification of science forced entrepreneurial practitioners to propose novel arguments as to why their scientific and technological inventions actually worked. Instead of reaching consensus, they kept on producing philosophical and scientific arguments that, despite the harsh, *ad hominem* asides, I find fascinating even today. Despite their commercial genealogy, the visual epistemologies of Ruysch, Bidloo, Le Blon, and d'Agoty offer valuable philosophical insights for a disinterested observer from three centuries away. It is a pity, though, that these heated conversations usually remained at the level of scientific theory and philosophy. Entrepreneurial secrecy ensured that few of them willingly disclosed the technological details and methods of producing visual representations. The divergence of science and technology had already begun.

Perhaps modern science did not emerge by establishing consensus over new scientific discoveries. This book has suggested that it is better characterized by

the complex philosophical debates that commerce engendered. Instead of focusing on how scientific knowledge gets stabilized, historians might need to pay more attention to how it is commodified and debated. All scientific consensus is overturned eventually, as knowledge accumulates across the centuries, but philosophical arguments, and the commercial context that sets them in motion, recur again and again. Disagreement, not consensus, lies at the heart of the modern scientific enterprise.

EPILOGUE

By the close of the eighteenth century, the glory of the Netherlands had lost some of its former lure, even in the field of science.[32] Britain and France slowly became more and more powerful competitors, and the industrial revolution, with its scientific and technological inventions, would become associated with the English, and not the Dutch. Then the country was occupied by the revolutionary French army in 1795, and the princely collections were transported to Paris. Thanks to international commerce, the renowned collections of Dutch naturalists became dispersed, to decorate the shelves of Uffenbach's residence, the cabinets of Peter the Great, or the collections of English, French, or Swedish notabilities. The archives of Dutch naturalists and physicians were also on sale, and scholars of early modern Dutch science often find that their sources are available in English, Russian, or German archives, and not necessarily in the Netherlands. In tracing the networks of these entrepreneurial networks, oftentimes I found myself following in the footsteps of the Uffenbach brothers, sitting in libraries in Oxford, visiting the bookstores of the Kalverstraat in Amsterdam, or looking at dusty manuscripts in the Germanic castles of erstwhile dukes. Doing transnational history today is not unlike studying natural history and anatomy a few centuries ago.

New discoveries, moreover, made many of the earlier inventions of Dutch scholars appear irrelevant. Color mezzotints became obsolete with the advent of lithography. Ruysch's particular method of preparation fell into oblivion, as other physicians perfected their own methods of preserving specimens. Empty shells went out of fashion in natural history, turning conchological collections into objects of aesthetics, and not of science.[33] And, in the nineteenth century, evolutionary biology slowly began to overshadow taxonomy, just as classification had supplanted the earlier, Renaissance histories of nature. Yet the impact of commerce on scientific work did not disappear. As Charles Darwin wrote a good 150 years after Ruysch and Seba, his own talent lay in "keeping accounts, replies to correspondence, and investing money very well."[34] And, in twenty-first-century

America and Europe, commerce and science are still tightly connected. This book focused on the relationship of commodification, visual representations, and science in the early modern Netherlands, and late modern scenarios of entrepreneurial science obviously differ in many respects from the practice of three hundred years ago. Yet, looking back at the stories this book has told, the differences might loom less large than the similarities. The more I learned about the characters in this book, from Seba through Merian to Bidloo, the more I was struck by how their concerns resonated with the issues of contemporary science today. Every once in a while, then, the historical enterprise might benefit from drawing parallels between two distinct historical eras, instead of enumerating all their difference-making details. The story of this book was set in the early modern Netherlands, but it could be retold in the twenty-first-century world, too.

ACKNOWLEDGMENTS

First I would like to thank Ania and Lily. Thank you.

This origins of this book go back to my years at Harvard's History of Science department. Throughout those years, I gratefully enjoyed the measured financial support of the university. I did further research during a year I spent as a postdoctoral fellow at Northwestern University's Science in Human Culture program. The book took its final shape at Hunter College's History department. At all these three places, I am deeply thankful to my colleagues (grad students, faculty, and administrators), whose contributions to this work are too numerous to recount.

I could conduct my research in Europe and in the United States thanks to the financial support of various institutions. I express my gratitude to the Committee on Graduate Studies at Harvard, the Minda de Gunzburg Center for European Studies at Harvard, the Social Science Research Council and the National Science Foundation (award SES-0621009), and the Hunter College Presidential Travel Award. At an early stage of research, the New York Academy of Medicine awarded me a Paul Klemperer fellowship. While I stayed in London, the Wellcome Trust Centre for the History of Medicine at UCL provided me with a scholarly community. In the Netherlands, I am grateful for the hospitality of the Institute for the History and Foundations of Science at Utrecht University. The Descartes Centre for the History and Philosophy of the Sciences and the Humanities in Utrecht provided me with the opportunity to revise the manuscript under ideal conditions during the months I spent there in 2011 and 2012. I was able to put the finishing touches to the book while I was the Birkelund Fellow at the Cullman Center for Scholars and Writers at the New York Public Library, the best place for pursuing scholarly and creative work. I am truly grateful to Jean Strouse, Marie d'Origny, Caitlin Kean, Paul Delaverdac, and all the other fellows for making my year at the library pleasurable.

My research has been facilitated by several libraries, archives, and museums. In Cambridge, I am thankful that I could use the collections of the Houghton Library, the Museum of Comparative Zoology's Rare Book Room, the rare book collections of the Botany Libraries, the Francis M. Countway Library's Center for the History of Medicine, and the

Fogg Art Museum. In Chicago, I am thankful to the librarians at the Northwestern University Library, and at the Regenstein Library of the University of Chicago. In New York, I would like to thank the librarians of the New York Academy of Medicine, and especially Arlene Shaner. In Amsterdam, I am grateful for the help of the librarians at the University of Amsterdam, and especially at the Artis Library. I am also thankful for permission to use the holdings of the Municipal Archives of Amsterdam, the Rijksmuseum's print cabinet, and the Tropenmuseum's library. In Utrecht, I would like to thank staff at the University Library's rare book collections, and at the Municipal Archives. In Leiden, I would also like to thank the staff of the University Library and the Municipal Archives. I am especially grateful for permission to visit the Leiden University Medical Center's Anatomical Museum. In The Hague, I am thankful to staff at the Nationaal Archief, the Koninklijke Bibliotheek, and the Municipal Archives. In Erlangen, I am very grateful to the librarians of the University of Erlangen for granting me access to the Trew Collection. In Gotha, I would like to thank the librarians of the Forschungsbibliothek Erfurt-Gotha. In Göttingen, I express my gratitude to Dr. Helmut Rohlfing and the librarians for providing access to the Uffenbach manuscripts. In Saint Petersburg, I am thankful to staff at the Archives of the Russian Academy of Sciences, St. Petersburg branch, and at the Kunstkamera. In London, I am thankful to staff at the British Library, the British Museum, the Wellcome Library, and University College London Library. In Oxford, I benefited from visits to the Bodleian. In Paris, I would like to thank the staff of the Archives nationales, the Bibliothèque Nationale de France, and the Bibliothèque de l'Art et l'Architecture. Finally, in Budapest, I am grateful for the help of librarians at the Országos Széchényi Könyvtár.

As I argued in this book, images are much more expensive to produce than plain text. This is still the case in the twenty-first century. I am therefore especially grateful to those institutions that have offered financial support for publishing this book: the Stichting Historia Medicinae (the Netherlands), the C. Louise Thijssen-Schoute Stichting (the Netherlands), and the Hunter College Shuster Faculty Fellowship Fund. I also express appreciation to the Warner Fund at the University Seminars at Columbia University for their help in publication. Material in this work was presented to the University Seminars: The History and Philosophy of Science. I also want to express my gratitude to all the various museums, archives, libraries, auction houses, and private collectors that have given permission to publish images from their collections, often freely or at highly discounted prices. I published the earlier versions of some chapters in the *British Journal for the History of Science* (Cambridge University Press), in the *Journal of the History of Ideas* (copyright University of Pennsylvania Press, all rights reserved), and in an edited volume (Sven Dupré and Christoph Lüthy, *Silent Messengers: The Circulation of Material Objects of Knowledge*, Berlin: LIT Verlag, 2011), and I thank Cambridge Journals Online and the University of Pennsylvania Press for their permission to include this material here. It might be jarring to voice criticism in a section devoted to thanks. Nonetheless, I wanted to note that some public libraries and museums charge prohibitively expensive licensing

and photography fees for items in the public domain, ignoring the financial situation of scholarly publishing. May this practice change soon.

A large number of people have helped this project to its completion. At Harvard, Mario Biagioli proved to be an ideal mentor whose unfailing support fundamentally shaped this project. From the beginning, Katharine Park offered advice and help on countless occasions about early modern visual and material culture; I am privileged to have been able to work with her. When I decided to study visual culture in the Netherlands, Hugo van der Velden offered to provide guidance, and it has been a pleasure to discuss my project with him ever since. Benjamin Schmidt graciously agreed to serve as an external reader for my work, and his perceptive comments provided food for thought, improved my argument, and made this book better structured. I would also like to thank Susan Dackerman for guiding and supervising my forays into art history, and for her helpful suggestions in shaping especially my last chapter. Ann Blair read a version of this manuscript in its entirety, for which I am truly grateful, and her comments were invaluable throughout. Caroline Duroselle-Melish, Márton Farkas, Jean-François Gauvin, Márk Somos, Matthew Underwood, and Beth Yale have read and commented on one or several chapters. Janet Browne, Ivan Gaskell, Suzanne Karr-Schmidt, and Steven Shapin pointed me to material that I would have neglected otherwise. I am very thankful for their help. I am especially indebted to Bill Rankin, who not only commented on several chapters, but also designed the map of Amsterdam. At Northwestern, Ken Alder offered unfailing support and carefully read and commented on several of the chapters. Conversations with Claudia Swan, Joel Mokyr, Kapil Raj, and Meghan Roberts offered much insight. In New York and beyond, I am grateful for the advice and suggestions of Pamela Smith, Alix Cooper, James Delbourgo, Michael Gordin, Justin Grosslight, Sarah Lowengard, Justin Smith, Margaret Schotte, Nancy Siraisi, and Nasser Zakariya. Joanna Ebenstein has allowed me to test out my ideas in front of audiences beyond the academy, my heartfelt thanks for it. Comments from Elizabeth Eisenstein, Elise Lipkowitz, and Oded Rabinovitch have much improved the chapter on Seba. Evan Ragland was an excellent conversational partner on all matters relating to Dutch anatomy.

In the Netherlands, Wijnand Mijnhardt and Maarten Prak have offered much help in accommodating me during my stay in Utrecht, and became constant sources of ideas. Paul Hoftijzer and Lodewijk Palm shared some of their unpublished work on the topic, for which I am truly grateful. I have discussed my research and received helpful advice from Harm Beukers, Klaas van Berkel, Floris Cohen, Jozien Driessen-van het Reve, Sven Dupré, Alette Fleischer, Esther van Gelder, Roelof van Gelder, Arie Gelderblom, Eric Jorink, Rina Knoeff, Luuc Kooijmans, Dirk van Miert, Ilja Nieuwland, Willem Otterspeer, Lissa Roberts, Bert Roemer, Bram Stoffele, Koen Vermeir, Rienk Vermij, and Huib Zuidervaart. Edwin Demper has helped with the translation of several abstruse passages, and Katarzyna Cieślik and Pál Galicza helped locate additional materials in Amsterdam

when I was in the United States. In England, Simon Schaffer's wit and perspicacity have been an inspiration, and his suggestions profoundly transformed several of the chapters here. From the beginning, I have benefited tremendously from Hal Cook's thoughtful comments and encyclopedic knowledge of Dutch Golden Age science. In addition, Stephen Johnston, Valentina Pugliano, Chitra Ramalingam, William Schupbach, and Alex Wragge-Morley offered helpful suggestions and new directions for my research. Martin Fotta did not only share lodgings, but also offered advice on matters of anthropology. Mihály Köllő brought in the perspective of a contemporary neuroscientist to my research. In Hungary, Iván Horváth graciously helped me test my ideas in Budapest every December during the past three years, and Balázs Gyenis served as a great partner in discussing the history and philosophy of science together.

A the University of Chicago Press, Karen Merikangas Darling has done an exemplary work in shepherding this book during its long gestation. I am grateful to her, and the two anonymous reviewers, whose comments have much improved this work. My parents, Edit Mikó and István Margócsy, provided constant support throughout my graduate years and beyond. They read through the chapters, located materials in Hungary, and offered all the help parents can. I am thankful for it.

ABBREVIATIONS

AN Archives nationales, Paris

BL British Library

BM British Museum

BnF Bibliothèque Nationale de France

Bodleian Bodleian Library, Oxford

GAA Stadsarchief Amsterdam

Gotha Universitäts- und Forschungsbibliothek Erfurt-Gotha

Linnaean Correspondence Swedish Linnaeus Society. *The Linnaean Correspondence.*
Ferne/Voltaire: Centre international d'étude du XVIIIe siècle. linnaeus.c.18.net.

Miedema Hessel Miedema. *Denkbeeldig schoon: Lambert ten Kates
opvattingen over beeldende kunst.* Leiden: Primavera Pers, 2006

KB Koninklijke Bibliotheek, The Hague

RAS Archives of the Russian Academy of Sciences, St. Petersburg branch

SUB Göttingen Niedersächsische Staats- und Universitätsbibliothek Göttingen

Trew Correspondence Briefsammlung Trew, Universitätsbibliothek Erlangen

UBA Universiteitsbibliotheek Amsterdam

UBL Universiteitsbibliotheek Leiden

Vosmaer Correspondence Nationaal Archief 2.21.271 Collectie Vosmaer 69.

Wellcome The Wellcome Collection, London

NOTES

CHAPTER ONE

1. "Zu Abkou hielten wir auch ein wenig, und kamen endlich um ellf Uhr Mittags nach Amsterdam, fünfhalb kleine Meilen, da wir up den nieuwen Dyck in gen grooten Kaysershoff of het wapen van Embden by myn Heer Henckel wohl einkehrten." Uffenbach, *Merkwürdige Reisen*, II/414. The various, excerpted, English translations of Uffenbach from the early twentieth century are untrustworthy and should not be consulted.

2. "Den 20 May Dienstag Morgens waren wir [...] in Nic. Vischers Konst en Caertwynckel, in welchem mein Bruder sehr viele schöne Kupferstich von alten Meistern um billigen Preiss kauffte. [...] Nachmals waren wir in einem Winckel oder Laden op de nieuwen Dyck gegen unserm Wirthshaus dem grooten Kaysershof über. Es stehet über der Thüre: Alderhande rariteyten te Koop." Uffenbach, *Merkwürdige Reisen*, II/416–17.

3. "Eine schöne Andromedam von Erz Ellenßhoch bote er vor hundert Holländische Gulden, einem Herculem von Stein siebenzehen Gulden." Uffenbach, *Merkwürdige Reisen*, II/417.

4. In this volume, I apply the slightly anachronistic umbrella term of science to describe the various modes of early modern knowledge-making practices that included practical mathematics, natural philosophy, natural history, medicine, among others. For those involved in such practices, I use the term scientific practitioner. For a defense of using a similar terminology, see Harkness, *The Jewel House*, xvii. On the Uffenbach brothers, see Bennett, "Shopping for Instruments"; Unverfehrt, *Zeichnungen von Meisterhand*; and on their Dutch visit especially Van de Roemer, "Neat Nature." For their social status in Frankfurt as members of the Frauenstein Society, see Soliday, *A Community in Conflict*, 90.

5. On Merian, see Kinukawa, *Art Competes with Nature*; Kinukawa, "Natural History as Entrepreneurship"; Davis, *Women on the Margins*; Wettengl, *Maria Sibylla Merian*; Reitsma, *Merian and Daughters*.

6. "Sie ist bey zwey und sechzig Jahr alt, aber noch gar munter, und eine sehr höfliche manierliche Frau, sehr künstlich in Wasserfarben zu mahlen, und gar fleissig." Uffenbach, *Merkwürdige Reisen*, III/553.

7. Rumphius, *D'Amboinsche rariteitkamer*. For a modern, annotated edition, see Rumphius, *The Ambonese Curiosity Cabinet*.

8. For a discussion of salaries and wages, see Soltow and Van Zanden, *Income and Wealth Inequality*, 44.

9. On Schijnvoet's chests, see Van de Roemer, "Neat Nature"; for an extended discussion of Schijnvoet, see also Van de Roemer, "De geschikte natuur."

10. On the topic of finance and aesthetics, see Margócsy, "The Fuzzy Metrics of Money."

11. "Auf diesem Stück verrichtet der berühmte Anatomicus Tulpius die Section. Hievor soll ein noch lebender Burgermeister allhier tausend thaler geboten haben, wie es dann gewiß gar schön." Uffenbach, *Merkwürdige Reisen*, III/546.

12. On the cultures of museums, collecting, and curiosities in the Netherlands, see Kistemaker and Bergvelt, *De wereld binnen handbereik*; Bergvelt, Jonker, and Wiechmann, *Schatten in Delft*; Jorink, *Reading the Book of Nature*, ch. 5; Cook, *Matters of Exchange*. For a European overview, see Daston and Park, *Wonders and the Order of Nature*; Impey and Macgregor, *The Origins of Museums*; Pomian, *Collectors and Curiosities*; Schnapper, *Collections et collectionneurs*; Findlen, *Possessing Nature*; Smith and Findlen, *Merchants and Marvels*; Evans and Marr, *Curiosity and Wonder*; Bleichmar and Mancall, *Collecting across Cultures*; Collet, *Die Welt in der Stube*.

13. Cook, *Matters of Exchange*, 277; Jorink, personal communication, June 21, 2012.

14. Scheller, "Rembrandt en de encyclopedische kunstkamer."

15. "Er prahlte ungemein, und indem er uns seinse Sachen zeigte, thate er wie ein Marktschreyer, und sagte alle Augenblicke: Sicht der Herr, etc." Uffenbach, *Merkwürdige Reisen*, III/621.

16. On Rachel Ruysch, see Berardi, *Science into Art*.

17. "Dannenhero ist nicht genug zu bewundern, wie er die viele praeparata so mühsam zusammen bringen, und meistentheils selbst machen können." Uffenbach, *Merkwürdige Reisen*, III/639.

18. The exact price was three ducatons; one ducaton was worth five guilders three stuivers. Uffenbach, *Merkwürdige Reisen*, III/640.

19. "Dieses aber schiene uns nicht natürlich zu seyn, wie denn auch herr Rau versicherte, daß seine Sachen vielfältig mit Farbe und Firniß überstrichen seyen." Uffenbach, *Merkwürdige Reisen*, III/641.

20. The treatment to prevent such mishaps involved coating with oil of turpentine the case in which the butterflies were held, as Uffenbach learned from Adam de Berghe in Delft. Uffenbach, *Merkwürdige Reisen*, III/336.

21. On the problems of preserving fish color, see Fallours, *Poissons, écrevisses et crabes*; for a new edition see Samuel Fallours, *Tropical Fishes of the East Indies*.

22. On color printing in natural history, see Kusukawa, *Picturing the Book of Nature*; Nickelsen, "Botanists, Draughtsmen and Nature."

23. As chapter 6 reveals, Le Blon's idea did not fully succeed in practice. On this point, see also Leonhard and Felfe, *Lochmuster und Linienspiel*, 54.

24. "Herr le Blond machte noch ein groß Geheimniß daraus, und sagte, das wäre vor grosse Herren, die ihme die Erfindung, ehe er sie gemein machte, wohl bezahlen

müßten." Uffenbach, *Merkwürdige Reisen*, III/535. For the translation, see Lilien, *Jacob Christoph Le Blon*, 22.

25. Uffenbach, *Merkwürdige Reisen*, III/655.

26. On the topic of early modern commerce and science, see Cook, *Matters of Exchange*; Smith and Findlen, *Merchants and Marvels*; Huigen, De Jong, and Kolfin, *The Dutch Trading Companies*; Freedberg, "Science, Commerce and Art"; Schiebinger, *Plants and Empire*; Schiebinger and Swan, *Colonial Botany*; Smith, *The Business of Alchemy*; for an overview of more recent developments, see Shapin, *The Scientific Life*; Andersen, Bek-Thomsen, and Kjaergaard, "The Money Trail."

27. "Wenn es nur etwas neues bekommt, lässet er es sogleich in Kupfer stechen, und dedicirt es auf Englische Art [. . .], Einheimischen und Fremden, davor man ihm ein paar Guineen geben muß, wie mir D. Rarger und andere, so auch damit incommodirt worden, geklaget." Uffenbach, *Merkwürdige Reisen*, II/594. On Petiver's strategies, see Delbourgo, "Listing People."

28. "Er bietet allen Fremden, so zu ihm kommen, ein Exemplar von seinem Muscho an, die er sich aber gar theuer bezahlen lässet." Uffenbach, *Merkwürdige Reisen*, II/583.

29. Daston, "The Ideal and the Reality of the Republic of Letters"; Goldgar, *Impolite Learning*; Grafton, "A Sketch Map of a Lost Continent"; see also the whole issue of the *Republic of Letters* 1 (2009); Goodman, *The Republic of Letters*; Miller, *Peiresc's Europe*; Bots and Waquet, *La République des Lettres*; Grosslight, "Small Skills, Big Networks."

30. Raj, *Relocating Modern Science*; Bennett, "The Mechanics' Philosophy"; Smith, *The Body of the Artisan*; Harkness, *The Jewel House*; Roberts, Schaffer, and Dear, *The Mindful Hand*; Carney, *Black Rice*; Dupré and Lüthy, *Silent Messengers*; Roberts, *Centres and Cycles of Accumulation*; Schaffer, Roberts, Raj, and Delbourgo, *The Brokered World*.

31. For a recent review on commerce and science in the Netherlands, see Van Berkel, "The Dutch Republic."

32. Merton, "The Reward System of Science"; Merton, "Science and Technology in a Democratic Order."

33. Habermas, *The Structural Transformation of the Public Sphere*.

34. David, "The Historical Origins of 'Open Science'"; Broman, "The Habermasian Public Sphere"; Terrall, "Public Science in the Enlightenment"; Roche, *Le siècle des Lumières*; Golinski, *Science as Public Culture*; Stewart and Gascoigne, *The Rise of Public Science*.

35. On Uffenbach's visit to Leiden, see Knoeff, "The Visitor's View."

36. "Ich fragte, ob sie nicht mit dem horto medico in Amsterdam communicirten; der Gärtner aber klagte, daß sie in Amsterdam gar zu neidisch wären, und ihre Sachen gar zu hoch hielten." Uffenbach, *Merkwürdige Reisen*, III/404.

37. "Man kan es aber nicht wohl sehen, weil es immer verändert, und von Herrn Bidloo zu denen Collegiis nach Haus geholet wird." Uffenbach, *Merkwürdige Reisen*, III/450.

38. Uffenbach, *Merkwürdige Reisen*, III/452.

39. Schmidt, "Inventing Exoticism"; Schmidt, "Mapping an Exotic World."

40. "Er handelt auch mit Blumen, und versichert, daß Herr D. Eberhard in Frankfurt gar viele von ihme bekomme." Uffenbach, *Merkwürdige Reisen*, III/685.

41. Uffenbach, *Bibliotheca Uffenbachiana universalis*.

42. Braudel, *The Wheels of Commerce*.

43. On the rich trades, see Israel, *Dutch Primacy in World Trade*. On the Baltic trade, see Lemmink and Van Koningsbrugge, *Baltic Affairs*; Veluwenkamp, *Archangel*. For a general overview of Dutch economy, see De Vries and Van der Woude, *The First Modern Economy*; Gelderblom, "From Antwerp to Amsterdam"; Lesger, *The Rise of the Amsterdam Market and Information Exchange*.

44. The classic is Boxer, *The Dutch Seaborne Empire*. See also Den Heijer, *De geschiedenis van de WIC*; Gaastra, *De geschiedenis van de VOC*; Postma, *The Dutch in the Atlantic Slave Trade*; Knaap, *Kruidnagelen en Christenen*. For the role of medicine in the East India Company, see also Bruijn, *Ships' Surgeons of the East India Company*; and for navigational science, Davids, *Zeewezen en wetenschap*. In recent years, the literature on the relationship of the Dutch with particular regions of the world has exploded to the extent that it is impossible to review here.

45. Venema, *Kiliaen van Rensselaer (1586–1643)*, 99.

46. Quinn and Roberds, "An Economic Explanation of the Early Bank of Amsterdam."

47. Teensma, "Abraham Idaña's beschrijving van Amsterdam."

48. Hart, Jonker, and Van Zanden, *A Financial History of the Netherlands*, 48.

49. Peter Spufford, "Access to Credit and Capital"; Lesger, "The Printing Press and the Rise of the Amsterdam Information Exchange."

50. Go, *Marine Insurance in the Netherlands*.

51. Verhoeven, *Anders reizen?*; Van Strien, *Touring the Low Countries*; De Vries, *Barges and Capitalism*; Mączak, *Travel in Early Modern Europe*; Roche, *Humeurs vagabondes*. See also Eskildsen, "Exploring the Republic of Letters."

52. Ten Horne, *Naeuw-keurig Reysboek*.

53. Jordan, *Voyages historiques de l'Europe*.

54. Uffenbach, *Merkwürdige Reisen*, III/390.

55. Cook, *Matters of Exchange*.

56. Van Berkel, "Een onwillige Mecenas?"; Rumphius, *Het Amboinsche Kruid-boek*.

57. Goldgar, *Tulipmania*.

58. Schmidt, "Inventing Exoticism"; Schmidt, "Mapping an Exotic World."

59. Van Helden, Dupré, Van Gent, and Zuidervaart, *The Origins of the Telescope*. See also Davids, *The Rise and Decline of Dutch Technological Leadership*.

60. Ruestow, *The Microscope in the Dutch Republic*; Fournier, *The Fabric of Life*; Wilson, *The Invisible World*.

61. Jan van Musschenbroek to Daniel Schumacher, Leiden, 1724, *RAS* Fond 1 Opis 3 No. 8, f. 289.

62. De Clercq, "Exporting Scientific Instruments around 1700."

63. For the importance of local knowledges within Europe, see Cooper, *Inventing the Indigenous*.

64. "Soo had ik […] wat veel thee gedronken, soo dat die my perste agter op de plaats te gaan om het water af te slaan. Op dese plaats dan was een linde-boom, op welke ik verscheide ruspen vond, die wat geelagtig hair hadden." Stephanus Blankaart, *Schouburg der Rupsen, Wormen, Maden, en Vliegende Dierties daar uit voortkomende*, II/36, manuscript, *KB* 71 J 53.

65. On the problematic epistemological status of images, see Swan, *Art, Science and Witchcraft in Early Modern Holland*; on the problematic relationship between scientific practitioners and untrustworthy illustrators, see Daston, "Observation." On the visual culture of the Netherlands, see also Alpers, *The Art of Describing*.

66. On some of the complexities of visual reportage, see Parshall, "'Imago contrafacta'"; Swan, "Ad vivum, naer het leven, from the life"; Clifton, "'Ad vivum mire depinxit.'"

67. Bleichmar, "Training the Naturalist's Eye in the Eighteenth Century"; Daston and Galison, *Objectivity*; Daston and Galison, "The Image of Objectivity."

68. "Bey Kunstsachen muß man sich nicht so lange auffhalten, wo es sich schicken will als bey Antiquitäten und exotischen Raritäten, und bey diesen nicht so lange wie bey den Naturalibus, wie wohl dabey eines jeden Absehen mit in Consideration zu ziehen ist." Marperger, *Die geöffnete Raritäten- und Naturalien-Kammer*, 8.

69. Cook, *Matters of Exchange*. See also Jones, "Matters of Fact."

70. Kusukawa, "The Uses of Pictures in Printed Books"; Kusukawa, "The *Historia piscium* (1686)." See also Landau and Parshall, *The Renaissance Print*; Lincoln, *The Invention of the Italian Renaissance Printmaker*.

71. Uffenbach, *Merkwürdige Reisen*, III/525.

72. Tongiorgio Tomasi and Hirschauer, *The Flowering of Florence*.

73. Campbell, *Tapestry in the Baroque*; Gerlinde Klatte, "New Documentation for the 'Tenture des Indes' Tapestries in Malta"; Niekrasz, *Woven Theaters of Nature*.

74. Neri, *The Insect and the Image*.

75. It was sold by Sotheby's on December 17, 2008, Sale AM1060 Lot 13. See also Lots 14 and 15 for further examples. For early religious examples, see Giulio Clovio, *The Crucifixion*, 1568, British Museum 1895,0915.1407. See Bury, *The Print in Italy*. For Rembrandt on silk, see his *The Hundred Guilder Print*, reworked by William Baillie, c. 1775, Baltimore Museum of Art 1946.112.7845.

76. Reeds, "Leonardo da Vinci and Botanical Illustration."

77. Laird, *Mrs. Delany and her Circle*; Linney, "The *Flora Delanica*"; Hayden, *Mrs. Delany's Flower Collages from the British Museum*. The originals are preserved in the *BM* (British Delany collection).

78. Andersen and Nesbitt, *Flora Danica*.

79. Maerker, *Model Experts*; Mazzolini, "Plastic Anatomies and Artificial Dissections"; Maerker, "Handwerker, Wissenschaftler und die Produktion anatomischer Modelle in Florenz"; Messbarger, *The Lady Anatomist*.

80. Rodari, *Anatomie de la couleur*, 107; Gelbart, *The King's Midwife*.

81. Smith, *The Body of the Artisan*; Smith and Beentjes, "Nature and Art, Making and Knowing."

82. Van de Roemer, "Het lichaam als borduursel."

83. Collins, *Changing Order*; Latour and Woolgar, *Laboratory Life*; Shapin and Schaffer, *Leviathan and the Air Pump*; Biagioli, *Galileo, Courtier*; Galison, *How Experiments End*.

84. Latour, "Drawing Things Together"; Shapin, "Here and Everywhere." See also Ivins, *Prints and Visual Communication*; Eisenstein; *The Printing Press as an Agent of Change*.

85. This was already noted by Law, "Notes on the Theory of the Actor-Network." For similar arguments, see especially Raj, *Relocating Modern Science*; Bourguet, Licoppe, and Sibum, *Instruments, Travel and Science*; Miller and Reill, *Visions of Empire*; Ben-Zaken, *Cross-Cultural Exchanges in the Eastern Mediterranean*; Harris, "Mapping Jesuit Science"; Cook and Lux, "Closed Circles or Open Networks?"; Fan, "The Global Turn in the History of Science"; Bleichmar, *Visible Empire*.

86. See, for instance, Geertz, *Local Knowledge*; Schmitt, *Aristotle and the Renaissance*; Hankins, *Plato in the Renaissance*; Jardine and Grafton, "'Studied for action'"; Ogilvie, *The Science of Describing*; Kusukawa, "Leonhard Fuchs on the Importance of Pictures."

87. "So gehet es aber mit öffentlichen Societäten. Sie blühen eine kleine Zeit, die Stiffter und ersten Glieder treiben alles so hoch sie können; nachmals kommen allerhand Hindernisse." Uffenbach, *Merkwürdige Reisen*, II/456.

88. On the late blossoming of scientific societies, see Mijnhardt, *Tot Heil van 't Menschdom*.

89. On restricted flows of knowledge, see Vermeir and Margócsy, "States of Secrecy"; Proctor and Schiebinger, *Agnotology*; Schiebinger, *Plants and Empire*; Galison, "Removing Knowledge"; Biagioli, "Replication or Monopoly?"; Long, *Openness, Secrecy, Authorship*; Rankin and Long, *Secrets and Knowledge in Medicine and Science*.

90. MacLeod, *Inventing the Industrial Revolution*; Biagioli, "Patent Republic." See also Rose, *Authors and Owners*; Woodmansee, *The Author, Art, and the Market*; Pottage and Sherman, *Figures of Invention*.

91. Shapin and Schaffer, *Leviathan and the Air Pump*.

92. Mauss, *Essai sur le don*; Appadurai, *The Social Life of Things*. For a review of Mauss' reception, see Sigaud, "The Vicissitudes of *The Gift*." See also Graeber, *Toward an Anthropological Theory of Value*.

93. Douglas and Isherwood, *The World of Goods*; Miller, *A Theory of Shopping*.

94. Hayden, *When Nature Goes Public*; Anderson, *The Collectors of Lost Souls*.

95. On the commodification and consumption of science, see the essays in Brewer and Porter, *Consumption and the World of Goods*. On the commodification of early modern culture, see Jardine, *Worldly Goods*; Brewer, McKendrick, and Plumb, *The Birth of a Consumer Society*; Brewer, *The Consumption of Culture*; Brewer, "The Error of Our Ways"; De Vries, *The Industrious Revolution*.

96. For similar arguments, see Schmidt, "Inventing Exoticism"; and Bleichmar, "Training the Naturalist's Eye in the Eighteenth Century."

97. See Smith, *The Body of the Artisan*; Roberts, Schaffer, and Dear, *The Mindful Hand*; and Smith and Schmidt, *Making Knowledge in Early Modern Europe*.

98. For the first, see Daston and Galison, "The Image of Objectivity"; Daston and Galison, *Objectivity*. For the second, see Foucault, *The Order of Things*; Freedberg, *The Eye of the Lynx*; Ogilvie, "Image and Text in Natural History"; Piñon, *Livres de zoologie*. For the third, see Stafford, *Artful Science*.

99. Shapin and Schaffer, *Leviathan and the Air Pump*, 283.

100. Biagioli, *Galileo, Courtier*.

CHAPTER TWO

1. On Amman and Linnaeus, see Rowell, "Linnaeus and Botanists in Eighteenth-Century Russia." There is a dearth of literature on Amman.

2. Linnaeus to Amman, L0173, May 20, 1737, *The Linnaean Correspondence*, linnaeus .c18.net.

3. Johann Christian Buxbaum, *Nova plantarum genera*, 236.

4. Amman to Linnaeus, L0220, November 26, 1737, *The Linnaean Correspondence*.

5. For treating curiosities as useful knowledge, see Cook, *Matters of Exchange*; Spary, "Botanical Networks revisited"; for a diverging view, see Swan, "Collecting Naturalia in the Shadow of the Early Modern Dutch Trade." On their religious significance, see Jorink, *Reading the Book of Nature*; Berkel, *Citaten uit het boek der natuur*; for an overview, see Van Gelder, "De wereld binnen handbereik."

6. Collinson to Amman, May 22, 1738, *RAS* R1 Fond 74A Dela 19. On Collinson, see O'Neill, *Peter Collinson*.

7. Collinson to Amman, London, August 16, 1738, *RAS* R1 Fond 74A Dela 19.

8. For a discussion of such terms, see Blair, *Too Much to Know*, 117–21.

9. See Cook, *Matters of Exchange*; Cooper, *Inventing the Indigenous*; Ogilvie, *The Science of Describing*; Schiebinger and Swan, *Colonial Botany*; Smith and Findlen, *Merchants and Marvels*; Reeds, *Botany in Medieval and Renaissance Universities*; Givens, Reeds, and Touwaide, *Visualizing Medieval Medicine and Natural History*; Stroup, *A Company of Scientists*.

10. Egmond, Hoftijzer, and Visser, *Carolus Clusius*; Egmond, *The World of Carolus Clusius*; Van Gelder, *Tussen hof en keizerskroon*; Van Gelder, *Bloeiende kennis*; Rankin, "Becoming an Expert Practitioner"; Rankin, *Panaceia's Daughters*.

11. Goldgar, *Tulipmania*.

12. The data are for the early eighteenth century; see Overvoorde, *Geschiedenis van het postwezen in Nederland*, 274. See also Marchand, *Le maître de poste et le messager*; and for a theoretical evaluation of the impact of postal networks, Siegert, *Relays*.

13. Collinson to Breyne, January 8, 1747, *Gotha* Chart B. 785, 334.

14. Gronovius to Amman, April 5, 1736, *RAS* R1 74a, dela 0.

15. Gronovius to Breyne, July 1, 1736, and December 18, 1739, *Gotha* Chart B. 786.

16. Breyne, "Botanica quae hortum meum concernunt." *Gotha* Chart A. 876, f. 32–36.

17. "Germinating History: 200-year-old Seeds Spring to Life." *The Kew Millenium Seed Bank Project.* http://www.kew.org/msbp/news/200_year_old_seeds.htm (accessed November 12, 2010).

18. Rafalska-Łasocha, Łasocha, and Jasińska, "Cold Light in the Painting *Group Portrait in the Chemist's House.*"

19. Collinson to Amman, September 12, 1739, *RAS* R1. Fond 74A, Dela 19.

20. Stearns, "James Petiver," 363. On Petiver, see also Coulton, "The Darling of the '*Temple-Coffee-House Club.*'" For Petiver's use of Dutch encyclopedias, see Winterbottom, "Using the *Hortus malabaricus* in Seventeenth-Century Madras"; and Winterbottom, "Company Culture."

21. Robbins, *Elephant Slaves and Pampered Parrots.*

22. Van Gelder, "Arken van Noach."

23. Barge, *De oudste inventaris der oudste academische anatomie in Nederland.*

24. Vermij and Reumer, *Op reis met Clara.* On the more permanent zoos, see Pieters, "The Menagerie of 'the White Elephant' in Amsterdam"; Vanhaelen, "Local Sites, Foreign Sights."

25. Haupt et al., *Le bestiaire de Rodolphe II.*

26. Sliggers, *Een vorstelijke dierentuin.*

27. Obviously, the difference is partly explained by the larger number of plant species in the world. For quadrupeds, see Ridley, "Introduction: Representing Animals"; on plants, see Stearn, "The Background of Linnaeus's Contributions to the Nomenclature and Methods of Systematic Biology," 5; Linnaeus, *Species plantarum.*

28. Belozerskaya, *The Medici Giraffe*; Balis, "Hippopotamus Rubenii."

29. Swart, "Riding High," 125–27.

30. The exact amount is £165, though the seller later boasted of a much higher price. Little, "Uncovering a Protectoral Stud," 261.

31. The buyer had to default after the payment of £500, however. Faust, *Zoologische Einblattdrucke und Flugschriften vor 1800*, V/24, 692.1.

32. On monkeys, Robbins, *Elephant Slaves and Pampered Parrots*, 28; on cockatoos, see Gebhard, *Het leven van Mr. Nicolaas Cornelisz. Witsen*, 325.

33. Recent work on early modern conchology includes Dance, *Shell Collecting*; Dietz, "Mobile Objects"; Leonhard, "Shell Collecting"; Van de Roemer, "Neat Nature"; Spary, "Scientific Symmetries."

34. Gersaint, *Catalogue raisonné de coquilles et autres curiosités naturelles*, 18.

35. Rumphius, *The Ambonese Curiosity Cabinet*, 94.

36. Lister, *Journey to Paris in the Year 1698*, 59 for Buco, 62 for Tournefort, 132 for Morin.

37. Kistemaker and Bergvelt, *De wereld binnen handbereik*, 368; Pomian, *Collectors and Curiosities.* See also Van Seters, *Pierre Lyonet (1706–1789).*

38. On the history of entomology, see Neri, *The Insect and the Image*; Jorink, *Reading the Book of Nature*, ch. 4; Ogilvie, "Nature's Bible"; d'Aguilar, *Histoire de l'entomologie*; Meli, "The Representation of Insects in the Seventeenth Century."

39. Stearns, "James Petiver," 364.

40. The comparison collapses, however, when reproducibility is also considered. See Latour, "Drawing Things Together."

41. Merian, *Metamorphosis insectorum surinamensium*, aan den lezer.

42. On the material constraints of microscopical research, including size, see Ratcliff, *The Quest for the Invisible*.

43. He was probably referring to Hernandez, *Nova plantarum, animalium et mineralium Mexicanorum historia*.

44. Petiver to Breyne, April 10, 1706, *Gotha* Chart B. 787.

45. Stearns, "James Petiver: Promoter of Natural Science," 265.

46. On Seba's exchanges with Russia, see the next chapter, and Driessen-van het Reve, *De Kunstkamera van Peter de Grote*. On his German trade, see his letters to Johann Jakob Scheuchzer at *UBA* HS. E. f. 151 and *UBA* HS E. f. 152. On Merian's financial strategies on her Suriname trip, see Wettengl, *Maria Sibylla Merian*.

47. Juliette Jowit, "Scientists Prune List of World's Plants," *Guardian,* September 20, 1010, 1.

48. Wilkins, *An Essay towards a Real Character and a Philosophical Language, ep. ded.* In contemporary parlance, commerce meant both nonfinancial and financial exchanges.

49. Bauhin, *Pinax theatri botanici.* See also Ogilvie, "Encyclopaedism in Renaissance Botany."

50. "De Boekvercopers Verbeek hebben in de Auctie van de Boeken van Boerhaven gecogt het exemplaar van Vaillant's Botanicum Parisiense, daar de heer Boerhaven seer veel by geschreven had, het geen wat synonyma en verder niets te beduyden had." Gronovius to Breyne, September 20, 1740, *Gotha* Chart B. 786. See Vaillant, *Botanicon Parisiense.*

51. On the use of illustrated encyclopedias in the training of naturalists, see Bleichmar, "Training the Naturalist's Eye in the Eighteenth Century"; and for the somewhat later development of field guides, see Scharf, "Identification Keys, the 'Natural Method,' and the Development of Plant Identification Manuals."

52. ———, *Ortus sanitatis*; ———. *Gart der Gesundheit.* This paragraph is heavily influenced by Ogilvie, *The Science of Describing,* 25–86.

53. Gesner, *Historiae animalium.* See Fischel, *Natur im Bild*; Piñon, "Conrad Gessner and the Historical Depth of Renaissance Natural History"; Fischel, "Collections, Images and Form in Sixteenth-Century Natural History"; Kusukawa, "The Sources of Gessner's Pictures for the *Historiae animalium.*" For the recently discovered drawings of Gesner, see Egmond, "A Collection within a Collection."

54. Aldrovandi, *Quadrupedum omnium bisulcorum historia*, 93. On Aldrovandi, see especially Findlen, *Possessing Nature.*

55. Aldrovandi, *Quadrupedum omnium bisulcorum historia*, 878–89.

56. Kusukawa, "Leonhart Fuchs on the Importance of Pictures."

57. Foucault, *The Order of Things*.

58. Ogilvie, "Image and Text in Natural History"; Freedberg, *The Eye of the Lynx*; Kusukawa, "The *Historia piscium* (1686)"; Piñon, *Livres de zoologie*.

59. Sloan, "John Locke, John Ray, and the Problem of the Natural System"; Heller, "The Early History of Binomial Nomenclature"; Eddy, "Tools for Reordering." See also Müller-Wille, "Systems and How Linnaeus Looked at Them in Retrospect."

60. For a similar argument with regard to the textile industry, see Reddy, "The Structure of a Cultural Crisis."

61. Fuchs, *De historia stirpium commentarii insignes*.

62. Cordus, *Annotationes in Pedacij Dioscoridis Anazarbei de Medica material libros V.*

63. "flos a te missus, hepaticae albae nomine describitur a Valerio Cordo descriptionis plantarum libro 2 capite 115 . . ." Conrad Gesner to Johannes Funck, March 26, 1564, in: Gesner, *Epistolarum medicinarum . . . libri III*, f. 94v. The reference is to Cordus, *Annotationes in Pedacij Dioscoridis Anazarbei de Medica materia libros V*, 153.

64. Carolus Clusius to Petrus Paaw, Frankfurt, March 28, 1593, Leiden University Library shelfmark BPL 885; the reference is to Clusius, *Rariorum aliquot stirpium per Pannoniam . . . observatarum historia*. On Clusius, see the literature cited earlier in this chapter, as well as Hunger, *Charles de l'Escluse*.

65. Anselmus de Boodt to Clusius, Prague, October 12, 1602, Leiden University Library VUL 101 / Boodt A_002. The reference is to Matthioli, *Opera quae extant omnia*, Cap. XLVII, p. 543–44.

66. The prices and variant names come from the manuscript P. Cos, *Verzameling van een meenigte Tulipaanen*. Haarlem, 1637. Wageningen University Library Spec Coll. R362B03 Bot. ill.

67. For a discussion of these books, see Segal, *De tulp verbeeld*.

68. For a list of such classificatory systems, see Linnaeus, *Bibliotheca botanica*, 177–89.

69. Ray, *Historia plantarum*. On Ray, see Raven, *John Ray, Naturalist*; and for more recent work, Wragge-Morley, *Knowledge and Ethics in the Work of Representing Natural Things*.

70. John Ray to Hans Sloane, Black Notley, February 11, 1685 (n.s.), Lankester, *The Correspondence of John Ray*, 160–61.

71. This was equivalent to 15 pounds or over 160 Dutch guilders. Tancred Robinson to John Ray, Geneva, April 18, 1684, Lankester, *The Correspondence of John Ray*, 141.

72. Tancred Robinson to John Ray, London, May 21, 1687, Lankester, *The Correspondence of John Ray*, 193.

73. Ray to Sloane, Black Notley, July 17, 1696, Ellis, *Original Letters of Eminent Literary Men*, 203.

74. Ray to Sloane, September 17, 1696, Lankester, *The Correspondence of John Ray*, 307.

75. I thank Joel Mokyr for discussing this point with me.

76. Ray, *Synopsis methodica stirpium Britannicarum editio tertia.*

77. Druce, *The Dillenian Herbaria*, xlv.

78. Dendrology, the study of trees, was actually often treated separately from the rest of botany in early modern natural history.

79. Aldrovandi, *De reliquis animalibus exanguibus*; Aldrovandi, *De animalibus insectis.*

80. Moffett, *Insectorum sive Minimorum Animalium theatrum;* Lister, *English Spiders.* Lister's major work in this field is his English translation and re-edition of Goedaert, *Of Insects.*

81. I will be referring to the Latin translation: Buonanni, *Recreatio mentis et oculi.*

82. Buonanni, *Musaeum Kircherianum.*

83. Buonanni, *Recreatio mentis et oculi*, III/3 for the Netherlands, III/157 for Portugal, III/40 for Syracuse, III/332 for Brazil.

84. Buonanni, *Recreatio mentis et oculi,* ad lectorem.

85. "Ik vinde dat hy omtrent de Hoorns en Schulpen een admirabel werk gedaan heeft, dewyl hy een catalog gemaakt heeft van alle de Schulpen en Hoorns van Bonannus en die benaamt met de ouwerwetse en Hedendaagse duitsche namen, dat is so als de Liefhebbers sederd 100 jaren de selve genaamt hebben." Gronovius to Breyne, May 30, 1742, *Gotha* Chart B. 386.

86. Buonanni, *Recreatio mentis et oculi,* III/15 and 16.

87. Buonanni, *Recreatio mentis et oculi*, III/18 was "sed rara," and III/374 "ea summo pretio ducitur, quia raro invenitur," whereas a turbo from p. 118 III/40 was "frequens."

88. "Priuantur quidem praecipua venustate." Buonanni, *Recreatio mentis et oculi*, 86.

89. Lister, *Historiae sive synopsis conchyliorum.* On Martin Lister, see Roos, *Web of Nature*; Roos, "The Art of Science."

90. Unwin, "A Provincial Man of Science at Work."

91. Lister, *English Spiders*, 107–9.

92. Lister, *English Spiders*, 48.

93. Lodge to Lister, August 21, 1674, *Bodleian* MS Lister 34, f. 170.

94. On Malpighi, see Meli, *Mechanism, Experiment, Disease*; Meli, *Marcello Malpighi, Anatomist and Physician*; Adelmann, *Marcello Malpighi and the Evolution of Embryology.* On Leeuwenhoek, see Palm and Snelders, *Antoni van Leeuwenhoek 1632–1723*; Ruestow, *The Microscope in the Dutch Republic.* On Swammerdam, see Cobb, *The Egg and the Sperm Race*; Cobb, "Malpighi, Swammerdam and the Colourful Silkworm"; Kooijmans, *Gevaarlijke kennis.* One eagerly awaits the forthcoming biography of Eric Jorink.

95. On Rumphius in Asia, see Raj, *Relocating Modern Science.* See also De Witt, *Rumphius Memorial Volume*; ———, *Rumphius gedenkboek.*

96. "Ich war in willens diejenige stücke, so mitzo senden werde und in Rumphio stehen nach ihre rechte pagin. zu beschreijben, aber die zeit wil es mir nicht zulassen, und werden Ihro Excellenz selbsten die mühe nehmen solches nach zu sehen." Seba to Scheuchzer, December 28, 1723, *UBA* Hs. Ef 151.

97. Collinson to Beurer, February 7, 1744/5, *Trew*.

98. Petiver to Breyne, April 10, 1706, *Gotha* Chart. B 787.

99. *The Amboina Rarity-Chamber*, BL MS Add. 3324, f. 146–67.

100. Petiver, *Aquatilium animalium amboinae*.

101. *BL* MS Add. 3324, f. 62.

102. "I hope in a little time to finish a Catalogue of the English shells, I have hither to observed, the land ones may exceed 20, the fresh water ones not more, but those on our Sea Coaste already near 100, and of these last many more I believe are yet to be discovered, the whole List you shall have by the next, with the shells themselves, if you desier them." Petiver to Breyne, April 10, 1706, *Gotha* Chart B. 787.

103. Sloane to Breyne, March 15, 1714/5, *Gotha* Chart. A 788.

104. "Nous annonçons celles [i.e., those lots on sale] qui se trouvent gravées dans la Conchyliologie de Monsieur Dargenville en marquant la Planche et la Lettre; nous avons aussi cité quelquefois Rumphius." Helle and Rémy, *Catalogue raisonné d'une collection considerable de coquilles*, ix.

105. Arnout Vosmaer, *Systema Testaceorum*, Nationaalarchief Den Haag Inv. 2.21.271 No. 71.

106. Vosmaer, *Beredeneerde en systematische catalogus van eene verzameling*.

107. The recent years have seen a proliferation of works on early modern zoology, including Enenkel and Smith, *Early Modern Zoology*; Meli and Guerrini, "The Representation of Animals in the Early Modern Period"; Boehrer, *A Cultural History of Animals in the Renaissance*; Ridley, "Animals in the Eighteenth Century."

108. Franzius, *Historia animalium sacra*.

109. Tulp, *De drie boecken der medicijnsche aenmerkingen*, 71, for the captain, see 119–20. The Dutch translation gives a faithful but abbreviated version of Tulp's original work in Latin.

110. Tulp, *De drie boecken der medicijnsche aenmerkingen*, 273. An Amsterdam *pond* was slightly heavier than the current American pound.

111. "Als hy drincken zoude greep hy de oor van de kan met d'eene handt [. . .], daer na wischte hy sijn lippen af, niet minder geschickt, alsof ghy den alder curieusten Hovelingh ghesien hadt." Tulp, *De drie boecken der medicijnsche aenmerkingen*, 276.

112. On comparative anatomy, see Guerrini, *Experimenting with Humans and Animals*; Cunningham, *The Anatomist Anatomis'd*.

113. I thank Justin Smith for discussing this point with me.

114. On Tyson, see Smith, "Language, Bipedalism, and the Mind-Body Problem in Edward Tyson's Orang-Outang."

115. Tyson, *Phocaena, or the Anatomy of a Porpess*, 10.

116. Tyson, *Phocaena, or the Anatomy of a Porpess*, 15.

117. Tyson, *Orang-Outang, sive Homo Sylvestris*, 2.

118. On Perrault, see Guerrini, "The King's Animals and the King's Books."

119. Perrault, *Memoir's for a natural history of animals*, preface. I am citing the contemporary English translation. Guerrini offers a detailed account of the tortuous publication history of the French original.

120. Valentini, *Amphitheatrum zootomicum*. Gerardus Blasius offered a more synthetic account a few decades earlier, but also with little eye for taxonomy; see Blasius, *Anatome animalium*.

121. Charleton, *Onomastikon zoikon*; Ray, *Synopsis methodica animalium quadrupedum et serpentini generis*.

122. Klein, *Quadrupedum dispositio brevisque historia naturalis*; Brisson, *Regnum animale in classes IX distributum*.

123. Pennant, *Synopsis of Quadrupeds*, A2.

124. Koerner, *Linnaeus: Nature and Nation*; Müller-Wille, "Walnut Trees in Hudson Bay, Coral Reefs in Gotland."

125. Müller-Wille, "Collection and Collation"; Heller, "The Early History of Binomial Nomenclature"; Eddy, "Tools for Reordering."

126. It did provide one illustration by Georg Ehret on his sexual system, but no single species was depicted in its entirety.

127. Heller, "Linnaeus on Sumptuous Books."

128. Gronovius to Amman, January 27, 1739, *RAS* R1 Fond 74A Dela 19. Gronovius to Breyne, September 20, 1740, *Gotha* Chart B. 786.

129. Contardi, "Linnaeus Institutionalized."

130. Pennant, *Synopsis of Quadrupeds*, A3.

131. Gronovius to Breyne, April 20, 1745, *Gotha* Chart B. 786.

132. For this point, see Loveland, *Rhetoric and Natural History*, 157. See also Sloan, "The Buffon-Linnaeus Controversy"; Roger, *Buffon*.

133. Buffon, *Histoire naturelle, générale et particulière, avec la description du Cabinet de roi*. On the close relationship between Buffon's style and Perrault's rhetorics, see Guerrini, "Perrault, Buffon, and the Natural History of Animals."

134. The volumes on quadrupeds were preceded by the treatment of general natural history, cosmology, and humankind, however.

CHAPTER THREE

1. Seba, *Locupletissimi rerum naturalium thesauri accurata descriptio*. On Albertus Seba and the publication history of the *Thesaurus*, see Engel, "The Life of Albert Seba"; Engel, "The Sale-Catalogue of the Cabinets of Natural History of Albertus Seba"; Holthuis, "Albert Seba's 'Locupletissimi rerum naturalium thesauri' (1734–1765) and the 'Planches de Seba' (1827–1831)"; Boeseman, "The Vicissitudes and Dispersal of Albertus Seba's Zoological Specimens"; Ahlrichs, "Albertus Seba"; Bauer and Günther, "Origin and Identity of the Von Borcke Collection."

2. "Ante tres circiter hebdomadas Amstelodami D. Seba obiit, qui thesauri sui tomos duos priores editos,vidit, tertium vero imperfectum reliquit, quartum vero ad praelum paratum." Gronovius to Amman, Leiden, 1736, *RAS* R1 74a.

3. Gronovius to Richardson, September 2, 1736, Turner, *Extracts from the literary and scientific correspondence of Richard Richardson*, Letter CXLVIII. Letter originally in English.

4. Christie's Sale 9326 (New York, March 10, 2000), Lot 18.

5. Sotheby's Sale N07585 (New York, January 10–11, 2001), Lot 490.

6. Seba, *Locupletissimi rerum naturalium thesauri accurata descriptio*, I/praefatio autoris.

7. "De processen onder de Erfgenamen van Seba syn ten eynde gebragt, waar door sy dat werk wederom op de pers gebragt hebben." Gronovius to Breyne, Leiden, May 30, 1742, *Gotha* Chart B 786, f. 305. The well-connected Breyne also received the same information from Hendrick Janssonius van Waesbergen.

8. For a useful overview, see Landwehr, *Studies in Dutch Books with Coloured Plates*.

9. On the Renaissance forgery of the Ancients, see Grafton, *Forgers and Critics*.

10. Linnaeus, *Systema naturae*; Gronovius to Amman, Leiden, July 24, 1737, *RAS* R1 74a Dela 0.

11. Burmann, *Thesaurus zeylanicus*; Rumphius, *Het Amboinsche Kruid-boek*.

12. Hoftijzer, "Metropolis of Print," 249; Chartier, "Magasin de l'univers ou magasin de la République?," 292.

13. Hunt, Jacob, and Mijnhardt, *The Book that Changed Europe*, 88.

14. Keblusek, *Boeken in de hofstad*, 56.

15. Van Eeghen, *De Amsterdamse boekhandel 1680–1725*, 33. On the complex publication strategies of a Leiden publisher, see Hoftijzer, *Pieter van der Aa (1659–1733)*.

16. Schriks, *Het Kopijrecht*, 138; Lindeboom, "Boerhaave as Author and Editor." On Boerhaave, see Lindeboom, *Hermann Boerhaave*; Knoeff, *Hermann Boerhaave (1668–1738)*; Kooijmans, *Het orakel*; Powers, *Inventing Chemistry*.

17. Febvre and Martin, *The Coming of the Book*, 197. See also Margócsy, "A Komáromi Csipkés Biblia Leidenben."

18. [De la Mettrie], *L'homme machine*. On Luzac, see Van Vliet, *Elie Luzac (1721–1796)*. On the fine, see Van Vliet, "Leiden and Censorship during the 1780s"; Thijssen, "Some New Data Concerning the Publication of 'L'homme machine' and 'L'homme plus que machine.'" Thijssen's citation of a 20,000-guilder fine seems exaggerated to me.

19. Janssonius van Waesbergen to Breyne, August 7, 1742, *Gotha* Chart A. 788, 744; Burmann to Breyne, June 9, 1739, *Gotha* Chart B. 785, 249. Rumphius, *Het Amboinsche Kruid-boek*; Burmann, *Rariorum Africanarum plantarum decades*.

20. Catesby, *The Natural History of Carolina, Florida, and the Bahama Islands*. Sloane to Breyne, September 6, 1734, *Gotha* Chart A. 788, 647; Sloane to Breyne, November 9, 1737, *Gotha* Chart A. 788, 653.

21. Breyne, *Exoticarum plantarum centuriae*; Waesbergen to Breyne, October 9, 1712, *Gotha* Chart A. 788, 743.

22. Kusukawa, *Picturing the Book of Nature*. For a recent overview of Renaissance printing,

see Pettegree, *The Book in the Renaissance*; Maclean, *Scholarship, Commerce, Religion*; Grafton, *The Culture of Correction in Renaissance Europe*.

23. For the complex processes of editorial intervention, and the complexities of publishing in general, see Johns, *The Nature of the Book*.

24. Kusukawa, *Picturing the Book of Nature*, 226.

25. For nuanced readings that question the intentions and effectiveness of anonymity, see Rabinovitch. "Anonymat et carrières littéraires au XVIIe siècle"; DeJean, "Lafayette's Ellipses"; Terrall, "The Uses of Anonymity in the Age of Reason." For the complexities of scientific authorship in France, see Biagioli, "Etiquette, Interdependence, and Sociability in Seventeenth-Century Science."

26. On the management of information, see Blair, *Too Much to Know*; and for the survival of humanist data management systems, Soll, *The Information Master*.

27. In this chapter, I deliberately ignore piracy—that is, the unaltered republication of a book under the same authorial name but by a different publisher, because it does not involve tampering with the authorial persona, unlike plagiarism and forgery. On the complex history of piracy, see Johns, *Piracy*.

28. On the *Tabulae anatomicae*, see Vesalius' scathing words in Vesalius, *De humani corporis fabrica*, letter to the printer. Dryander, for example, copied two of the six illustrations from Vesalius' *Tabulae anatomicae sex* in his *Anatomia Mundini,* and also took a number of images from Berengario da Carpi. On Amusco, see Klestinec, "Juan Valverde de (H)Amusco and Print Culture."

29. O'Malley, *Andreas Vesalius of Brussels*, 90–91. While Guinter is also mentioned on the title page, Vesalius' name is much more prominently displayed.

30. Kusukawa, *Picturing the Book of Nature*, 87.

31. Harkness, *The Jewel House,* 15–19; on the relationship to Fuchs, see Anderson, *An Illustrated History of the Herbals*, 177. As Gerard himself acknowledged on the title page, the *Herball* was "gathered by John Gerarde," implying the equation of the authorship with incremental, editorial compilation and commentary. Gerard, *The Herball,* t.p.

32. Shapin, *A Social History of Truth*.

33. Ruestow, *The Microscope in the Dutch Republic,* 22.

34. On Witsen, see Peters, *De wijze koopman*.

35. For the growing control of eighteenth-century authors in Britain, see Sher, *The Enlightenment and the Book*, 209, which also offers a helpful overview of self-publishing and profit-sharing schemes. See also Felton, "The Enlightenment and the Modernization of Authorship."

36. Linnaeus, *Hortus Cliffortianus*; Gronovius to Amman, August 6, 1739; *RAS R1 74a Dela 0.*

37. Breyne, *Dissertatio physica de Polythalamiis*; Beughem served only as a printer for the book. For recent accounts on the financial aspects of scientific publishing, see especially Marr, *Between Raphael and Galileo*. For earlier work, see Darnton, *The Business of Enlightenment*.

38. *Gotha* Chart A. 876, 39–40.

39. On these debates, see Levine, *The Battle of the Books*; Fumaroli, *La Querelle des Anciens et des Modernes.*

40. On eighteenth-century memorials to Boerhaave, see Scholten, "Frans Hemsterhuis's Memorial to Herman Boerhaave."

41. For a detailed, and brilliant, dissection of this phenomenon, see Goldgar, *Impolite Learning*, ch. 3. On scientific authorship, see Biagioli and Galison, *Scientific Authorship*; and Frasca-Spada and Jardine, *Books and the Sciences in History.*

42. Descartes, *The Use of the Geometrical Playing Cards.* For a forgery of Pierre Bayle's letters, see Goldgar, *Impolite Learning*, 146.

43. "Les Amateurs de lettres ne doivent avoir aucun égard aux éditions qui ne sont point faits sous ses yeux et par ses ordres, encore moins à tous ces petits ouvrages qu'on affecte de débiter sous mon nom, à ces vers qu'on envoie au *Mercure* et aux journaux étrangers, et qui ne sont que le ridicule effet d'une réputation bien vaine et bien dangereuse," cited by Lee, "The Apocryphal Voltaire," 265.

44. [Mabbut], *Sir Isaac Newton's tables*, t.p.; for the denunciation, see ———, *A True Estimate of the Value of Leasehold Estates.*

45. Boterbloem, *The Fiction and Reality of Jan Struys.* Struys' work was probably ghost-written by Olfert Dapper, in consultation with Struys, and significant portions of it were lifted from Dapper's own scholarly work, rewritten and presented from a first-hand observer's perspective.

46. Schriks, *Het Kopijrecht*, 139; Van Eeghen, "Leidse professoren en het auteursrecht in de achttiende eeuw." On the general development of copyright and piracy, see Rose, *Authors and Owners*; Woodmansee, *The Author, Art, and the Market*; Feather, *Publishing, Piracy and Politics*; Johns, *Piracy.*

47. Terrall, *The Man Who Flattened the Earth*, 292–94.

48. Alder, "History's Greatest Forger"; Renn, *Galileo in Context*, 327–70.

49. Engel, "The Life of Albert Seba," 92.

50. GAA Toegangsnummer 5075 Deel 8535 Act 666, December 29, 1739. *Inventaris van den boedel en nalatenschap van Albertus Seba, begonnen den 24 May 173 en voltrokken geslooten den 29 December 1739.*

51. Van Rheede tot Drakensteyn, *Hortus indicus malabaricus*; Blasius, *Anatome animalium*; Bidloo, *Anatomia humani corporis.* See Van Eeghen, *De Amsterdamse boekhandel, 1680–1725*, IV/129–31.

52. Bruyn, *Reizen over Moskovie*; Ten Kate, *Aenleiding tot de kennisse der Nederduitsche sprake.*

53. Boers, "Een teruggevonden gevelsteen uit de Kalverstraat," 223; Verheyen, *Corporis humani anatomia editio nova.*

54. Janssonius van Waesbergen, *Catalogus librorum medicorum, pharmaceuticorum . . . in off. Jansionio-Waesbergiana prostantium.*

55. Sources on the origins of Seba's wealth are scarce, but the printed wedding song of

Seba and Anna Lopes suggestively writes about the bride that "de droogen schenken haar vermoogen," suggesting the importance of the pharmaceutical trade in the couple's richness. ———. *Ter bruiloft van Albertus Seba met Anna Lopes.*

56. For a list of the drugs Seba delivered to Jan Christoffel Hartman in 1727, see GAA inv. no. 27/35, Archief van het Collegium Medicum, Bijlagen by het Renvooiboek, 131.

57. GAA Toegangsnummer 5075 Deel 12150 Act 16. *Scheiding,* March 19, 1742. According to Kees Zandvliet, 200,000 guilders were enough to make it to the *Top 250* of the Golden Age Netherlands; see Zandvliet, *De 250 rijksten van de Gouden Eeuw.*

58. Driessen-van het Reve, *De Kunstkamera van Peter de Grote,* 115–16.

59. On the auction, see Engel, "The Sale Catalogue of the Cabinets of Natural History of Albertus Seba"; and ———, *Catalogues van de uitmuntende cabinetten . . nagelaten door wylen den Heere Albertus Seba.*

60. McCracken Peck, "Alcohol and Arsenic, Pepper and Pitch."

61. Gronovius to Breyne, Leiden, August 21, 1743, *Gotha* Chart B. 786, 311.

62. Driessen-van het Reve, *De Kunstkamera van Peter de Grote,* 242.

63. Kistemaker et al., *The Paper Museum of the Academy of Science in St. Petersburg c. 1725–1760.*

64. Seba, *Locupletissimi rerum naturalium thesauri accurata descriptio,* I/aan den lezer.

65. On subscriptions, see Sher, *The Enlightenment and the Book*; Yale, *Manuscript Technologies.* For a Dutch context, see Hunt et al., *The Book that Changed Europe,* 102–4.

66. ———. "Wetstein et Smith, Imprimeurs de cette Bibliotheque." *Bibliothèque raisonnée* 11 (1734) January-February: 236–39.

67. Most one-volume natural history and anatomy atlases cost 15–30 guilders. Merian's *Metamorphosis* sold for 15 guilders, and Bidloo's *Anatomia* traded for 27–30 guilders.

68. L'Admiral, *Naauwkeurige waarnemingen, van veele gestaltverwisselende gekorvene Diertjes,* 2.

69. "Rien aussi n'arretera le cours de l'impression, parce que toutes les Planches sont dèja gravées, et meme le Premier Tome est fini." *Bibliothèque Raisonné* 11 (1734) January-February: 236–39.

70. "Toutes les choses dont nous avons fait mention jusqu'a present, outre beaucoup d'autres qu'il seroit trop long de détailler, sont représentées dans leur grandeur et figure naturelle, sur les Planches de Cuivre, gravées par les meilleurs Maitres, d'apres les Originaux que l'Auteur possede dans son cabinet. En un mot, les Descriptions sont si exactes, et les Gravures si belles, que Monsieur BOERHAAVE, cet Illustre Professeur a Leyde, a rendu publiquement ce témoignage, qu'il n'a point encore paru d'Ouvrage en ce genre qui soit égal a celui-ci." *Bibliothèque Raisonné* 11 (1734) January-February: 236–39.

71. ———. "[review of] Albertus Seba. *Thesaurus.*" *Bibliothèque Raisonné* 12 (1734) April-June: 357–84.

72. "If I remember well, the price of a coloured one would come to five hundred gilders." Gronovius to Richardson, September 2, 1736, Turner, *Extracts from the Literary*

and Scientific Correspondence of Richard Richardson, Letter CXLVIII. Pieters claims that hand-colored volumes were circulating for 200 guilders in Pieters, "Natura artis magistra," 65. For the practices of hand-coloring, see Nickelsen, "The Challenge of Colour."

73. Arnout Vosmaer's preface to Renard, *Fishes, Crayfishes, and Crabs.* Note that the text refers to Renard's work, although it applies equally well to Seba's.

74. Barthes, "The Death of the Author"; Barthes, *S/Z*; Hillis Miller, "The Critic as Host."

75. For a full list of the legal documents relating to the case, see Engel, "The Life of Albert Seba."

76. *GAA* Toegangsnummer 5075 Deel 8533 Act 222, April 22 & 23, 1738.

77. Van Royen's planned *Ericetum africanum* never saw light, but the illustrations have survived. "De plaaten van het boek van Roeye de Ericis Africanis werden tegenwoordig in het koper gesneeden, en alreede syn er so veele afgedaan, dat die heer daar al vyf honderd guldens verschooten heeft." Johann Frederik Gronovius to Johann Philipp Breyne, Leiden, May 30, 1742, *Gotha* Chart B. 786. For Sloane, see Petiver to Breyne, London, April 10, 1706, *Gotha* Chart B. 787, 482; Sloane, *A voyage to the islands Madera, Barbados, Nieves, S. Christophers and Jamaica.*

78. If we use the prices mentioned in the accounts of Breyne, drawing and engraving 449 plates would have cost roughly 7,800 Dutch guilders, which is somewhat higher than the amount from Van Royen's unfinished project.

79. ———, *Catalogues van de uitmuntende cabinetten . . . nagelaten door wylen den Heere Albertus Seba.*

80. *RAS* 2.1.164, 301–5, printed in Driessen-van het Reve, *De Kunstkamera van Peter de Grote,* 305.

81. On Gaubius, see Hamer-van Duynen, *Hieronymus David Gaubius (1705–1780).* With the exception of one manuscript, now preserved at the Artis Library of the *UBA* (MS Legk. 36), the whole text of *Volume IV* was missing.

82. Ghostwriting has been studied mainly in the context of contemporary biomedical science, a clearly different scenario. See, for instance, Ross et al., "Guest Authorship and Ghostwriting in Publications Related to Rofecoxib"; Shapiro, Wenger and Shapiro, "The Contributions of Authors to Multiauthored Biomedical Research Papers"; Logdberg, "Being the Ghost in the Machine"; Jacobs and Wager, "European Medical Writers Association (EMWA) Guidelines on the Role of Medical Writers in Peer-Reviewed Publications"; Gotzche et al., "What Should Be Done to Tackle Ghostwriting in the Medical Literature?"; Bosch, Esfandiari, and McHenry, "Challenging Medical Ghostwriting in US Courts."

83. On Vosmaer, see Sliggers, *Een vorstelijke dierentuin*; and the manuscript autobiography, Arnout Vosmaer. *Memorie tot mijn leven behorende.* The Hague: Nationaalarchief 2.21.271, no. 57.

84. Arnout Vosmaer, "Conditie tot de onderneming van de Hollandsche beschrijving van het 4de deel van Albertus Seba Thesaurus." *Vosmaer Correspondence.*

85. Here, the term "ghostwriting" simply refers to any act of writing under the guise of another author.

86. "Gezonde de Beschrijving der 4 eerste Tab. van 4e deel om te zien of dus na genoegen der Heeren Erfgen: is. Dat ik my vleie dat op dezen voet aan de Requis: in de behandeling van het werk, zoo als my die zyn opgegeeven, zal voldaan zyn, namentl. *met maar kort en zakelyk, de zaaken van het kabinet eenvoudig te beschrijven zonder my, zoo min mogelyk, in Nat. Kund. beschouw: dier zaaken in te laaten.*" Vosmaer to Homrigh, June 2, 1759, *Vosmaer Correspondence.*

87. "Ik kan niet zien welk quaat, maar wel in tegendeel wat goed of nut het zoude toebrengen, dat in eene gepaste voorreeden te kennen gegeven werd ('t welk tog al om bekend is) dat de twee laatste delen na 's mans dood beschreven zyn, hier by zoude men een kort verhaal van het leven van dHr Seba kunnen ingeven en doen zien dat men als den auteur moest aanmerken." Vosmaer to Homrigh, s.d. [June 15, 1756], *Vosmaer Correspondence.*

88. "Vermits nu het oogmerk niet schijnt te sijn bij de heeren uitgevers, den smaak van het publijk, maar alleen hun eijgen concept te volgen." Gaubius to Vosmaer, January 12, 1757, *Vosmaer Correspondence.*

89. "het werk absolut moet uytgegeven worden als een werk van Albertus Seba en ook in 't minste geen mentie moet gemaakt worden dat daar door andere angearbeyd is." Homrigh to Vosmaer, July 16, 1756, *Vosmaer Correspondence.*

90. "want Seba heeft die afbeelding uit de teekeningen der *Kaapsche Dieren*, waarschynelyk ontleend, deze teekeningen, waaren eerst in de Bibliotheek van Boerhaave gevonden, en nu in het bezit van den beroemden Hoogleeraar Joh. Burman, want het is bekend, dat Seba veele afbeeldingen uit andere boeken onder de zyne geplaatst heeft; en hoe veel hulp Boerhaave aan het werk van Seba toegebracht heeft is yder bekend." Pallas, *Dierkundig mengelwerk*, 6.

91. Artedi, *Ichthyologia*. See also Merriman, "A Rare Manuscript Adding to Our Knowledge of the Work of Peter Artedi"; which reports that the US Bureau of Fisheries then possessed a copy of Artedi's manuscript for Seba's *Thesaurus*. Despite extensive research, the present location of this manuscript is unknown to me.

92. "'t 3e deel mede na 's Mans overlyden in het licht gebracht, en door ander schryver of schryveren behandeld zynde, ik zeer gaarne wilden zien welk een voetspoor men gevolgd heeft, om daar na (voor zo verre de Natuur der Zaaken van het 4e deel zulks lyden kunnen) het mynen te schikken en interichten." Vosmaer to Homrigh, May 18, 1756, *Vosmaer Correspondence.*

93. "wy hebbe soo veel mogelyk de Intentie van den heer Seba voldaen, wyle maar seer eenvoudig derselve gevolgt hebbe, en altoos uit oog gehouden om niet buijten de smaak derselver te gaan, alsoo onse intentie altyd geweest is en nog is om het als een werk van den Ouden man uyt te geven en de Liefhebbers in geen ander denkbeeld te brengen." Homrigh to Vosmaer, May 21, 1756, *Vosmaer Correspondence.*

94. "de geheele letterdruk van het derde deel is hier bij Luzac niet bevindelyk, en mijn

exemplaar moet ik houden om het reseteerende van mijn werk te kunnen in ordre volvoeren." Gaubius to Vosmaer, June 9, 1756, *Vosmaer Correspondence.*

95. "UWED begrypt dat ik mijne beschrijving naar de afgezette plaaaten zoude moeten schikken en inrichten, alzo van zeer veele soorten die by geen auteuren bekend zyn, niet veel anders als eene koleur beschryving, en wat voor soort van dier of dieren het zijn, zal konnen gegeven werden, met eenige korte mitbreyding of aanmerking naar het voorbeeld van dHR Seba." Vosmaer to Homrigh, s.d. [June 15, 1756], *Vosmaer Correspondence.*

96. For a comparison of descriptive and philosophical trends in natural history, see Rudwick, *Bursting the Limits of Time.*

97. "'t is UWED genoeg bewust, de bepaalinge waar aan de eigenaars van dit werk ons verbinden, namentlyk, niet te veel letterdruk, de behandeling, zoo na mogelyk, Seba eigen, te volgen, en op dien voet mach ik my in geen bereedeneerde denkbeelden inlaaten, noch laateren ontdekkingen gebruijken? De nooet, echtern, onder myne inleiding, denk ik, zal niet konnen wedersprooken worden, 't moet daar in, noch den Naam voeggen van een vroegger observator als Iussieu." Vosmaer to Gaubius, January 9, 1757, *Vosmaer Correspondence*; Jussieu, "Examen de quelques productions marines."

98. Probably the footnote to Table XCV in the final publication, which explains that Jussieu and others have classified some of the marine plants as the exoskeleton of marine animals. "Na deze beschryving van den heere A. Seba, hebben de Heeren Peyssonel et Jussieu, en nu onlangs de Heer J. Ellis, overtuigende bewyzen gevonden, dat een groot gedeelte dezer Lighaamen (zoo niet alle) waarlyk het werk is van verscheide Diertjes, zynde een soort van zoo genaamde Polypen." Seba, *Locupletissimi rerum naturalium thesauri accurata descriptio*, III/Plate XCV.

99. "Men met een openbaar onwaarheid het publijk soekt t'abuseeren, vertoonende, als of in 't leven van den Zal Hr. Seba het geheele werk aan plaaten en schrift so danig in gereedheid was geweest, dat er niets als het drukken daaraan otbrak. . ." Gaubius to Vosmaer, May 28, 1757, *Vosmaer Correspondence.*

100. "il restoit encore [. . .] un certain vuide que Mr. Seba avoit, sans doute, resolu de remplir par d'autres espèces de poissons, comme il paroit visiblement dans ses prolègomènes sur la Planche XXXV." Seba, *Locupletissimi rerum naturalium thesauri accurata descriptio*, III/97, plate XXXII.

101. "Ik hebbe volgens UED versoek, zij Ed. gecommuniceerd, als dat de erfgenaamen het gezegde op pag. 97 zoo als dat gedrukt is maar zullen houden, en dus geen gebruik maaken van het veranderde. Bij mijn thuis komst heb ik 't werk ook eens ingezien, om als Ued bevonden, dat te veele plaatzen doch blijkt dat het werk naderhand door andere is opgevat en afgemaakt; en wat zou dan een veranderinge van die pag. kunnen helpen, temaer daar de verandering geenzints verbeetering bevat, maar misleiding waar voor zijn WelEd anderzintz zich te recht zoo afkeering toond." Vosmaer to Homrigh, July 9, 1757, *Vosmaer Correspondence.*

102. Seba, *Locupletissimi rerum naturalium thesauri accurata descriptio*, III/Table XXXI Figure 8.

103. "Mijne Koraal-Beschrijving was lang afgeweest, had ik maar gezien dat 'er werk op de Pers quam, ten tweede zal Ued, mijne Beschrijving maar eens inziende, wel bespeuren dat ik 'er meer werk van gemaakt heb, zoo dra als ik otdekt heb, dat men heeft doen zien dat het werk door andere na DHR Sebas dood, opgevat en volvoerd is geworden; dus heb ik meerder moeijten aan gewend om de zaaken klaar en kennelijk te beschrijven." Vosmaer to Homrigh, 1757, *Vosmaer Correspondence*.

104. See Seba, *Locupletissimi rerum naturalium thesauri accurata descriptio*, III/Tabula III for Ellis, and III/Tabula 113 for Gualtieri.

105. Vosmaer to Gaubius, January 9, 1757, *Vosmaer Correspondence*.

106. Wallach, "Synonymy and Preliminary Identifications of the Snake Illustrations of Albertus Seba's *Thesaurus* (1734–1735)."

107. Gualtieri, *Index testarum conchyliorum*, Tabula 106.

108. "U moet ten dien opzicht weeten dat vader Seba de afgebeelde Insecten van twee kleyne printwerkjes, die voor veele jaaren door eene Hoefnagel en 't ander door eene Hollaar in 't licht gebracht zyn, ik beken niet te weeten waer om, want de verbeelde diertjes zyn tamelyk gemen of slegt, in zyn werk ingelascht heeft." Vosmaer to Merkus, November 1763, *Vosmaer Correspondence*. For Hollar, see Seba, *Locupletissimi rerum naturalium thesauri accurata descriptio*, IV/Plate LXXXVII Num. 13. For Hoefnagel, see Num. 20.

109. "alsoo wij imand […] hebben die de vertaling van 't eerste en tweede deel in 't fransch heeft gedaan, en ons daar prompt mede sal helpen dan komt het indezelve smaak." Homrigh to Vosmaer, May 27, 1757, *Vosmaer Correspondence*.

110. "[ik] twyffele niet ofte UE hebt gesien 't werk van Astruc dat onlangs te Parys is uytgekoomen, namentlyk L'Histoire des Insectes aux environs de Paris, 2 volume quarto misschien soude dit werk nog konnen dienen en UE beschryving eenig ligt konnen by setten, 't zy selfs in de benaamingen." Merkus to Vosmaer, November 5, 1763, *Vosmaer Correspondence*. While Merkus mentions Astruc, the reference is in fact to Geoffroy, *Histoire abrégée des insectes aux environs de Paris.*

111. "de Beschryving *maar zoo kort, en zoo eenvoudig als my immers mogelyk was moest maken; en my doch voor als onthouden om eenige zweem van geleerdheid in het werk te mengen.*" Vosmaer to Merkus, November 1763, *Vosmaer Correspondence*.

112. "Mr. *Geoffroy*, dans son Histoire abregée des Insectes des Environs de Paris, rapporte la même chose, et prend ces Insectes pour deux différentes espéces [sic]." Seba, *Locupletissimi rerum naturalium thesauri accurata descriptio*, IV/Plate LXXXIX Num. 7 & 8.

113. "Gy zult liever eene waare en onopgesmukte Beschryving zien, hier alleen naar bloote Afbeeldingen der Voorwerpen, voor heen waarlyk in weezen geweest zynde, opgemaat, dan wydloopige Beschryvingen, van anderen ontleend, of op alleronzekerste berichten ter neder gesteld." Seba, *Locupletissimi rerum naturalium thesauri accurata descriptio*, IV/vii, aan den lezer.

114. On Ireland, see Radnóti, *The Fake,* 178–80; on Crèvecoeur, see Adams, *Travelers and Travel Liars,* 158–59; on Rousseau, Dufour, *Recherches bibliographiques sur les oeuvres imprimées de J.-J. Rousseau,* I/253–62.

115. On the topic, see also Ronell, *Dictations: Haunted Writing.* For an argument on the earlier origins of authenticity and forgery in the fine arts, see Wood, *Forgery, Replica, Fiction.*

116. ———. "Description du cabinet d'Albert Seba." *Journal général de la littérature de France* 4 (1801): 159–60.

117. Seba, *Planches de Seba.*

CHAPTER FOUR

1. Trew, "An Observation on the Method," 446.

2. Note the similarity to the scenario described in Shapin, "The Invisible Technician."

3. On Bellekin, see Van Seters, "Oud-Nederlandse Parelmoerkunst"; Vreeken, "Parelmoeren plaque met mythologische voorstelling."

4. For a similar approach, see Swann, *Curiosities and Texts.*

5. Brook, *Vermeer's Hat,* 14.

6. Calaresu, "Making and Eating Ice Cream in Naples." On the eighteenth-century connections between food and science, see Spary, *Eating the Enlightenment.*

7. Wijnands, *Een sieraad voor de stad,* 37–38.

8. McCracken Peck, "Preserving Nature for Study and Display," 15.

9. Stearns, "James Petiver," 363; Petiver, "Brief directions for the easie making and preserving collections," printed sheet, *BM* 46 e 11 (9).

10. See Dannenfeldt, "Egyptian Mumia"; or, for instance, Lanzoni, *Tractatus de balsamatione cadaverum.*

11. On dissections and sainthood, see Park, *Secrets of Women.*

12. On Vesalius, see O'Malley, *Andreas Vesalius of Brussels*; Kusukawa, *Picturing the Book of Nature.*

13. On the market for anatomical prints, see Karr-Schmidt, *Altered and Adorned*; Dackerman, *Prints and the Pursuit of Knowledge in Early Modern Europe*; Klestinec, "Juan Valverde de (H)Amusco and Print Culture."

14. On anatomy lessons and theaters, see Hansen, "Galleries of Life and Death"; Wolters van der Wey, "A New Attribution for the Antwerp Anatomy Lesson"; Huisman, *The Finger of God*; Ferrari, "Public Anatomy Lessons and the Carnival"; Klestinec, *Theaters of Anatomy*; Rupp, "Theatra anatomica"; Rupp, "The New Science and the Public Sphere in the Premodern Era"; Slenders, *Het theatrum anatomicum in de noordelijke Nederlanden*; Zuidervaart, "Het in 1658 opgerichte theatrum anatomicum te Middelburg."

15. French, *Harvey's Natural Philosophy.*

16. For an overview of anatomical debates, see Meli, *Mechanism, Experiment, Disease*;

Kooijmans, *Gevaarlijke kennis*; Wragge-Morley, "Connoisseurship and the Making of Medical Knowledge."

17. The history of anatomical preparations has been somewhat neglected. See, however, Cook, "Time's Bodies"; Kooijmans, *De doodskunstenaar*; and Cole, "The History of Anatomical Injections." For a biography of de Bils, see Jansma, *Louis de Bils en de anatomie van zijn tijd*; Fokker, "Louis de Bils en zijn tijd."

18. De Bils, *Kopye van zekere ampele acte van Jr. Louijs de Bils*. For a Latin version printed in the same year, see De Bils, *Exemplar fusioris Codicilli*. For the English version, see De Bils, *The Copy of a Certain Large Act [Obligatory] of Yonker Lovis de Bils*.

19. De Bils, *Kopye*, 8.

20. De Bils, *Kopye*, 4.

21. De Bils, *Kopye*, 5; De Bils, *Waarachtig gebruik der tot noch toe gemeende giijlbuis*. A Latin version was also published; see De Bils, *Epistolica dissertatio*.

22. For the contract between de Bils and Louvain, see De Bils, "Ludivici de Bils actorum anatomicorum vera delineatio"; De Haas, *Bossche scholen van 1629 tot 1795*; Lindeboom, *Geschiedenis van de medische wetenschap in Nederland*, 53.

23. De Haas, *Bossche scholen van 1629 tot 1795*, 130.

24. Farrington, *An account of a journey through Holland, Frizeland, etc.*, 50.

25. Uffenbach, *Merkwürdige Reisen*, III/621–22.

26. Sterne, *The Life and Opinions of Tristram Shandy*, 45.

27. The work of Frederik Ruysch has recently gained much interest. Works with appeal to the larger public include Blom, *To Have and to Hold*; and Purcell and Gould, *Finders, Keepers*. Ruysch's best biography is Kooijmans, *De doodskunstenaar*, also available in English as Kooijmans, *Death Defied*, but see also Scheltema, *Het leven van Frederik Ruysch*; Berardi, *Science into Art*; Luyendijk-Elshout, "'An der Klaue erkennt man den Löwen,' aus den Sammlungen des Frederik Ruysch"; Hansen, "Galleries of Life and Death"; Hansen, "Resurrecting Death"; Roemer, "From *vanitas* to Veneration"; Roemer, "Het lichaam als borduursel."

28. Fontenelle, "Eloge de Monsieur Ruysch," IV/196.

29. Biagioli, *Galileo, Courtier*; Lux, *Patronage and Royal Science in Seventeenth-Century France*; Pumphrey, "Science and Patronage in England."

30. For examples of patronage by the Orange family on a limited scale, see Orenstein, *Hendrick Hondius and the Business of Prints in Seventeenth-Century Holland*, 86–88. Arguably, the case of the Huygens family is a question in point; see Stoffele, "Christiaan Huygens—A Family Affair."

31. Van Berkel, "De illusies van Martinus Hortensius." The expression *mercator sapiens* comes from Caspar Barlaeus' inaugural speech at the establishment of the Amsterdam Athenaeum in 1632: Barlaeus, *Mercator sapiens*. See also Van Miert, *Illuster onderwijs*.

32. On the support of entrepreneurs in the Netherlands, see Davids, "Beginning Entrepreneurs and Municipal Governments in Holland."

33. Cook, *Matters of Exchange*; Van Gelder, *Het Oost-Indisch avontuur*; Cook, "Medical Communication in the First Global Age."
34. For similar claims about the Dutch book trade, see Hoftijzer, *Engelse Boekverkopers bij de Beurs*.
35. De Clercq, *At the Sign of the Oriental Lamp*, 119–22 and 197.
36. On the advertising function of many artisanal publications, see Hilaire-Pérez, "Technology as Public Culture in the Eighteenth Century"; Jones, "The Great Chain of Buying"; Hilaire-Pérez and Thébaud-Sorger, "Les techniques dans l'espace public"; Berg and Clifford, "Selling Consumption in the Eighteenth Century"; Wigelsworth, *Selling Science in the Age of Newton*; Doherty, *A Study in Eighteenth-Century Advertising Methods*; Myers, Harris, and Mandelbrote, *Books for Sale*.
37. For publications for patronage, see Biagioli, *Galileo, Courtier*; Long, *Openness, Secrecy, Authorship*; Popplow, "Why Draw Pictures of Machines"; McGee, "The Origin of Early Modern Machine Design."
38. Kooijmans, "Rachel Ruysch."
39. See Mirto and Van Veen, *Pieter Blaeu: Letters to Florentines*; Lindeboom, *Het Cabinet van Jan Swammerdam*; and Lindeboom, *The Letters of Jan Swammerdam to Melchisedec Thévenot*, 72–73.
40. Dudok van Heel, "Ruim honderd advertenties van kunstverkopingen uit de Amsterdamsche Courant." For natural historical sales, see 17.9.1715, "een uytmuntent Cabinet van alle soorten van fraye Zeegewassen en veel andere Rariteyten meer"; 1.2.1720, "3 beeltjes, konstig uyt een stuk Palmhout gesneden, eenige Hoorns en Schelpen, de geboort Christi konstig geschildert, een klein Breughels"; 4.5.1724, a "curieuse Kabinette met Hoorns, Schulpen en Zeegewassen, Flessen met vreemde gediertens in Liquor, dozen met insectens, groot goed etc., kostelyke Schilderyen van brave Meesters, 2 Marmere Beeldjes verbeeldende de 5 zinnen, etc. door Quellinus."
41. At the late burgomaster Gerbrand Pancras' collections sale, "2 stuks extra van Juffrouw Ruys" are mentioned (10.3.1716); see Dudok van Heel, "Ruim honderd advertenties van kunstverkopingen uit de Amsterdamsche Courant." On 21.2.1719, the late Jacob van Hoek's collection was advertised for sale, incl. a painting of Rachel Ruysch, by H. Sorg (=the painter Hendrick Sorgh). Together with the same Sorg and a certain P. Steen, Frederik Ruysch Pool arranged for the sale of the late Cornelis Nuyts' collection of paintings, as can be seen in an advertisement from 8.3.1718.
42. Bisseling, "Uit de Amsterdamse Courant."
43. *Amsterdamsche Courant*, September 25, 1731. By 1771, the sale of such collections became such a public event that a catalogue of the sale of Gerrit Braamcamp's collection of paintings was sold in almost one thousand copies, only to be pirated by another bookseller, and to be thereafter followed by a new edition at a reduced price from the original publishers. See Braamcamp, *Catalogus van het uytmuntend Cabinet*; Bille, *De tempel der kunst*. On the many uses of catalogues, see Huisman, "Inservio studiis Antonii a Dorth Vesaliensis."

44. De Clercq, *At the Sign of the Oriental Lamp*, 65–71. For similar moves in the English market, some of which pre-date the Dutch evidence, see Crawforth, "Evidence from Trade Cards for the Scientific Instrument Industry"; Bryden, "Evidence from Advertising for Mathematical Instrument Making in London." On advertising in the British medical scene, see Cook, *The Decline of the Old Medical Regime in Stuart London*. For eighteenth-century developments, see Ratcliff, *The Quest for the Invisible*, part 2.

45. The Russian court also ordered air pumps with the help of Musschenbroek's catalogues (as well as illustrations in 's Gravesande's works), and relied mostly on long-distance correspondence to arrange matters, incl. getting positive references from 's Gravesande for Musschenbroek's work and receiving instructions for the assembly of the pump. Daniel Schumacher to Albertus Seba, St. Petersburg, June 23, 1718, *RAS* Fond I Opis 3 Dela 2 f. 95; Daniel Schumacher to Johann Musschenbroek, March 14, 1724, *RAS* Fond I Opis 3 Dela 2 f. 197; Daniel Schumacher to [Johann Musschenbroek], March 9, 1726, *RAS* Fond I Opis 3 Dela 2 f. 332; 's Gravesande to Daniel Schumacher, August 23, 1724, *RAS* Fond I Opis 3 Dela 8 f. 153; Johann van Musschenbroek to Daniel Schumacher, 1724, *RAS* Fond I Opis 3 Dela 8 f. 289.

46. Blankaart, *Anatomia reformata*, 3rd ed., Verhandeling wegens het balsemen der menschelyke Lighamen, art. XXVI.

47. Blankaart, *Verhandelinge van het podagra*, 294–301. See also Banga, *Geschiedenis van de geneeskunde en van hare beoefenaren in Nederland*, 621–22. For a discussion of secrets in the English scene, see Pelling, *Medical Conflicts in Early Modern London*. For the French, see Le Paulmier, *L'orviétan*.

48. On Van der Heyden, see Sutton, *Jan van der Heyden*; De Vries, *Jan van der Heyden*. The fire-fighting side of Van der Heyden is analyzed in Van der Heyden, *A Description of Fire Engines with Water Hoses and the Method of Fighting Fires now used in Amsterdam*. See also the slightly different case of Cornelius Meijer in Klaas van Berkel, "'Cornelius Meijer inventor et fecit.'"

49. Shapin and Schaffer, *Leviathan and the Air Pump*; Steven Shapin, "Pump and Circumstance." See also Dear, "Totius in Verba"; Licoppe, "The Crystallization of a New Narrative Form in Experimental Reports"; Dear, *Discipline and Experience*.

50. Braudel traces the history of shopwindows back to 1728, when they appeared in London. Braudel, *The Wheels of Commerce*, 68; citing a French visitor: "What we do not on the whole have in France, is glass like this, generally very fine and very clear. The shops are surrounded with it and usually the merchandise is arranged behind it, which keeps the dust off, while still displaying the goods to passers-by, presenting a fine sight from every direction," from [P.-J. Fougeroux], *Voiage d'Angleterre, d'Hollande et de Flandre*, 1728, Victoria and Albert Museum, 86 NN 2, f. 29.

51. The sale in England might have come through because William of Orange also brought several Dutch fire engines to England as part of his Glorious Revolution. Van der Heyden, *A Description of Fire Engines with Water Hoses and the Method of*

Fighting Fires now used in Amsterdam, xii–xiii. For the fire engines in Moscow, see Bruyn, *Reizen over Moskovie*, 29.

52. Roemer, "From *vanitas* to Veneration," 173.

53. The expression occurs very frequently throughout Ruysch's works, see for instance his description of the face of a young child: "Aanmerkt ten eersten, Dat het Aangesichte zeer schoon, wel besneden en levendig van couleur is." Frederik Ruysch, *Thesaurus IV*, 9. Unless otherwise specified, I am quoting Ruysch's words from Ruysch, *Opera omnia anatomico-medico-chirurgica*.

54. Jan Swammerdam to Melchisedec Thévenot, 1671, in Lindeboom, *The Letters of Jan Swammerdam to Melchisedec Thévenot*, 63. I owe this reference to Eric Jorink. On the entrance fee to the museum, János Miskolczy-Szijgyártó wrote in his diary in the 1710s that "pennám mind ezeket le nem írhattya, a'kinek kedve s pénze vagyon hozzá, experiállya," see Dúzs, "Hogyan utazott 170 évvel ezelőtt a magyar calvinista candidatus." In *De doodskunstenaar*, Kooijmans claims that medical professionals could enter free of charge, but other visitors had to pay an entrance fee. On advertisements, and how Ruysch used them in advertising his public anatomical dissections, see also Heckscher, *Rembrandt's Anatomy of Dr. Nicolaas Tulp*.

55. On the wide variety of visitors, see the partially surviving guest books preserved at the library of the University of Amsterdam: Frederik Ruysch, *Album Frederik Ruysch*, *UBA* MS IE 20 and 21.

56. On the concept of paratexts, see Genette, *Paratexts*.

57. Ruysch, *Thesaurus IV*, 24. See also Ruysch, *Thesaurus V*, 5:"Indien alle Ontleders zoo gedaan hadde, en de onkosten, moeyte, en andere zaken haar niet hadden te rugh gehouden, zoo zouden wy veel verder gekomen zyn in de kennisse van 's menschen Lichaam: ook zoude men de Jeught niet opgehouden hebben, met het disputeeren over het zyn en niet zyn dezer en geener kleyne deeltjens, die zy noyt togh konde vertoonen. Wanneer ik voor desen de Ontleders quam vragen, ofte zy dit of dat my geliefde te vertonen (mihi demonstrare), 't geen sy door Figuren hadden afgebeeld, zoo kreeg ik wel haast een kort antwoord, namentlyk, zodanig is 't my doenmaals voorgekomen, en nu kan ik u zulks niet vertoonen, en daar mede most ik heenen gaan: Nu, op dat ik my van zo een onnosel antwoord niet zoude bedienen, zo conserveer ik alles, wat van my door Figuuren werd afgebeeld, en zulks niet zonder groote kosten, en dog kan het zelve veele Eeuwen zo gehouden werden, en dat in de zelve staaat, waar in het nu is, zonder de minste veranderingh."

58. See for instance Ruysch, *Thesaurus II*, 16, where a "phiala continens duas portiones Penis Virilis" was exhibited.

59. "Proinde facile, ut spero, connivebit Dominus, quod voto tuo respondere, Scrotique praeparationem supra citatam publice notam facere nondum induci possim, neque, ut mihi persuadeo, id a me exiges, cum mecum perpendas, quam multi dentur, qui instar Corniculae Aesopicae alienis superbire gaudeant plumis. Accuratam autem de-

lineationem arteriarum anterioris partis Scroti Tibi denegare nequeo, quam tabulae secundae Figura secunda repraesentat." Ruysch, *Epistola secunda ad Gaubium,* 17.

60. Ruysch, *Epistola tertia ad Gaubium,* 23.

61. Valentini, *Musaeum musaeorum,* II/Appendix XIIX, 59–61. For instance, Johann Conrad Rassel's collection in Halberstadt had opening hours every Tuesday and Friday between 2 and 4 for local visitors, and had open doors for travelers passing through the country each day of the week. Valentini, *Musaeum musaeorum,* II/Appendix XIX, 61–69.

62. Driessen-van het Reve, *De Kunstkamera van Peter de Grote,* 130–32.

63. Ruysch, *Thesaurus IV,* 45. In a similar manner, William III of England wore a black ribbon that attached to his left arm a golden bag filled with the hair of his deceased wife, Queen Mary, as his first surgeon noticed during the king's dissection; see Ronjat, *Lettre de Mr. Ronjat,* 25.

64. "De groote lieden in Engeland zyn gewoon tot een gedagtenisse van haar overleeden Vrouwen, uyt een vlok des hayrs en ringh te laten maken, welke hayren zeer konstig door een gevlogten zyn: maar veel considerabelder zoude het zyn, indiense de harten zelfs van haar beminde aldus gebalsemt zynde, in een goude off zilvere bus bewaarde, tot een eeuqighe gedaghtenisse, waar door onze konste zoude komen te floreeren." Ruysch, *Thesaurus IV,* 45. The embalming of hearts was a fairly common procedure in early modern royal funerals.

65. Kistemaker et al., *Peter de Grote en Holland,* 183.

66. Van het Meurs, "Het leven van den beroemden F. Ruysch," 469.

67. Ruysch, *Thesaurus VI,* ad lectorem.

68. Uffenbach writes that 3 ducatons were asked for, with one ducaton being 5 guilders 3 stuivers. Uffenbach, *Merkwürdige Reisen,* III/639–40. Uffenbach writes that Rau charged 500 guilders for his course, but this is surely a typo.

69. Driessen-van het Reve, *De Kunstkamera van Peter de Grote.* The following section is heavily based on Driessen-van het Reve's findings.

70. Knoppers, "The Visits of Peter the Great to the United Provinces in 1697–98 and 1716–17."

71. Driessen-van het Reve, *De Kunstkamera van Peter de Grote,* 136.

72. Driessen-van het Reve, *De Kunstkamera van Peter de Grote,* 86–103.

73. Driessen-van het Reve, *De Kunstkamera van Peter de Grote,* 107–17.

74. Driessen-van het Reve, *De Kunstkamera van Peter de Grote,* 131–32.

75. Ruysch recalled that Peter once called him "his teacher," and thereby immediately turned the usual patronage relationship upside down.

76. Radzjoen, "De anatomische collectie van Frederik Ruysch in Sint-Petersburg," 51.

77. *GAA* 5075, Notarial Archives Abraham Tzeewen, inv. 7598, April 17, 1717; Driessen-van het Reve, *De Kunstkamera van Peter de Grote,* 139–40.

78. *GAA* 5075, Notarial Archives Abraham Tzeewen, inv. 7598, April 23, 1717; Driessen-van het Reve, *De Kunstkamera van Peter de Grote,* 141–42.

79. *GAA* 5075, Notarial Archives Abraham Tzeewen, inv. 7648, December 28, 1730.

80. For recent analyses of the various publication strategies of particular early modern authors, see Ratcliff, "Abraham Trembley's Strategy of Generosity and the Scope of Celebrity in the Mid-Eighteenth Century"; and Biagioli, "Replication or Monopoly?"

81. For the traditional view on the development of the public sphere, see Habermas, *The Structural Transformation of the Public Sphere*; Blanning, *The Culture of Power and the Power of Culture*. For more qualified approaches, see, for instance, Goodman, *The Republic of Letters*. For the development of communication networks in seventeenth-century science, see Miller, *Peiresc's Europe*. On the emergence of scientific societies and academies, see McClellan, *Science Reorganized*; Hahn, *The Anatomy of a Scientific Institution*; Lux, *Patronage and Royal Science in Seventeenth-Century France*; Gordin, "The Importation of Being Earnest."

82. Merton, "The Reward System of Science"; Mokyr, *The Gifts of Athena*; Mokyr, "The Intellectual Origins of Modern Economic Growth"; David, "The Historical Origins of 'Open Science'"; Davids, "Public Knowledge and Common Secrets"; and Davids, "Openness or Secrecy? Industrial Espionage in the Dutch Republic." See also Berg, "Reflection on Joel Mokyr's *The Gifts of Athena*." Work on the social and rhetorical structures that underlie claims of openness and public science includes, among many others, Golinski, *Science as Public Culture*; Stewart and Gascoigne, *The Rise of Public Science*.

83. Bots and Waquet, *La République des Lettres*; Goldgar, *Impolite Learning*; Daston, "The Ideal and the Reality of the Republic of Letters"; Broman, "The Habermasian Public Sphere."

84. Mokyr, "The Market for Ideas and the Origins of Economic Growth in Eighteenth Century Europe"; Mokyr, "Knowledge, Enlightenment, and the Industrial Revolution."

85. Biagioli, *Galileo, Courtier*; Freedberg, *The Eye of the Lynx*; Findlen, *Possessing Nature*; see Biagioli, op. cit. (22); Moran, *Patronage and Institutions*; Pumphrey, "Science and Patronage in England, 1570–1625: A Preliminary Study."

86. On print culture's instability, see Johns, *The Nature of the Book*. Tacit knowledge and its bodily function is emphasized in Smith, *The Body of the Artisan*; see also Polányi, *Personal Knowledge*.

87. *GAA* 5075, Notarial Archives Abraham Tzeewen, inv. 7598, April 17, 1717.

CHAPTER FIVE

1. For the catalogue, see ———. *Bibliotheca et Museum Bidloianum*.

2. For a very long-term view on real estate prices in Amsterdam, see Eichholtz, "A Long Run House Price Index."

3. For the Ancient debates on human anatomy, see Cosans, "Galen's Critique of Rationalist and Empiricist Anatomy"; Hankinson, "Galen's Anatomical Procedures." For

modern brain imaging, see Alac, "Working with Brain Scans"; Beaulieu, "Images Are Not the (Only) Truth"; Joyce; "Appealing Images." For an overview of early modern debates, including the one between Ruysch and Bidloo, see Cunningham, *The Anatomist Anatomis'd*, 223–94. For a debate across the centuries, see Elkins, "Two Conceptions of the Human Form"; Punt, *Bernard Siegfried Albinus (1697–1770)*; Huisman, "Squares and Diopters."

4. On vivisection and animal experimentation, see Guerrini, *Experimenting with Humans and Animals*. On the shrimp, see Harvey, *The Anatomical Exercises,* 34.

5. Pranghofer, "'It could be seen more clearly in Unreasonable Animals than in Humans.'"

6. On Leiden University, see Otterspeer, *Groepsportret met dame II.*

7. For an early criticism of this view, see Bidloo, *Opera omnia anatomico-chirurgica,* ch. 1 *de nervis.*

8. For mechanical objectivity, see Daston and Galison, "The Image of Objectivity"; Daston and Galison, *Objectivity.*

9. On the concept of auto-inscription, see Brain and Wise, "Muscles and Engines"; De Chadarevian, "Graphical Method and Discipline"; Douard, "E.-J. Marey's Visual Rhetoric and the Graphic Decomposition of the Body." On the evidence of preparations, see Rheinberger, "Präparate—Bilder ihrer selbst"; Rheinberger, "Die Evidenz des Präparates."

10. For a representative quote, see "Ik hebbe kleene Kinderkens, die ik over twintigh jaaren heb gebalsemt, en tot nu toe soo netjes bewaard, datse eer schynen te slapen; als ontzielt te zyn." Ruysch, *Alle de ontleed- genees- en heelkundige werke,* 487.

11. The anecdote of the baby is recounted by several authors, incl. Dúzs, "Hogyan utazott 170 évvel ezelőtt a magyar calvinista candidatus."

12. [Bidloo?], *Mirabilitas mirabilitatum.* A copy survives at the British Library, *BL* cat. no. 548 F 16. (12.), which bears a note of identification on the title page: "Q an a Godofredo Bidloo conscripta?."

13. Rau, *Oratio inauguralis de methodo anatomen docendi et discendi,* 9 and 29.

14. "Maar wy begrypen ook, dat door de aangedronge stoffe die vaten uytgespannen en opgevult worden, dewelke gelyk takken uyt een bloetvoerende slagader, als haar stam, voortkomen, maar welkers oorsprong echter naauwer is in zyn natuurlyke opening, als dat die het rode deel van 't bloet tot zich kan nemen, schoon zy fynder deeltjes als dit dikste deel gemakkelyk ontfangt: en waarom ook deze vaatjes, tot een tegennatuurlyke grootte vergroot zynde, *Valschelyk voor bloetvoerende pypies gehouden worden*; dewyl deze in gezontheit alleen Wyvoerende, als ik zo spreken mag, geweest zyn." Ruysch, *Alle de ontleed- genees- en heelkundige werke,* 1183–84. Boerhaave's letter is reprinted in its entirety in this volume.

15. On the Boerhaave-Ruysch debate, see Knoeff, "Chemistry, Mechanics and the Making of Anatomical Knowledge."

16. On the microscopy of disease, see Meli, "Blood, Monsters and Necessity in Malpighi's *De polypo cordis.*"

17. "Wat my aanbelangt, ik zal in tegendeel myne zake alleen door proeven beweren, en zodanig bybrengen, welke met de Ogen des lichaams konnen gezien worden, want dit is ondervinding; maar die alleen een beschouwing door de Ogen des verstants vereisschen, zal ik aan anderen overlaten, die vermeynen, dat de redeneringen boven de waarnemingen te schatten zyn." Ruysch, *Alle de ontleed- genees- en heelkundige werke*, 1196.

18. On Bidloo's atlas, see Dumaitre, *La curieuse destinée des planches anatomiques de Gérard de Lairesse*; Fournier, "De microscopische anatomie in Bidloo's *Anatomia humani corporis*"; Herrlinger, "Bidloo's 'Anatomia'—Prototyp Barocker Illustration?"; Vasbinder, "Govard Bidloo en W. Cowper." For biographical information, see Kooijmans, *De doodskunstenaar*, 95–97, 107–23, and 217–36; and Krul, "Govard Bidloo." Bidloo's association with the Nil is documented in Dongelmans, *Nil volentibus arduum*, 139–40. A source on Bidloo's early career is a letter about assisting the Six family in planning the purchase of a house for 13,000 guilders. Govard Bidloo to Joachim Oudaen, Amsterdam, May 9, 1676, *UBA* OTM HS L 4.

19. Bidloo, *De dood van Pompeus, treurspel*. For the satire, see Bidloo, *De muitery en nederlaag van Midas*.

20. Bidloo, *Verhaal der laatste ziekte en het overlijden van Willem de IIIde*.

21. Bidloo, *Komste van zijne Majesteit Willem III*.

22. "Naardien alle Schryvers van Geschiedenissen en Vertoogen niet zoo gelukkig zijn, dat zy zich van hunne eigene tegenwoordigheid, ofte getrouwe oor- en ooggetuigen kunnen bedienen." Bidloo, *Komste van zijne Majesteit Willem III, aan den lezer*.

23. "De Koning over de Brug gekoomen zynde (de leezer merke aan, dat de hier volgende prent het ontfangen van zyn Majesteit, als buiten de Westenderbrug, is verbeeldende; het welk alleen is geschied, om het vertoog in beeter en duidelijker schikking te brengen; naardien, als verder blijken zal, alleen de plaats en niets anders hier in verschil, of verandering maakt), wierd door de Wel Eedele Achtbaare Heernen Burgemeesters en Regeerders van 's Graavenhaage onder een onbeschryvelijk geroep en gejuih van duizende duizenden, ontfangen." Bidloo, *Komste van zijne Majesteit Willem III*, 29–30.

24. On the debate, see Knoeff, "Over 'het kunstige, toch verderfelyke gestel.'" Ruysch's part of the debate is reprinted in Ruysch, *Alle de ontleed- genees- en heelkundige werke*; for Bidloo's part, see Bidloo, *Vindiciae quarundam delineationum anatomicarum*.

25. "Affectata tamen et nova, scilicet, haec condiendi cadavera methodus vulgo atque huic et illi idiotae medicastro placuit: sed, Catone judice, *quidquid vulgo placet, vel solum ideo omni suspicione dignum, etiamsi quoddam virtutis specimen prae se ferre videatur. Sed* ineptus sim, et arti Anatomes dirus, si dissimilem atque praelectorem Ruyschium non agnoscam *laboriosum, indefessum, die ac nocte rebus intentum anatomicus maxime,* intellige, fucandis, adulterandis minio, cocco, cerussa et quavis *arte meretricia* exornandis: hisce, fateor, se supra *communem anatomicorum* famam et sortem extulis altissime." Bidloo, *Vindiciae quarundam delineationum anatomicarum*, 14–15.

26. Félibien, *Entretiens sur les vies et sur les ouvrages des plus excellens peintres*, 33. Bidloo owned a 1705 London edition of the work, ———, *Bibliotheca et Museum Bidloianum*, 80.

27. "Ego hasce papillas pyramidales et subrotundas (vide Fig: 6.) delineavi, non quod vel clariss: Malpighii, vel mea unquam fuerit sententia (egregium vero Ruyschianae inscitiae exemplum) nerveo-glandosa haec corpora mathematice, sed comparative esse pyramidalia et subrotunda: quam crasse porro erraverit, rete subcuticulare foraminulis pertusum vere rotundis, ope microscopii (vide fig. IV) adauctaque duplo, eorum magnitudine (vide fig. VI) exhibens, patet, cum pro papillarum motu et dispositione, compressione, intumescentia, flacciditate et similibus corporis reticularis foraminum figura mutari debeat: ut proponitur, fig. nova. I. Corneum autem corpus hoc, nec papillas demonstrabit hasce, ut credo, marmoreas; rigidae enim si extrarent, inflexiles et immobiles, eadem esset omnium allidentium contractandarumque materiarum sensibus perceptio; posse eas extendi, deprimi, vi externa; intumescere, flaccescere liquorum spirituumque copia, aut penuria atque ab vicinarum partium compressione, vel et inter sese, mutata quarundam figura, aliarum itidem ut et superficiem partis in qua sunt, nec non, consequenter, foramina, sive aperturas corporis reticularis cui inhaerent, figura quoque juxta papillarum circumscriptiones, debere mutari, nemo (Ruyschio excepto praelectore) inficias ibit." Bidloo, *Vindiciae quarundam delineationum anatomicarum*, 6–7.

28. On early modern and modern cinematography, see Biagioli, *Galileo's Instruments of Credit*, 135–218; Cartwright, *Screening the Body*; Hopwood, Schaffer and Secord, "Seriality and Scientific Objects in the Nineteenth Century."

29. "Fig. XV. Referente Arteriae aortae, cera repletae, in corpore sex post partum mensium infantis (quam separatam reservo), praecipuas e trunco distributiones; Minores enim sub involucris, ossibus atque musculis reconditae, cultello persequi saepius non potui. Ex hac videre est quam diversimode interdum ejus propagines ducantur atque sint situatae. Lubet huic divaricationis descriptioni, modum, quo vasa haec impleantur, ut et quorundam curiositati satisfiat, praefigere." Bidloo, *Anatomia humani corporis*, Tab. XXIII Fig. 15.

30. "Indien zyn Cabinet voorzien, en verciert is met diergelyke doode lichamen van Jongelingen, over de twee Jaaren bewaart, waarom legt hy ze dan niet ten toon, gelyk ik gedaan hebbe in de voorlede honds-dagen?" Ruysch, *Alle de ontleed- genees- en heelkundige werke*, 252.

31. "abunde enim scio, pleraque, quae in *Musaeo ejus pauperculo* inveniuntur non esse ab ipso praeparata, sed aliunde accersita." Ruysch, *Alle de ontleed- genees- en heelkundige werke*, 33.

32. Latour, "Drawing Things Together."

33. Daston and Galison, "The Image of Objectivity"; Daston and Galison, *Objectivity*.

34. Te Heesen, "News, Paper, Scissors: Clippings in the Sciences and Arts around 1920"; Johnston, *Making Mathematical Practice*; Klein, *Experiments, Models, Paper Tools*.

35. "Posse *mentis oculis videri,* concipi, quomodo arteriae coronales divaricari debeant in corde, quis mente non carens, lubens non annuit?" Bidloo, *Vindiciae quarundam delineationum anatomicarum,* 19.

36. "Ipsi Epist 2 pag 10 *arteriae mammariae interiores bis inordinata ramificatione, inordinato,* credo ipsum velle insolito, irregulari, *cursu distribuuntur.* Quo jure negat, in aorta ejusque divaricatione, ab me observatum? *placet,* enim, ut ipse ait, *naturae aliquando varietate frui.* Epist. sexta. pag. 11. *ludit,* ipsi, *natura saepius circa arteriae bronchialis exortum,* sed vasis, mihi delineandis, ludere non licet, hisce more solito, modeste, incedendum est: sed monente Seneca, *ignorat naturae potentiam, qui illi non putat aliquando licere, nisi quod saepius facit.*" Bidloo, *Vindiciae quarundam delineationum anatomicarum,* 16.

37. For the concept of typical, see Daston and Galison, "The Image of Objectivity," 87–88.

38. Bidloo never criticized Ruysch's museum catalogues because "catalogum enim Rariorum, observationibus annexum, non tango, ne Ruyschiana *coemeteria,* violare profanus dicar." Bidloo, *Vindiciae quarundam delineationum anatomicarum,* 60.

39. *GAA* 5075, Notarial Archives, Inv. 7648 Abraham Tzeewen, Act 981, December 28, 1730 for the price; for the number of specimens, see Ruysch, *Catalogus musaei Ruyschiani.*

40. Prak, "Painters, Guilds, and the Art Market in the Dutch Golden Age," 148–49. On the art markets, see also Montias, *Art at Auction in 17th Century Amsterdam*; Montias, *Artists and Artisans in Delft.*

41. ———, *Catalogues van de uitmuntende cabinetten . . nagelaten door wylen den Heere Albertus Seba*; the prices are noted in the copy at the *UBA.*

42. Hier streeft de konst natuur voorby / [. . .] / Maar Bidloo van een edel vier / Ontsteken, nen door lust gedreven, / Weerstaet dien trotschen vyant fier, / En schenkt den dooden zelfs het leven." Van der Goes, "Op de anatomische wonderheden van Govard Bidloo."

43. "Den Professor Hotten refereert [. . .] dat hy [. . .] met de heer Doctor Cosson ende den apothecaris Taurinus nader onsersoek hadde gedaan van den toestant van het Cabinet van de heer Professor Bidloo, alsmede van 't Cabinet van de Universiteyt, staande in de gallerye van de Academischen tuyn, ende bevonden dat in 't een ende 't ander alle vegetable mettertijs was komen te vergaan, sijnde niets goed gebleven als de mineralen, gesteenten ende verruwstoffen; ende dat derhalven waeren te raiden geworden de H. C. ende B. te exhorteren tot 't combineren van 'de voors. Cabinetten, wanneer men met kleyne kosten een seer completen collectie soude kennen maeken." Molhuysen, *Bronnen tot de geschiedenis der Leidsche Universiteit,* IV/135.

44. For Bidloo's gift to Petiver, see Petiver, *Gazophylacii naturae et artis decas prima-decima,* Table VI Fig. 5. For specimens from Ruysch, see Petiver, *Gazophylacii naturae et artis decas prima-decima,* Table X Fig. 9, Table XII Fig. 9, Table XXIV Fig. 1; and Petiver, *Musei Petiveriani centuria prima-decima,* #118, 395, 396, 519, 604, 627, 651, 692.

45. Farrington, *An account of a journey through Holland, Frizeland, etc.,* 11–12.

46. "Den Custos Anatomiae aen de heeren Curat: en Burgermeesteren hebbende bekent gemackt, dat den Professor Bidlo van intentie was om eenige kassen met rariteijten, dewelke hij voor heen op 't Theatrum Anatomicum had doen brengen, wederom van daar te laten transporteren, versoekende hij Custos te mogen weeten hoe hij sigh daar omtrent soude hebben te gedragen. Waar op gedelibereert sijnde en goedgevonden en verstaen, dat den gemelten heer Bidloo sal worden aengesegt, dat hij een Lyste sal overleveren van 't geene hij oordeelt aen hem toe te behooren, om 't selve gesien sijnde, nader te resolveren soo als men na redelijckheijt sal oordeelen te behoren." *UBL* ACi 29, Resolutien van de Curatoren en Burgermeesteren 1696–1711, March 24, 1710, f. 539. For the reminder, see *UBL* ACi 30, Res. Cur. 1711–1725, f. 65.

47. ———, *Bibliotheca et Museum Bidloianum*; the prices are noted in a copy in St. Petersburg, but not in the *BL* copy.

48. For Ruysch's specimens, see "'t Gestel van 't oor en de gehoor-deelen van yvoir, uit het Cabinet van den Heer Professor Ruysch" and "Een Boekje van den Heer Professor Ruysch; waerin 17 Sceletons van Bladen etc." Ten Kate, *Catalogus van het vermaarde Cabinet*, 88 and 96.

49. For Ruysch's specimens, see "'t Gestel van 't oor en de gehoor-deelen van yvoir, uit het Cabinet van den Heer Professor Ruysch" and "Een Boekje van den Heer Professor Ruysch; waerin 17 Sceletons van Bladen etc." Lambert ten Kate. *Catalogus van het vermaarde Cabinet*, 88 and 96. On Limburg's collection, see Van Limburg, *Catalogus insignium librorum praecipue*.

50. "Er haette seine Sachen nicht zum Zierrath, sondern zum Gebrauch." Uffenbach, *Merkwürdige Reisen*, II/622.

51. Albinus, *Index supellectilis anatomicae quam Academiae Batavae legavit Johannes Jacobus Rau*.

52. Ronjat, *Lettre de Mr. Ronjat, Ecrite de Londres à un Medecin de ses amis en Hollande*, 23.

53. Hoftijzer, *Engelse Boekverkopers bij de Beurs*, 348.

54. The 1735 edition might well have used some of the engravings that were printed for Smith and Walford's English edition, but remained with Boom in the end, I would guess.

55. For details of the publication contract, see Van Eeghen, *De Amsterdamse boekhandel 1680–1725*, IV/129–31.

56. On the Royal Society's response, see Robert Southwell to Govard Bidloo, n.d., *Wellcome* MS 7671/5.

57. "Ik meene ook dat u E. wel kunt afneemen dat het ons omtrent het verkoopen van onze Anatomie niet min schaadelijk zijn zal. Wy hebben een tijd lang niet kunnen bevatten, wat'er van geweest zy, als ons nu 't elkens voorquam, dat'er in Engeland een nieuwe, en beeter werd gedrukt, als de onze is: maar nu werden wy daar in verlicht: indien wy dit hadden gedacht, dat u. E. op deze wijze daar mede zoude gehandeld hebben, wy kunnen u. E. wel verzeekeren, dat u E. noit figuren van ons zoude gehad hebben." Bidloo, *Gulielmus Cowper, criminis literarii citatus*, 8.

58. Hermann Boerhaave to William Sherard, April 17, 1718, in Lindeboom, *Boerhaave's Letters*, I/67. When Luigi Marsigli decided to keep the copperplates of his *Danubius Pannonico-mysticus*, the Dutch publishers stipulated in the contract that he was not allowed to republish them for a full 100 years. Stoye, *Marsigli's Europe (1680–1730)*, 298–300.

59. Blankaart, *Anatomia reformata* 2nd edition. For list price, see ———. *Bibliotheca et Museum Bidloianum*, 50.

60. Pápai Páriz, *Pax corporis*.

61. On commodification, see Biagioli, *Galileo, Courtier*; Appadurai, *The Social Life of Things*; Anderson, "The Possession of Kuru: Medical Science and Biocolonial Exchange."

62. Ratcliff, "Abraham Trembley's Strategy of Generosity and the Scope of Celebrity in the Mid-Eighteenth Century."

63. Cook, "Time's Bodies."

CHAPTER SIX

1. On Le Blon, see Lilien, *Jacob Christoph Le Blon*. Le Blon's prints were catalogued by Singer, "Jakob Christoffel Le Blon." For his anatomical prints, see Krivatsy, "Le Blon's Anatomical Color Engravings."

2. BL Additional MS. 4299. At another point, Le Blon claimed that his first prints were "le portrait de S. M. Roy de Grande la Bretagne, une Ste Vierge avec l'Enfant Jesus et St Jean Battiste apres Barozzio, une piece anatomique et une petite tete de N. Sauveur de la Ste Veronicque." BL Additional MS. 4299, f. 75–76.

3. On Veronica's veil, see Belting, *Likeness and Presence*; Kessler and Wolf, *The Holy Face and the Paradox of Representation*; Koerner, *The Moment of Self-Portraiture in German Renaissance Art*; Kuryluk, *Veronica and Her Cloth*. For the survival of the images in Protestant circles, see Vanhaelen, "Iconoclasm and the Creation of Images in Emanuel de Witte's 'Old Church in Amsterdam.'" For the image's transformation from religious icon to an allegory of artistic activity, see Wolf, "From Mandylion to Veronica." On Le Blon's use of the image, see Scott, "The Colour of Justice."

4. Gotha Chart. A. 875, 162.

5. Smith, *The Body of the Artisan*; on artisanal work, see also Bennett, "The Mechanics' Philosophy"; Zilsel, "The Sociological Roots of Science"; Vérin, *La gloire des ingénieurs*; Smith and Schmidt, *Making Knowledge in Early Modern Europe*; Roberts et al., *The Mindful Hand*.

6. On tacit, and embodied knowledges, see Polányi, *Personal Knowledge*; Smith, *The Body of the Artisan*; O'Connor, "Embodied Knowledge"; Epstein, "Craft Guilds, Apprenticeship, and Technological Change in Preindustrial Europe"; Epstein, "Property Rights to Technical Knowledge in Premodern Europe, 1300–1800." Epstein's oeuvre has been very influential for me while writing this chapter.

7. Talking about globalized bioprospecting in late capitalist Mexico, Cori Hayden similarly argues that "it is this potential for transforming plants into 'information,' and information into a patentable product, that allows proponents to label bioprospecting a form of sustainable—or ecologically friendly—economic development. And it is also, of course, precisely this question that provokes deep concern on the part of prospecting critics and participants about the capacity of source countries and communities to maintain control over such easily dispersed and manipulated information." Hayden, *When Nature Goes Public*, 58–59.

8. Obviously, certain types of artisanal knowledge had been claimed communicable earlier, and recipe books contained many "secrets" that could be shared with others. While I do not claim priority for Le Blon, I do believe that the late seventeenth century marked an intensification of the belief in the communicability of knowledge. See Eamon, *Science and the Secrets of Nature*; Rankin and Long, *Secrets and Knowledge in Medicine and Science*. For a long-term history of intellectual property, see Long, *Openness, Secrecy, Authorship*.

9. For a more complex, and less teleological, account of eighteenth-century theories and practices of invention, see the forthcoming Jones, *Reckoning with Matter*.

10. On books, see Eisenstein, *The Printing Press as an Agent of Change*; and Johns, *The Nature of the Book*. For prints, see Ivins, *Prints and Visual Communication*; Landau and Parshall, *The Renaissance Print*; Bury, *The Print in Italy*.

11. Paper illustrations are the exclusive focus of Lefèvre et al., *The Power of Images in Early Modern Science*. Paper images are fruitfully contrasted to instruments in Kusukawa and Maclean, *Transmitting Knowledge*. For a rethinking of this dichotomy, see Biagioli, *Galileo's Instruments of Credit*; Chadarevian and Hopwood, *Models: The Third Dimension of Science*; and Karr-Schmidt, *Art—A User's Guide*.

12. Pon, *Raphael, Dürer, and Marcantonio Raimondi*; Van Hout and Huvenne, *Rubens et l'art de la gravure*; Witcombe, *Copyright in the Renaissance*.

13. Great Britain Patent Office, *Printing Patents*, 69.

14. Great Britain Patent Office, *Printing Patents*, 83.

15. Doorman, *Octrooien voor uitvinding in de Nederlanden uit de 16e-18e eeuw*, G. 405, September 30, 1642; patent and privilege are interchangeable terms.

16. Weale, "Progress of Machinery and Manufactures in Great Britain," 227. On Holman, see also Shesgreen, *The Criers and Hawkers of London*, 98–99.

17. Fock, *Het Nederlandse interieur in beeld 1600–1900*; Koldeweij, *Goudleer in de Republiek der zeven Verenigde Provincien*; Koldeweij, "The Marketing of Gilt Leather in Seventeenth-Century Holland"; on advertising gilt leather, see Fuhring, "Gouden Pracht in de Gouden Eeuw."

18. Doorman, *Octrooien voor uitvinding in de Nederlanden uit de 16e-18e eeuw*, G.106, February 11, 1611.

19. Doorman, *Octrooien voor uitvinding in de Nederlanden uit de 16e-18e eeuw*, G. 127, December 17, 1613; G 286, August 5, 1628.

20. Doorman, *Octrooien voor uitvinding in de Nederlanden uit de 16e-18e eeuw*, G. 171, May 19, 1618.

21. Griffiths, "Early Mezzotint Publishing in England—II."

22. Wax, *The Mezzotint*, 15.

23. For a recent review, see Thomas, "Noble or Commercial?"

24. Pissarro, "Prince Rupert and the Invention of Mezzotint."

25. Griffiths, *The Print in Stuart Britain 1603–1689*, 193; Wuestman, "The Mezzotint in Holland."

26. On this, see Hunter, *Wicked Intelligence*.

27. Evelyn, *Sculptura, or, the history, and art of chalcography*, epistle dedicatory.

28. Evelyn, *Sculptura, or, the history, and art of chalcography*, 145.

29. Evelyn, *Sculptura, or, the history, and art of chalcography*, 148.

30. Griffiths, *The Print in Stuart Britain 1603–1689*, 194.

31. Faithorne, *The art of graveing, and etching, wherein is expressed the true way of graueing in copper*.

32. Browne, *Art pictoria, or an Academy*.

33. Wuestman, "The Mezzotint in Holland," 72.

34. Griffiths, "Early Mezzotint Publishing in England—II," 138.

35. Newton's law of gravity, obviously, is an excellent example of how mechanical philosophy and mathematical law did not always go hand in hand. For a recent overview of mechanical philosophy, see Garber and Roux, *The Mechanization of Natural Philosophy*; see also Henry, "Occult Qualities and the Experimental Philosophy."

36. Shank, *The Newton Wars and the Beginning of the French Enlightenment*; Jacob, *The Newtonians and the English Revolution*; Jacob and Stewart, *Practical Matter*; Jorink and Maas, *Newton and the Netherlands*.

37. Daston and Park, *Wonders and the Order of Nature*; and, obviously, Cassirer, *The Philosophy of the Enlightenment*.

38. Powers, *Inventing Chemistry*, 16. On Boerhaave's evolving views on Newton in his later career, see also Knoeff, "How Newtonian Was Hermann Boerhaave?" As Bidloo's case suggests, obviously, there were alternative approaches to medicine in this period, as well.

39. Delbourgo, "The Newtonian Slave Body."

40. Riskin, "The Defecating Duck, or, the Ambiguous Origins of Artificial Life"; see also Voskuhl, *Androids in the Enlightenment*.

41. Spary, *Eating the Enlightenment*, 43.

42. Piles, *Cours de peinture par principes*, 494 sqq. For a review of the concurrent, irrational strand of aesthetics, see the highly problematic work of the Nazi philosopher Baeumler, *Das Irrationalitätsproblem in der Ästhetik und Logik des 18. Jahrhunderts bis zur Kritik der Urteilskraft*.

43. Peter Rabus, *Boekzaal van Europa. May and June 1693*, 461. See also Van de Roemer,

"Regulating the Arts," 201. See also Weststeijn, *The Visible World*; and Blankert et al., *Dutch Classicism in Seventeenth-Century Painting*.

44. Moxon, *Mechanick Exercises*.

45. Schaffer, "Enlightened Automata"; see also Alder, "French Engineers Become Professionals."

46. "Herr Le Blon, ein Maler und Deutscher von Geburt, welcher wie er sagte, ein Schuler der Carlo Maratti war, kam gegen das Jahr 1704 in Holland. Er werckte einen Versuch, die theorie der großen Neutons von dem farben auf die Malereij aufzuwercken." *SUB Göttingen*, MS Uffenbach 9, Ausgezogene Schriftstellen aus Büchern, 297.

47. On color prints in general, see Lowengard, *The Creation of Color in Eighteenth Century Europe*; Rodari, *Anatomie de la couleur*; Grasselli, *Colorful Impressions*; Gascoigne, *Milestones in Colour Printing*.

48. Ten Kate's correspondence was published in Miedema, *Denkbeeldig schoon*. Further references to the correspondence will be to this edition (*Miedema*). On ten Kate, see Ten Cate, *Lambert ten Kate Hermansz*. His collection is discussed in Van Gelder, "Lambert ten Kate als kunstverzamelaar"; on his Newtonianism, see Rienk Vermij, "The Formation of the Newtonian Philosophy"; Dijksterhuis, "'Will the Eye Be the Sole Judge?'"; Dijksterhuis, "Low Country Opticks"; Miedema, "Newtonismus und wissenschaftliches Kunstideal."

49. As a painter, Van Limborch found ten Kate's and Le Blon's ideas fascinating, but had many difficulties with implementing them in his practice. For a good example, see Miedema, "Lambert ten Kate in Correspondence with Hendrick van Limborch."

50. All quotes are from Le Blon, *The Beau Ideal*, epistle dedicatory. On ancient theories of harmonic proportion, see, for instance, Barker, *The Science of Harmonics in Classical Greece*, 263–437. Note that the Greek word *analogia* means proportion, and Le Blon's term *analogy* is probably equivalent to this.

51. Le Blon's 1707 work might never have been published, as only one printed copy survives, inserted into the ten Kate correspondence. See Le Blon, *Generaale proportie der beelden*.

52. Dürer, *Underweysung der Messung*; Dürer, *De symmetria partium in rectis formis humanorum corporum*. The potential musical overtones of human proportions were also discussed by the Venetian Francesco Giorgi, as discussed by Panofsky, "The History of the Theory of Human Proportions as a Reflection of the History of Styles," 91.

53. Lairesse, *Groot Schilderboek*, 21.

54. "Ik heb my verwonderd dat Lares, in zyn boek, deeze materie zo onnozel behandelt; ze is waarlyk niet een hair beter dan de meeting die Albert Durer gebruikt." Van Limborch to ten Kate, March 8, 1707, *Miedema*, 32.

55. Miedema, "Een tienduizendste van een Rijnlandse voet."

56. Ten Kate to Van Limborch, April 29, 1707, *Miedema*, 49; where he discusses measure-

ments of the Laocoön and David. Ten Kate's purchase of the Laocoön casts is dis-
cussed in ten Kate to Van Limborch, December 20, 1706, *Miedema*, 24; and Van Lim-
borch to ten Kate, January 11, 1707, *Miedema*, 28. The postmortem auction catalogue
of his collection lists these casts in detail; see ten Kate, *Catalogus van het vermaarde
Cabinet.*

57. Ten Kate's theory of human proportions is briefly expounded in ten Kate, *Ideal Beauty
in Painting and Sculpture*, 49. The development of ten Kate's thought on this topic can
be followed in detail throughout *Miedema*.

58. Ten Kate, "Proef-ondervinding over de scheiding der couleuren." See also Vermij,
"The Formation of the Newtonian Philosophy," 199.

59. Newton, *Opticks*, 109–12.

60. On soap bubbles in science, see Schaffer, "A Science Whose Business is Bursting."

61. On the experiments with color, see Miedema, "Lambert ten Kate in Correspondence
with Hendrick van Limborch."

62. "La premiere Idée de la possibilité de pouvoir imprimer avec les Couleurs *harmonieuse-
ment rangées*, occupoit tellement mon Esprit, que je ne pouvois pas m'empecher d'y
songer sérieusement." *BL* MS Additional 4299, f. 75. (emphasis mine).

63. On primary colors and color theory in general, see Shapiro, "Artists' Colors and New-
ton's Colors."

64. Baxandall, *Shadows and Enlightenment.*

65. Ten Kate to Van Limborch, March 20, 1709, *Miedema*, 150–52.

66. Note that this experiment is closely related to Aristotle's investigations in color the-
ory. The Greek philosopher, however, believed that the harmonious combination of
black and white pigments produced the visible color spectrum, and not only shadows.
See Sorabji, "Aristotle, Mathematics, and Colour."

67. Le Blon to Van Limborch, January 3, 1711, *Miedema*, 182–185.

68. "wel is waar, dat door Uw Ed.ts herinneren hoe dat de alder grooteste Coloristen
seekere wonderenswaerde Teerigheeden in haere Naekten gebragt hebben, alleen
door het gevall uijt den Penseel, sonder dat ze selvs reden daer van souden hebben
kunnen geeven, [. . .] maer na verder overdenken diene ik hierop: dat deeze Meesters
[. . .] niet meesters genoeg geweest bennen, om het selvde altijd weederom, en overal
gelijkgoed in een lichaem te doen [. . .] en dat onze gepraesupponert Fleeschgraeuw
diergelijken gans geene van doen heeft, en, tot onse Intentie dienende, volmaakt goed
weesen kan sonder eenige Accidentien, de welke men altemal wiskondig maaken
kan." Le Blon to Van Limborch, January 3, 1711, *Miedema*, 182–85.

69. Obviously, like ten Kate's and Le Blon's ideas, Newton's beliefs did not quite map onto
reality. See Schaffer, "Glass Works."

70. "Herr Le Blond machte noch ein groß Geheimniß daraus, und sagte, das wäre vor
grosse Herren, die ihme die Erfindung, ehe er sie gemein machte, wohl bezahlen
müßten." Uffenbach, *Merkwürdige Reisen*, III/535. The translation is from Lilien, *Ja-
cob Christoph Le Blon*, 22.

71. Lilien, *Jacob Christoph Le Blon*, 24, citing the original patent rolls. On the British patent system, see MacLeod, *Inventing the Industrial Revolution*.

72. Le Blon, *Coloritto*, epistle dedicatory.

73. Howard, *A Short Narrative of an Extraordinary Delivery of Rabbets*. On St. André, see James Caulfield, *Portraits, Memoirs, and Characters, of Remarkable Persons*, 190–96.

74. Le Blon, *Coloritto*, epistle dedicatory.

75. Le Blon, *Coloritto*, epistle dedicatory.

76. Le Blon, *Coloritto*, 17–18.

77. Le Blon, *The Beau Ideal*, preface.

78. Le Blon, *The Beau Ideal*, 6.

79. Hogarth, *The Analysis of Beauty*, 9.

80. Le Blon, *The Beau Ideal*, preface.

81. Le Blon, *The Beau Ideal*, epistle dedicatory.

82. Mortimer, "An Account of Mr. James Christopher Le Blon's Principles of Printing," 103.

83. Note the parallels with Marx, "Formal and Real Subsumption of Labour under Capital."

84. On the history of invention in France, and in particular on this case of color printing in France, see Hilaire-Pérez, *L'invention technique au siècle des Lumières*, 119–24.

85. Hilaire-Pérez, "Diderot's Views on Artists' and Inventors' Rights."

86. Hilaire-Pérez and Garçon, "'Open Technique' between Community and Individuality in Eighteenth-Century France."

87. On du Fay, see Bycroft, "Wonders in the Academy." One eagerly awaits Bycroft's forthcoming work on du Fay.

88. "sans conséquence, qu'avec 3 planches chargées chacune d'une seule mere couleur, l'une bleue, l'autre jaune, et la troisiéme rouge, il produisoit en les appliquant successivement sur un papier, sur un taffetas, sur un satin, toutes les diversités des couleurs qui font un tableau complet" [Louis Bertrand Castel], "Coloritto, or the Harmony of Colouring," *Journal des Trévoux* (1737), 1436. On Castel, see Hankins and Silverman, *Instruments and the Imagination*, 72–84; Franssen, "The Ocular Harpsichord of Louis-Bertrand Castel."

89. "plus d'atteinte qu'il ne convient au secret de l'Auteur." [Castel], "Coloritto, or the Harmony of Colouring," 1444.

90. "le seul moyen de [. . .] conserver un secret qui seroit tres utile [. . .] seroit d'accorder au sr. Le Blond un privilege a condition qu'il donneroit son secret aux personnes qui luy seroient designees par S.M." *AN* F.12 993 Dossier Gautier d'Agoty.

91. "trauailler et leur declarer touts les secrets, et la pratique de son art." *AN* F.12 6469 Request a pieces Cotte C. Memoire. The original order is *AN* Cote E 2166, f.122–123.

92. "qu'ils ne pourroient pretendre a aucune part dans les profits qui pourroient resulter de l'exercice dudit priuilege." *AN* F. 12 6469 Memoire. See also Lilien, *Jacob Christoph Le Blon*, 68.

93. Biagioli, "Patent Republic"; Belfanti, "Guilds, Patents, and the Circulation of Technical Knowledge"; Goose, "Immigrants and English Economic Development," 138; Pettegree, "'Thirty Years On,'" 298.

94. Doorman, *Octrooien voor uitvinding in de Nederlanden uit de 16e-18e eeuw*, May 7, 1660.

95. Long, "Invention, Secrecy, Theft," 224; Isoré, "De l'existence des brevets d'invention en droit français avant 1791," 102.

96. Biagioli, "Patent Republic." For the early modern system, especially in France, see Frumkin, "Les anciens brevets d'invention"; Bondois, "Le privilège exclusif au XVIIIe siècle."

97. For a similar conceptualization of the preconditions of modern patent law, see Pottage and Sherman, *Figures of Invention*.

98. MacLeod, *Inventing the Industrial Revolution*, 49.

99. Gallon, *Machines et inventions approuvées par l'Académie Royale des Sciences*, iii.

100. MacLeod, *Inventing the Industrial Revolution*, 41.

101. For the original privilege, see *AN* Cote E 1184 A.

102. *AN* Cote E 1188 A.

103. *AN* Minutier Central Cote LIII/301, May 12, 1742; For the founding document, see *AN* Minutier Central Cote LIII/301, May 19, 1742.

104. Lavezzi, "Peinture et savoirs scientifiques."

105. "Il a reconnu par un ecrit public qu'il en avoit appris la theorie de pere Castel jesuite, le S. Gaultier a puise ce secret dans la meme source." *AN* F.12 7863.

106. "C'est comme les Observateurs du Microscope, s'ils ne sçavent aussi connoître les effets de la lumiere et de l'ombre, et la figure et contour des Corps, ils prendront les Bulles pour des Molécules et les Animalcules pour des Ressorts." D'Agoty, *Observations sur l'Histoire naturelle, sur la Physique et la Peinture* (1752), 47. Note the similarity of the argument to Bredekamp, *Galileo, der Künstler*.

107. "Fouillent-ils les entrailles? Injectent-ils les vaisseaux? Connaissent-ils les attaches, et le mouvement mecanique des muscles?" D'Agoty, *Observations sur l'Histoire naturelle, sur la Physique et la Peinture* (1752), 73.

108. Gautier d'Agoty, *Chroa-genesie*.

109. See *BnF* MS Fr. 22136, f. 24.

110. ———. "Des Herrn Gautier . . . Brief an den Herrn de Bosse." *Hamburgisches Magazin 7* (1751), 458–469. *SUB Göttingen*. MS Uffenbach 9, 297–305.

111. "Les vrais Artistes sont des Sçavans, parce que leurs operations sont toujours fondées sur quelque Science, et ils ne sont appelles du nom d'Artistes, que parcequ'a leur sçavoir ils joignent l'Ouvrage des mains." D'Agoty, *Observations sur l'Histoire naturelle, sur la Physique et la Peinture* (1752), 171.

112. Gautier de Montdorge, *L'art d'imprimer les tableaux*.

113. "les Secrets se communiquent dans l'instant, mais il faut plusieurs années pour posséder un Art." *Observations sur l'Histoire naturelle, sur la Physique et la Peinture* (1753), 177.

114. For similar arguments about the communicability of mathematics, see Kaiser, Ito, and Hall, "Spreading the Tools of Theory"; and Steingart, "A Group Theory of Group Theory."

115. "Je veux faire entendre qu'il n'y a que moi capable dans le monde de donner des Planches anatomiques et d'observer les Objets, parce que je suis Anatomiste Phisicien et Peintre tout à la fois." D'Agoty, *Observations sur l'Histoire naturelle, sur la Physique et la Peinture* (1753), 47.

116. For further examples of competing epistemologies of invention, see Jones, *Reckoning with Matter.*

CHAPTER SEVEN

1. On Peter the Great, see Hughes, *Peter the Great.* On science in Peter's Russia, see Werrett, "An Odd Sort of Exhibition." On Peter's travels, see especially Knoppers, "The Visits of Peter the Great to the United Provinces in 1697–98 and 1716–17"; Waegemans, *De tsaar van Groot Rusland in de Republiek.*

2. Jacob de Bie to the Burgomasters of Amsterdam, May 7, 1717, *GAA* 5027 Archief diplomatieke missiven 57–59.

3. Driessen-van het Reve, *De Kunstkamera van Peter de Grote.*

4. Gordin, "The Importation of Being Earnest."

5. Buberl and Dückershoff, *Palast des Wissens*; Kistemaker et al., *Peter de Grote en Holland.*

6. St. Petersburg Academy of Sciences, *Musei imperialis Petropolitani [partes plurimae].*

7. Cited by Driessen-van het Reve, *De Kunstkamera van Peter de Grote*, 193.

8. On the development of Dutch innovations in international communication, which transformed family-based firms with relatives stationed in foreign cities into companies that handled communication through the postal system, see Veluwenkamp, "Schémas de communication internationale et système commercial néerlandais, 1500–1800."

9. On Witsen, see Peters, *De wijze koopman*; Wladimiroff, *De kaart van een verzwegen vriendschap.*

10. On the Dutch in the Baltic, see Lemmink and Van Koningsbrugge, *Baltic Affairts.* On Dutch cultural networks, see Cools, Keblusek and Noldus, *Your Humble Servants.*

11. Musschenbroek to Schumacher, Leiden, 1724, *RAS* Fond 1 Opis 3 No. 8.

12. Delbourgo, "Sir Hans Sloane's Milk Chocolate and the Whole History of the Cacao"; Ben-Zaken, *Cross-Cultural Exchanges in the Eastern Mediterranean.*

13. For more detail on this, see Margócsy, "The Fuzzy Metrics of Money."

14. Malinowski, *Argonauts of the Western Pacific.* For examples of incommensurable objects in contemporary biomedicine, see Beck, "Medicalizing Culture(s) or Culturalizing Medicine(s)"; Lederer, *Flesh and Blood.* See also Radin, *Contested Commodities.*

15. For examples, see Comaroff and Comaroff, "Colonizing Currencies: Beasts, Bank-

notes, and the Colour of Money in South Africa"; Davenport, "Two Kinds of Value in the Eastern Solomon Island"; Kopytoff, "The Cultural Biography of Things"; Weiss, "Coffee, Cowries, and Currencies"; Guyer, *Marginal Gains*.

16. Vincent, *Wondertooneel der nature*. On Vincent, see Roemer, *De geschikte natuur*, and Mason, *Infelicities*, 92–99.

17. Petiver claimed that Vincent had "I believe the most completed collection of any one man in ye world." Petiver to Jean Salvadore, London, November 2, 1711, *BL* MS Sloane 3338, f. 2. For the description of the cabinet by the Uffenbachs, during a second visit to the Netherlands in 1718, see *SUB Göttingen* MS Uffenbach 46, 98–109.

18. The Surinamese toad is a reference to Vincent's research on the much-contested reproduction of this animal; see Vincent, *Descriptio pipae seu Bufonis aquatici Surinamensis*.

19. " . . . par hazard [. . .] vous voudriez resoudre a achepter les 2 petits cabinets marque dans la nouvelle description inserre dans le livre du crapeau fol: 86 et fol: 87 article no. 8 et 6." Vincent to Sloane, Haarlem, August 21, 1725, *BM* MS Sloane 4048, f. 45.

20. Kusukawa, *Picturing the Book of Nature*, 104–5.

21. On visual facts, see Swan, "Ad vivum, naer het leven, from the life"; and Parshall, "'Imago contrafacta.'" On the history of facts, see especially Poovey, *A History of the Modern Fact*; Daston, "Baconian Facts, Academic Civility, and the Prehistory of Objectivity"; Shapiro, *A Culture of Fact*; Cook, *Matters of Exchange*; Bender and Wellbery, "Rhetoricality: On the Modernist Return of Rhetoric."

22. Daston and Galison, "The Image of Objectivity"; Daston and Galison, *Objectivity*.

23. Bleichmar, "Training the Naturalist's Eye in the Eighteenth Century."

24. Bredekamp, *Galileo, der Künstler*; Van de Roemer, "Het lichaam als borduursel"; Smith, *The Body of the Artisan*.

25. On performativity, see Austin, *How To Do Things with Words*. On its connections to classification, in a rather different context, see Herzfeld, *The Social Production of Indifference*.

26. Kusukawa, *Picturing the Book of Nature*, 258.

27. Biagioli, *Galileo, Courtier*.

28. Shapin and Schaffer, *Leviathan and the Air Pump*.

29. Prak, *The Dutch Republic in the Seventeenth Century*.

30. Cook, *Matters of Exchange*.

31. Proctor and Schiebinger, *Agnotology*; Oreskes and Conway, *Merchants of Doubt*; Brandt. *The Cigarette Century*.

32. For a qualified assessment of late-eighteenth-century Netherlands, see Kloek and Mijnhardt, *Dutch Culture in a European Perspective*.

33. Seters, *Pierre Lyonet (1706–1789)*.

34. Cited by Shapin, *The Scientific Life*, 34.

BIBLIOGRAPHY

PRIMARY SOURCES

————. *Gart der Gesundheit*. Mainz: Peter Schöffer, 1485.

————. *Ortus sanitatis*. Mainz: Jacob Meydenbach, 1491.

————. *Ter bruiloft van Albertus Seba met Anna Lopes*. Amsterdam: n. p., 1698. Zeeuwse Bibliotheek Kluis 1148 A 285.

————. *Bibliotheca et Museum Bidloianum*. Leiden: Samuel Luchtmans, 1713.

————. *Catalogues van de uitmuntende cabinetten . . nagelaten door wylen den Heere Albertus Seba*. Amsterdam: Sluyter, Schut and Blinkvliet, 1752.

————. *A True Estimate of the Value of Leasehold Estates*. London: J. Roberts, 1731.

Albinus, Bernhard Siegfried. *Index supellectilis anatomicae quam Academiae Batavae legavit Johannes Jacobus Rau*. Leiden: Henricus Mulhovius, 1725.

Albinus, Bernhard Siegfried. *Tabulae sceleti et musculorum corporis humani*. Leiden: Joannes et Hermannus Verbeek, 1747.

Aldrovandi, Ulisse. *De animalibus insectis*. Bologna: Bellagamba, 1602.

Aldrovandi, Ulisse. *De reliquis animalibus exanguibus*. Bologna: Bellagamba, 1606.

Aldrovandi, Ulisse. *Quadrupedum omnium bisulcorum historia*. Frankfurt am Main: Zunner, Haubold and Rotel, 1647.

Artedi, Petrus. *Ichthyologia sive opera omnia de piscibus*. Leiden: Conradus Wishoff, 1738.

Audran, Gérard. *Les proportions du corps humain, mesurées sur les plus belles figures de l'antiquité*. Paris: Girard Audran, 1683.

Barge, J. A. J. *De oudste inventaris der oudste academische anatomie in Nederland*. Leiden: H.E. Stenfert Kroese, 1934.

Barlaeus, Caspar. *Mercator sapiens: oratie gehouden bij de inwijding van de Illustre School te Amsterdam op 9 januari 1632*. Translated and introduced by S. van der Woude. Amsterdam: Universiteitsbibliotheek, 1967.

Bauhin, Caspar. *Pinax theatri botanici*. Basel: sumptibus et typis Ludovicus Regius, 1623.

[Bidloo, Govard?]. *Mirabilitas mirabilitatum*. N.p.: n.p., n.d.

Bidloo, Govard. *Anatomia humani corporis*. Amsterdam: vidua Joannis a Someren, 1685.

Bidloo, Govard. *De dood van Pompeus, treurspel*. Amsterdam: erfg. van Jacob Lescailje, 1684.

Bidloo, Govard. *Gulielmus Cowper, criminis literarii citatus.* Leiden: Jordanus Luchtmans, 1700.

Bidloo, Govard. *Komste van zijne Majesteit Willem III.* The Hague: Arnoud Leers, 1691.

Bidloo, Govard. *De muitery en nederlaag van Midas.* Leiden: Langerak, 1723.

Bidloo, Govard. *Opera omnia anatomico-chirurgica.* Leiden: Samuel Luchtmans, 1715.

Bidloo, Govard. *Verhaal der laatste ziekte en het overlijden van Willem de IIIde.* Leiden: Jordanus Luchtmans, 1702.

Bidloo, Govard. *Vindiciae quarundam delineationum anatomicarum.* Leiden: Jordanus Luchtmans, 1697.

Bils, Lodewijk de. *The Copy of a Certain Large Act [Obligatory] of Yonker Lovis de Bils.* Rotterdam: Naeranus, 1659.

Bils, Lodewijk de. *Epistolica dissertatio.* Rotterdam: Naeranus, 1659.

Bils, Lodewijk de. *Exemplar fusioris Codicilli.* Rotterdam: Naeranus, 1659.

Bils, Lodewijk de. *Kopye van zekere ampele acte van Jr. Louijs de Bils.* Rotterdam: Naeranus, 1659.

Bils, Lodewijk de. "Ludivici de Bils actorum anatomicorum vera delineatio." In *Responsio ad epistolam Tobiae Andreae,* edited by Lodewijk de Bils. Marburg: Salomon Schadewitz, 1678.

Bils, Lodewijk de. *Waarachtig gebruik der tot noch toe gemeende gijlbuis beneffens de verrijzenis der lever.* Rotterdam: Naeranus, 1658.

Blankaart, Stephanus. *Anatomia reformata.* 2nd ed. Leiden: Luchtmans, 1688.

Blankaart, Stephanus. *Anatomia reformata.* 3rd ed. Leiden: Luchtmans, 1695.

Blankaart, Stephanus. *Verhandelinge van het podagra.* Amsterdam: Jan ten Hoorn, 1684.

Blasius, Gerardus. *Anatome animalium.* Amsterdam: vidua Joannis a Someren, 1681.

Braamcamp, Gerrit. *Catalogus van het uytmuntend Cabinet.* Amsterdam: J. Smit et al., 1771.

Breyne, Jacob. *Exoticarum plantarum centuriae.* Gdańsk: sumptibus autoris, 1674.

Breyne, Johann Philip. *Dissertatio physica de Polythalamiis.* Gdańsk: Cornelius a Beughem, 1732.

Brisson, Mathurin Jacques. *Regnum animale in classes IX distributum.* Leiden: Haak, 1756–62.

Browne, Alexander. *Art pictoria, or an Academy.* London: J. Redmayne, 1669.

Bruyn, Cornelis de. *Reizen over Moskovie, door Persie en Indien.* Amsterdam: R. and G. Wetstein, J. Oosterwyk, H. van de Gaet, 1714.

Buffon, George-Louis Leclerc de. *Histoire naturelle, générale et particulière, avec la description du Cabinet de roi.* Paris: L'imprimerie royale, 1749–67.

Buonanni, Filippo. *Musaeum Kircherianum.* Rome: Plach, 1709.

Buonanni, Filippo. *Recreatio mentis et oculi in obseruatione animalium testaceorum.* Rome: Varesi, 1684.

Burmann, Johannes. *Rariorum Africanarum plantarum decades.* Amsterdam: Boussiere, 1738–39.

Burmann, Johannes. *Thesaurus zeylanicus, exhibens plantas in insula Zeylana nascentes.* Amsterdam: Janssonius-Waesbergen & Salomon Schouten, 1737.

Buxbaum, Johann Christian. *Nova plantarum genera.* St. Petersburg: Academia scientiarum imperialis petropolitanae, 1728–29.

Catesby, Mark. *The Natural History of Carolina, Florida, and the Bahama Islands.* London: for the author, 1731–43.

Charleton, Walther. *Onomastikon zoikon.* London: Jacob Allestry, 1671.

Clusius, Carolus. *Rariorum aliquot stirpium per Pannoniam . . . observatarum historia.* Antwerp: Plantin, 1584.

Cockburn, William. *The Symptoms, Nature, Cause and Cure of Gonorrhea.* 3rd ed. London: G. Strahan, 1719.

Cordus, Valerius. *Annotationes in Pedacij Dioscoridis Anazarbei de Medica materia libros V, . . . , et historiae stirpium libri iiii.* Strasbourg: Iosias Rihelius, 1561.

D'Argenville, Antoine-Joseph Dézallier. *La conchyliologie.* Paris: De Bure, 1742.

Descartes, René. *The Use of the Geometrical Playing Cards, as also a Discourse of the Mechanick Powers.* London: J. Moxon, 1697.

Dryander, Johannes. *Anatomia Mundini.* Marburg: Egenolff, 1541.

Dürer, Albrecht. *De symmetria partium in rectis formis humanorum corporum.* Nuremberg: vidua Dureriana, 1532.

Dürer, Albrecht. *Underweysung der Messung.* Nuremberg: Hieronymus Andreas, 1525.

Evelyn, John. *Sculptura, or, the history, and art of chalcography.* London: J. C. for G. Beedle, and T. Collins and J. Crook, 1662.

Faithorne, William. *The art of graveing, and etching, wherein is expressed the true way of graueing in copper.* London: Willm Faithorne, 1662.

Fallours, Samuel. *Poissons, écrevisses et crabes . . . que l'on trouve autour des l'isles Moluques.* Amsterdam: Reinier et Josué Ottens, 1754.

Fallours, Samuel. *Tropical Fishes of the East Indies.* Edited by Theodore Pietsch. Cologne: Taschen, 2010.

Farrington, John. *An account of a journey through Holland, Frizeland, etc. in severall letters to a friend.* Edited by Paul G. Hoftijzer. Leiden: Academic Press, 1994.

Félibien, André. *Entretiens sur les vies et sur les ouvrages des plus excellens peintres.* 2nd ed. Paris: Sebastien Mabre-Cramoisy, 1685.

Fontenelle, Bernard le Bovier de. "Eloge de Monsieur Ruysch." In *Historie de l'Académie royale des sciences,* edited by Bernard le Bovier de Fontenelle. Paris: Du Pont, 1785.

Franzius, Wolfgang. *Historia animalium sacra.* Wittenberg: Schurer and Gormann, 1612.

Fuchs, Leonhart. *De historia stirpium commentarii insignes.* Basel: Michael Isingrin, 1542.

Gallon, M. *Machines et inventions approuvées par l'Académie Royale des Sciences.* Paris: Martin, Coignard and Guérin, 1735.

Gautier d'Agoty, Jacques-Fabien. *Chroa-genesie, ou Génération des couleurs contre la système de Newton.* Paris: Delaguette, 1749.

Gautier de Montdorge, Antoine. *L'art d'imprimer les tableaux.* Paris: Mercier, Nyon, and Lambert, 1756.

Geoffroy, Jean-Etienne. *Histoire abrégée des insectes aux environs de Paris.* Paris: Durand, 1762.

Gerard, John. *The Herball or Generall Historie of Plantes.* London: John Norton, 1597.

Gersaint, Edmé F. *Catalogue raisonné de coquilles et autres curiosités naturelles.* Paris: Flahault et Prault Fils, 1736.

Gesner, Conrad. *Epistolarum medicinarum . . . libri III.* Zürich: Froschoverus, 1577.

Gesner, Conrad. *Historiae animalium.* Zürich: Froschoverus, 1551–58.

Goedaert, Johannes. *Of Insects: Done into English and Methodized with the Addition of Notes.* Edited by Martin Lister. London: John White, 1682.

Gualtieri, Nicola. *Index testarum conchyliorum.* Florence: C. Albizzini, 1742.

Harvey, William. *The Anatomical Exercises: De motu cordis and De circulatione sanguinis, in English Translation.* Mineola: Dover, 1995.

Helle, P. C. A., and Pierre Rémy. *Catalogue raisonné d'une collection considerable de coquilles.* Paris: Didot, 1757.

Hermann, Paul. *Paradisus batavus.* Leiden: Elzevier, 1698.

Hernandez, Franciscus. *Nova plantarum, animalium et mineralium Mexicanorum historia.* Rome: Mascardi, 1651.

Hogarth, William. *The Analysis of Beauty.* New Haven: Yale University Press, 1997.

Horne, Jan ten. *Naeuw-keurig Reysboek.* Amsterdam: Jan ten Horne, 1679.

Howard, John. *A Short Narrative of an Extraordinary Delivery of Rabbets.* London: John Clarke, 1727.

Janssonius van Waesbergen. *Catalogus librorum medicorum, pharmaceuticorum . . . in off. Janssonio-Waesbergiana prostantium.* Amsterdam: Janssoons van Waesberge, 1730.

Jordan, Claude. *Voyages historiques de l'Europe.* Paris: Nicolas le Gras, 1693–1700.

Jussieu, Bernard de. "Examen de quelques productions marines." *Mémoires de l'Académie des Sciences* (1742): 290–302.

Kate, Lambert ten. *Aenleiding tot de kennisse der Nederduitsche sprake.* Amsterdam: R & G. Wetstein, 1723.

Kate, Lambert ten. *Catalogus van het vermaarde Cabinet.* Amsterdam: Isaak Tirion, 1732.

Kate, Lambert ten. *Ideal Beauty in Painting and Sculpture.* London: C. Bathurst, 1769.

Kate, Lambert ten. "Proef-ondervinding over de scheiding der couleuren." *Verhandelingen, uitgegeven door de Hollandsche Maatschappij der Wetenschappen te Haarlem* 3 (1757): 17–30.

Klein, Jacob Theodor. *Quadrupedum dispositio brevisque historia naturalis.* Leipzig: Breitkopf, 1751.

L'Admiral, Jacob. *Naauwkeurige waarnemingen, van veele gestaltverwisselende gekorvene Diertjes.* Amsterdam: Changuion & Van Esveldt, 1740.

Lairesse, Gérard de. *Groot Schilderboek.* Amsterdam: Desbordes, 1712.

Lanzoni, Giuseppe. *Tractatus de balsamatione cadaverum.* Geneva: Chouet & Ritter, 1696.

Le Blon, Jacob Christoph. *The Beau Ideal, By the Late Ingenious and Learned Hollander, Lambert Hermanson ten Kate.* London: James Bettenham, 1732.

Le Blon, Jacob Christoph. *Coloritto; or the Harmony of Colouring in Painting: Reduced to Mechanical Practice, under Easy Precepts, and Infallible Rules.* London: s.p., 1725.

Le Blon, Jacob Christoph. *Generaale proportie der beelden.* Amsterdam: n.p., 1707.

Linnaeus, Carolus. *Bibliotheca botanica.* Amsterdam: vidua S. Schouten et filius, 1751.

Linnaeus, Carolus. *Flora lapponica.* Amsterdam: S. Schouten, 1737.

Linnaeus, Carolus. *Hortus Cliffortianus.* Amsterdam: for the author, 1737.

Linnaeus, Carolus. *Species plantarum.* Stockholm: Laurentius Salvius, 1753.

Linnaeus, Carolus. *Systema naturae.* Leiden: Haak, 1735.

Lister, Martin. *Historiae sive synopsis conchyliorum.* London: by the author, 1685–1692.

Lister, Martin. *Journey to Paris in the Year 1698.* London: Jacob Tonson, 1699.

Lister, Martin. *English Spiders.* Originally published 1678. Colchester: Harley Books, 1992.

Lovell, Robert. *Panzooryktologia, sive Panzoologicomineralogia, or a Compleat History of Animals and Minerals.* Oxford: Hall and Godwin, 1660.

[Mabbut, George]. *Sir Isaac Newton's tables for renewing and purchasing the leases of cathedral-churches and colleges.* London: Tho. Astley, 1742.

Marperger, Jakob Paul. *Die geöffnete Raritäten- und Naturalien-Kammer.* Hamburg: Benjamin Schiller, 1704.

Matthioli, Pietro Andrea. *Opera quae extant omnia.* Frankfurt: Nicolai Bassaeus, 1598.

Merian, Maria Sibylla. *Metamorphosis insectorum surinamensium.* Amsterdam: for the author, 1705.

[Mettrie, Julien Offray de la]. *L'homme machine.* Leiden: Elie Luzac, 1748.

Moffett, Thomas. *Insectorum sive Minimorum Animalium theatrum.* London: Thom. Cotes, 1634.

Mortimer, Cromwell. "An Account of Mr. James Christopher Le Blon's Principles of Printing." *Philosophical Transactions* (1731): 101–7.

Moxon, Joseph. *Mechanick Exercises, or, the Doctrine of Handy-Works Applied to the Art of Printing.* London: Joseph Moxon, 1683.

Newton, Isaac. *Opticks, or a Treatise of the Reflections, Refractions, Inflections, and Colours of Light.* 4th ed. London: William Innys, 1730.

Pallas, Peter Simon. *Dierkundig mengelwerk.* Utrecht: A. van Paddenburg en J. van Schoonhoven, 1770.

Pápai Páriz, Ferenc. *Pax corporis.* Budapest: Magvető, 1984.

Pennant, Thomas. *Synopsis of Quadrupeds.* Chester: J. Monk, 1771.

Perrault, Claude. *Memoir's for a natural history of animals.* London: Joseph Streater, 1688.

Petiver, James. *Aquatilium animalium amboinae.* London: C. Bateman, 1713.

Petiver, James. *Brief directions for the easie making and preserving collections of all natural curiosities.* London: s. p., 1709.

Petiver, James. *Gazophylacii naturae et artis decas prima-decima.* London: Christ. Bateman, 1702–9.

Petiver, James. *Musei Petiveriani centuria prima-decima.* London: Smith & Walford, 1694–1703.

Piles, Roger de. *Cours de peinture par principes.* Paris: Jacques Estienne, 1708.

Plukenet, Leonard. *Phytographia.* London: sumptibus autoris, 1691.

Rabus, Peter. *Boekzaal van Europe. May and June 1693.* Rotterdam: Pieter van der Slaar, 1693.

Rau, Johannes Jacob. *Oratio inauguralis de methodo anatomen docendi et discendi, habita in auditori majori in alma Academia Lugduno Batava.* Leiden: Samuel Luchtmans, 1713.

Ray, John. *Historia plantarum.* London: Maria Clark, 1686.

Ray, John. *Synopsis methodica animalium quadrupedum et serpentini generis.* London: Smith and Walford, 1693.

Ray, John. *Synopsis methodica stirpium Britannicarum editio tertia.* Edited by Johann Jakob Dillenius. London: William and John Innys, 1724.

Renard, Louis, and Theodore W. Pietsch. *Fishes, Crayfishes, and Crabs: Louis Renard's Natural History of the Rarest Curiosities of the Seas of the Indies.* Baltimore: Johns Hopkins University Press, 1995.

Ronjat, Etienne. *Lettre de Mr. Ronjat, écrite de Londres à un Medecin de ses amis en Hollande.* London: Henry Ribotteau, 1703.

Rumphius, Georg Eberhard. *D'Amboinsche rariteitkamer.* Amsterdam: François Halma, 1705.

Rumphius, Georg Eberhard. *Het Amboinsche Kruid-boek.* Amsterdam: Changuion, 1741–50.

Rumphius, Georg Eberhard. *The Ambonese Curiosity Cabinet.* Edited by E. M. Beekman. New Haven: Yale University Press, 1999.

Ruysch, Frederik. *Alle de ontleed- genees- en heelkundige werke.* Amsterdam: Janssonius Waesbergen, 1744.

Ruysch, Frederik. *Catalogus musaei Ruyschiani.* Amsterdam: Janssonius Waesbergen, 1731.

Ruysch, Frederik. *Observationum anatomico-chirurgiarum centuria et catalogus rariorum.* Amsterdam: Henricus et vidua Theodori Boom, 1691.

Ruysch, Frederik. *Opera omnia anatomico-medico-chirurgica.* Amsterdam: Janssonius Waesbergen, 1721–27.

Schumacher, Ivan Danilovich. *Gebäude der Kayserlichen Academie der Wissenschafften Nebst der Bibliotheck und Kunst-Cammer in St. Petersburg nach ihrem Grundriß, Aufriß und Durchschnitt vorgestellet.* St. Petersburg: Imperatorskaia akademiia nauk, 1741.

Seba, Albertus. *Locupletissimi rerum naturalium thesauri accurata descriptio.* Amsterdam: Janssonius Waesbergen, J. Wetstein & Gul. Smith, 1734–65.

Seba, Albertus. *Planches de Seba.* Paris: F. G. Levrault, 1827.

Sloane, Hans. *A voyage to the islands Madera, Barbados, Nieves, S. Christophers and Jamaica.* London: B. M., 1707–25.

St. Petersburg Academy of Sciences. *Musei imperialis Petropolitani [partes plurimae].* St. Petersburg: Acad. Scientiarum, 1741–45.

Sterne, Laurence. *The Life and Opinions of Tristram Shandy*. Originally published 1759–67. Harmondsworth: Penguin, 1967.

Swammerdam, Jan. *Bybel der Natuure*. Edited by Hermann Boerhaave. Leiden: Severinus, Boudewyn van der Aa, Pieter van der Aa, 1737.

Sweerts, Emmanuel. *Florilegium*. Amsterdam: Joannes Janssonius, 1620.

Tournefort, Jacques Pitton de. *Elémens de botanique, ou Méthode pour connoître les plantes*. Paris: Imprimerie Royale, 1694.

Trew, C. J. "An Observation on the Method of preserving Anatomical Preparations in Liquors." *Acta Germanica, Or, The Literary Memoirs of Germany* (1742): 446–48.

Tulp, Nicolaes. *De drie boecken der medicijnsche aenmerkingen*. Amsterdam: Jacob Benjamyn, 1650.

Tyson, Edward. *Orang-Outang, sive Homo Sylvestris, or, the Anatomy of a Pygmie*. London: Thomas Bennet, 1699.

Tyson, Edward. *Phocaena, or the Anatomy of a Porpess, . . . with a Praeliminary Discourse*. London: Benj. Tooke, 1680.

Uffenbach, Zacharias Conrad von. *Bibliotheca Uffenbachiana universalis*. Frankfurt: Jo. Benj. Andrae & Henr. Hott, 1729–30.

Uffenbach, Zacharias Conrad von. *Merkwürdige Reisen durch Niedersachsen, Holland und Engelland*. Ulm: Johann Friedrich Gaum, 1753–54.

Vaillant, Sébastien. *Botanicon Parisiense*. Leiden: Pieter van der Aa, 1723.

Valentini, Michael Bernhard. *Amphitheatrum zootomicum*. Frankfurt: haeredus Zunnerianorum, 1720.

Valentini, Michael Bernhard. *Musaeum musaeorum, oder vollständige SchauBühne aller Materialien und Specereyen*. Frankfurt: Johann David Zunner, 1714.

Van der Goes, Antonides. *Gedichten*. Amsterdam: Jan Rieuwertsz, 1685.

Van der Heyden, Jan. *A Description of Fire Engines with Water Hoses and the Method of Fighting Fires now used in Amsterdam*. Originally published 1690. Translated and introduced by L. Stibbe Multhauf. Canton: Science History Publications, 1996.

Van het Meurs, L. L. "Het leven van den beroemden F. Ruysch." *Algemeen Magazijn Historiekunde* 3 (1785): 447–88.

Van Limburg, Abraham. *Catalogus insignium librorum praecipue*. Amsterdam: Jan Boom, 1720.

Van Rheede tot Drakensteyn, Hendrik. *Hortus indicus malabaricus*. Amsterdam: Joannes van Someren, Joannes van Dyck, Henricus Boom, et vidua Theodorus Boom, 1678–1703.

Verheyen, Philippus. *Corporis humani anatomia editio nova*. Amsterdam: R. & J. Wetstein and W. Smith, 1731.

Vesalius, Andreas. *De humani corporis fabrica*. Basel: Oporinus, 1543.

Vincent, Levinus. *Descriptio pipae seu Bufonis aquatici Surinamensis*. Haarlem: by the author, 1726.

Vincent, Levinus. *Wondertooneel der nature*. Amsterdam: Francois Halma, 1706.

Vosmaer, Arnout. *Beredeneerde en systematische catalogus van eene verzameling.* The Hague: Van Os, 1764.

Wilkins, John. *An Essay towards a Real Character and a Philosophical Language.* London: Sa: Gellibrand and for John Martin, 1668.

SECONDARY SOURCES

———, ed. *Rumphius gedenkboek.* Haarlem: Coloniaal Museum, 1902.

Adams, Percy G. *Travelers and Travel Liars, 1660–1800.* Berkeley: University of California Press, 1962.

Adelmann, Howard. *Marcello Malpighi and the Evolution of Embryology.* Ithaca: Cornell University Press, 1966.

Aguilar, Jacques d'. *Histoire de l'entomologie.* Paris: Delachaux et Niestlé, 2006.

Ahlrichs, Erhard. "Albertus Seba." *Ostfriesische Familienkunde* 6 (1986): 1–48.

Alac, Morana. "Working with Brain Scans: Digital Images and Gestural Interaction in fMRI Laboratory." *Social Studies of Science* 38 (2008): 483–504.

Alder, Ken. "French Engineers Become Professionals, Or, How Meritocracy Made Knowledge Objective." In *The Sciences in Enlightened Europe,* edited by William Clark, Jan Golinski, and Simon Schaffer, 94–125. Chicago: University of Chicago Press, 1999.

Alder, Ken. "History's Greatest Forger: Science, Fiction, and Fraud along the Seine." *Critical Inquiry* 30 (2004): 702–16.

Alpers, Svetlana. *The Art of Describing: Dutch Art in the Seventeenth Century.* Chicago: University of Chicago Press, 1983.

Andersen, Casper, Jakob Bek-Thomsen, and Peter C. Kjaergaard. "The Money Trail: A New Historiography for Networks, Patronage, and Scientific Careers." *Isis* 103 (2012): 310–15.

Andersen, Finn, and Paul Nesbitt. *Flora Danica.* Edinburgh: Royal Botanic Garden, 1994.

Anderson, Frank J. *An Illustrated History of the Herbals.* New York: Columbia University Press, 1977.

Anderson, Warwick. *The Collectors of Lost Souls: Turning Kuru Scientists into Whitemen.* Baltimore: Johns Hopkins University Press, 2008.

Anderson, Warwick. "The Possession of Kuru: Medical Science and Biocolonial Exchange." *Comparative Studies in Society and History* 42 (2000): 713–44.

Appadurai, Arjun, ed. *The Social Life of Things: Commodities in Cultural Perspective.* Cambridge: Cambridge University Press, 1986.

Austin, J. L. *How To Do Things with Words.* Oxford: Clarendon Press, 1962.

Baeumler, Alfred. *Das Irrationalitätsproblem in der Ästhetik und Logik des 18. Jahrhunderts bis zur Kritik der Urteilskraft.* Darmstadt: Wissenschaftliche Buchgesellschaft, 1967.

Balis, Arnout. "Hippopotamus Rubenii: Een hoofdstukje uit de geschiedenis van de zoologie." In *Feestbundel: Bij de opening van het Kolveniershof en het Rubenianum,* edited by Frans Baudouin, 128–42. Antwerp: Kunsthistorische Musea, 1981.

Banga, Jelle. *Geschiedenis van de geneeskunde en van hare beoefenaren in Nederland.* Schiedam: Interbook, 1975.

Barker, Andrew. *The Science of Harmonics in Classical Greece.* Cambridge: Cambridge University Press, 2007.

Barthes, Roland. "The Death of the Author." In *Image / Music / Text*, edited by Roland Barthes, 142–47. New York: Hill and Wang, 1977.

Barthes, Roland. *S/Z.* Paris: Seuil, 1970.

Bauer, Aaron M., and Rainer Günther. "Origin and Identity of the Von Borcke Collection of Amphibians and Reptiles in the Museum für Naturkunde in Berlin: A Cache of Seba Specimens?" *Zoosystematics and Evolution* 89 (2013): 167–85.

Baxandall, Michael. *Shadows and Enlightenment.* New Haven: Yale University Press, 1995.

Beaulieu, Anne. "Images Are Not the (Only) Truth: Brain Mapping, Visual Knowledge, and Iconoclasm." *Science, Technology and Human Values* 27 (2002): 53–86.

Beaurepaire, Pierre-Yves, and Pierrick Pourchasse, eds. *Les Circulations internationales en Europe, années 1680—années 1780.* Rennes: Presses universitaires de Rennes, 2010.

Beck, Stefan. "Medicalizing Culture(s) or Culturalizing Medicine(s)." In *Biomedicine as Culture: Instrumental Practices, Technoscientific Knowledge and New Modes of Life*, edited by Regula Valérie Burri and Joseph Dumit, 17–34. New York: Routledge, 2007.

Belfanti, Carlo. "Guilds, Patents, and the Circulation of Technical Knowledge: Northern Italy during the Early Modern Age." *Technology and Culture* 45 (2004): 569–89.

Belozerskaya, Marina. *The Medici Giraffe: And Other Tales of Exotic Animals and Power.* New York: Little, Brown, 2006.

Belting, Hans. *Likeness and Presence: A History of the Images before the Era of Art.* Chicago: University of Chicago Press, 1994.

Bender, John, and David E. Wellbery, eds. *The Ends of Rhetoric: History, Theory, Practice.* Stanford: Stanford University Press, 1990.

Bender, John, and David E. Wellbery. "Rhetoricality: On the Modernist Return of Rhetoric." In *The Ends of Rhetoric: History, Theory, Practice*, edited by John Bender and David E. Wellbery, 3–43. Stanford: Stanford University Press, 1990.

Bennett, James A. "The Mechanics' Philosophy and the Mechanical Philosophy." *History of Science* 24 (1986): 1–28.

Bennett, James A. "Shopping for Instruments in Paris and London." In *Merchants and Marvels: Commerce, Science and Art in Early Modern Europe*, edited by Pamela Smith and Paula Findlen, 370–98. New York: Routledge, 2002.

Ben-Zaken, Avner. *Cross-Cultural Exchanges in the Eastern Mediterranean 1560–1660.* Baltimore: Johns Hopkins University Press, 2010.

Berardi, Marianne. "Science into Art: Rachel Ruysch's Early Development as a Still-Life Painter." PhD diss., University of Pittsburgh, 1998.

Berg, Maxine, ed. "Reflection on Joel Mokyr's *The Gifts of Athena*." Special issue, *History of Science* (2007): 45.

Berg, Maxine, and Helen Clifford. "Selling Consumption in the Eighteenth Century: Advertising and the Trade Card in Britain and France." *Cultural and Social History* 4 (2007): 145–70.

Bergvelt, Ellinoor, Michiel Jonker, and Agnes Wiechmann, eds. *Schatten in Delft: burgers verzamelen 1600–1750*. Zwolle: Waanders, 1992.

Berkvens-Stevelinck, C., Hans Bots, Paul G. Hoftijzer, and O. S. Lankhorst, eds. *Le magasin de l'univers: The Dutch Republic as the centre of the European book trade*. Leiden: Brill, 1992.

Biagioli, Mario. "Etiquette, Interdependence, and Sociability in Seventeenth-Century Science." *Critical Inquiry* 22 (1996): 193–238.

Biagioli, Mario. *Galileo, Courtier: The Practice of Science in the Culture of Absolutism*. Chicago: University of Chicago Press, 1994.

Biagioli, Mario. *Galileo's Instruments of Credit: Telescopes, Images, Secrecy*. Chicago: University of Chicago Press, 2006.

Biagioli, Mario. "Patent Republic: Specifying Inventions, Constructing Authors and Rights." *Social Research* 73 (2006): 1129–72.

Biagioli, Mario. "Replication or Monopoly? The Economics of Invention and Discovery in Galileo's Observations of 1610." *Science in Context* 13 (2000): 547–90.

Biagioli, Mario, and Peter Galison, eds. *Scientific Authorship: Credit and Intellectual Property in Science*. New York: Routledge, 2003.

Bille, Clara. *De tempel der kunst, of, het kabinet van den heer Braamcamp*. Amsterdam: De Bussy, 1961.

Bisseling, C. H. "Uit de Amsterdamse Courant, 1695, no. 84, 1720, no. 36." *Nederlands Tijdschrift voor Geneeskunde* 65 (1921): 3113.

Blair, Ann. *Too Much to Know: Managing Scholarly Information before the Modern Age*. New Haven: Yale University Press, 2010.

Blankert, Albert, ed. *Dutch Classicism in Seventeenth-Century Painting*. Rotterdam: NAi, 1999.

Blanning, T. C. W. *The Culture of Power and the Power of Culture*. Oxford: Oxford University Press, 2002.

Bleichmar, Daniela. "Training the Naturalist's Eye in the Eighteenth Century: Perfect Global Visions and Local Blind Spots." In *Skilled Visions: Between Apprenticeship and Standards*, edited by Cristina Grasseni, 166–90. Oxford: Berghahn, 2007.

Bleichmar, Daniela. *Visible Empire: Botanical Expeditions and Visual Culture in the Hispanic Enlightenment*. Chicago: University of Chicago Press, 2012.

Bleichmar, Daniela, and Peter C. Mancall, eds. *Collecting across Cultures: Material Exchanges in the Early Modern Atlantic World*. Philadelphia: University of Pennsylvania Press, 2011.

Blom, Philipp. *To Have and to Hold: An Intimate History of Collectors and Collecting*. New York: Overlook Press, 2002.

Boehrer, Bruce, ed. *A Cultural History of Animals in the Renaissance*. London: Berg, 2009.

Boers, O. W. "Een teruggevonden gevelsteen uit de Kalverstraat." *Maandblad Amsteloda- mum* 47 (1959): 221–24.

Boeseman, Marinus. "The Vicissitudes and Dispersal of Albertus Seba's Zoological Speci- mens." *Zoologische mededelingen* 44 (1970): 177–206.

Bondois, Paul-M. "Le privilège exclusif au XVIIIe siècle." *Revue d'histoire économique et sociale* 21 (1933): 140–89.

Bosch, X., B. Esfandiari, and L. McHenry. "Challenging Medical Ghostwriting in US Courts." *PLOS Medicine* 9/1 (2012): e1001163.

Boterbloem, Kees. *The Fiction and Reality of Jan Struys: A Seventeenth-Century Dutch Globetrotter.* London: Palgrave Macmillan, 2008.

Bots, Hans, and Françoise Waquet, eds. *La République des Lettres.* Paris: De Boeck, 1997.

Boxer, Charles Ralph. *The Dutch Seaborne Empire, 1600–1800.* New York: Knopf, 1965.

Bourguet, Marie-Noëlle, Christian Licoppe, and Heinz Otto Sibum, eds. *Instruments, Travel and Science: Itineraries of Precision from the Seventeenth to the Twentieth Century.* London: Routledge, 2002.

Brain, Robert, and M. Norton Wise. "Muscles and Engines: Indicator Diagrams and Helmholtz's Graphical Methods." In *The Science Studies Reader,* edited by Mario Bi- agioli, 51–66. London: Routledge, 1998.

Brandt, Allan. *The Cigarette Century.* New York: Basic Books, 2007.

Braudel, Fernand. *The Wheels of Commerce. Civilization and Capitalism II.* New York: Harper & Row, 1982.

Bredekamp, Horst. *Galileo, der Künstler. Die Mond, die Sonne, die Hand.* Berlin: Akademie Verlag, 2007.

Brewer, John, ed. *The Consumption of Culture: Word, Image, and Object in the 17th and 18th Centuries.* London: Routledge, 1995.

Brewer, John. "The Error of our Ways: Historians and the Birth of Consumer Society." *Cultures of Consumption Working Papers* 2004.

Brewer, John, Neil McKendrick, and J. H. Plumb. *The Birth of a Consumer Society.* London: Europa Press, 1982.

Brewer, John, and Roy Porter, eds. *Consumption and the World of Goods.* London: Rout- ledge, 1993.

Broman, Thomas. "The Habermasian Public Sphere and 'Science' in the Enlightenment." *History of Science* 36 (1998): 123–49.

Brook, Timothy. *Vermeer's Hat: The Seventeenth Century and the Dawn of the Global World.* New York: Bloomsbury, 2008.

Bruijn, Iris. *Ships' Surgeons of the East India Company: Commerce and the Progress of Medi- cine in the Eighteenth Century.* Leiden: Leiden University Press, 2009.

Bryden, D. J. "Evidence from Advertising for Mathematical Instrument Making in Lon- don, 1556–1714." *Annals of Science* 49 (1992): 301–36.

Buberl, Brigitte, and Michael Dückershoff, eds. *Palast des Wissens. Die Kunst- und Wun- derkammer Zar Peters des Großen.* Munich: Hirmer Verlag, 2003.

Bury, Michael. *The Print in Italy, 1550–1620*. London: British Museum, 2001.

Bycroft, Michael. "Wonders in the Academy: The Value of Strange Facts in the Experimental Research of Charles Dufay." *Historical Studies in the Natural Sciences* 43 (2013): 334–70.

Calaresu, Melissa. "Making and Eating Ice Cream in Naples: Rethinking Consumption and Sociability in the Eighteenth Century." *Past and Present* 220 (2013): 35–78.

Campbell, Thomas P., ed. *Tapestry in the Baroque: Threads of Splendor*. New York: Metropolitan Museum of Art, 2008.

Carney, Judith A. *Black Rice: The African Origins of Rice Cultivation in the Americas*. Cambridge: Harvard University Press, 2002.

Cartwright, Nancy. *Screening the Body: Tracing Medicine's Visual Culture*. Minneapolis: University of Minnesota Press, 1995.

Cassirer, Ernst. *The Philosophy of the Enlightenment*. Princeton: Princeton University Press, 2009.

Cate, C. L. ten. *Lambert ten Kate Hermansz. (1674–1731): taalgeleerde en konstminnaar*. Utrecht: Stichting ten Kate, 1987.

Caulfield, James. *Portraits, Memoirs, and Characters, of Remarkable Persons*. London: Hr. R. Young, 1819.

Chadarevian, Soraya de. "Graphical Method and Discipline: Self-Recording Instruments in Nineteenth-Century Physiology." *British Journal for the History of Science* 29 (1996): 17–41.

Chadarevian, Soraya de, and Nick Hopwood, eds. *Models: The Third Dimension of Science*. Stanford: Stanford University Press, 2004.

Chartier, Roger. "Magasin de l'univers ou magasin de la République? Le commerce du livre néerlandais aux XVIIe et XVIIIe siècles." In *Le magasin de l'univers: The Dutch Republic as the Centre of the European Book Trade*, edited by C. Berkvens-Stevelinck, Hans Bots, Paul G. Hoftijzer and O. S. Lankhorst, 289–307. Leiden: Brill, 1992.

Clark, William, Jan Golinski, and Simon Schaffer, eds. *The Sciences in Enlightened Europe*. Chicago: University of Chicago Press, 1999.

Clercq, Pieter de. *At the Sign of the Oriental Lamp: The Musschenbroek Workshop in Leiden, 1660–1750*. Rotterdam: Erasmus, 1997.

Clercq, Pieter de. "Exporting Scientific Instruments around 1700: The Musschenbroek Documents in Marburg." *Tractrix* 3 (1991): 79–120.

Clifton, James. "'Ad vivum mire depinxit': Toward a Reconstruction of Ribera's Art Theory." *Storia dell'arte* 83 (1995): 111–32.

Cobb, Matthew. *The Egg and the Sperm Race*. London: Pocket Books, 2007.

Cobb, Matthew. "Malpighi, Swammerdam and the Colourful Silkworm: Replication and Visual Representation in Early Modern Science." *Annals of Science* 59 (2002): 111–47.

Cole, F. J. "The History of Anatomical Injections." In *Studies in the History and Method of Science*, edited by C. Singer, vol. 2, 285–343. Oxford: Clarendon Press, 1921.

Collet, Dominik. *Die Welt in der Stube: Begegnungen mit Außereuropa in Kunstkammern der Frühen Neuzeit.* Göttingen: Vandenhoeck and Ruprecht, 2007.

Collins, Harry. *Changing Order: Replication and Induction in Scientific Practice.* Beverly Hills: Sage, 1985.

Comaroff, Jean, and John L. Comaroff. "Colonizing Currencies: Beasts, Banknotes, and the Colour of Money in South Africa." In *Commodification: Things, Agency and Identities: The Social Life of Things Revisited,* edited by Wim van Binsbergen and Peter Geschiere, 145–74. Münster: LIT, 2005.

Contardi, Simone. "Linnaeus Institutionalized: Felice Fontana, Giovanni Fabbroni, and the Natural History Collections of the Royal Museum of Physics and Natural History of Florence." In *Linnaeus in Italy: The Spread of a Revolution in Science,* edited by Marco Beretta and Alessandro Tosi, 113–28. Canton: Science History Publications, 2007.

Cook, Harold J. *The Decline of the Old Medical Regime in Stuart London.* Ithaca: Cornell University Press, 1986.

Cook, Harold J. *Matters of Exchange: Commerce, Medicine and Science in the Dutch Golden Age.* New Haven: Yale University Press, 2007.

Cook, Harold J. "Medical Communication in the First Global Age: Willem ten Rhijne in Japan, 1674–1676." *Disquisitions on the Past and Present* 11 (2004): 16–36.

Cook, Harold J. "Time's Bodies: Crafting the Preparation and Preservation of Naturalia." In *Merchants and Marvels: Commerce and Representation of Nature in Early Modern Europe,* edited by Pamela Smith and Paula Findlen, 223–47. London: Routledge, 2002.

Cook, Harold J., and David S. Lux. "Closed Circles or Open Networks? Communicating at a Distance during the Scientific Revolution." *History of Science* 36 (1998): 179–211.

Cools, Hans, Marika Keblusek, and Badeloch Noldus, eds. *Your Humble Servants: Agents in Early Modern Europe.* Hilversum: Verloren, 2006.

Cooper, Alix. *Inventing the Indigenous: Local Knowledge and Natural History in Early Modern Europe.* Cambridge: Cambridge University Press, 2007.

Cosans, Christopher E. "Galen's Critique of Rationalist and Empiricist Anatomy." *Journal of the History of Biology* 30 (1997): 35–54.

Coulton, Richard. "The Darling of the '*Temple-Coffee-House Club*': Science, Sociability and Satire in Early Eighteenth-Century London." *Journal for Eighteenth Century Studies* 35 (2012): 43–65.

Crawforth, Michael A. "Evidence from Trade Cards for the Scientific Instrument Industry." *Annals of Science* 42 (1985): 453–544.

Cunningham, Andrew. *The Anatomist Anatomis'd: An Experimental Discipline in Enlightenment Europe.* Farnham: Ashgate, 2010.

Dackerman, Susan, ed. *Prints and the Pursuit of Knowledge in Early Modern Europe.* New Haven: Yale University Press, 2011.

Dance, Peter. *Shell Collecting: An Illustrated History.* Berkeley: University of California Press, 1966.

Dannenfeldt, Karl H. "Egyptian Mumia: The Sixteenth-Century Experience and Debate." *Sixteenth Century Journal* 16 (1985): 163–80.

Darnton, Robert. *The Business of Enlightenment: A Publishing History of the Encyclopédie.* Cambridge: Harvard University Press, 1979.

Daston, Lorraine. "Baconian Facts, Academic Civility, and the Prehistory of Objectivity." *Annals of Scholarship* 8 (1991): 337–63.

Daston, Lorraine. "The Ideal and the Reality of the Republic of Letters in the Enlightenment." *Science in Context* 4 (1991): 367–86.

Daston, Lorraine. "Observation." In *Prints and the Pursuit of Knowledge in Early Modern Europe,* edited by Susan Dackerman, 125–33. New Haven: Yale University Press, 2011.

Daston, Lorraine, and Peter Galison. "The Image of Objectivity." *Representations* 40 (1992): 81–128.

Daston, Lorraine, and Peter Galison. *Objectivity.* Cambridge: Zone Books, 2007.

Daston, Lorraine, and Katharine Park. *Wonders and the Order of Nature, 1150–1750.* New York: Zone Books, 1998.

Dauser, Regina, Stefan Hächler, Michael Kempe, Franz Mauelshagen, and Martin Stuber, eds. *Wissen im Netz. Botanik und Pflanzentransfer in europäischen Korrespondenznetzen des 18. Jahrhunderts.* Berlin: Akademie Verlag, 2008.

Davenport, William H. "Two Kinds of Value in the Eastern Solomon Islands." In *The Social Life of Things: Commodities in Cultural Perspective,* edited by Arjun Appadurai, 95–109. Cambridge: Cambridge University Press, 1986.

David, Paul. "The Historical Origins of 'Open Science': An Essay on Patronage, Reputation and Common Agency Contracting in the Scientific Revolution." *Capitalism and Society* 3 (2008).

Davids, C. A. "Beginning Entrepreneurs and Municipal Governments in Holland at the Time of the Dutch Republic." In *Entrepreneurs and Entrepreneurship in Early Modern Times: Merchants and Industrialists within the Orbit of the Dutch Staple Market,* edited by Clé Lesger and Leo Noordegraaf, 167–83. The Hague: Hollandse Historische Reeks, 1995.

Davids, C. A. *Zeewezen en wetenschap. De wetenschap en de ontwikkeling van de navigatietechniek in Nederland tussen 1585 en 1815.* Amsterdam: De Bataafsche Leeuw, 1986.

Davids, Karel. "Openness or Secrecy? Industrial Espionage in the Dutch Republic." *Journal of European Economic History* 23 (1995): 333–74.

Davids, Karel. "Public Knowledge and Common Secrets: Secrecy and its Limits in the Early Modern Netherlands." *Early Science and Medicine* 10 (2005): 411–26.

Davids, Karel. *The Rise and Decline of Dutch Technological Leadership: Technology, Economy, and Culture in the Netherlands, 1350–1800.* Leiden: Brill, 2008.

Davis, Natalie Zemon. *Women on the Margins: Three Seventeenth-Century Lives.* Cambridge: Harvard University Press, 1995.

Dear, Peter. *Discipline and Experience: The Mathematical Way in the Scientific Revolution.* Chicago: University of Chicago Press, 1995.

Dear, Peter. "Totius in Verba: Rhetoric and Authority in the Early Royal Society." *Isis* 76 (1985): 144–61.

DeJean, Joan. "Lafayette's Ellipses: The Privileges of Anonymity." *PMLA* 99 (1984): 884–902.

Delbourgo, James. "Listing People." *Isis* 103 (2013): 735–42.

Delbourgo, James. "The Newtonian Slave Body: Racial Enlightenment in the Atlantic World." *Atlantic Studies* 9 (2012): 185–208.

Delbourgo, James. "Sir Hans Sloane's Milk Chocolate and the Whole History of the Cacao." *Social Text* 29 (2010): 71–101.

Dietz, Bettina. "Mobile Objects: The Space of Shells in Eighteenth-Century France." *British Journal for the History of Science* 39 (2006): 363–82.

Dijksterhuis, Fokko Jan. "'Will the Eye Be the Sole Judge?' 'Science' and 'Art' in the Optical Inquiries of Lambert ten Kate and Hendrik van Limborch around 1710." *Netherlands Yearbook of Art History* 61 (2011): 308–30.

Dijksterhuis, Fokko Jan. "Low Country Optics: The Optical Pursuits of Lambert ten Kate and Daniel Fahrenheit in Early Dutch 'Newtonianism.'" In *Newton and the Netherlands: How Isaac Newton was Fashioned in the Dutch Republic,* edited by Eric Jorink and Ad Maas, 159–83. Leiden: Leiden University Press, 2012.

Doherty, Francis. *A Study in Eighteenth-Century Advertising Methods: The Anodyne Necklace.* Lewiston: Edwin Mellen Press, 1992.

Dongelmans, B. P. M. *Nil volentibus arduum: documenten en bronnen.* Utrecht: H & S, 1982.

Doorman, Gerard. *Octrooien voor uitvinding in de Nederlanden uit de 16e-18e eeuw.* The Hague: Martinus Nijhoff, 1940.

Douard, John W. "E.-J. Marey's Visual Rhetoric and the Graphic Decomposition of the Body." *Studies in History and Philosophy of Science* 26 (1995): 175–204.

Douglas, Mary, and Baron Isherwood. *The World of Goods: Towards an Anthropology of Consumption.* New York: Basic Books, 1979.

Driessen-van het Reve, Jozien J. *De Kunstkamera van Peter de Grote. De Hollandshe inbreng gereconstrueerd uit brieven van Albert Seba en Johann Daniel Schumacher uit de jaren 1711–1752.* Hilversum: Verloren, 2006.

Druce, George Claridge. *The Dillenian Herbaria.* Oxford: Clarendon Press, 1907.

Dudok van Heel, S. A. C. "Ruim honderd advertenties van kunstverkopingen uit de Amsterdamsche Courant, 1712–1725." *Jaarboek van het Genootschap Amstelodamum* 69 (1977): 107–22.

Dufour, Théophile. *Recherches bibliographiques sur les oeuvres imprimées de J. J. Rousseau.* 2 vols. Paris: Giraud-Badin, 1925.

Dumaitre, Paul. *La curieuse destinée des planches anatomiques de Gérard de Lairesse, peintre en Hollande.* Amsterdam: Rodopi, 1982.

Dupré, Sven, and Christoph Lüthy, eds. *Silent Messengers: The Circulation of Material Objects of Knowledge in the Early Modern Low Countries.* Berlin: LIT Press, 2011.

Dúzs, Sándor. "Hogyan utazott 170 évvel ezelőtt a magyar calvinista candidatus." *Protestáns Képes Naptár* (1884): 44–59.

Eamon, William. *Science and the Secrets of Nature: Books of Secrets in Medieval and Early Modern Culture*. Princeton: Princeton University Press, 1994.

Eddy, Matthew D. "Tools for Reordering: Commonplacing and the Space of Words in Linnaeus' *Philosophia Botanica*." *Intellectual History Review* 20 (2010): 227–52.

Egmond, Florike. "A Collection within a Collection: Rediscovered Animal Drawings from the Collections of Conrad Gessner and Felix Platter." *Journal of the History of Collections* 25 (2013): 149–70.

Egmond, Florike. *The World of Carolus Clusius: Natural History in the Making, 1550–1610*. London: Pickering and Chatto, 2010.

Egmond, Florike, Paul G. Hoftijzer, and Robert Visser, eds. *Carolus Clusius: Toward a Cultural History of a Renaissance Naturalist*. Amsterdam: KNAW, 2007.

Eichholtz, Piet M. A. "A Long Run House Price Index: The *Herengracht* Index, 1628–1973." *Real Estate Economics* 25 (1997): 175–92.

Eisenstein, Elizabeth. *The Printing Press as an Agent of Change: Communications and Cultural Transformations in Early Modern Europe*. Cambridge: Cambridge University Press, 1979.

Elkins, James. "Two Conceptions of the Human Form: Bernard Siegfried Albinus and Andreas Vesalius." *Artibus et historiae* 7 (1986): 91–106.

Ellis, Sir Henry. *Original Letters of Eminent Literary Men*. London: Camden Society, 1843.

Enenkel, Karl A. E., and Paul J. Smith, eds. *Early Modern Zoology: The Construction of Animals in Science, Literature and the Visual Arts*. Leiden: Brill, 2007.

Engel, Hendrick. "The Life of Albert Seba." *Svenska Linné-Sällsk. Årsskrift* 20 (1937): 75–100.

Engel, Hendrick. "The Sale-Catalogue of the Cabinets of Natural History of Albertus Seba (1752): A Curious Document from the Period of *naturae curiosi*." *Bulletin of the Research Council of Israel Section B: Zoology* 10 (1961): 119–31.

Epstein, Stephan R. "Craft Guilds, Apprenticeship, and Technological Change in Preindustrial Europe." *Journal of Economic History* 58 (1998): 684–713.

Epstein, Stephan R. "Property Rights to Technical Knowledge in Premodern Europe, 1300–1800." *American Economic Review* 94 (2004): 382–87.

Eskildsen, Kasper Risbjerg. "Exploring the Republic of Letters: German Travellers in the Dutch Underground, 1690–1720." In *Scientists and Scholars in the Field: Studies in the History of Fieldwork and Expeditions*, edited by Kristian H. Ielsen, Michael Harbsmeier, and Christopher J. Ries, 101–22. Aarhus: Aarhus University Press, 2012.

Evans, R. J. W., and Alexander Marr, eds. *Curiosity and Wonder from the Renaissance to the Enlightenment*. Aldershot: Ashgate, 2006.

Fan, Fa-ti. "The Global Turn in the History of Science." *East Asian Science, Technology and Society* 6 (2012): 249–58.

Faust, Ingrid. *Zoologische Einblattdrucke und Flugschriften vor 1800.* Stuttgart: Hiersemann, 2003.

Feather, John. *Publishing, Piracy and Politics: An Historical Study of Copyright in Britain.* New York: Mansell, 1994.

Febvre, Lucien, and Henri-Jean Martin. *The Coming of the Book: The Impact of Printing 1450–1800.* London: Verso, 1997.

Felton, Marie-Claude. "The Enlightenment and the Modernization of Authorship." *Papers of the Bibliographical Society of America* 105 (2011): 439–69.

Ferrari, Giovanna. "Public Anatomy Lessons and the Carnival: The Anatomy Theatre of Bologna." *Past and Present* 117 (1987): 50–106.

Findlen, Paula. *Possessing Nature: Museum, Collecting, and Scientific Culture in Early Modern Italy.* Berkeley: University of California Press, 1994.

Fischel, Angela. "Collections, Images and Form in Sixteenth-Century Natural History: The Case of Conrad Gessner." *Intellectual History Review* 20 (2010): 147–64.

Fischel, Angela. *Natur im Bild: Zeichnung und Naturerkenntnis bei Conrad Gessner und Ulisse Aldrovandi.* Berlin: Gebr. Mann, 2009.

Fock, Willemijn, ed. *Het Nederlandse interieur in beeld 1600–1900.* Zwolle: Waanders, 2001.

Fokker, A. A. "Louis de Bils en zijn tijd." *Nederlands Tijdschrift voor Geneeskunde* 9 (1865): 167–214.

Foucault, Michel. *The Order of Things.* London: Tavistock, 2000.

Fournier, Marian. *The Fabric of Life: Microscopy in the Seventeenth Century.* Baltimore: Johns Hopkins University Press, 1996.

Fournier, Marian. "De microscopische anatomie in Bidloo's *Anatomia humani corporis.*" *Gewina* 8 (1985): 187–208.

Franssen, Maarten. "The Ocular Harpsichord of Louis-Bertrand Castel: The Science and Aesthetics of an Eighteenth-Century Cause Célèbre." *Tractrix* 3 (1991): 15–78.

Frasca-Spada, Marina, and Nick Jardine, eds. *Books and the Sciences in History.* Cambridge: Cambridge University Press, 2000.

Freedberg, David. *The Eye of the Lynx: Galileo, his Friends, and the Beginnings of Modern Natural History.* Chicago: University of Chicago Press, 2002.

Freedberg, David. "Science, Commerce and Art: Neglected Topics at the Junction of History and Art History." In *Art in History, History in Art. Studies in Seventeenth-Century Dutch Culture,* edited by David Freedberg and Jan de Vries, 377–428. Los Angeles: Getty Center, 1991.

French, Roger. *Harvey's Natural Philosophy.* Cambridge: Cambridge University Press, 1994.

Frumkin, M. "Les anciens brevets d'invention: Les pays du continent Européen au XVIIe siècle." *Archives internationales d'histoire des sciences* 7 (1954): 315–23.

Fuhring, Peter. "Gouden Pracht in de Gouden Eeuw: een reclameprent voor Amsterdams goudleer." *Bulletin van het Rijksmuseum* 49 (2001): 171–78.

Fumaroli, Marc. *La Querelle des Anciens et des Modernes, XVIIe-XVIIIe siècles.* Paris: Gallimard, 2001.

Gaastra, Femme S. *De geschiedenis van de VOC*. Leiden: Walburg Pers, 1991.

Galison, Peter. *How Experiments End*. Chicago: University of Chicago Press, 1987.

Galison, Peter. "Removing Knowledge." *Critical Inquiry* 31 (2004): 145–64.

Garber, Daniel, and Sophie Roux, eds. *The Mechanization of Natural Philosophy*. Dordrecht: Springer, 2013.

Gascoigne, Bamber. *Milestones in Colour Printing, 1457–1859*. Cambridge: Cambridge University Press, 1997.

Gebhard, J. F., Jr. *Het leven van Mr. Nicolaas Cornelisz. Witsen (1641–1717)*. Utrecht: J. W. Leeflang, 1882.

Geertz, Clifford. *Local Knowledge: Further Essays in Interpretive Anthropology*. New York: Basic Books, 1983.

Gelbart, Nina Rattner. *The King's Midwife: A History and Mystery of Madame du Coudray*. Berkeley: University of California Press, 1998.

Gelderblom, Oscar. "From Antwerp to Amsterdam: The Contribution of Merchants from the Southern Netherlands to the Rise of the Amsterdam Market." *Review* 26 (2003): 247–82.

Genette, Gérard. *Paratexts: Thresholds of Interpretation*. Cambridge: Cambridge University Press, 1997.

Givens, Jean Ann, Karen Reeds, and Alain Touwaide, eds. *Visualizing Medieval Medicine and Natural History, 1200–1550*. Aldershot: Ashgate, 2006.

Go, Sabine. *Marine Insurance in the Netherlands 1600–1870*. Amsterdam: Amsterdam University Press, 2009.

Goey, Ferry de, and Jan Willem Veluwenkamp, eds. *Entrepreneurs and Institutions in Europe and Asia, 1500–2000*. Amsterdam: Aksant, 2002.

Goldgar, Anne. *Impolite Learning: Conduct and Community in the Republic of Letters*. New Haven: Yale University Press, 1995.

Goldgar, Anne. *Tulipmania: Money, Honor, and Knowledge in the Dutch Golden Age*. Chicago: University of Chicago Press, 2007.

Golinski, Jan. *Science as Public Culture: Chemistry and Enlightenment in Britain, 1760–1820*. Cambridge: Cambridge University Press, 1992.

Gooding, David, Trevor J. Pinch, and Simon Schaffer, eds. *The Uses of Experiment: Studies in the Natural Sciences*. Cambridge: Cambridge University Press, 1989.

Goodman, Dena. *The Republic of Letters: A Cultural History of the French Enlightenment*. Ithaca: Cornell University Press, 1994.

Goose, Nigel. "Immigrants and English Economic Development in the Sixteenth and Early Seventeenth Centuries." In *Immigrants in Tudor and Early Stuart England*, edited by Nigel Goos and Lien Luu, 136–60. Brighton: Sussex Academic Press, 2005.

Gordin, Michael D. "The Importation of Being Earnest: The Early St. Petersburg Academy of Sciences." *Isis* 9 (2000): 1–31.

Gotzche, Peter C., Jerome P. Kassirer, Karen L. Woolley, et al. "What Should Be Done

to Tackle Ghostwriting in the Medical Literature?" *PLOS Medicine* 6/2 (2009), 122–25.

Gould, Stephen Jay, and Rosamund Purcell. *Finders, Keepers: Eight Collectors.* New York: W. W. Norton, 1994.

Graeber, David. *Toward an Anthropological Theory of Value: The False Coin of Our Own Dreams.* New York: Palgrave, 2001.

Grafton, Anthony. *The Culture of Correction in Renaissance Europe.* London: British Library, 2011.

Grafton, Anthony. *Forgers and Critics: Creativity and Duplicity in Western Scholarship.* Princeton: Princeton University Press, 1990.

Grafton, Anthony. "A Sketch Map of a Lost Continent: The Republic of Letters." *Republic of Letters* 1 (2009). http://rofl.stanford.edu/node/34.

Grasselli, Margaret Morgan. *Colorful Impressions: The Printmaking Revolution in Eighteenth Century France.* Washington: National Gallery of Art, 2003.

Grasseni, Cristina, ed. *Skilled Visions: Between Apprenticeship and Standards.* Oxford: Berghahn, 2007.

Great Britain Patent Office. *Printing Patents: Abridgements of Patent Specifications Relating to Printing, 1617–1857.* London: Printing Historical Society, 1969.

Griffiths, Antony. "Early Mezzotint Publishing in England—II: Peter Lely, Tompson, and Brown." *Print Quarterly* 7 (1990): 130–45.

Griffiths, Antony. *The Print in Stuart Britain 1603–1689.* London: British Museum Press, 1998.

Grosslight, Justin. "Small Skills, Big Networks: Marin Mersenne as Mathematical Intelligencer." *History of Science* 51 (2013): 337–74.

Grote, Andreas, ed. *Macrocosmos in Microcosmo, die Welt in der Stube: zur Geschichte des Sammelns, 1450 bis 1800.* Opladen: Leske and Budrich, 1994.

Guerrini, Anita. *Experimenting with Humans and Animals: From Galen to Animal Rights.* Baltimore: Johns Hopkins University Press, 2003.

Guerrini, Anita. "The King's Animals and the King's Books: The Illustration for the Paris Academy's *Histoire des animaux*." *Annals of Science* 67 (2010): 383–404.

Guerrini, Anita. "Perrault, Buffon, and the Natural History of Animals." *Notes and Records of the Royal Society* 66 (2012): 393–409.

Guyer, Jane. *Marginal Gains: Monetary Transactions in Atlantic Africa.* Chicago: University of Chicago Press, 2004.

Haas, Martinus de. *Bossche scholen van 1629 tot 1795.* Den Bosch: Teulings, 1926.

Haase, Wolfgang, ed. *Aufstieg und Niedergang der Römischen Welt.* New York: W. de Gruyter, 1994.

Habermas, Jürgen. *The Structural Transformation of the Public Sphere.* Cambridge: MIT Press, 1989.

Hahn, Roger. *The Anatomy of a Scientific Institution: The Paris Academy of Sciences, 1666–1803.* Berkeley: University of California Press, 1971.

Hamer-van Duynen, Sophia Wilhelmina. *Hieronymus David Gaubius (1705–1780): Zijn correspondentie met Antonio Nunes Ribeiro Sanches en andere tijdgenoten*. Amsterdam: Van Gorcum, 1978.

Hankins, James. *Plato in the Renaissance*. Leiden: Brill, 1990.

Hankins, Thomas L., and Robert J. Silverman. *Instruments and the Imagination*. Princeton: Princeton University Press, 1999.

Hankinson, R. J. "Galen's Anatomical Procedures: A Second-Century Debate in Medical Epistemology." In *Aufstieg und Niedergang der Römischen Welt*, edited by Wolfgang Haase, 1834–55. New York: W. de Gruyter, 1994.

Hansen, Julie V. "Galleries of Life and Death: The Anatomy Lesson in Dutch Art, 1603–1773." PhD diss., Stanford University, 1996.

Hansen, Julie V. "Resurrecting Death: Anatomical Art in the Cabinet of Dr. Frederik Ruysch." *Art Bulletin* 78 (1996): 663–79.

Harkness, Deborah. *The Jewel House: Elizabethan London and the Scientific Revolution*. New Haven: Yale University Press, 2007.

Harris, Steven J. "Mapping Jesuit Science: The Role of Travel in the Geography of Knowledge." In *The Jesuits: Cultures, Sciences and the Arts, 1540–1773*, edited by John W. O'Malley, Gauvin Alexander Bailey, and Steven J. Harris, 212–40. Toronto: University of Toronto Press, 1999.

Hart, Marjolein 't, Joost Jonker, and Jan Luiten van Zanden, eds. *A Financial History of the Netherlands*. Cambridge: Cambridge University Press, 1997.

Haupt, Herbert, Thea Wilberg-Vignau, Eva Irblich, and Manfred Staudinger. *Le bestiaire de Rodolphe II: Cod. min. 129 et 130 de la Bibliothèque nationale d'Autriche*. Paris: Citadelles, 1990.

Hayden, Cori. *When Nature Goes Public: The Making and Unmaking of Bioprospecting in Mexico*. Princeton: Princeton University Press, 2003.

Hayden, Ruth. *Mrs. Delany's Flower Collages from the British Museum*. New York: Pierpont Morgan Library, 1986.

Heckscher, William S. *Rembrandt's Anatomy of Dr. Nicolaas Tulp: An Iconological Study*. New York: New York University Press, 1958.

Heesen, Anke te. "News, Paper, Scissors: Clippings in the Sciences and Arts around 1920." In *Things that Talk: Object Lessons from Art and Science*, edited by Lorraine Daston, 297–327. New York: Zone Books, 2004.

Heijer, Henk den. *De geschiedenis van de WIC*. Zutphen: Walburg, 1994.

Heller, John L. "The Early History of Binomial Nomenclature." *Huntia* 1 (1964): 33–70.

Heller, John L. "Linnaeus on Sumptuous Books." *Taxon* 25 (1976): 33–52.

Henry, John. "Occult Qualities and the Experimental Philosophy: Active Principles in Pre-Newtonian Matter Theory." *History of Science* 24 (1986): 335–81.

Herrlinger, Robert. "Bidloo's 'Anatomia'—Prototyp Barocker Illustration?" *Gesnerus* 23 (1966): 40–47.

Herzfeld, Michael. *The Social Production of Indifference: Exploring the Symbolic Roots of Western Bureaucracy.* Chicago: University of Chicago Press, 1993.

Hilaire-Pérez, Liliane, ed. *Les chemins de la nouveauté: Innover, inventer au regard de l'histoire.* Paris: Editions de CTHS, 2003.

Hilaire-Pérez, Liliane. "Diderot's Views on Artists' and Inventors' Rights: Invention, Imitation, and Reputation." *British Journal for the History of Science* 35 (2002): 129–50.

Hilaire-Pérez, Liliane. *L'invention technique au siècle des Lumières.* Paris: Albin Michel, 2000.

Hilaire-Pérez, Liliane. "Technology as Public Culture in the Eighteenth Century: The Artisan's Legacy." *History of Science* 45 (2007): 135–53.

Hilaire-Pérez, Liliane, and Anne-Françoise Garçon. "'Open Technique' between Community and Individuality in Eighteenth-Century France." In *Entrepreneurs and Institutions in Europe and Asia, 1500–2000,* edited by Ferry de Goey and Jan Willem Veluwenkamp, 237–56. Amsterdam: Aksant, 2002.

Hilaire-Pérez, Liliane, and Marie Thébaud-Sorger. "Les techniques dans l'espace public. Publicité des inventions et littérature d'usage au XVIIIe siècle (France, Angleterre)." *Revue de synthèse* 127 (2006): 393–428.

Hillis Miller, J. "The Critic as Host." *Critical Inquiry* 3 (1977): 439–47.

Hoftijzer, Paul G. *Engelse Boekverkopers bij de Beurs: De Geschiedenis van de Amsterdamse Boekhandels Bruyning en Swart, 1637–1724.* Amsterdam: APA, 1987.

Hoftijzer, Paul G. "Metropolis of Print: The Amsterdam Book Trade in the Seventeenth Century." In *Urban Achievement in Early Modern Europe: Golden Ages in Antwerp, Amsterdam and London,* edited by Patrick O'Brien, Derek Keene, Marjolein 't Hart, and Harmen van der Wee, 249–63. Cambridge: Cambridge University Press, 2001.

Hoftijzer, Pail G. *Pieter van der Aa (1659–1733). Leids drukker en boekverkoper.* Hilversum: Verloren, 1999.

Holthuis, L. B. "Albert Seba's 'Locupletissimi rerum naturalium thesauri' (1734–1765) and the 'Planches de Seba' (1827–1831)." *Zoologische mededelingen* 43 (1969): 239–52.

Hopwood, Nick, Simon Schaffer, and Jim Secord, eds. "Seriality and Scientific Objects in the Nineteenth Century." Special issue, *History of Science* 48 (2010).

Hughes, Lindsey. *Peter the Great: A Biography.* New Haven: Yale University Press, 2002.

Huigen, Siegfried, Jan L. de Jong, and Elmer Kolfin, eds. *The Dutch Trading Companies as Knowledge Networks.* Leiden: Brill, 2010.

Huisman, Gerda C. "Inservio studiis Antonii a Dorth Vesaliensis: The Many Uses of a Seventeenth-Century Book Sales Catalogue." *Quaerendo* 41 (2011): 276–85.

Huisman, Tim. *The Finger of God: Anatomical Practice in 17th Century Leiden.* Leiden: Primavera Pers, 2009.

Huisman, Tim. "Squares and Diopters: The Drawing System of a Famous Anatomical Atlas." *Tractrix* 4 (1992): 1–11.

Hunger, F. W. T. *Charles de l'Escluse (Carolus Clusius): Nederlandsch kruidkundige, 1526–1609*. The Hague: Martinus Nijhoff, 1927.

Hunt, Lynn, Margaret C. Jacob, and Wijnand Mijnhardt. *The Book that Changed Europe: Picart and Bernard's Religious Ceremonies of the World*. Cambridge: Harvard University Press, 2010.

Hunter, Matthew C. *Wicked Intelligence: Visual Art and the Science of Experiment in Restoration London*. Chicago: University of Chicago Press, 2013.

Hunter, Michael, ed. *Printed Images in Early Modern Britain: Essays in Interpretation*. Farnham: Ashgate, 2010.

Impey, Oliver, and Arthur Macgregor, eds. *The Origins of Museums: The Cabinet of Curiosities in Sixteenth and Seventeenth Century Europe*. Oxford: Clarendon Press, 1985.

Isoré, Jacques. "De l'existence des brevets d'invention en droit français avant 1791." *Revue historique de droit français et étranger* (1937): 94–130.

Israel, Jonathan. *Dutch Primacy in World Trade, 1585–1740*. Oxford: Clarendon Press, 1989.

Ivins, William, Jr. *Prints and Visual Communication*. Cambridge: Harvard University Press, 1953.

Jacob, Margaret. *The Newtonians and the English Revolution 1689–1720*. Ithaca: Cornell University Press, 1976.

Jacob, Margaret, and Larry Stewart. *Practical Matter: Newton's Science in the Service of Industry and Empire, 1687–1851*. Cambridge: Harvard University Press, 2006.

Jacobs, Adam, and Elizabeth Wager. "European Medical Writers Association (EMWA) Guidelines on the Role of Medical Writers in Peer-Reviewed Publications." *Current Medical Research and Opinion* 21 (2005): 317–21.

Jansma, Jan Reinier. *Louis de Bils en de anatomie van zijn tijd*. Hoogeveen: n.p., 1912.

Jardine, Lisa. *Worldly Goods: A New History of the Renaissance*. London: Macmillan, 1996.

Jardine, Lisa, and Anthony Grafton. "'Studied for action': How Gabriel Harvey Read his Livy." *Past and Present* 129 (1990): 30–78.

Johns, Adrian. *The Nature of the Book: Print and Knowledge in the Making*. Chicago: University of Chicago Press, 1998.

Johns, Adrian. *Piracy: The Intellectual Property Wars from Gutenberg to Gates*. Chicago: University of Chicago Press, 2009.

Johnston, Stephen. "Making Mathematical Practice: Gentlemen, Practitioners and Artisans in Elizabethan England." PhD diss., Cambridge University, 1994.

Jones, Colin. "The Great Chain of Buying: Medical Advertisement, the Bourgeois Public Sphere and the Origins of the French Revolution." *American Historical Review* 101 (1996): 13–40.

Jones, Matthew. "Matters of Fact." *Modern Intellectual History* 7 (2010): 629–42.

Jones, Matthew. *Reckoning with Matter: Calculating Machines, Innovation, and Thinking about Thinking from Pascal To Babbage*. Chicago: University of Chicago Press, forthcoming.

Jorink, Eric. *Het 'Boeck der Natuere.' Nederlandse geleerden en de wonderen van Gods schepping 1575–1715*. Leiden: Primavera Pers, 2006.

Jorink, Eric. *Reading the Book of Nature in the Dutch Golden Age, 1575–1715*. Leiden: Brill, 2010.

Jorink, Eric, and Ad Maas, eds. *Newton and the Netherlands: How Isaac Newton Was Fashioned in the Dutch Republic*. Leiden: Leiden University Press, 2012.

Joyce, Kelly. "Appealing Images: Magnetic Resonance Imaging and the Production of Authoritative Knowledge." *Social Studies of Science* 35 (2005): 437–62.

Kaiser, David, Kenji Ito, and Karl Hall. "Spreading the Tools of Theory: Feynman Diagrams in the United States, Japan, and the Soviet Union." *Social Studies of Science* 34 (2004): 879–922.

Karr-Schmidt, Suzanne. *Altered and Adorned: Using Renaissance Prints in Daily Life*. New Haven: Yale University Press, 2011.

Karr-Schmidt, Suzanne. "Art—A User's Guide: Interactive and Sculptural Printmaking in the Renaissance." PhD diss., Yale University, 2006.

Keblusek, Marika. *Boeken in de hofstad: Haagse boekcultuur in de Gouden Eeuw*. Hilversum: Verloren, 1997.

Kessler, Herbert L., and Gerhard Wolf, eds. *The Holy Face and the Paradox of Representation*. Bologna: Unova Alfa Editoriale, 1998.

Kinukawa, Tomomi. *Art Competes with Nature: Maria Sibylla Merian (1647–1717) and the Culture of Natural History*. PhD diss., University of Wisconsin-Madison, 2001.

Kinukawa, Tomomi. "Natural History as Entrepreneurship: Maria Sibylla Merian's Correspondence with J. G. Volkamer II and James Petiver." *Archives of Natural History* 28 (2011): 313–27.

Kistemaker, Renée, and Ellinoor Bergvelt, eds. *De wereld binnen handbereik: Nederlandse kunst- en rariteitenverzamelingen 1585–1735*. Zwolle: Waanders, 1992.

Kistemaker, Renée, Natalja Kopaneva, and Annemiek Overbeek, eds. *Peter de Grote en Holland: Culturele en wetenschappelijke betrekkingen tussen Rusland en Nederland ten tijde van tsaar Peter de Grote*. Amsterdam: Amsterdam Historisch Museum, 1997.

Kistemaker, Renée, Natalja P. Kopaneva, D. J. Meijers, and G. V. Vilinbakhov, eds. *The Paper Museum of the Academy of Science in St. Petersburg c. 1725–1760*. Amsterdam: KNAW, 2004.

Klatte, Gerlinde. "New Documentation for the 'Tenture des Indes' Tapestries in Malta." *Burlington Magazine* 153 (2011): 464–69.

Klein, Ursula. *Experiments, Models, Paper Tools: Cultures of Organic Chemistry in the Nineteenth Century*. Stanford: Stanford University Press, 2003.

Klestinec, Cynthia. "Juan Valverde de (H)Amusco and Print Culture: The Editorial Apparatus in Vernacular Anatomy Texts." *Zeitsprünge* 9 (2005): 78–94.

Klestinec, Cynthia. *Theaters of Anatomy: Students, Teachers, and Traditions of Dissection in Renaissance Venice*. Baltimore: Johns Hopkins University Press, 2011.

Kloek, Joost, and Wijnand Mijnhardt, eds. *Dutch Culture in a European Perspective: 1800, Blueprints for a National Community.* Assen: Van Gorcum, 2004.

Knaap, Gerrit J. *Kruidnagelen en Christenen. De Verenigde Oost-Indische Compagnie en de bevolking van Ambon 1656–1696.* Dordrecht: Foris, 1987.

Knoeff, Rina. "Chemistry, Mechanics and the Making of Anatomical Knowledge: Boerhaave vs. Ruysch on the Nature of Glands." *Ambix* 53 (2006): 201–19.

Knoeff, Rina. *Hermann Boerhaave (1668–1738): Calvinist Chemist and Physician.* Amsterdam: KNAW, 2002.

Knoeff, Rina. "How Newtonian Was Hermann Boerhaave?" In *Newton and the Netherlands: How Isaac Newton Was Fashioned in the Dutch Republic,* edited by Eric Jorink and Ad Maas, 93–112. Leiden: Leiden University Press, 2012.

Knoeff, Rina. "Over 'het kunstige, toch verderfelyke gestel.' Een cultuurhistorische interpretatie van Bidloos anatomische atlas." *Gewina* 26 (2003): 189–202.

Knoeff, Rina. "The Visitor's View: Early Modern Tourism and the Polyvalence of Anatomical Exhibits." In *Centres and Cycles of Accumulation in and around the Netherlands,* edited by Lissa Roberts, 155–76. Berlin: LIT Press, 2011.

Knoppers, Jake. "The Visits of Peter the Great to the United Provinces in 1697–98 and 1716–17 as Seen in Light of the Dutch Sources." Master's thesis, McGill University, 1969.

Koerner, Joseph Leo. *The Moment of Self-Portraiture in German Renaissance Art.* Chicago: University of Chicago Press, 1993.

Koerner, Lisbet. *Linnaeus: Nature and Nation.* Cambridge: Harvard University Press, 1999.

Koldeweij, E. F. "Goudleer in de Republiek der zeven Verenigde Provincien. Nationale ontwikkelingen en de Europese context." PhD diss., Leiden University, 1996.

Koldeweij, E. F. "The Marketing of Gilt Leather in Seventeenth-Century Holland." *Print Quarterly* 13 (1996): 136–48.

Kooijmans, Luuc. *Death Defied: The Anatomy Lessons of Frederik Ruysch.* Leiden: Brill, 2011.

Kooijmans, Luuc. *De doodskunstenaar.* Amsterdam: Bert Bakker, 2004.

Kooijmans, Luuc. *Gevaarlijke kennis. Inzicht en angst in de dagen van Jan Swammerdam.* Amsterdam: Bert Bakker, 2007.

Kooijmans, Luuc. *Het orakel. De man die de geneeskunde opnieuw uitvond: Hermann Boerhaave (1668–1738).* Amsterdam: Balans, 2011.

Kooijmans, Luuc. "Rachel Ruysch." In *Digitaal Vrouwenlexicon van Nederland,* 2004. http://www.inghist.nl/Onderzoek/Projecten/DVN/lemmata/data/Ruysch%20Rachel.

Kopytoff, Igor. "The Cultural Biography of Things: Commoditization as Process." In *The Social Life of Things: Commodities in Cultural Perspective,* edited by Arjun Appadurai, 64–94. Cambridge: Cambridge University Press, 1986.

Krivatsy, Peter. "Le Blon's Anatomical Color Engravings." *Journal of the History of Medicine and Allied Sciences* 23 (1968): 153–58.

Krul, R. "Govard Bidloo." *Haagsch Jaarboekje* 2 (1890): 49–75.

Kuryluk, Ewa. *Veronica and Her Cloth: History, Symbolism, and Structure of a "True" Image.* Cambridge: B. Blackwell, 1991.

Kusukawa, Sachiko. "The *Historia piscium* (1686)." *Notes and Records of the Royal Society* 54 (2000): 179–97.

Kusukawa, Sachiko. "Leonhard Fuchs on the Importance of Pictures." *Journal of the History of Ideas* 58 (1997): 403–27.

Kusukawa, Sachiko. *Picturing the Book of Nature: Image, Text, and Argument in Human Anatomy and Medical Botany.* Chicago: University of Chicago Press, 2012.

Kusukawa, Sachiko. "The Sources of Gessner's Pictures for the *Historiae animalium.*" *Annals of Science* 67 (2010): 303–28.

Kusukawa, Sachiko. "The Uses of Pictures in Printed Books: The Case of Clusius' *Exoticorum libri decem.*" In *Carolus Clusius: Toward a Cultural History of a Renaissance Naturalist,* edited by Florike Egmond, Paul G. Hoftijzer, and Robert Visser, 221–46. Amsterdam: KNAW, 2007.

Kusukawa, Sachiko, and Ian Maclean, eds. *Transmitting Knowledge: Words, Images, and Instruments.* Oxford: Oxford University Press, 2006.

Laird, Mark. *Mrs. Delany and her Circle.* New Haven: Yale Center for British Art, 2009.

Landau, David, and Peter W. Parshall. *The Renaissance Print: 1470–1550.* New Haven: Yale University Press, 1996.

Landwehr, John. *Studies in Dutch Books with Coloured Plates Published 1662–1875.* The Hague: Junk, 1976.

Lankester, Edwin. *The Correspondence of John Ray.* New York: Arno Press, 1975.

Latour, Bruno. "Drawing Things Together." In *Representations in Scientific Practice,* edited by Michael Lynch and Steve Woolgar, 20–69. Cambridge: MIT Press, 1990.

Latour, Bruno, and Steve Woolgar. *Laboratory Life: The Social Construction of Scientific Facts.* Beverly Hills: Sage, 1979.

Lavezzi, Elisabeth. "Peinture et savoirs scientifiques: le cas des *Observations sur la Peinture (1753)* de Jacques Gautier d'Agoty." *Dix-huitième siècle* 31 (1999): 233–47.

Law, John. "Notes on the Theory of the Actor-Network: Ordering, Strategy and Heterogeneity." *Systems Practice* 5 (1992): 379–93.

Lederer, Susan E. *Flesh and Blood: Organ Transplantation and Blood Transfusion in Twentieth-Century America.* Oxford: Oxford University Press, 2008.

Lee, J. Patrick. "The Apocryphal Voltaire: Problems in the Voltairean Canon." In *The Enterprise of Enlightenment: A Tribute to David Williams from His Friends,* edited by Terry Pratt and David McCallam, 265–74. Bern: Peter Lang, 2004.

Lefèvre, Wolfgang, ed. *Picturing Machines 1400–1700.* Cambridge: MIT Press, 2004.

Lefèvre, Wolfgang, Jürgen Renn, and Urs Schoepflin, eds. *The Power of Images in Early Modern Science.* Basel: Birkhäuser, 2003.

Lemmink, J. Ph. S., and J. S. A. M. van Koningsbrugge, eds. *Baltic Affairs: Relations between the Netherlands and North-Eastern Europe 1500–1800.* Nijmegen: Instituut voor Noord- en Oosteuropese Studies, 1990.

Leonhard, Karin. "Shell Collecting. On 17th-Century Conchology, Curiosity Cabinets and Still Life Painting." In *Early Modern Zoology: The Construction of Animals in Science, Literature and the Visual Arts*, edited by Karl A. E. Enenkel and Paul J. Smith, 177–214. Leiden: Brill, 2007.

Leonhard, Karin, and Robert Felfe. *Lochmuster und Linienspiel: Überlegungen zur Druckgraphik des 17. Jahrhunderts.* Freiburg: Rombach, 2006.

Lesger, Clé. "The Printing Press and the Rise of the Amsterdam Information Exchange around 1600." In *Creating Global History from Asian Perspectives: Proceedings of Global History Workshop: Cross-Regional Chains in Global History: Europe-Asia Interface through Commodity and Information Flows*, edited S. Akita, 87–102. Osaka: Osaka University, 2006.

Lesger, Clé. *The Rise of the Amsterdam Market and Information Exchange: Merchants, Commercial Expansion and Change in the Spatial Economy of the Low Countries, c. 1550–1630.* Aldershot: Ashgate, 2006.

Levine, Joseph M. *The Battle of the Books: History and Literature in the Augustan Age.* Ithaca: Cornell University Press, 1991.

Licoppe, Christian. "The Crystallization of a New Narrative Form in Experimental Reports (1660–1690): The Experimental Evidence as a Transaction between Philosophical Knowledge and Aristocratic Power." *Science in Context* 7 (1994): 205–44.

Lilien, Otto M. *Jacob Christoph Le Blon, 1667–1741: Inventor of Three- and Four-Colour Printing.* Stuttgart: A. Hiersemann, 1985.

Lincoln, Evelyn. *The Invention of the Italian Renaissance Printmaker.* New Haven: Yale University Press, 2000.

Lindeboom, Gerrit A. "Boerhaave as Author and Editor." *Bulletin of the Medical Library Association* 62 (1974): 137–48.

Lindeboom, Gerrit A., ed. *Boerhaave's Letters.* Leiden: Brill, 1962.

Lindeboom, Gerrit A. *Geschiedenis van de medische wetenschap in Nederland.* Bussum: Fibula—van Dishoeck,1972.

Lindeboom, Gerrit A. *Hermann Boerhaave: The Man and His Work.* 2nd ed. Rotterdam: Erasmus, 2007.

Lindeboom, Gerrit A. *Het Cabinet van Jan Swammerdam.* Amsterdam: Rodopi, 1980.

Lindeboom, Gerrit A., ed. *The Letters of Jan Swammerdam to Melchisedec Thévenot.* Amsterdam: Swets & Zeitlinger, 1975.

Linney, Verna Lillian. "The *Flora Delanica*: Mary Delany and Women's Art, Science and Friendship in Eighteenth- Century England." PhD diss., York University, 1999.

Little, Patrick. "Uncovering a Protectoral Stud: Horses and Horse-Breeding at the Court of Oliver Cromwell, 1653–8." *Historical Research* 82 (2009): 252–67.

Logdberg, L. "Being the Ghost in the Machine." *PLOS Medicine* 8/8 (2011): e1001071.

Long, Pamela O. "Invention, Secrecy, Theft: Meaning and Context in Late Medieval Technical Transmission." *History and Technology* 16 (2000): 223–41.

Long, Pamela O. *Openness, Secrecy, Authorship: Technical Arts and the Culture of Knowledge from Antiquity through Renaissance.* Baltimore: Johns Hopkins University Press, 2001.

Loveland, Jeff. *Rhetoric and Natural History: Buffon in Polemical and Literary Context.* Oxford: Voltaire Foundation, 2001.

Lowengard, Sarah. *The Creation of Color in Eighteenth Century Europe.* New York: Gutenberg-e, 2006.

Lux, David S. *Patronage and Royal Science in Seventeenth-Century France: The Académie de Physique in Caen.* Ithaca: Cornell University Press, 1989.

Luyendijk-Elshout, A. M. "'An der Klaue erkennt man den Löwen,' aus den Sammlungen des Frederik Ruysch." In *Macrocosmos in Microcosmo, die Welt in der Stube: zur Geschichte des Sammelns, 1450 bis 1800,* edited by Andreas Grote, 643–60. Opladen: Leske and Budrich, 1994.

Maclean, Ian. *Scholarship, Commerce, Religion: The Learned Book in the Age of Confessions, 1560–1630.* Cambridge: Harvard University Press, 2012.

MacLeod, Christine. *Inventing the Industrial Revolution: The English Patent System, 1660–1800.* Cambridge: Cambridge University Press, 1988.

Mączak, Antoni. *Travel in Early Modern Europe.* Cambridge: Polity Press, 1995.

Maerker, Anna. "Handwerker, Wissenschaftler und die Produktion anatomischer Modelle in Florenz, 1775–1790." *Zeitsprünge* 9 (2005): 101–16.

Maerker, Anna. *Model Experts: Wax Anatomies and Enlightenment in Florence and Vienna, 1775–1815.* Manchester: Manchester University Press, 2011.

Malinowski, Bronisław. *Argonauts of the Western Pacific: An Account of Native Enterprise and Adventure in the Archipelagoes of Melanesian New Guinea.* London: Routledge, 1922.

Marchand, Patrick. *Le maître de poste et le messager. Une histoire du transport public en France au temps du cheval 1700–1850.* Paris: Belin, 2006.

Margócsy, Dániel. "The Fuzzy Metrics of Money: The Finances of Travel and the Reception of Curiosities in Early Modern Europe." *Annals of Science* 70 (2013).

Margócsy, Dániel. "A Komáromi Csipkés Biblia Leidenben." *Magyar Könyvszemle* 124 (2008): 15–26.

Marr, Alexander. *Between Raphael and Galileo: Mutio Oddi and the Mathematical Culture of the Late Renaissance.* Chicago: University of Chicago Press, 2011.

Marx, Karl. "Formal and Real Subsumption of Labour under Capital. Transitional Forms." In *The Production Process of Capital. Economic Manuscripts of 1861–3,* edited by Karl Marx. 2002. www.marxists.org.

Mason, Peter. *Infelicities: Representations of the Exotic.* Baltimore: Johns Hopkins University Press, 1998.

Mauss, Marcel. *Essai sur le don, forme et raison de l'échange dans les sociétés archaiques.* Paris: Alcan, 1925.

Mazzolini, Renato G. "Plastic Anatomies and Artificial Dissections." In *Models: The Third*

Dimension of Science, edited by Soraya de Chadarevian and Nick Hopwood, 43–70. Stanford: Stanford University Press, 2004.

McClellan, James E. *Science Reorganized: Scientific Societies in the Eighteenth Century*, New York: Columbia University Press, 1985.

McGee, David. "The Origin of Early Modern Machine Design." In *Picturing Machines 1400–1700*, edited by Wolfgang Lefèvre, 53–87. Cambridge: MIT Press, 2004.

Meli, Domenico Bertoloni. "Blood, Monsters and Necessity in Malpighi's *De polypo cordis*." *Medical History* 45 (2001): 511–22.

Meli, Domenico Bertoloni, ed. *Marcello Malpighi, Anatomist and Physician*. Florence: Olschki, 1997.

Meli, Domenico Bertoloni. *Mechanism, Experiment, Disease: Marcello Malpighi and Seventeenth-Century Anatomy*. Baltimore: Johns Hopkins University Press, 2011.

Meli, Domenico Bertoloni. "The Representation of Insects in the Seventeenth Century: A Comparative Approach." *Annals of Science* 67 (2010): 405–29.

Meli, Domenico Bertoloni, and Anita Guerrini, eds. "The Representation of Animals in the Early Modern Period." Special issue, *Annals of Science* 67/3 (2010).

Merriman, Daniel. "A Rare Manuscript Adding to Our Knowledge of the Work of Peter Artedi." *Copeia* 2 (1941): 66–69.

Merton, Robert. "The Reward System of Science." In *On Social Structure and Science*, edited by Piotr Sztompka, 286–304. Chicago: University of Chicago Press, 1996.

Merton, Robert. "Science and Technology in a Democratic Order." *Journal of Legal and Political Sociology* 1 (1942): 115–26.

Messbarger, Rebecca. *The Lady Anatomist: The Life and Work of Anna Morandi Manzolini*. Chicago: University of Chicago Press, 2010.

Miedema, Hessel. *Denkbeeldig schoon: Lambert ten Kates opvattingen over beeldende kunst*. Leiden: Primavera Pers, 2006.

Miedema, Hessel. "Lambert ten Kate in Correspondence with Hendrick van Limborch." *Simiolus* 35 (2011): 174–87.

Miedema, Hessel. "Newtonismus und wissenschaftliches Kunstideal." In *Holland nach Rembrandt: Zur niederländischen Kunst zwischen 1670 und 1750*, edited by Ekkerhard Mai, 119–32. Cologne: Böhlau, 2006.

Miedema, Hessel. "Een tienduizendste van een Rijnlandse voet." In *De verbeelde wereld. Liber amicorum voor Boudewijn Bakker*, edited by Jaap Evert Abrahamse, 199–202. Bussum: Thoth, 2008.

Mijnhardt, Wijnand. *Tot Heil van 't Menschdom. Culturele genootschappen in Nederland, 1750–1815*. Amsterdam: Rodopi, 1987.

Miller, Daniel. *A Theory of Shopping*. Ithaca: Cornell University Press, 1998.

Miller, David Philip, and Peter Hans Reill, eds. *Visions of Empire: Voyages, Botany, and Representations of Nature*. Cambridge: Cambridge University Press, 1996.

Miller, Peter N. *Peiresc's Europe: Learning and Virtue in the Seventeenth Century*. New Haven: Yale University Press, 2000.

Mirto, Alfonso, and H. Th. van Veen. *Pieter Blaeu: Letters to Florentines.* Amsterdam: APA, 1993.

Mokyr, Joel. *The Gifts of Athena: Historical Origins of the Knowledge Economy.* Princeton: Princeton University Press, 2002.

Mokyr, Joel. "The Intellectual Origins of Modern Economic Growth." *Journal of Economic History* 55 (2005): 285–351.

Mokyr, Joel. "Knowledge, Enlightenment, and the Industrial Revolution: Reflections on *The Gifts of Athena." History of Science* 45 (2007): 185–96.

Mokyr, Joel. "The Market for Ideas and the Origins of Economic Growth in Eighteenth Century Europe." *Tijdschrift voor Sociale en Economische Geschiedenis* 4 (2007): 1–39.

Molhuysen, Philip Christiaan. *Bronnen tot de geschiedenis der Leidsche Universiteit. 1574–1811.* The Hague: Martinus Nijhoff, 1913–24.

Montias, John Michael. *Art at Auction in 17th Century Amsterdam.* Amsterdam: Amsterdam University Press, 2003.

Montias, John Michael. *Artists and Artisans in Delft: A Socio-Economic Study of the Seventeenth Century.* Princeton: Princeton University Press, 2002.

Moran, Bruce T. *Patronage and Institutions: Science, Technology, and Medicine at the European Court, 1500–1750.* Rochester: Boydell Press, 1991.

Müller-Wille, Staffan. "Collection and Collation: Theory and Practice of Linnaean Botany." *Studies in History and Philosophy of Biological and Biomedical Sciences* 38 (2007): 541–62.

Müller-Wille, Staffan. "Systems and How Linnaeus Looked at Them in Retrospect." *Annals of Science* 70 (2013).

Müller-Wille, Staffan. "Walnut Trees in Hudson Bay, Coral Reefs in Gotland: Linnean Botany and Its Relation to Colonialism." In *Colonial Botany: Science, Commerce and Politics in the Early Modern World,* edited by Londa Schiebinger and Claudia Swan, 34–48. Philadelphia: University of Pennsylvania Press, 2005.

Myers, Robin, Michael Harris, and Giles Mandelbrote, eds. *Books for Sale: The Advertising and Promotion of Print since the Fifteenth Century.* New Castle: Oak Knoll Press, 2009.

Neri, Janice. *The Insect and the Image: Visualizing Nature in Early Modern Europe, 1500–1700.* Minneapolis: University of Minnesota Press, 2011.

Nickelsen, Kärin. "The Challenge of Colour: Eighteenth-Century Botanists and the Hand-Colouring of Illustrations." *Annals of Science* 63 (2006): 3–23.

Nickelsen, Kärin. "Botanists, Draughtsmen and Nature: Constructing Eighteenth-Century Botanical Illustrations." *Studies in History and Philosophy of Biology and Biomedical Sciences* 37 (2006): 1–25.

Niekrasz, Carmen. *Woven Theaters of Nature: Flemish Tapestry and Natural History, 1550–1600.* PhD diss., Northwestern University, 2007.

O'Brien, Patrick, Derek Keene, Marjolein 't Hart, and Harmen van der Wee, eds. *Urban Achievement in Early Modern Europe: Golden Ages in Antwerp, Amsterdam and London.* Cambridge: Cambridge University Press, 2001.

O'Connor, Erin. "Embodied Knowledge: The Experience of Meaning and the Struggle towards Proficiency in Glassblowing." *Ethnography* 6 (2005): 183–204.

Ogilvie, Brian W. "Encyclopaedism in Renaissance Botany: From *Historia* to *Pinax*." In *Pre-Modern Encyclopedic Texts: Proceedings of the Second Comers Congress*, edited by Peter Brinkley, 89–99. Leiden: Brill, 1997.

Ogilvie, Brian W. "Image and Text in Natural History, 1500–1700." In *The Power of Images in Early Modern Science*, edited by Wolfgang Lefèvre, Jürgen Renn, and Urs Schoepflin, 141–66. Basel: Birkhäuser, 2003.

Ogilvie, Brian W. "Nature's Bible: Insects in Seventeenth-Century European Art and Science." *Tidsskrift for kulturforskning* 7 (2008): 5–21.

Ogilvie, Brian W. *The Science of Describing: Natural History in Renaissance Europe.* Chicago: University of Chicago Press, 2006.

O'Malley, Charles Donald. *Andreas Vesalius of Brussels, 1514–1564.* Berkeley: University of California Press, 1964.

O'Neill, Jean. *Peter Collinson and the Eighteenth-Century Natural History Exchange.* Philadelphia: American Philosophical Society, 2008.

Orenstein, Nadine M. *Hendrick Hondius and the Business of Prints in Seventeenth-Century Holland.* Rotterdam: Sound & Vision, 1996.

Oreskes, Naomi, and Erik Conway. *Merchants of Doubt: How a Handful of Scientists Obscured the Truth on Issues from Tobacco Smoke to Global Warming.* New York: Bloomsbury, 2010.

Otterspeer, Willem. *Groepsportret met dame II. De vesting van de macht: de Leidse Universiteit, 1673–1775.* Amsterdam: Bert Bakker, 2002.

Overvoorde, J. C. *Geschiedenis van het postwezen in Nederland voor 1795.* Leiden: Sijthoff, 1902.

Palm, Lodewijk C., and H. A. M. Snelders, eds. *Antoni van Leeuwenhoek 1632–1723: Studies on the Life and Work of the Delft Scientist.* Amsterdam: Rodopi, 1982.

Panofsky, Erwin. "The History of the Theory of Human Proportions as a Reflection of the History of Styles." In *Meaning in the Visual Arts,* edited by Erwin Panofsky, 55–107. New York, Doubleday, 1955.

Park, Katharine. *Secrets of Women: Gender, Generation, and the Origins of Human Dissection.* New York: Zone Books, 2006.

Parshall, Peter. "'Imago contrafacta.' Images and Facts in the Northern Renaissance." *Art History* 16 (1993): 554–79.

Paulmier, C. S. Le. *L'orviétan: histoire d'une famille de charlatans du Pont-Neuf aux XVIIe et XVIIIe siècles.* Paris: Librairie illustrée, 1893.

Peck, Robert McCracken. "Alcohol and Arsenic, Pepper and Pitch: Brief Histories of Preservation Techniques." In *Stuffing Birds, Pressing Plants, Shaping Knowledge*, edited by Sue Ann Prince, 27–54. Philadelphia: American Philosophical Society, 2003.

Peck, Robert McCracken. "Preserving Nature for Study and Display." In *Stuffing Birds, Pressing Plants, Shaping Knowledge*, edited by Sue Ann Prince, 11–26. Philadelphia: American Philosophical Society, 2003.

Pelling, Margaret. *Medical Conflicts in Early Modern London: Patronage, Physicians, and Irregular Practitioners 1550–1640*. Oxford: Oxford University Press, 2003.

Peters, Marion. *De wijze koopman: het wereldwijde onderzoek van Nicolaes Witsen (1641–1717), burgemeester en VOC-bewindhebber van Amsterdam*. Amsterdam: Bakker, 2010.

Pettegree, Andrew. *The Book in the Renaissance*. New Haven: Yale University Press, 2010.

Pettegree, Andrew. "'Thirty Years On': Progress towards Integration amongst the Immigrant Population of Elizabethan London." In *English Rural Society, 1500–1800: Essays in Honour of Joan Thirsk*, edited by J. Chartres and D. Hey, 297–312. Cambridge: Cambridge University Press, 1990.

Pieters, Florence F. J. M. "The Menagerie of 'the White Elephant' in Amsterdam, with Some Notes on Other 17th and 18th Century Menageries in the Netherlands." In *Die Kulturgeschicte des Zoos*, edited by Lothar Dittrich, Dietrich von Engelhardt, and Annelore Rieke-Müller, 47–66. Berlin: VMB, 2001.

Pieters, Florence F. J. M. "Natura artis magistra: Linnaeus en natuurhistorische prachtwerken." In *Aap, vis, boek: Linnaeus in de Artis bibliotheek*, edited by Piet Verkruijsse and Chinglin Kwa, 63–79. Zwolle: Waanders, 2007.

Piñon, Laurent. "Conrad Gessner and the Historical Depth of Renaissance Natural History." In *Historia: Empiricism and Erudition in Early Modern Europe*, edited by Gianna Pomata and Nancy Siraisi, 241–68. Cambridge: MIT Press, 2005.

Piñon, Laurent. *Livres de zoologie*. Paris: Klincksieck, 2000.

Pissarro, Orovida C. "Prince Rupert and the Invention of Mezzotint." *Walpole Society* 36 (1956–58): 1–10.

Polányi, Michael. *Personal Knowledge: Towards a Post-Critical Philosophy*. Chicago: University of Chicago Press, 1974.

Pomian, Krzysztof. *Collectors and Curiosities: Paris and Venice, 1500–1800*. London: Polity Press, 1990.

Pon, Lisa. *Raphael, Dürer, and Marcantonio Raimondi: Copying and the Italian Renaissance Print*. New Haven: Yale University Press, 2004.

Poovey, Mary. *A History of the Modern Fact: Problems of Knowledge in the Sciences of Wealth and Society*. Chicago: University of Chicago Press, 1998.

Popplow, Marcus. "Why Draw Pictures of Machines: The Social Context of Early Modern Machine Drawings." In *Picturing Machines 1400–1700*, edited by Wolfgang Lefèvre, 17–48. Cambridge: MIT Press, 2004.

Postma, Johannes. *The Dutch in the Atlantic Slave Trade*. Cambridge: Cambridge University Press, 1990.

Pottage, Alan, and Brad Sherman. *Figures of Invention: A History of Modern Patent Law*. Oxford: Oxford University Press, 2011.

Powers, John C. *Inventing Chemistry: Hermann Boerhaave and the Reform of the Chemical Arts*. Chicago: University of Chicago Press, 2012.

Prak, Maarten. *The Dutch Republic in the Seventeenth Century: The Golden Age*. Cambridge: Cambridge University Press, 2005.

Prak, Maarten. "Painters, Guilds, and the Art Market in the Dutch Golden Age." In *Guilds, Innovation, and the European Economy, 1400–1800*, edited by Maarten Prak and Stephan R. Epstein, 143–71. Cambridge: Cambridge University Press, 2008.

Prak, Maarten, and Stephan R. Epstein, eds. *Guilds, Innovation, and the European Economy, 1400–1800*. Cambridge: Cambridge University Press, 2008.

Pranghofer, Sebastian. "'It could be seen more clearly in Unreasonable Animals than in Humans': The Representation of the Rete Mirabile in Early Modern Anatomy." *Medical History* 53 (2009): 561–86.

Prince, Sue Ann, ed. *Stuffing Birds, Pressing Plants, Shaping Knowledge*. Philadelphia: American Philosophical Society, 2003.

Proctor, Robert N., and Londa Schiebinger, eds. *Agnotology: The Making and Unmaking of Ignorance*. Stanford: Stanford University Press, 2008.

Pumphrey, Stephen. "Science and Patronage in England, 1570–1625: A Preliminary Study." *History of Science* 42 (2004): 137–88.

Punt, Hendrick. *Bernard Siegfried Albinus (1697–1770), "On Human Nature": Anatomical and Physiological Ideas in Eighteenth Century Leiden*. Amsterdam: B. M. Israel, 1983.

Quinn, Stephen, and William Roberds. "An Economic Explanation of the Early Bank of Amsterdam: Debasement, Bills of Exchange, and the Emergence of the First Central Bank." In *The Origin and Development of Financial Markets and Institutions from the Seventeenth Century to the Present*, edited by Jeremy Atack and Larry Neal, 32–70. Cambridge: Cambridge University Press, 2009.

Rabinovitch, Oded. "Anonymat et carrières littéraires au XVIIe siècle : Charles Perrault entre anonymat et revendication." *Littératures classiques* 80 (2013): 87–104.

Radin, Margaret Jane. *Contested Commodities*. Cambridge: Harvard University Press, 1996.

Radnóti, Sándor. *The Fake: Forgery and Its Place in Art*. Lanham: Rowman and Littlefield, 1999.

Radzjoen, Anna. "De anatomische collectie van Frederik Ruysch in Sint-Petersburg." In *Peter de Grote en Holland: Culturele en wetenschappelijke betrekkingen tussen Rusland en Nederland ten tijde van tsaar Peter de Grote*, edited by Renée Kistemaker, Natalja Kopaneva, and Annemiek Overbeek, 47–54. Amsterdam: Amsterdam Historisch Museum, 1997.

Rafalska-Łasocha, Alicja, Wieslaw Łasocha, and Anna Jasińska. "Cold Light in the Painting *Group Portrait in the Chemist's House*." In *The Global and the Local: The History of Science and the Cultural Integration of Europe*, edited by M. Kokowski, 969–72. Cracow: Polish Academy of Arts and Sciences, 2006.

Raj, Kapil. *Relocating Modern Science: Circulation and the Construction of Knowledge in South Asia and Europe, 1650–1900*. New York: Macmillan, 2007.

Rankin, Alisha. "Becoming an Expert Practitioner: Court Experimentalism and the Medical Skills of Anna of Saxony (1532–1585)." *Isis* 98 (2007): 23–52.

Rankin, Alisha. *Panaceia's Daughters: Noblewomen as Healers in Early Modern Germany*. Chicago: University of Chicago Press, 2013.

Rankin, Alisha, and Elaine Long, eds. *Secrets and Knowledge in Medicine and Science 1500–1800*. Aldershot: Ashgate, 2011.

Ratcliff, Marc. "Abraham Trembley's Strategy of Generosity and the Scope of Celebrity in the Mid-Eighteenth Century." *Isis* 95 (2004): 555–75.

Ratcliff, Marc. *The Quest for the Invisible: Microscopy in the Enlightenment*. Aldershot: Ashgate, 2009.

Raven, Charles E. *John Ray, Naturalist: His Life and Works*. Cambridge: Cambridge University Press, 1942.

Reddy, William M. "The Structure of a Cultural Crisis: Thinking about Cloth in France before and after the Revolution." In *The Social Life of Things: Commodities in Cultural Perspective*, edited by Arjun Appadurai, 261–84. Cambridge: Cambridge University Press, 1988.

Reeds, Karen. *Botany in Medieval and Renaissance Universities*. New York: Garland, 1991.

Reeds, Karen. "Leonardo da Vinci and Botanical Illustration: Nature Prints, Drawings, and Woodcuts ca. 1500." In *Visualizing Medieval Medicine and Natural History, 1200–1550*, edited by Jean Ann Givens, Karen Reeds, and Alain Touwaide, 205–38. Aldershot: Ashgate, 2006.

Reitsma, Ella. *Merian and Daughters: Women of Art and Science*. Los Angeles: J. Paul Getty Museum, 2008.

Renn, Jürgen, ed. *Galileo in Context*. Cambridge: Cambridge University Press, 2001.

Rheinberger, Hans-Jörg. "Die Evidenz des Präparates." In *Experimente: Praktiken der Evidenzproduktion im 17. Jahrhundert*, edited by Herlmar Schramm, Ludger Schwarte, and Jan Lazardzig, 1–17. Berlin: de Gruyter, 2006.

Rheinberger, Hans-Jörg. "Präparate—Bilder ihrer selbst. Eine bildtheoretische Glosse." In *Oberflächen der Theorie*, edited by Horst Bredekamp and G. Werner, 9–19. Berlin: Akademie Verlag, 2003.

Ridley, Glynis, ed. "Animals in the Eighteenth Century." Special issue, *Journal for Eighteenth-Century Studies* 33/4 (2010).

Ridley, Glynis. "Introduction: Representing Animals." *Journal for Eighteenth-Century Studies* 33/4 (2010): 431–36.

Riskin, Jessica. "The Defecating Duck, or, the Ambiguous Origins of Artificial Life." *Critical Inquiry* 20 (2003): 599–633.

Robbins, Louise E. *Elephant Slaves and Pampered Parrots: Exotic Animals in Eighteenth-Century Paris*. Baltimore: Johns Hopkins University Press, 2002.

Roberts, Lissa, ed. *Centres and Cycles of Accumulation in and around the Netherlands during the Early Modern Period*. Berlin: LIT Press, 2011.

Roberts, Lissa, Simon Schaffer, and Peter Dear, eds. *The Mindful Hand: Inquiry and Invention from the Late Renaissance to Early Industrialization*. Amsterdam: KNAW, 2007.

Roche, Daniel. *Humeurs vagabondes. De la circulation des hommes et de l'utilité des voyages*. Paris: Fayard, 2003.

Roche, Daniel. *Le siècle des Lumières en province: académies et académiciens provinciaux, 1680–1789.* Paris: Mouton, 1978.

Rodari, Florian. *Anatomie de la couleur: l'invention de l'estampe en couleurs.* Paris: Bibliothèque nationale de France, 1996.

Roger, Jacques. *Buffon: A Life in Natural History.* Ithaca: Cornell University Press, 1997.

Ronell, Avital. *Dictations: Haunted Writing.* Bloomington: Indiana University Press, 1986.

Roos, Anna Marie. "The Art of Science: A Rediscovery of the Lister Copperplates." *Notes and Records of the Royal Society* 60 (2012): 19–40.

Roos, Anna Marie. *Web of Nature: Martin Lister (1639–1712): The First Arachnologist.* Leiden: Brill, 2011.

Rose, Mark. *Authors and Owners: The Invention of Copyright.* Cambridge: Harvard University Press, 1993.

Ross, Joseph S., Kevin P. Hill, David S. Egilman, and Harlan M. Krumholz. "Guest Authorship and Ghostwriting in Publications Related to Rofecoxib." *Journal of the American Medical Association* 299 (2008): 1800–1812.

Rowell, Margery. "Linnaeus and Botanists in Eighteenth-Century Russia." *Taxon* 29 (1980): 15–26.

Rudwick, Martin J. S. *Bursting the Limits of Time: The Reconstruction of Geohistory in the Age of Revolution.* Chicago: University of Chicago Press, 2005.

Ruestow, Edgar. *The Microscope in the Dutch Republic: The Shaping of Discovery.* Cambridge: Cambridge University Press, 1996.

Rupp, Jan C. C. "The New Science and the Public Sphere in the Premodern Era." *Science in Context* 8 (1995): 487–507.

Rupp, Jan C. C. "Theatra anatomica: culturele centra in het Nederland van de zeventiende eeuw." In *De productie, distributie en consumptie van cultuur,* edited by Wijnand Mijnhardt and Joost Kloek, 13–36. Amsterdam: Rodopi, 1991.

Schaffer, Simon. "Enlightened Automata." In *The Sciences in Enlightened Europe,* edited by William Clark, Jan Golinski, and Simon Schaffer, 126–68. Chicago: University of Chicago Press, 1999.

Schaffer, Simon. "Glass Works: Newton's Prisms and the Uses of Experiment." In *The Uses of Experiment: Studies in the Natural Sciences,* edited by David Gooding, Trevor J. Pinch, and Simon Schaffer, 67–104. Cambridge: Cambridge University Press, 1989.

Schaffer, Simon. "A Science Whose Business Is Bursting: Soap Bubbles as Commodities in Classical Physics." In *Things that Talk: Object Lessons from Art and Science,* edited by Lorraine Daston, 147–92. New York: Zone Books, 2004.

Schaffer, Simon, Lissa Roberts, Kapil Raj, and James Delbourgo, eds. *The Brokered World: Go-Betweens and Global Intelligence, 1770–1820.* Sagamore Beach: Science History Publications, 2009.

Scharf, Sara T. "Identification Keys, the 'Natural Method,' and the Development of Plant Identification Manuals." *Journal of the History of Biology* 42 (2009): 73–117.

Scheller, R. W. "Rembrandt en de encyclopedische kunstkamer." *Oud-Holland* 84 (1969): 81–147.

Scheltema, Peter. *Het leven van Frederik Ruysch.* Sliedrecht: Gebroeders Luijt, 1886.

Schiebinger, Londa. *Plants and Empire: Colonial Bioprospecting in the Atlantic World.* Cambridge: Harvard University Press, 2004.

Schiebinger, Londa, and Claudia Swan, eds. *Colonial Botany: Science, Commerce, and Politics in the Early Modern World.* Philadelphia: University of Pennsylvania Press, 2005.

Schmidt, Benjamin. "Inventing Exoticism: The Project of Dutch Geography and the Marketing of the World, circa 1700." In *Merchants and Marvels: Commerce, Science and Art in Early Modern Europe*, edited by Pamela Smith and Paula Findlen, 347–70. New York: Routledge, 2002.

Schmidt, Benjamin. "Mapping an Exotic World: The Global Project of Geography, circa 1700." In *The Global Eighteenth Century*, edited by Felicity Nussbaum, 19–37. Baltimore: Johns Hopkins University Press, 2003.

Schmitt, Charles B. *Aristotle and the Renaissance.* Cambridge: Harvard University Press, 1983.

Schnapper, Antoine. *Collections et collectionneurs dans la France du XVIIe siècle.* Paris: Flammarion, 1988–1994.

Scholten, Frits. "Frans Hemsterhuis's Memorial to Herman Boerhaave." *Simiolus* 35 (2011): 199–217.

Schriks, Christiaan F. J. *Het Kopijrecht.* Zutphen: Walburg Pers, 2004.

Scott, Katie. "The Colour of Justice. Invention and Privilege in the French Enlightenment: The Case of Colour." In *Les chemins de la nouveauté: Innover, inventer au regard de l'histoire*, edited by Liliane Hilaire-Pérez, 167–86. Paris: Editions de CTHS, 2003.

Segal, Sam. *De tulp verbeeld: Hollandse tulpenhandel in de 17de eeuw.* Hillegom: Museum voor de Bloembollenstreek, 1992.

Shank, J. B. *The Newton Wars and the Beginning of the French Enlightenment.* Chicago: University of Chicago Press, 2008.

Shapin, Steven. "Here and Everywhere: Sociology of Scientific Knowledge." *Annual Review of Sociology* 21 (1996): 289–321.

Shapin, Steven. "The Invisible Technician." *American Scientist* 77 (1989): 554–63.

Shapin, Steven. "Pump and Circumstance: Robert Boyle's Literary Technology." *Social Studies of Science* 14 (1984): 481–520.

Shapin, Steven. *The Scientific Life: A Moral History of a Late Modern Vocation.* Chicago: University of Chicago Press, 2008.

Shapin, Steven. *A Social History of Truth: Civility and Science in Seventeenth-Century England.* Chicago: University of Chicago Press, 1995.

Shapin, Steven, and Simon Schaffer. *Leviathan and the Air Pump: Hobbes, Boyle and Experimental Life.* Princeton: Princeton University Press, 1985.

Shapiro, Alan E. "Artists' Colors and Newton's Colors." *Isis* 85 (1994): 600–630.

Shapiro, Barbara. *A Culture of Fact: England, 1550–1720.* Ithaca: Cornell University Press, 2003.

Shapiro, D. W., N. S. Wenger, and M. F. Shapiro. "The Contributions of Authors to Multiauthored Biomedical Research Papers." *Journal of the American Medical Association* (1994): 438–42.

Sher, Richard B. *The Enlightenment and the Book: Scottish Authors and Their Publishers in Eighteenth-Century Britain, Ireland, and America.* Chicago: University of Chicago Press, 2006.

Shesgreen, Sean, ed. *The Criers and Hawkers of London. Engravings and Drawings by Marcellus Laroon.* Stanford: Stanford University Press, 1990.

Siegert, Bernhard. *Relays: Literature as an Epoch of the Postal System.* Stanford: Stanford University Press, 1999.

Sigaud, Lygia. "The Vicissitudes of *The Gift.*" *Social Anthropology* 10 (2002): 335–58.

Singer, Hans Wolfgang. "Jakob Christoffel Le Blon." *Mitteilungen der Gesellschaft für vervielfältigende Kunst* (1901): 1–21.

Slenders, J. A. M. *Het theatrum anatomicum in de noordelijke Nederlanden, 1555–1800.* Nijmegen: Instituut voor Geschiedenis der Geneeskunde, 1989.

Sliggers, Bert C. *Een vorstelijke dierentuin: de menagerie van Willem V.* Zutphen: Walburg Pers, 1992.

Sloan, Phillip. "The Buffon-Linnaeus Controversy." *Isis* 67 (1976): 356–75.

Sloan, Phillip. "John Locke, John Ray, and the Problem of the Natural System." *Journal of the History of Biology* 5 (1972): 1–53.

Smith, Justin E. H. "Language, Bipedalism, and the Mind-Body Problem in Edward Tyson's Orang-Outang (1699)." *Intellectual History Review* 17 (2007): 291–304.

Smith, Pamela. *The Body of the Artisan: Art and Experience in the Scientific Revolution.* Chicago: University of Chicago Press, 2004.

Smith, Pamela. *The Business of Alchemy: Science and Culture in the Holy Roman Empire.* Princeton: Princeton University Press, 1994.

Smith, Pamela, and Tonny Beentjes. "Nature and Art, Making and Knowing: Reconstructing Sixteenth-Century Lifecasting Techniques." *Renaissance Quarterly* 63/1 (2010): 128–79.

Smith, Pamela, and Paula Findlen, eds. *Merchants and Marvels: Commerce, Science and Art in Early Modern Europe.* New York: Routledge, 2002.

Smith, Pamela, and Benjamin Schmidt, eds. *Making Knowledge in Early Modern Europe: Practices, Objects, and Texts, 1400–1800.* Chicago: University of Chicago Press, 2008.

Soliday, Gerald Lyman. *A Community in Conflict: Frankfurt Society in the Seventeenth and Eighteenth Centuries.* Hanover: Brandeis University Press, 1974.

Soll, Jacob. *The Information Master: Jean-Baptiste Colbert's Secret State Intelligence System.* Ann Arbor: University of Michigan Press, 2009.

Soltow, Lee, and Jan Luiten van Zanden. *Income and Wealth Inequality in the Netherlands 16th-20th Century.* Amsterdam: Het Spinhuis, 1998.

Sorabji, Richard. "Aristotle, Mathematics, and Colour." *Classical Quarterly* 22 (1972): 293–308.

Spary, Emma. "Botanical Networks Revisited." In *Wissen im Netz. Botanik und Pflanzentransfer in europäischen Korrespondenznetzen des 18. Jahrhunderts*, edited by Regina Dauser, Stefan Hächler, Michael Kempe, Franz Mauelshagen, and Martin Stuber, 47–64. Berlin: Akademie Verlag, 2008.

Spary, Emma. *Eating the Enlightenment: Food and the Sciences in Paris, 1670–1760.* Chicago: University of Chicago Press, 2012.

Spary, Emma. "Scientific Symmetries." *History of Science* 62 (2004): 1–46.

Spufford, Peter. "Access to Credit and Capital in the Commercial Centres of Europe." In *A Miracle Mirrored: The Dutch Republic in European Perspective*, edited by Karel Davids and Jan Lucassen, 303–38. Cambridge: Cambridge University Press, 1995.

Stafford, Barbara. *Artful Science: Enlightenment, Entertainment and the Eclipse of Visual Education.* Cambridge: MIT Press, 1994.

Stearn, William T. "The Background of Linnaeus's Contributions to the Nomenclature and Methods of Systematic Biology." *Systematic Zoology* 8 (1959): 4–22.

Stearns, Raymond Phineas. "James Petiver: Promoter of Natural Science, c. 1663–1718." *Proceedings of the American Antiquarian Society, New Series* 62 (1952): 243–365.

Steingart, Alma. "A Group Theory of Group Theory: Collaborative Mathematics and the 'Uninvention' of a 1000-Page Proof." *Social Studies of Science* 42 (2012): 185–213.

Stewart, Larry, and John Gascoigne. *The Rise of Public Science: Rhetoric, Technology, and Natural Philosophy in Newtonian Britain, 1660–1750.* Cambridge: Cambridge University Press, 1992.

Stoffele, Bram. "Christiaan Huygens—A Family Affair: Fashioning a Family in Early Modern Court Culture." Master's thesis, Utrecht University, 2006.

Stoye, John. *Marsigli's Europe (1680–1730): The Life and Times of Luigi Ferdinando Marsigli, Soldier and Virtuoso.* New Haven: Yale University Press, 1994.

Stroup, Alice. *A Company of Scientists: Botany, Patronage, and Community at the Parisian Royal Academy of Sciences.* Berkeley: University of California Press, 1990.

Sutton, Peter C. *Jan van der Heyden: 1637–1712.* New Haven: Yale University Press, 2006.

Swan, Claudia. "Ad vivum, naer het leven, from the life. Defining a Mode or Representation." *Word and Image* 2 (1995): 353–72.

Swan, Claudia. *Art, Science and Witchcraft in Early Modern Holland. Jacques de Gheyn II (1565–1629).* Cambridge: Cambridge University Press, 2005.

Swan, Claudia. "Collecting Naturalia in the Shadow of the Early Modern Dutch Trade." In *Colonial Botany: Science, Commerce, and Politics in the Early Modern World*, edited by Londa Schiebinger and Claudia Swan, 223–36. Philadelphia: University of Pennsylvania Press, 2005.

Swann, Marjorie. *Curiosities and Texts: The Culture of Collecting in Early Modern England.* Philadelphia: University of Pennsylvania Press, 2001.

Swart, Sandra. "Riding High—Horses, Power and Settler Society in Southern Africa,

c. 1654–1684." In *Breeds of Empire: The 'Invention' of the Horse in Southeast Asia and Southern Africa, 1500–1950*, edited by Greg Bankoff and Sandra Swart, 123–40. Copenhagen: NIAS Press, 2007.

Teensma, B. N. "Abraham Idaña's beschrijving van Amsterdam, 1685." *Jaarboek Amstelodamum* 84 (1991): 113–38.

Terrall, Mary. *The Man Who Flattened the Earth: Maupertuis and the Sciences in the Enlightenment*. Chicago: University of Chicago Press, 2002.

Terrall, Mary. "Public Science in the Enlightenment." *Modern Intellectual History* 2 (2005): 265–76.

Terrall, Mary. "The Uses of Anonymity in the Age of Reason." In *Scientific Authorship: Credit and Intellectual Property in Science*, edited by Mario Biagioli and Peter Galison, 91–112. New York: Routledge, 2003.

Thijssen, W. T. "Some New Data Concerning the Publication of 'L'homme machine' and 'L'homme plus que machine.'" *Janus* 64 (1977): 160–77.

Thomas, Ben. "Noble or Commercial? The Early History of Mezzotint in Britain." In *Printed Images in Early Modern Britain: Essays in Interpretation*, edited by Michael Hunter, 279–96. Farnham: Ashgate, 2010.

Tongiorgio Tomasi, Lucia, and Gretchen A. Hirschauer. *The Flowering of Florence: Botanical Art for the Medici*. Washington: National Gallery of Art, 2002.

Turner, Dawson. *Extracts from the Literary and Scientific Correspondence of Richard Richardson*. Yarmouth: C. Sloman, 1835.

Unverfehrt, Gerd. *Zeichnungen von Meisterhand: Die Sammlung Uffenbach aus der Kunstsammlung der Universität Göttingen*. Göttingen: Vandenhoeck & Ruprecht, 2000.

Unwin, Robert W. "A Provincial Man of Science at Work: Martin Lister, F.R.S., and His Illustrators 1670–1683." *Notes and Records of the Royal Society* 49 (1995): 209–30.

Van Berkel, Klaas, ed. *Citaten uit het boek der natuur. Opstellen over Nederlandse wetenschapsgeschiedenis*. Amsterdam: Bert Bakker, 1998.

Van Berkel, Klaas. "'Cornelius Meijer inventor et fecit': On the Representation of Science in Late Seventeenth-Century Rome." In *Merchants and Marvels: Commerce, Science and Art in Early Modern Europe*, edited by Pamela Smith and Paula Findlen, 277–96. New York: Routledge, 2002.

Van Berkel, Klaas. "The Dutch Republic: Laboratory of the Scientific Revolution." *BMGN—Low Countries Historical Review* 125 (2010): 81–105.

Van Berkel, Klaas. "De illusies van Martinus Hortensius: Natuurwetenschap en patronage in de Republiek." In: *Citaten uit het boek der natuur: Opstellen over Nederlandse wetenschapsgeschiedenis*, edited by Klaas van Berkel, 63–85. Amsterdam: Bert Bakker, 1998.

Van Berkel, Klaas. "Een onwillige Mecenas? De VOC en het Indische natuuronderzoek." In *Citaten uit het boek der natuur: Opstellen over Nederlandse wetenschapsgeschiedenis*, edited by Klaas van Berkel, 131–46. Amsterdam: Bert Bakker, 1998.

Van Binsbergen, Wim, and Peter Geschiere, eds. *Commodification: Things, Agency and Identities: The Social Life of Things Revisited*. Münster: LIT, 2005.

Van de Roemer, Bert. "From *vanitas* to Veneration: The Embellishments in the Anatomical Cabinet of Frederik Ruysch." *Journal of the History of Collections* 22 (2010): 169–86.

Van de Roemer, Bert. "De geschikte natuur: theorieën over natuur en kunst in de verzameling van zeldzaamheden van Simon Schijnvoet (1652–1727)." PhD diss., University of Amsterdam, 2005.

Van de Roemer, Bert. "Het lichaam als borduursel: kunst en kennis in het anatomisch kabinet van Frederik Ruysch." *Nederlands Kunsthistorisch Jaarboek* 58 (2008): 216–40.

Van de Roemer, Bert. "Neat Nature: The Relation between Nature and Art in a Dutch Cabinet of Curiosities from the Early Eighteenth Century." *History of Science* 42 (2004): 47–84.

Van de Roemer, Bert. "Regulating the Arts. Willem Goeree versus Samuel van Hoogstraten." *Netherlands Yearbook of Art History* 61 (2011): 184–206.

Van Eeghen, I. H. *De Amsterdamse boekhandel 1680–1725.* Amsterdam: Scheltema & Holkema, 1960–78.

Van Eeghen, I. H. "Leidse professoren en het auteursrecht in de achttiende eeuw." *Economisch-historisch jaarboek* 24 (1950): 179–208.

Van Gelder, Esther. *Bloeiende kennis. Groene ontdekkingen in de Gouden Eeuw.* Hilversum: Verloren, 2012.

Van Gelder, Esther. "Tussen hof en keizerskroon: Carolus Clusius en de ontwikkeling van de botanie aan Midden-Europese hoven (1574–1593)." PhD diss., Leiden University, 2011.

Van Gelder, J. G. "Lambert ten Kate als kunstverzamelaar." *Netherlands Yearbook of Art History* 21 (1970): 139–86.

Van Gelder, Roelof. "Arken van Noach: Dieren op de schepen van de VOC." In *Kometen, monsters en muilezels: Het veranderende natuurbeeld en de natuurwetenschap in de zeventiende eeuw,* edited by Florike Egmond, Eric Jorink, and Rienk Vermij, 35–51. Haarlem: Arcadia, 1999.

Van Gelder, Roelof. *Het Oost-Indisch avontuur: Duitsers in dienst van de VOC.* Nijmegen: SUN, 1997.

Van Gelder, Roelof. "De wereld binnen handbereik. Nederlandse kunst- en rariteitenverzamelingen, 1585–1735." In *De wereld binnen handbereik: Nederlandse kunst- en rariteitenverzamelingen 1585–1735,* edited by Renée Kistemaker and Ellinoor Bergvelt, 15–38. Zwolle: Waanders, 1992.

Vanhaelen, Angela. "Iconoclasm and the Creation of Images in Emanuel de Witte's 'Old Church in Amsterdam.'" *Art Bulletin* 87 (2005): 249–64.

Vanhaelen, Angela. "Local Sites, Foreign Sights: A Sailor's Sketchbook of Human and Animal Curiosities in Early Modern Amsterdam." *Res: Journal of Anthropology and Aesthetics* 45 (2004): 256–72.

Van Helden, Albert, Sven Dupré, Rob van Gent, and Huib Zuidervaart, eds. *The Origins of the Telescope.* Amsterdam: KNAW, 2010.

Van Hout, Nico, and Paul Huvenne, eds. *Rubens et l'art de la gravure.* Gent: Ludion, 2004.

Van Miert, Dirk. *Illuster onderwijs. Het Amsterdamse Athenaeum in de Gouden Eeuw, 1632–1704*. Amsterdam: Bert Bakker, 2005.

Van Seters, W. H. "Oud-Nederlandse Parelmoerkunst. Het werk van leden der familie Belquin, parelmoergraveurs en schilders in de 17e eeuw." *Nederlands Kunsthistorisch Jaarboek* 9 (1958): 173–237.

Van Seters, W. H. *Pierre Lyonet (1706–1789). Sa vie, ses collections de coquillages et de tableaux, ses recherches entomologiques*. The Hague: Martinus Nijhoff, 1962.

Van Strien, Kees. *Touring the Low Countries: Accounts of British Travelers, 1660–1720*. Amsterdam: Amsterdam University Press, 1998.

Van Vliet, Rietje. *Elie Luzac (1721–1796): Boekverkoper van de Verlichting*. Nijmegen: Vantilt, 2005.

Van Vliet, Rietje. "Leiden and Censorship during the 1780s. The Overraam Affair and Elie Luzac on the Freedom of the Press." In *News and Politics in Early Modern Europe (1500–1800)*, edited by J. W. Koopmans, 203–18. Leuven: Dudley, 2005.

Vasbinder, W. "Govard Bidloo en W. Cowper." PhD diss., Utrecht University, 1948.

Veluwenkamp, Jan Willem. *Archangel: Nederlandse ondernemers in Rusland, 1550–1785*. Amsterdam: Balans, 2000.

Veluwenkamp, Jan Willem. "Schémas de communication internationale et système commercial néerlandais, 1500–1800." In *Les Circulations internationales en Europe, années 1680—années 1780*, edited by Pierre-Yves Beaurepaire and Pierrick Pourchasse, 83–98. Rennes: Presses universitaires de Rennes, 2010.

Venema, Janny. *Kiliaen van Rensselaer (1586–1643): Designing a New World*. Hilversum: Verloren, 2010.

Verhoeven, Gerrit. *Anders reizen? Evoluties in vroegmoderne reiservaringen van Hollandse en Brabantse elites (1600–1750)*. Hilversum: Verloren, 2009.

Vérin, Hélène. *La gloire des ingénieurs. L'intelligence technique du XVIe au XVIIIe siècle*. Paris: Albin Michel, 1993.

Verkruijsse, Piet, and Chinglin Kwa, eds. *Aap, vis, boek: Linnaeus in de Artis bibliotheek*. Zwolle: Waanders, 2007.

Vermeir, Koen, and Dániel Margócsy. "States of Secrecy: An Introduction." *British Journal for the History of Science* 45 (2012): 153–64.

Vermij, Irene, and Jelle W. F. Reumer. *Op reis met Clara: De geschiedenis van een bezienswaardige neushoorn*. Rotterdam: Natuurmuseum, 1992.

Vermij, Rienk. "The Formation of the Newtonian Philosophy: The Case of the Amsterdam Mathematical Amateurs." *British Journal for the History of Science* 36 (2003): 183–200.

Voskuhl, Adelheid. *Androids in the Enlightenment: Mechanics, Artisans, and Cultures of the Self.* Chicago: University of Chicago Press, 2013.

Vreeken, H. "Parelmoeren plaque met mythologische voorstelling." *Bulletin van de Vereniging Rembrandt* 12 (2002): 17–19.

Vries, Jan de. *Barges and Capitalism: Passenger Transportation in the Dutch Economy, 1632–1839*. Wageningen: A. A. G. Bijdragen, 1978.

Vries, Jan de. *The Industrious Revolution: Consumer Behavior and the Household Economy, 1650 to the Present.* Cambridge: Cambridge University Press, 2008.

Vries, Jan de, and Ad van der Woude. *The First Modern Economy: Success, Failure, and Perseverance of the Dutch Economy, 1500–1815.* Cambridge: Cambridge University Press, 1997.

Vries, Lyckle de. *Jan van der Heyden.* Amsterdam: Meulenhoff, 1984.

Waegemans, Emmanuel. *De tsaar van Groot Rusland in de Republiek. De tweede reis van Peter de Grote naar Nederland, 1716–1717.* Groningen: Instituut voor Noord- en Oosteuropese Studies, 2013.

Wallach, Van. "Synonymy and Preliminary Identifications of the Snake Illustrations of Albertus Seba's *Thesaurus* (1734–1735)." *Hamadryad* 35 (2011): 1–190.

Wax, Carol. *The Mezzotint: History and Technique.* New York: Harry N. Abrams, 1990.

Weale, John. "Progress of Machinery and Manufactures in Great Britain, from the Saxon Era to the Reign of Queen Anne." *Quarterly Papers on Engineering* 5 (1846): 1–234.

Weiss, Brad. "Coffee, Cowries, and Currencies: Transforming Material Wealth in Northwest Tanzania." In *Commodification: Things, Agency and Identities: The Social Life of Things Revisited,* edited by Wim van Binsbergen and Peter Geschiere, 175–200. Münster: LIT, 2005.

Werrett, Simon. "An Odd Sort of Exhibition: The St. Petersburg Academy of Sciences in Enlightened Russia." PhD diss., Cambridge University, 2000.

Weststeijn, Thijs. *The Visible World: Samuel van Hoogstraten's Art Theory and the Legitimation of Painting in the Dutch Golden Age.* Amsterdam: Amsterdam University Press, 2008.

Wettengl, Kurt, ed. *Maria Sibylla Merian, 1647–1717: Artist and Naturalist.* Ostfildern: G. Hatje, 1998.

Wigelsworth, Jeffrey R. *Selling Science in the Age of Newton: Advertising and the Commoditization of Knowledge.* Farnham: Ashgate, 2010.

Wijnands, Onno. *Een sieraad voor de stad. De Amsterdamse Hortus Botanicus 1683–1983.* Amsterdam: Amsterdam University Press, 1994.

Wilson, Catherine. *The Invisible World: Early Modern Philosophy and the Invention of the Microscope.* Princeton: Princeton University Press, 1996.

Winterbottom, Anna. "Company Culture: Information, Scholarship, and the East India Company Settlements, 1660–1720." PhD diss., University of London, 2011.

Winterbottom, Anna. "Using the *Hortus malabaricus* in Seventeenth-Century Madras." In *Plant Diversity, Morphology, Taxonomy & Ethnobotany: An Introspection,* edited by Muktesh Kumar. Calicut: University of Calicut Press, in press.

Witcombe, Christopher L. C. E. *Copyright in the Renaissance: Prints and the Privilegio in Sixteenth-Century Venice and Rome.* Leiden: Brill, 2004.

Witt, H. C. D. de, ed. *Rumphius Memorial Volume.* Baarn: Hollandia, 1969.

Wladimiroff, Igor. *De kaart van een verzwegen vriendschap: Nicolaes Witsen en Andrej Winius en de Nederlandse cartografie van Rusland.* PhD diss., Rijksuniversiteit Groningen, 2008.

Wolf, Gerhard. "From Mandylion to Veronica: Picturing the 'Disembodied' Face and Disseminating the True Images of Christ in the Latin West." In *The Holy Face and the Paradox of Representation*, edited by Herbert L. Kessler and Gerhard Wolf, 153–80. Bologna: Nuova Alfa Editoriale, 1998.

Wolters van der Wey, Beatrijs. "A New Attribution for the Antwerp Anatomy Lesson of Dr. Joannes van Buyten." *Journal of Historians of Netherlandish Art* 1 (2009). http://www.jhna.org/index.php/past-issues/volume-1-issue-2/108-antwerp-anatomy-lesson.

Wood, Christopher S. *Forgery, Replica, Fiction: Temporalities of German Renaissance Art.* Chicago: University of Chicago Press, 2008.

Woodmansee, Martha. *The Author, Art, and the Market: Rereading the History of Aesthetics.* New York: Columbia University Press, 1994.

Wragge-Morley, Alexander. "Connoisseurship and the Making of Medical Knowledge: The Case of William Cheselden's *Osteographia* (1733)." Unpublished research article, 2013.

Wragge-Morley, Alexander. "Knowledge and Ethics in the Work of Representing Natural Things, 1650–1720." PhD diss., University of Cambridge, 2011.

Wuestman, Gerdien. "The Mezzotint in Holland: 'easily learned, neat and convenient.'" *Simiolus* 23 (1995): 63–89.

Yale, Elizabeth. *Script, Print, Speech, Mail: Communicating Science in Early Modern Britain.* Philadelphia: University of Pennsylvania Press, forthcoming in 2015.

Zandvliet, Kees. *De 250 rijksten van de Gouden Eeuw.* Amsterdam: Rijksmuseum, 2006.

Zilsel, Edgar. "The Sociological Roots of Science." *American Journal of Sociology* 47 (1942): 544–62.

Zuidervaart, Huib. "Het in 1658 opgerichte theatrum anatomicum te Middelburg." *Archief* (2009): 74–140.

INDEX